Romanesque

Editor: Rolf Toman
Text: Ulrike Laule • Uwe Geese
Photographs: Achim Bednorz

Feierabend

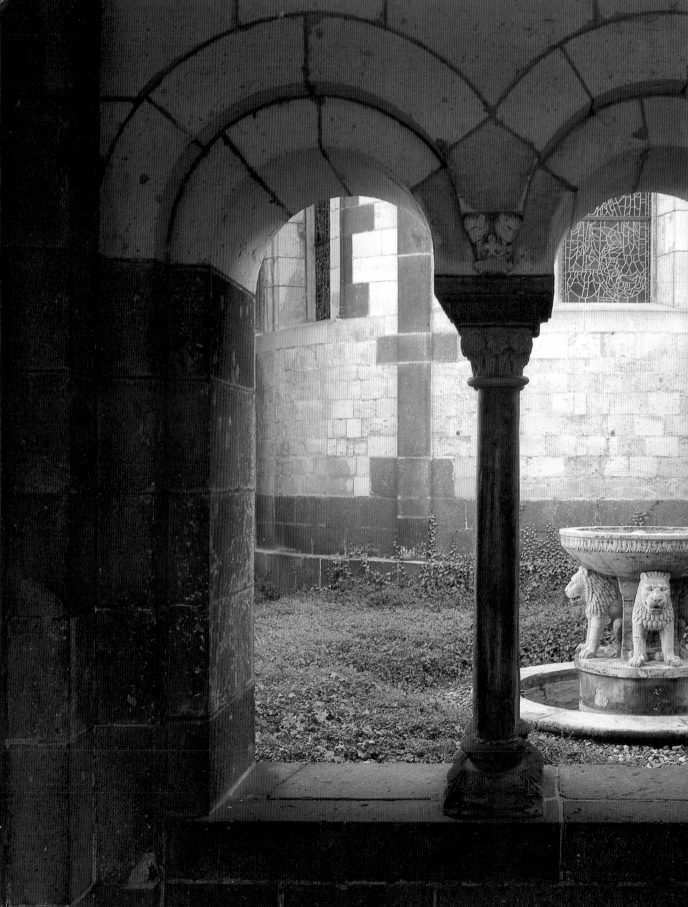

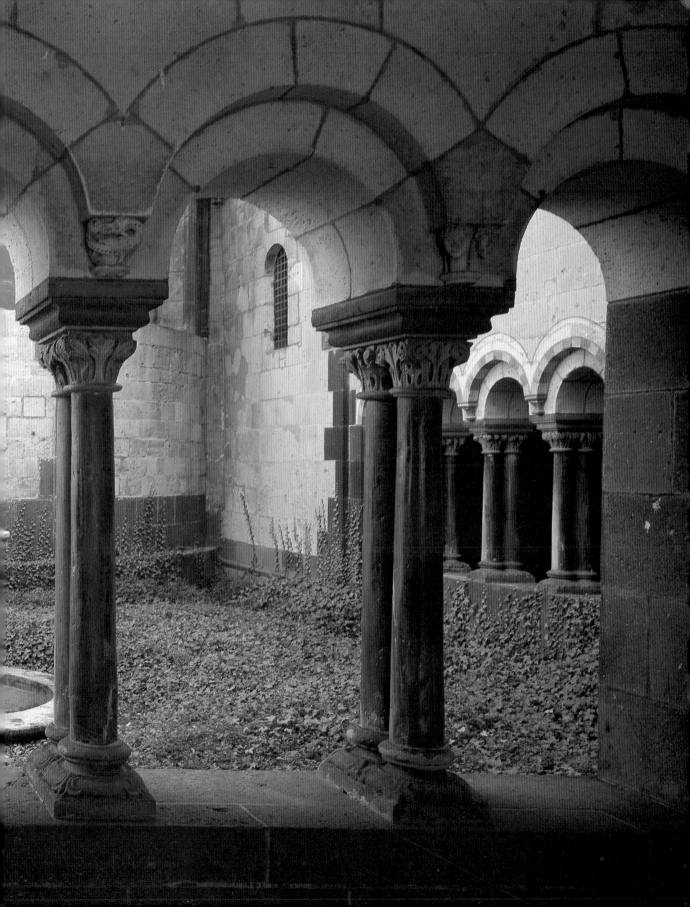

Content

Front cover:
Speyer, St Maria and St Stephan
Cathedral, detail of the crypt
(see page 51)

Back cover:
Evangelary of Henry the Lion
(see also page 222)

Preceding spread:
Maria Laach, Paradise with
Lion Fountain

Introduction

The indefinable charm of the Romanesque heritage is especially strong in the many churches of the period (c. 1000–c. 1250). Its principal sources are the simultaneous purity and variety of the stonework, and the often magnificent locations, not only of the monasteries, but also of the smaller country churches. The serenity emanating from these historical locations affects us, as well. At Fontenay (Burgundy), Silvacane, or Le Thoronet (both in Provence) the spirit of the Cistercians seems to speak directly to us through the simplicity and clarity of their architectural achievements. Visiting these places in winter, it is easy to develop a greater appreciation for the ascetic diligence the monks practiced in braving the cold and darkness. The deprivations of their intimate quarters become clear when we stand in an empty dormitorium and imagine all the beds lined up in rows in this space where the monks took their precisely measured allotment of sleep … Not for me, we might say as we drive away from the old monastery walls in our well-heated car.

How distant those times are! Yet the number of years—30 generations—is less significant than the enormous differences between then and now in terms of living conditions and ways of thought.

What do we know today about a medieval monk's requirements for his sleeping area? The common sleeping hall might have suited him just fine, perhaps helping him to resist the vice of laziness and the demon of fornication. And what of his delight in the beauty of the surrounding countryside? Only through great effort could he and his brother monks wrestle a tolerable living space out of implacable Nature. Establishing a civilized area was hard work! Our ability to experience the lifestyle and mindset of people from that time is unreliable and truncated: There is so much we simply don't know, and this leads to false assumptions and misinterpretations of the medieval material.

A good example of this can be seen in the "Steinsichtigkeit" (bare stone) of most Romanesque churches today, which impresses us with its sobriety and evokes a sense of gravity and dignity. In fact, much of the interior surface was originally covered with paintings. In this case, as in so many others, numerous fragments of historical, sociological, and especially philosophical data are useful and revealing. This is what we hope the readers of this book will find—alongside the art history—if they hope to do more than simply enjoy the beautiful illustrations.

Regarding the medieval construction site, which is only mentioned occasionally in the architectural sections of the book, we have this to say: Attentive readers of the Bible will note just how many images and terms are derived from the building trades. Apparently, architecture and the process of building have played an enormously important role in society from the earliest times. This hardly changed during the Middle Ages, when visual and written sources continued to paint a vivid picture of the goings-on at large construction projects.

Once the foundations of a structure were laid, building materials had to be obtained. Accounts tell of Louis the German having the city walls of Frankfurt and Regensburg torn

Serrabone, Notre-Dame, capital of the singer's tribune, late twelfth century

P. 6: **Near Tarascon, Chapel St-Gabriel,** c. 1200, western facade

7

Above: **St-Savin-sur-Gartempe,** detail of fresco: the tower of Babylon

P. 9: **Maria Laach, abbey church,** western facade, finished 1156

Below: **The tower of Babylon,** from Hrabanus Maurus, *De originibus*, 1023, Monte Cassino

Below: **Medieval construction site,** drawing after a thirteenth century bible illustration, Manchester

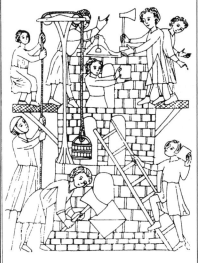

and forge-stokers. Their implements and occupations are recorded in innumerable images. Wooden scaffolding, the norm for construction sites until the advent of steel frameworks in the twentieth century, appears to have come into use north of the Alps in the mid-fourteenth century. Before that time, staging brackets were affixed to the top course of a wall to create a work surface that would be moved upward as the wall was built higher. Stretchers, trays, and baskets were used to deliver materials, presumably over a system of ramps. Cranes also came into use during the second half of the twelfth century. It's not hard to imagine the effort and perils involved in large-scale construction work during the Middle Ages—an undertaking that involved the whole community! For building God's house was part of the plan for salvation, and anyone who participated in this sacramental activity—whether by donating materials or with physical labor—received the Grace of God. The very process of building a church possessed an element of holiness.

Thus, if one were to highlight a single perspective from which to consider the artistic and other cultural phenomena of the Romanesque period, it would have to be the religious viewpoint, that is, the axiomatic Christianity that permeates and underpins all its works and deeds.

down to provide building materials for his endowments to those cities. Elsewhere, for example during the 1192 construction of Lyon Cathedral, marble and limestone were brought from the Forum of Trajan in nearby Fourvière. At the time, buildings from Antiquity were popular sources of quarrying materials.

Then began the work of myriad stonecutters, bricklayers, sculptors, mortar-mixers, stone polishers, whitewashers, carpenters, tilers, day laborers, gofers,

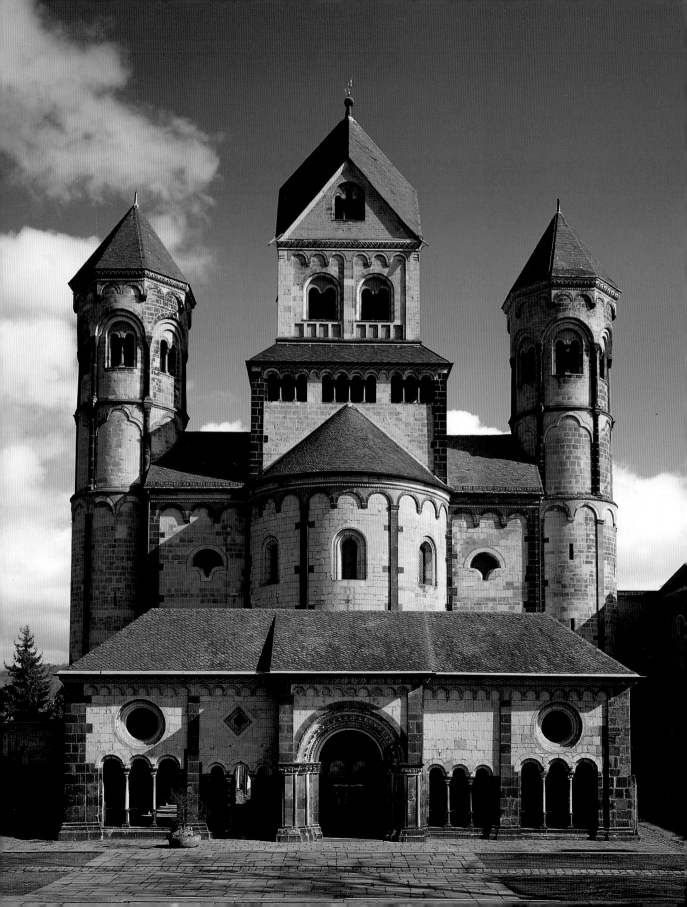

Charlemagne and the Carolingian Educational Reform

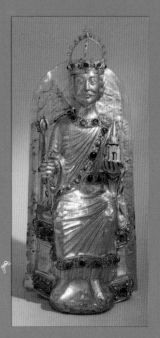

With its reversion to Roman forms, the Romanesque typifies medieval tradition. Even in Carolingian art—that of the Frankish Empire between c. 780 and 900—we see ties to Ancient Roman and Early Christian forms, as demonstrated by the Aachen Palace Chapel (illus. below). For this project, Charlemagne had spolia specially brought from Rome and Ravenna. This, along with his other rulings and sanctions, was of art-historical and cultural consequence. These are some of the more important events in his rise to become the mightiest ruler of his time: Born April 2, 747, he was the son of Pippin III, King of Franconia and Bertha, an earl's daughter. On Pippin's death in 768, his sons Charlemagne and Carloman inherited; when the latter died three years later, Charlemagne claimed all of Franconia as his own, disregarding the title of Carloman's sons. In 772 the 33-year-long war against the Saxons began. From 773 to 774 Charlemagne resumed the war his father had begun with the Lombards, finally capturing their capital city and declaring himself their king. At Rome he assumed the protectorate of Vatican City. In 788 he deposed Duke Tassilo III of Bavaria for allegedly conspiring with the Avars, turning the dukedom into a Frankish province. A war against the Avars three years later ended in 795 with the expansion of the Frankish sphere of influence out to Lake Balaton. The year 800 saw Charlemagne crowned Holy Roman Emperor by Pope Leo III in St Peter's Cathedral; he died 14 years later in Aachen, and his son Louis (the Pious) inherited the realm.

Charlemagne waged his wars against the Saxons and Avars with the additional objective of expanding Christendom. With its close ties to the papacy, his empire at its height rivalled those of Byzantium and Islam.

Charlemagne strengthened the internal organization of this empire by intensification of the public administration system and codification of statutory policies. He traveled about with his royal household, maintaining a presence in many places and exercising his authority locally, as was

Shrine with figure of Charlemagne as ruler, c. 1215, Aachen, cathedral treasure

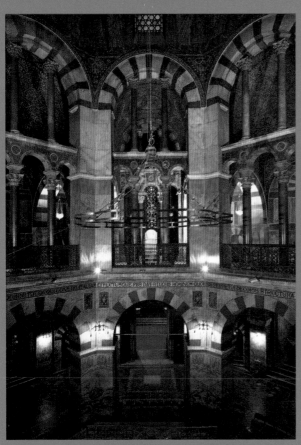

Aachen, Palace Chapel of Charlemagne, interior view of the octagon, finished in 798, decoration of the interior Wilhelminian

Aachen, Palace Chapel of Charlemagne, throne of Charlemagne

customary during the Middle Ages. After 794, however, he effectively made Aachen his residence, holding regular assemblies and synods there.

Charlemagne was a great reformer in many areas, and a prime example is his "cultural policy." Continuing the Franconian Church reform initiated by Pippin, he brought about liturgical innovations and emphasized the educational development of the clergy. Going further, he broadened this approach by advancing an educational program for the whole of Franconia. From 777 onward, he worked to draw scholars from near and far to his court—Lombards, Visigoths, Irishmen and Anglo-Saxons (a representative of the latter being Alcuin, the greatest scholar of his time). From 782 onward, the core of this illustrious circle of scholars was established. Their task was to set up a library and teaching facility at court, and this eventually became a focal educational institution, attracting all the brightest pupils. Alcuin himself wrote authoritative textbooks, and new schools were created on the model of the court school. Through "capitularies"— decrees and ordinances concerning legislation or religious instruction—the major churches and monasteries of the realm were given the duty of fostering and spreading education.

Among the more important of Charlemagne's educational endeavors was the implementation of a new script called the Carolingian Minuscule (see p. 223). This reform and standardization in writing came in conjunction with modification of the Latin language during the revision of older works— as for instance in Alcuin's emendation of the Old and New Testaments. "The well-known *Epistola de litteris colendis*, a circular composed by Alcuin, set out the principles that formed the basis of these endeavors and that made them essential in the judgment of Charlemagne and his aides. They were predicated on the conviction that virtuous living (*recte vivere*) and virtuous speech (*recte loqui*) go together ..."

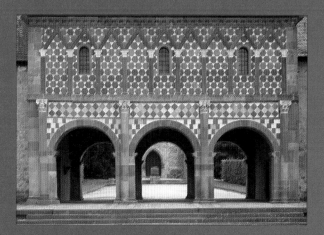

Lorsch, gateroom
of the former Carolingian abbey, 774

(J. Fleckenstein). The compilation and emendation of the Latin tradition familiar in that era—the works of the Church Fathers and of authors from Antiquity— traces back predominantly to the efforts of Carolingian scholars. Monks transcribed these originals so they could be incorporated into the collections of other libraries, leaving a sizable legacy for European intellectual life over the centuries that followed. Finally, the works authored by the court scholars themselves—the poems of Theodulf, Angilbert, and Modoin; or Einhard's *Vita Karoli Magni*—were some of the key works in what is called the "Carolingian Renaissance."

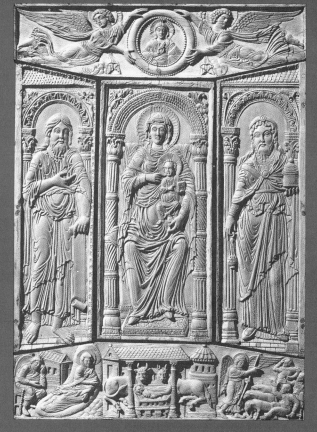

Former back cover of the Lorsch Evangelary,
c. 810, London, Victoria and Albert Museum

11

Emperor and Pope—
Two Powers in Conflict

When Charlemagne went to Rome for the first time in 794, he was received with great pomp. He came as the savior of the pope and Rome against the menace of the Lombards. Although his crowning as Holy Roman Emperor in the year 800 was arranged by Pope Leo III to ensure the unreserved support of the Frankish king, it actually marked the decline of the pope's worldly influence. Charlemagne exercised his increased power without sharing it, to the point of eclipsing the pope. With the growing Christianization of the early Middle Ages, the Frankish theocracy developed the notion of Divine Right. This signified the heavenly ordination of the king over his subjects, and incorporated his dominance over the Church. The anointing of a king, first practiced during Frankish times, was the symbolic expression of this Divine Right. The Carolingian theocracy, with its characteristic ties between politics and Christian mission, was perpetuated through the Ottonian and Salian emperors' reinforcement of the Imperial Church system. From 937 onward, German rulers were able to exert their authority on the selection of bishops and abbots in their empire's dioceses and monasteries. Their approval was a decisive factor,

and the investiture—in which the emperor conferred the crosier on the new bishop or abbot—was the ceremonial representation of imperial authority over the Church. The imperial church system demonstrates the privileged selection of the high-ranking ecclesiastics, who maintained their position by keeping their interests in line with those of the Crown. The reign of Henry III (1039–1056) is considered the zenith of the Germanic Holy Roman Empire. He more or less appointed himself the pope's overseer, deposing in his time three popes, designating a German bishop as occupant of the Holy See, and taking on the task of reforming the Church. After his untimely

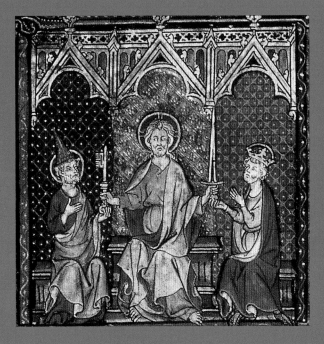

Christ hands the key to the pope and the sword to the emperor, miniature, twelfth century

death in 1056, however, this venture took an unexpected turn when, two decades later, his son Henry IV traveled cap in hand to Canossa to petition Pope Gregory VII to lift his excommunica-

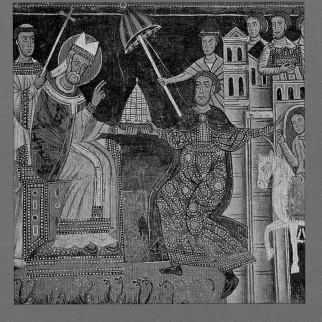

tion. Canossa became such a strong symbol of papal power over a sovereign that, even today, "to go to Canossa," (nach Canossa gehen) is a common German expression meaning to eat humble pie. How did things reach this point? Henry IV was only five when his father died, resulting in a decade-long power vacuum that weakened the monarchy. Rome used that time to establish the cause of Church Reform, which culminated in a radical stance by Gregory VII: He forbade the investiture of bishops

Donation of Constantine, fresco, twelfth century, Rome, Quattro SS Coronati

or abbots by the king, condemned lay occupation of ecclesiastical office, and rejected the Divine Right of the Emperor. This marked the height of papal power. Gregory VII took upon himself the notion that the pope alone should possess imperial majesty. "Concerning the source of this entitlement there can be no doubt. It is the Donation of Constantine, that unlimited privilege granted Pope Silvester I (314–335) by Emperor Constantine (d. 337) on relocating from Rome to Byzantium, by which he is said to have conferred various ceremonial, territorial and sovereignly rights upon the pope" (H. Fuhrmann). The Donation of Constantine, actually dating from between the mid-eighth and mid-ninth centuries, is perhaps the most famous forgery of the early Middle Ages: a counterfeit document with major political consequences, since it continued to serve through the late Middle Ages as the rationale for papal primacy.

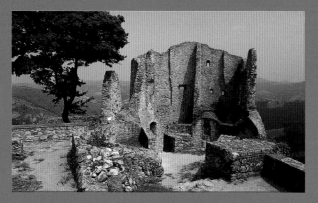

Canossa, castle ruins, mid-tenth century

To return to Henry IV and Gregory VII, the contest between kingship and papacy was sparked by a specific event: the appointment of a royal chaplain as Archbishop of Milan. Henry reacted to papal disapproval by deposing the pope; Gregory countered by excommunicating Henry. As a result, the German nobility distanced itself from the king, putting him on the defensive. His supplication at Canossa did indeed bring about the lifting of his excommunication, but the sacral dignity of the monarchy suffered lasting harm.

The question of investiture concerning the installation of higher clerical dignitaries found its solution in the Concordat of Worms (1122). But the Investiture Controversy had an even more significant impact. It resulted in a new perception of the relationship between *regnum* (worldly dominion) and *sacerdotium* (sphere of ecclesiastical power). Their unification during the theocratic empire of the early Middle Ages gave way to a dualism of powers in Gregory VII's time that set the trend right through to the end of the Middle Ages. The frequent political disputes of that period were often sparked by papal claims of primacy.

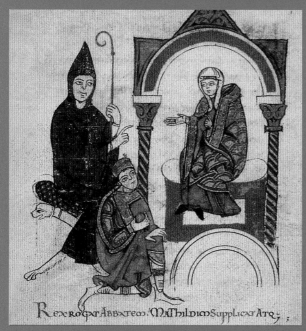

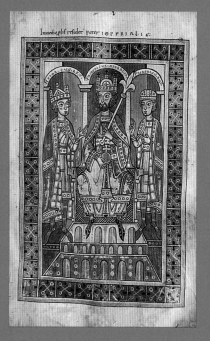

Emperor Henry VI asks Countess Mathilde of Tuscany and Abbot Hugo of Cluny to mediate for him with Pope Gregory VII, miniature, c. 1114/1115, Rome, Biblioteca Vaticana, Cod. Vat. lat. 4922, Folio 49r.

Emperor Frederick I Barbarossa and his sons, from the Chronic of the Guelfs of Weingarten, c. 1100

Medieval Hierarchies and the Concept of the Three Estates

Pictured on the right is Otto III (983–1002) with crown, scepter and orb; on either side of him we see two dignitaries each from the ecclesiastical and secular domains. Rarely have the dignity and eminence of imperial majesty been so vividly portrayed. For the emperor stood at the apex of the secular hierarchy, followed by kings, who, through the act of anointing, had been singled out from the ranks of nobility by grace of God to be rulers over their subjects. The princes, in turn, formed the upper stratum of the aristocracy and so on, as laid out in the familiar pyramidal diagram of medieval society. The pope, cardinals, bishops, abbots, deans, and pastors composed the corresponding hierarchy on the clerical side. In the effort to classify people's status and importance, still other distinctions of social rank were made. Christians were classified according to lifestyle as married, chaste, or dedicated celibate, the understanding being: good, better, best.

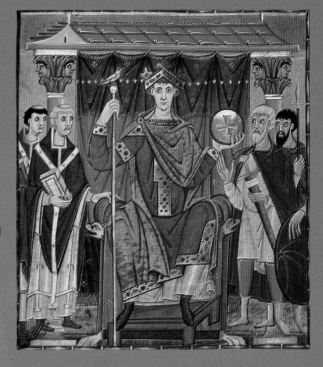

Otto III with staff and imperial orb, Evangelium of Otto III, end tenth century

Were the Middle Ages really as socially immobile as is thought? From the above example of clerical ranks, one can infer that a bishop would not have been born as such, but was chosen for his office, thus suggesting there was such a thing as a "career" in those days. Opportunities for advancement may have come from military achievement, financial influence or intellectual merit. Still, one cannot deny a certain rigidity in the structure of medieval society, as underscored by the numerous tenets, ser-

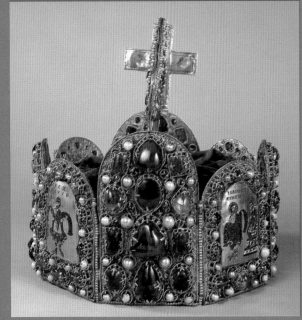

The imperial crown of the German emperors, last third of the tenth century, Vienna, Imperial Treasury

Cleric, farmer, and knight, stone reliefs from the former Cistercian monastery in Jerpoint, Ireland

mons, and codes regarding class, with all their normative rules of conduct befitting one's station.

Soon after the year 1000, the notion of a functionally tripartite society became increasingly common. One of the best-known formulations of this concept comes from Bishop Adalbero of Laon in the 1020s: "The house of God, which appears as one, is threefold. Here on Earth, some pray (*orant*), some fight (*pugnant*), and some work (*laborant*). These three belong together and are not separated. Thus on the work (*opera*) of one rests the achievement (*officium*) of the two others; each one in turn helps all."

One finds references to the three "estates" or classes: church, nobility, and peasantry; or clerics, knights, and farmers. Beginning in the tenth century, this trinitarian view of society superceded the traditional two-part division of spiritual and worldly (clerics and laity), and persisted through the end of the Middle Ages. It did not, however, take into account the differentiations within each class, nor did it include the bourgeoisie, merchants, scholars, and artists who entered the social arena during the gradual urban development of the later Middle Ages.

The dream of King Henry I, Chronicle of John of Worcester, c. 1130–1140

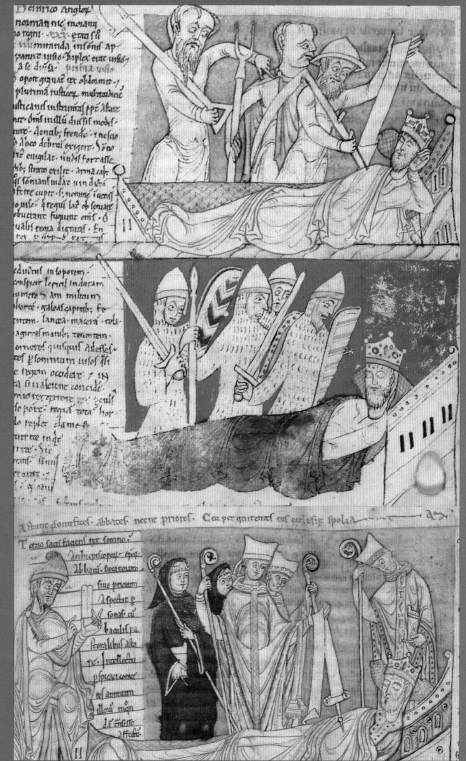

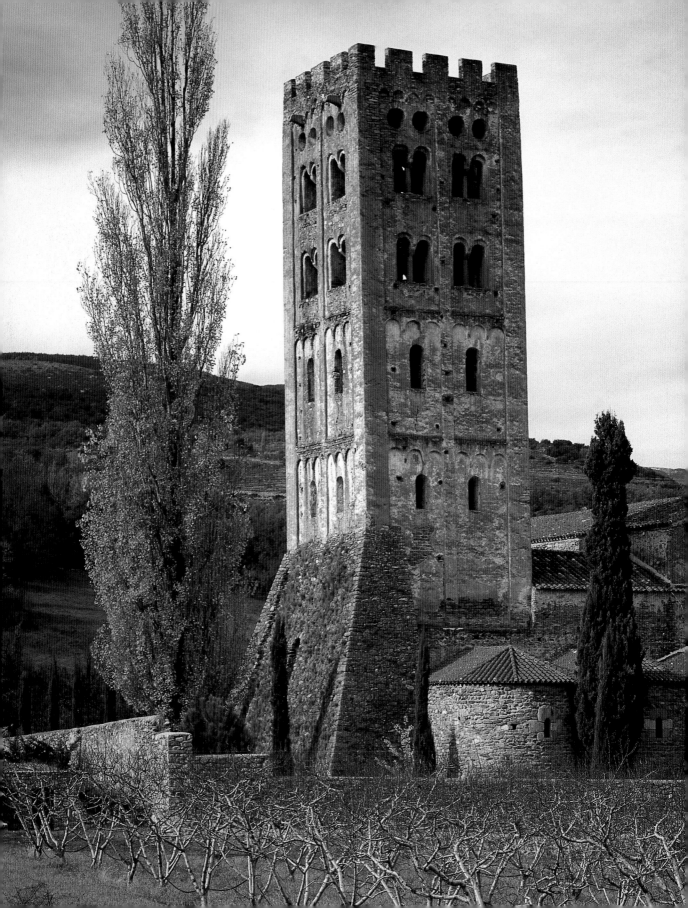

Monasticism in Romanesque Times

Along with educational reforms, Charlemagne targeted the organization of clerical life, a policy carried forward by his son Louis the Pious (814–840). Among the measures he took was a reorganization of the monastic system. His most important helper in this effort was Benedict of Aniane (the "Second Benedict," c. 750–821), abbot of a large monastery near Montpellier, France. His reform aspirations centered on making implementation of the Benedictine Rule mandatory for all monasteries. The Benedictine Rule was originated by the "First Benedict," Benedict of Nursia (c. 480–c. 560), the father of Western monasticism. Imperial legislation and awarding of privileges contributed decisively to the success of this unification. From 816 until well into the high Middle Ages, monastic life could occur only where the Benedictine Rule was recognized as the fundamental monastic law; in other words, monasticism and Benedictinism were one and the same. In addition to confraternities of monks, there were the convents of canons. Canons were members of chapters associated with a cathedral or collegiate church. They followed a less strict regime than the Benedictines,

St-Michel-de-Cuxa, abbey church, completed c. 1040

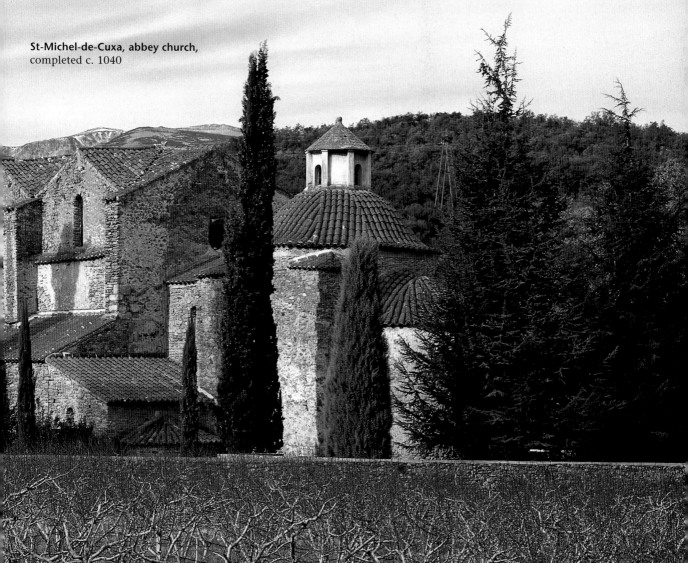

whose monks would pledge—besides obedience to their superiors—to inhabit the monastery permanently and to renounce forever the ways of the "world."

Louis' reform was the impetus behind monasticism's increasing prominence in western Christendom. In terms of religious status, its great period lasted from the ninth through the end of the eleventh centuries. The number of monks and nuns reached their peak between 1150 and 1300, but other social groups and institutions were gaining in importance at this time, and from the end of the twelfth throughout the thirteenth century, monastic influence declined markedly.

The history of monasticism is ever one of reforms. The Rule of Benedict was never standardized, nor was it always strictly followed. In supplemental regulations known as *consuetudines*, specific customs or procedures were defined for monastery life; these supplemental regulations sought to address points Bene-dict had either omitted or not covered thoroughly. The particulars would naturally differ between communities and were in some cases quite hotly debated. A functioning monastic community led by a strong and persuasive abbot could become a role model for other monasteries, making its own *consuetudines* the basis for a sweeping reform. An outstanding example of this is at Cluny, in Burgundy (see pp. 22–25). The reforms instituted there contributed greatly to the splendor of monasticism in the tenth and eleventh centuries. Other such centers included Brogne, Gorze, and Einsiedeln. These communities developed ways of life so widely admired that other abbeys were founded or reorganized according to their principles.

What kind of person sought out the monastic existence? Many came from the aristocracy, and were wealthy or at least well off; thus it was often those with the most freedom to indulge in earthly pleasures who chose to renounce them. However, there were also many people in monasteries who had not chosen that life. This was due to the centuries-old parental practice of "consecrating" a son or daughter to the convent when he or she was still only a child. Aside from religious reasons, this was often done as a means to avoid having to divide the family inheritance into too many portions. At the age of around 15, these abbey pupils would become monks and nuns, with little knowledge of life outside the convent or monas-tery. Others would enter a monastery late in life, in time to atone for their sins. Since this choice required abandonment of personal possessions, the admission of those who "came late to the calling" often involved substantial endowments to the monastery.

Toward the end of the eleventh century and above all during the twelfth, a further wave of reforms came about as a reaction to some monastic communities becoming too rich or straying too far from austerity. A return to former hermitic ideals on one hand and the ideal of poverty on the other lead to the founding of new orders: the Camaldonians, the Cartusians and the Premonstratensians (or Norbertines), among others. Unquestionably, the most significant among these were the Cistercians. They became the colonizers of the undeveloped regions of eastern and northern Europe, and had many filiations (daughter monasteries) stretching out as far as the British Isles, Italy and the Iberian peninsula. Saint Bernard of Clairvaux (1090–1153) is the prominent figure from this order. An enigmatic personality, Bernard was an ascetic monk and the most influential churchman of his time, referring to himself as the "Chimera of his century."

Above left: **S Juan de la Peña,** eleventh and twelfth centuries, youth being consecrated to a monastery; a bishop receives his dowry.

P. 19: **St-Martin-du-Canigou,** monastic complex in the Pyrenees

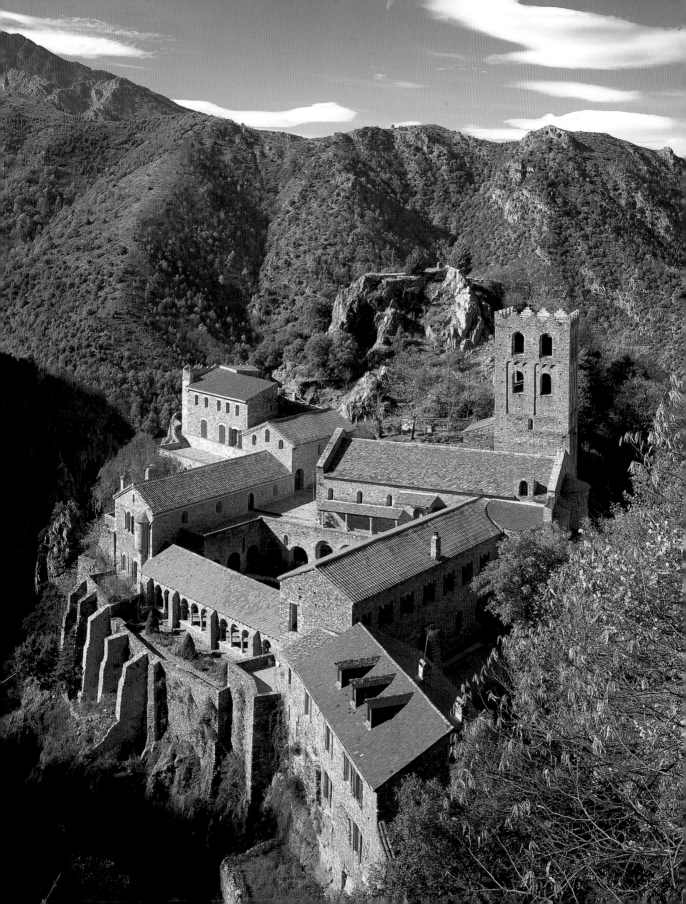

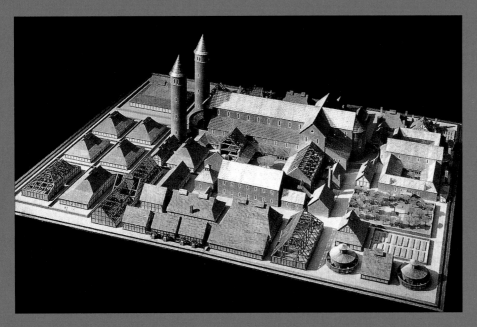

Abbey of St Gall,
model built according
to the plan of c. 820

The St Gall Monastery Plan

The abbey library at St Gall houses a document designated Codex 1092, and known worldwide as the St Gall Monastery Plan. Labeled in informative detail, the plan gives a comprehensive layout for a monastery. It was produced c. 827–830 at the important abbey of Reichenau, commissioned by Abbot Heito I (806–822) and Reginbert the librarian (c. 820–c. 845) and sent to Abbot Gozbert of St Gall, where a life of St Martin was added to it in the twelfth century. Under abbots Waldo (786–806) and Heito I Reichenau Abbey became one of the most important monasteries of the Carolingian empire, its abbots holding prominent positions in the court of the German kings and emperors.

Along with Heito, two Reichenau monks took part in Emperor Louis the Pious' reform synod at Aachen, copying out a certified version of the Rule of Benedict. A transcript of that text, originating at St Gall in 830 and applying to the entire western world, is today the oldest and most important version of the rule left to us. This Rule of Benedict and the Carolingian layout of Reichenau Abbey itself served as the basis for the St Gall Monastery Plan, which is thought to be the blueprint for the

Reichenau-Mittelzell, St Mary and St Mark Cathedral, view of the nave from the western transept

ideal Benedictine abbey. Abbot Gozbert of St Gall was organizing the renovation of his abbey at that time, and it is likely that Heito's plan was sent to him as an instructional aid since the inscriptions refer to the planned construction at St Gall. The grounds there are rectangular, with the spacious church

structure centered east-west, but pushed northward so that the cloister, adjoining the south side of the nave, is located more or less in the middle of the complex.

The church of St Gall has a nave and two aisles. At the west end are two free-standing round towers flanking a double-aisled western apse as wide as the building—possibly conceived as an atrium—which contains a smaller apse matching the width of the choir to the east. Moving eastward past the nine bays of the nave, we come to a three-part extended transept, and a square choir bay elevated by six or seven steps leading to a somewhat narrower apse. The choir bay is flanked by two rooms that add depth to the transept. On either side of the crossing one sees

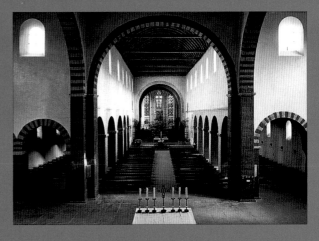

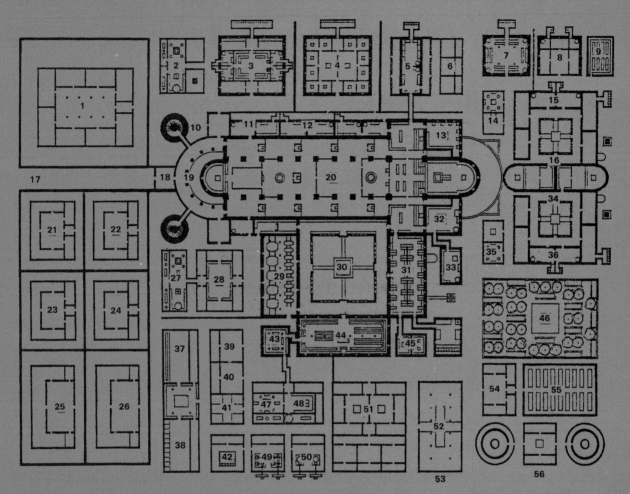

a pair of passages that apparently run along the walls of the choir bay and turn ninety degrees to meet under the choir. This is probably the entrance to the crypt, which would have allowed pilgrims to come and go without disturbing choir activities.

This arrangement is reflected at the cathedral of Our Lady in Constance (although this lacks an eastern apse because of the terrain, and its west end was never begun). The cathedral was

founded c. 810/820 or later by Bishop Wolfleoz, and after 904 Bishop Salomon III extended it with a passage-crypt in accordance with the St Gall plan. At Reichenau-Mittelzell, which rivalled Constance and also followed the St Gall plan, the westwork was actually built.

Above: **St Gall, Abbey Library, Ideal Abbey Plan,** made in the early ninth century on the island of Reichenau

1 VIP retinue quarters; 2 VIP kitchen, cellar, bakery & brewery; 3 VIP quarters; 4 External school; 5 Abbot's quarters; 6. Abbot's kitchen, cellar, bath; 7 Bloodletting and purging building; 8 Doctor's house and apothecary; 9 Herb garden; 10 Bell tower; 11 Porter; 12 School headmaster's house; 13 Library; 14 Bath and infirmary kitchen; 15 Hospital; 16 Cloister; 17 Entrance; 18 Entrance hall; 19 Choir; 20 Abbey church; 21 Servants' quarters; 22 Sheep fold; 23 Pigsty; 24 Goat pen; 25 Mares' stable; 26 Cow barn; 27 Visitors' kitchen; 28 Visitors' hostel; 29 Store-

room and wine cellar; 30 Cloister; 31 Monks' dormitory and warm room; 32 Sacristy; 33 Host bakery; 34 Cloister; 35 Kitchen; 36 Novices' school; 37 Horse stable; 38 Oxen barn; 39 Cooperage; 40 Lathe-turner's workshop; 41 Store-house; 42 Oast-house; 43 Monks' kitchen; 44 Monks' refectory; 45 Monks' bath house; 46 Cemetery; 47 Brewery; 48 Bakery; 49 Pestle and mortar house; 50 Mill; 51 Workshops for various craftsmen; 52 Threshing floor; 53 Granary; 54 Gardener's quarters; 55 Vegetable garden; 56 Poultry-keeper's house & hencoops

The Cluniacs and Monastic Reform

Reichenau was privileged in that it was not plagued by the perils facing most western monasteries during the late ninth and early tenth centuries. It was not exposed to the Viking predations on the northern and western sections of the empire, and it remained unscathed by the Huns' penentration into Burgundy. In the power vacuum left by the collapsing Carolingian empire, a monastery needed military protection. This would come from troops belonging to a secular or episcopal patron, who as owner was in return permitted to reap any profits from the economic activities of the monastery. Under these conditions, it became ever more difficult for the monks to live according to their customs. In those days, the continual desire for reform led to the founding of countless new monasteries that frequently succumbed to the above-mentioned difficulties. Thus, conditions were rather unfavorable when in 909 or 910 Duke William the Pious of Aquitaine endowed a monastery in honor of the apostles Peter and Paul, donating for it an estate in Cluny, Burgundy. In order to protect this endowment from any interference by an owner, he waived all rights for himself and his heirs, handing them over to the control of the

Holy See. By doing so, he revoked his protection of the young community, but sought to offset this by placing it under the protection of the apostles Peter and Paul—whom he called "glorious princes of Earth"—and by entrusting it to the "bishop of the bishops of the Holy Apostolic See"—in other words, the pope. In addition, he declared the purpose of the endowment: to safeguard salvation and physical well-being for himself, his family, his lords, King Odo and "all our faithful and devoted servants," for the continued existence and integrity of the Catholic faith, and for all believers in Christ—past, present and future. He also formulated duties, namely, "to perform each day deeds of charity for the poor, the needy, strangers and most especially pilgrims who came there."

Finally, William named Cluny's first abbot, Berno, whose successors would

thereafter be chosen by the brothers in free and independent elections. Berno came from Burgundian nobility and had already endowed a monastery in Gigny where, contrary to the custom of the day, he presided as abbot; and where they adhered so strictly to St Benedict's Rule that monks abandoned their own abbeys to enter his. Berno appears to have earned his reputation already as a reformer when William selected him, and during the 17 years of his abbacy, six more abbeys were presented to Cluny. However, it was apparently not Berno who wrote up the articles of incorporation that were so exceptional in both form and content, but his successor Odo, elected by the monks in 927. Odo's goal was to build a single large confraternity of all Christians, bringing together monks and laymen in the spirit of the Early Church. In his biography of Count Gerald of Aurillac, Odo created the image of the

"saintly layman," who, while carrying out his worldly duties, secretly lived the life a monk, renouncing violence and giving generous alms to the poor. In this way, Odo strongly advocated lay responsibility for protection of the abbey and benevolence to the needy. His own biographer, John of Salerno, gives an account of just how successful Odo was: a good friend of kings, on very close terms with bishops, and beloved by the great men of the world.

To ensure the security of his steadily growing cadre of abbeys, Odo maintained a tight network of promotion and protection through clerical and secular rulers. More than ten papal and five royal charters originated during his time, placing the group on a solid legal foundation. In 942, Aymard, Odo's deputy of several years, succeeded him. During his short tenure—he stepped down in 954 because of blindness—

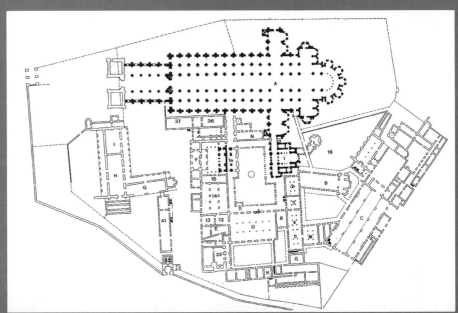

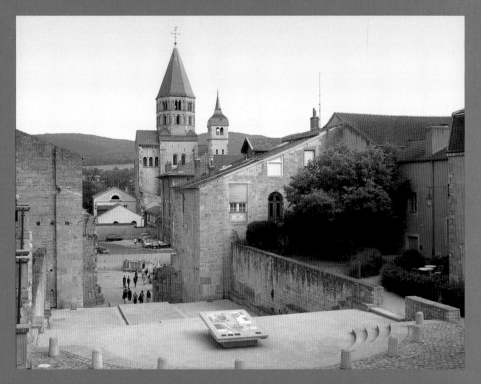

disrupting internal affairs at his home institution. This speaks volumes for the trust between him and his brothers. It was also Maiolus who established ties with the Ottonian court. Twice he was awarded high office: once when Otto I offered him custody of the empire's monasteries in Italy and Germany, and again when Otto II and Adelaide nominated him pope. He declined in both cases, placing his role as Christ's representative in the monastic community above the office of pope, in accordance with Benedict's Rule. This gives an indication of Cluny's prominence and reputation. Also from this time is the first written edition of the monastery's customs, a work demonstrating the importance—difficult for us to imagine now—of showing mercy to the poor and remembering the dead, whose names were recorded in long necrologies and read aloud at Mass. In that era's view of the hereafter, there could be nothing more precious than having one's name included in a necrology at Cluny or one of its monasteries. Maiolus died in 994, and was followed in office by Odilo

the abbey grew ten-fold until it housed about 130 monks. The fact that in documents of the time it is not the abbot of Cluny, but rather princes and counts, who are named alongside kings and popes reveals that Odo's aims of protecting and promoting his monasteries and priories through the rich and powerful had already

become reality. Aymard recommended Maiolus as his successor, who was duly elected in 954. By this time, the monks numbered around 150,

which must have made running the abbey more difficult. Nevertheless, Maiolus could be away for long periods reforming other abbeys without

P. 22 and right: **Cluny, former abbey church of St-Pierre-et-St-Paul (Cluny III)**, floor plan of the entire complex, reconstruction of its state c. 1150 (p. 22).

Right: east end, sixteenth century view, lithograph by Emile Sagot (after 1789), Paris, Bibliothèque Nationale, print gallery

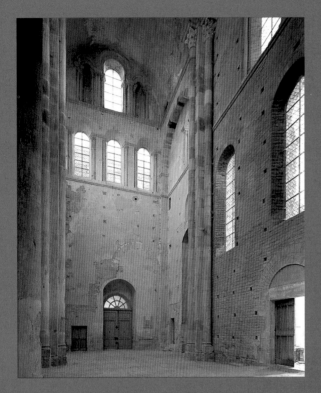

(his coadjutor since 992), who would preside there for over 50 years and be venerated as a saint almost immediately after his death. Odilo's first years as abbot were troubled by a plague and a great famine, which Odilo unflinchingly confronted by liquidating the church treasury and buying grain to feed the poor. Just as Maiolus had given land for clearing and use by farmers, Odilo would give lifetime use of abbey-owned land to noblemen designated as *Fideles Petri*, or followers of St Peter. In consideration for the land

and a funerary commemoration at Cluny, the nobles would pledge allegiance to the monastery.

The abbacy of Odilo's successor, Hugh of Semur (1049–1109), lasted 60 years. Cluny was then at the height of its prominence, and the community referred to itself somewhat provocatively as *Cluniazensis ecclesia*," (literally, "Cluniac community," but easily mistaken for "Cluniac church"). Three hundred monks lived at Cluny alone, and the number of abbeys given to and founded in the name of

Cluny, whose legal standing the abbot had persistently safeguarded, grew by leaps and bounds during Hugh's tenure. Shortly before 1055 he founded the priory of Marcigny as a nunnery, which most of the female members of his family entered over the years. Hugh's greatest accomplishment in increasing Cluny's prominence was his mediation between the emperor and the pope during the Investiture Controversy. In the century and a half since its inception, the community of Cluny had become a

major player in the power struggle between empire and Vatican. Thus it is hardly surprising that in 1088 a Cluniac monk named Odo ascended St Peter's throne as Pope Urban II. The rapport between Odo and Hugh continued to be defined by profound trust, and the pope lavished privileges and benefactions on his old monastery. It was he who said of the monks at Cluny: "they are the light of the world." Hugh's tenure marked the zenith of the Cluniac community. In 1088/1089, he

24

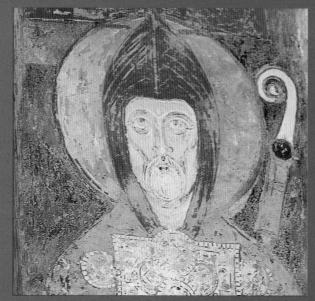

began the building of the long and meticulously planned third church.

But it is a natural law that the only place to go from the top is down. Cluny's seventh abbot, Pons, had come (like Hugh) from the Burgundian high aristocracy. He came to office in 1109 in a dazzling election at a very early age, and ended up bringing about the schism at Cluny. The causes cited for this include economic, personal and political problems stemming from three areas: the deepening quarrel among the bishops, the psychological and financial burdens arising out of the construction of Cluny III, and the increasing prominence of the Cistercians. In reality, the abbot's personality seems to have played a major role. This indicates that the successes of previous abbots, other virtues aside, relied substantially on their close familiarity with each member of the monastery as well as on their ability to maintain a steadfast foundation of mutual trust. At any rate, Pons could not manage this— but to elaborate on his mistakes and the reasons behind them would go beyond the scope of this book. The abbey became divided, the attached lay community was pulled into the conflict, and

Berzé-la-Ville, Château des Moines (summer residence of the abbots of Cluny), Romanesque chapel, detail of a fresco: image of an abbot

Pons left Cluny. He returned two years later and gained entrance to the abbey by force. After this the pope summoned him to Rome and (on his eventual arrival) imprisoned him for his crimes. He died in 1126, having been followed in office in 1122 by Peter the Venerable, whose competance, charitability, and credibility are credited for an amicable resolution at the monastery. In spite of great economic and political difficulties, Peter succeeded in getting the church completed and consecrated. It was after his death in 1156 that Cluny began to decline in importance, giving way to the great era of the Cistercians.

25

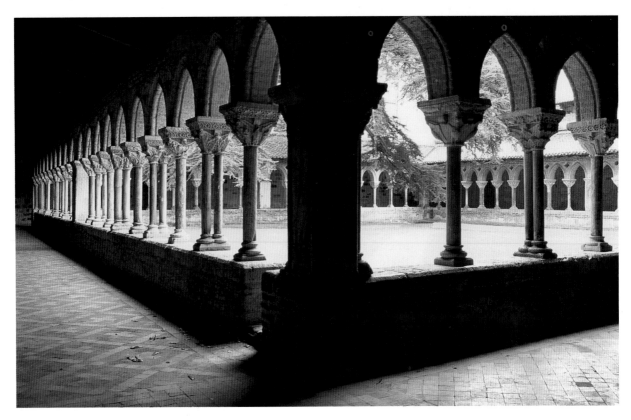

Monastic Life

In his hymn praising monasticism, the bishop and historiographer Otto von Freising (c. 1112–1158) wrote: "Even on Earth, they lead a life of heavenly, angelic sanctity and purity of conscience. They live together in a community ... go to sleep at the same time, rise together to pray, take meals in one room and busy themselves day and night with praying, reading, and working. They do this with such unflagging diligence that—apart from the brief period they grant their tired limbs to rest on a meager palette of brushwood or a coarse blanket—they consider it a gross infringement to allow any part

of their day to elapse without it being occupied with the divine. Even at mealtimes they continually listen to the Holy Scriptures, giving priority to spiritual rather than bodily satiation."

In fact, this ideal would only have corresponded to reality in the rare case of a saintly life. There were indeed such monks; admired by others and serving as their role models, they were masters of asceticism, exercising

Above: **Moissac, former abbey church of St-Pierre**, 1100, gallery of the cloister

Right: **Initial "I,"** Gregory the Great, Moralia in Job, Citeaux, c. 1111, Dijon, Bibliothèque municipale, Ms. 173, fol. 41 r

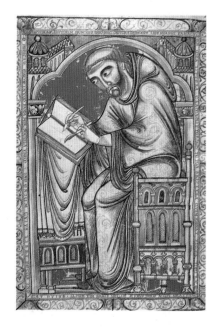

Writing Monk Eadwinus, *Eadwinus Psalterium*, c. 1170, Cambridge, Trinity College Library, Ms. R. 17.1, fol. 283 v

Le Thoronet, former Cistercian abbey, dormitory, end of the twelfth century

the utmost rigor upon themselves. They were however the exception rather than the rule. Numerous monastic histories provide anecdotal accounts of the monks' foibles. These may tend to exaggerate, too, but they present a counterbalance to an overly idealized image.

Daily monastic life was so structured and regimented with prayer, spiritual reading, and manual labor that adherence to the regimen left little time for idleness or chat. Furthermore, there were overseers whose duty it was to keep an eye on things. The constant presence of other monks served to support the regimen and supervise conduct, at least on the surface. This assurance continued even at night, since the monks slept clothed and by candlelight in a common dormitorium. All the

same, peril lurked everywhere: gluttony, alcoholism, carnal lust, pride, willfulness, and so on—in short, all the vices listed in the Benedictine canon as pitfalls for the monks to beware of and avoid.

Central to the community's life was the Divine Office, or Liturgy of the Hours, which strictly divided the course of the day, beginning between midnight and 2:00 a.m. with Matins, or Vigils, and ending between 6:00 and 8:00 p.m. with Compline. Between times, the day's prayers took place at around these times: Lauds (6:00 a.m.), Terce (9:00 a.m.), Sext (noon), None (3:00 p.m.) and Vespers (5:00 p.m.). The actual times varied somewhat according to season and geographical location. Sleep time was severely restricted, and fatigue appears to have been

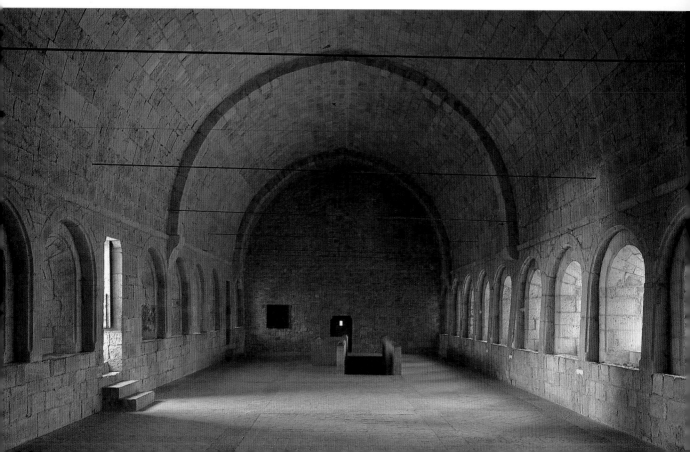

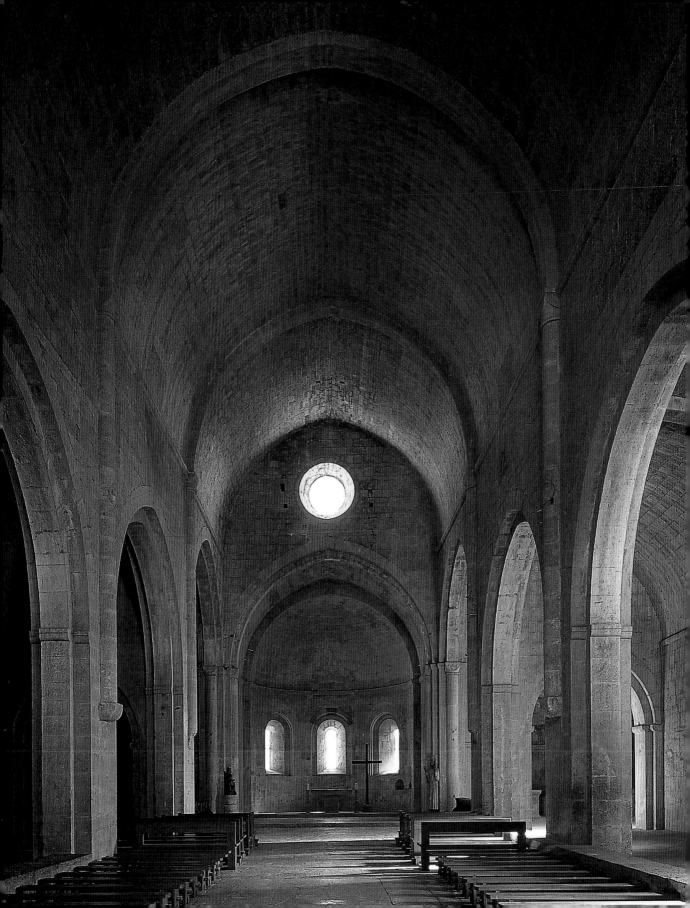

Le Thoronet, former Cistercian abbey, 1160–1180, abbey church, interior

Clothing of the monks, Hrabanus Maurus, *De Universo*, Monte Cassino, after 132

a frequent problem. Even so, sleeping outside the prescribed hours was considered a serious deliquency.

The familiar Benedictine double obligation *ora et labora* (pray and labor) was not stated in so many words in the Rule at this time. However, Benedict called for between three and eight hours a day of manual labor. This work generally amounted to lighter tasks such as gardening, crafts, and writing. Since membership was drawn primarily from the nobility, and the proportion of clerical monks increased steadily after the early Middle Ages, hard manual labor by monks was frowned upon. That was largely left to farmers and day-laborers from outside the monastic community.

The advent of the reform monasteries brought exceptions to this custom, as site clearing, fieldwork and construction work became part of the monks' duties. This eventually lead to differentiation and a division of labor within the monastery itself, with a distinction being made between the clergy and the *conversi*, or lay brothers. The *conversi* took simpler vows and assumed the labor of the community, lightening the burden on the full monks. The tasks of the *conversi* included housekeeping, laundry, cooking, etc., as well as social services incumbent upon the abbeys, such

as nursing, hospitality, and caring for the poor. As effectively "second class" brothers, the *conversi* were excluded from the liturgical center of the monastery as well as from voting for the new abbot.

How often and at what time of day the monks could eat depended on whether it was an ordinary, feasting, or fasting day. Benedict divided the year into four major parts. From Easter until Pentecost they ate twice per day; in the summer, once a day on Wednesday and Friday and twice the other days. September 13 marked the beginning of the great fasting period, when they normally ate just once a day at around 3:00 p. m. During Lent, the period of fasting just before Easter, there was a single evening meal. Exceptions were authorized exclusive-

ly for certain specific circumstances.

For the rest, it was left to the abbot to arrange a schedule he deemed beneficial and just. These regulations held for the monks of the eleventh and twelfth centuries as well, although they are known to have been broken frequently in Benedictine monasteries. During the twelfth century, the monks of Cluny received reproaches for their sumptuous meals and for fasting [only] when they felt like it. Critics argued that a monk should only eat as much as was sufficient to maintain the body and sustain life, a view that was widely shared by the more austere reformist orders.

Bernard of Clairvaux and the Cistercians

In 1070, a nobleman from Champagne named Robert endowed a monastery in Molesme. By that time, he had already gone through several phases of ever-increasing asceticism and harmony with the example of the Gospel in his quest to imitate the life of Christ. Molesme's strict observance of the Rule caused it to flourish rapidly, and it was apparently this very success that spurred its founding abbot, Robert, along with Prior Alberich and about 20 monks to aspire to an even more stringent asceticism. In about 1098, the group left Molesme to seek solitude at a spot called Cistercium in the diocese of Chalon-sur-Saône. There they founded a monastery—under very difficult initial conditions—that would for a considerable time be known to the Cistercians simply as *novum monasterium* ("the new monastery"). In accordance with St Benedict's original rule, they yearned to lead a life of personal poverty, rigorous asceticism, and hard work, without any amenities or extras.

But Molesme soon petitioned Pope Urban II for the return of its abbot, and the finding of Papal Legate Archbishop Hugh of Lyon obliged Robert to return to his former monastery. This incident left its mark on the Cistercians' attitude toward other monasteries. Their perception of themselves as the community that remained truest to the Rule precluded leaving for the sake of a more perfect way of life or indeed, for any other reason. After Robert's return to Molesme in 1099, Alberich became abbot at the *novum monasterium*, and the Englishman Stephen Harding its prior. Towards the end of his life, Robert again left Molesme, this time to enter Cluny. He died there in 1111 and was included in the Cluniac remembrance of the dead. His brothers took this as an unpardonable affront, and that certainly has something to do with the vehemence of Bernard of Clairvaux's assault on Cluny.

In 1108, Stephen Harding became the third abbot of the *novum monasterium*. Cistercian tradition says it was he who established the monastery's own set of customs, based solely on *ratio* and *auctoritas*, or reason and divine authority. Despite seemingly insurmountable initial difficulties, Cîteaux was quick to flourish. By 1113 the abbot found that it was already time to release a group of monks

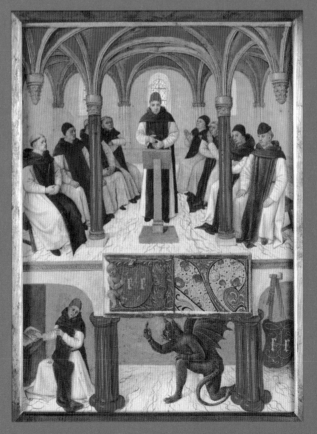

to establish a daughter monastery in La Ferté; others followed in 1114 and 1115 at Pontigny, Morimond, and Clairvaux. The entrance of a young nobleman named Bernard of Fontaines into Cîteaux played no small role in this development. As Bernard of Clairvaux, he would contribute significantly to the status of the Cistercian order in the Church and to its relationship with the pope. Born in 1090 in the castle of Fontaines, Bernard was educated at the abbey school of St-Vorles in Châtillon-sur-Seine, and at around the age of 20 he entered the most austere monastery in his area. As if that alone wasn't exceptional for the time, he quickly distinguished himself with his ardent missionary fervor, which he applied to convince 30 people from his immediate circle, including all of his adult siblings, to convert with him. For Stephen Harding, this signaled above all the need for a monastic constitution. Cluny was comprised of countless legally dependent abbeys and priories subject to widely varying obligations and regulations. The abbot of Cîteaux learned from this problem and made it his goal to form a homo-

Bernard of Clairvaux in the Chapter Hall; the Devil Tests St Bernard, miniature painting from the breviary of Etienne Chevalier by Jean Fouquet, c. 1450, Chantilly, Musée Condé

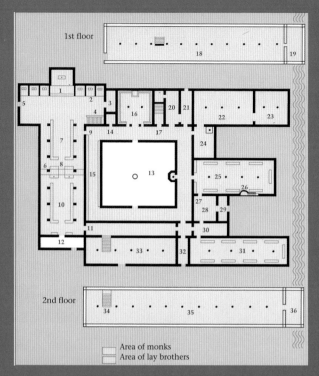

1st floor

2nd floor

Area of monks
Area of lay brothers

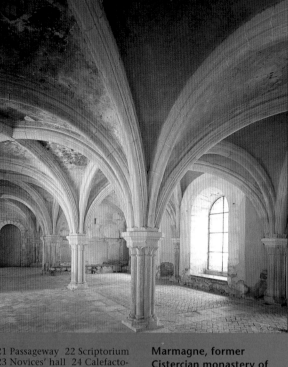

Cistercian abbey according to Bernard of Clairvaux
(This ideal layout corresponds largely to that of Fontenay)

1 Sanctuary and main altar
2 Side altars 3 Sacristy
4 Morning stairs 5 Door to
cemetery 6 Choir screen
7 Monks' choir 8 Choir for the
ill 9 Monks' door to cloister
10 Lay brothers' choir 11 Lay
brothers' entrance 12 Narthex
13 Cloister fountain 14 Arma-
rium (library) 15 Cloister wing
16 Chapter house 17 Day stairs
to dormitory 18 Monks'
dormitory 19 Monks' latrines
20 Auditorium (meeting room)

21 Passageway 22 Scriptorium
23 Novices' hall 24 Calefacto-
rium (warm room) 25 Refectory
26 Reader's seat 27 Pass-through
from kitchen 28 Kitchen
29 Storeroom 30 Lay brothers'
parlor 31 Lay brothers' refec-
tory 32 Lay brothers' alley
33 Cellar 34 Lay brothers' stair-
way 35 Lay brothers' dormitory
36 Lay brothers' latrines

**Marmagne, former
Cistercian monastery of
Fontenay,** chapter hall, end
of twelfth century (above);
church and monastic
buildings from the east
(below)

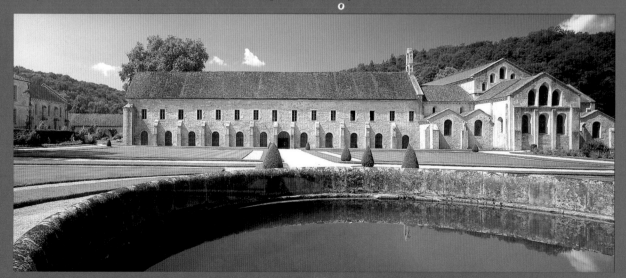

geneous federation of independent monasteries on an equal footing. To ensure consistency of religious life and adherence to the rules, he instituted a policy of general chapters and visitations. This meant that while the daughter monasteries remained autonomous and free to choose their own abbots, they would each be visited once a year by the abbot of Citeaux for a review and to clear up any problems. In addition, every year all the Cistercian abbots would meet to hold a general chapter, each abbot having a seat and a voice, to deliberate over common problems. Thus Stephen Harding established a standard that was to endure in the west for centuries. It is likely that Bernard had a major hand in creating this constitution, but what exactly his contributions were is no longer known.

By the last third of the twelfth century there were three versions of the constitution, none of which can be precisely dated. It must have been modified and refined at least as early as the era when the daughter monasteries were beginning to found their own satellites. Very soon after Bernard's arrival, Harding dispatched him to the abbot's post at Clairvaux. It was as

Clairvaux's abbot that he came to shape the destiny of the order and of the Church. Far from confining his zeal to missionary work, he fasted and labored so diligently that he eventually became seriously ill. What little spare time remained to the monks after manual labor, Bernard spent writing or dictating tracts, sermons, and letters of a missionary nature. In a flowing and elegant style, he would attack his listeners and readers, pouring out criticism, admonitions and mockery upon them. His writings were already being collected while he was still alive, and were to some extent revised by Bernard himself.

The abbot's reputation for extreme asceticism and missionary fervor drew attention to Clairvaux and made Bernard popular with his powerful religious and secular contemporaries. This, combined with the lucrative productivity of the monasteries'

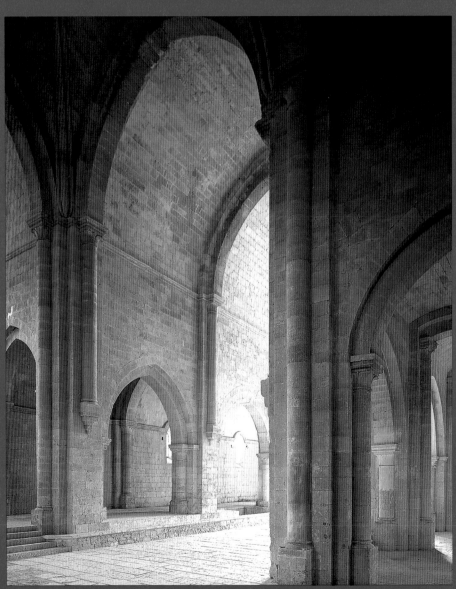

Silvacane, former Cistercian monastery, abbey church, southern wall of he central nave, c. 1160–c. 1230

Pontigny, former abbey church Notre-Dame-de-l'Assomption, from 1145, southern side with low transept and the broad choir with ambulatory, from 1186

surrounding estates, soon brought great economic success to the Cistercians: a success which interfered with their religious program. At the time of Bernard's death in 1153, Clairvaux alone possessed 69 daughter monasteries, with 75 dependent filiations; these in turn had spawned 22 additional monasteries.

Thus Clairvaux and its 166 convents accounted for almost half of all Cistercian monasteries, which at the time totaled 344. In the meantime, the strict constitution was not being followed consistently. As with Cluny, the Cistercians were receiving endowments from the holdings of bishops and nobles. Though well aware of the problems at Cluny, Bernard nevertheless strongly encouraged the rapid growth of his order in every way. During the time of its schism with

Cluny, when Clairvaux was battling its worst financial problems and internal difficulties, Bernard assailed the Cluniacs in a pages-long "Apologia," in which he castigated their pomposity and the feudal attitude of their abbot.

From 1130 Bernard took on a new task, engaging himself energetically on the side of Pope Innocent II in the papal schism. With

the settlement of the schism in 1139 and Innocent's recognition, the Cistercians' influence grew immensely, reaching its peak with the ascension of a Cistercian monk to the papal throne as Eugenius III. Another outlet for Bernard's energies was the Second Crusade, which he promoted with his usual fervor. He became identified with the cause, and

when the crusaders were utterly defeated, his credibility suffered. He persisted despite this, but when his pursuit of a third crusade failed, he returned to his writing activities. He died in 1153.

The order thrived during the twelfth century overall, but with the growth of cities and the rise of the middle class, things began to change. While the parliaments and constitutions of the new bourgeoisie came into their own alongside the old feudal system, the Cistercians' prominence gave way to the mendicant orders of Saints Francis and Dominic.

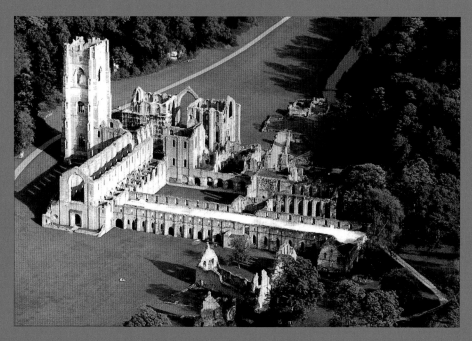

Fountains Abbey, aerial view of the monastery ruins in northern England

The Cistercian Aesthetic of Clarity

The oldest fully-preserved Cistercian church is in Burgundy at Fontenay Abbey. Founded by Bernard of Clairvaux in 1118 as the second daughter monastery in 1130 it was moved to a location in the forest outside Marmagne, and by 1147 the church was ready to be consecrated. The fact that Bernard himself was the abbey's founder and that Pope Eugenius III came in person for its consecration gives an indication of Fontenay's prestige in the order.

Behind its simple, towerless facade lies a three-aisled nave of seven bays. An aisleless transept with two rectangular chapels along the east side of each arm separates the nave from a rectangular choir. Square piers with

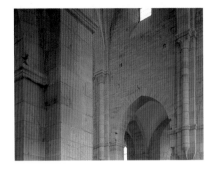

Noirlac, former Cistercian abbey,
detail of the abbey church

engaged semicolumns support the arcades of pointed arches that set off the transverse barrel vaults of the side-aisles. On the piers' inward-facing sides, rectangular pilasters become semicircular where they pass the spring of the arcade and continue on up to carry the massive transverse arches of the pointed barrel. The church gets

its only light through windows along the southern side-aisle and two sets of windows each at the east and west ends. The east windows flood the altar area, transforming it into a radiant chamber of light. The few decorative motifs are subtle; the piers have simple bases and captials, their pilasters have just a hint of a rounded molding along the edges, and a modest, slender cornice crowns the arcade. The décor frees the architecture of any crude, unfinished, or ungainly aspects, leaving instead an impression of gravity, ingenuity, and serenity. Built from superbly worked stone, the church represents a perfect illustration of both Bernard's standards and of his conception of monastic life.

One year after the completion of Fontenay, the bishop of Ca-

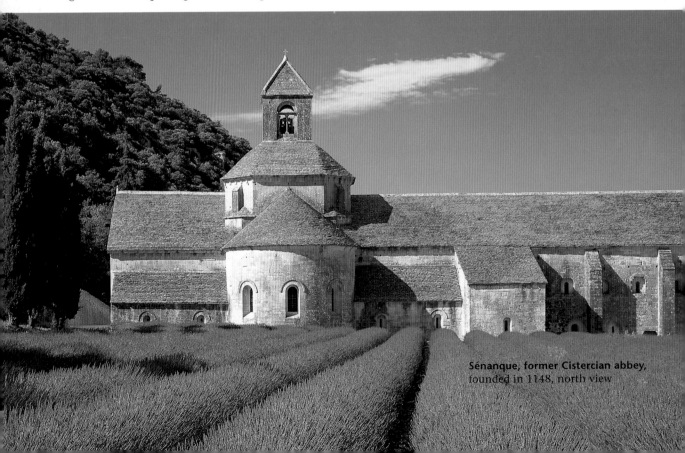

Sénanque, former Cistercian abbey,
founded in 1148, north view

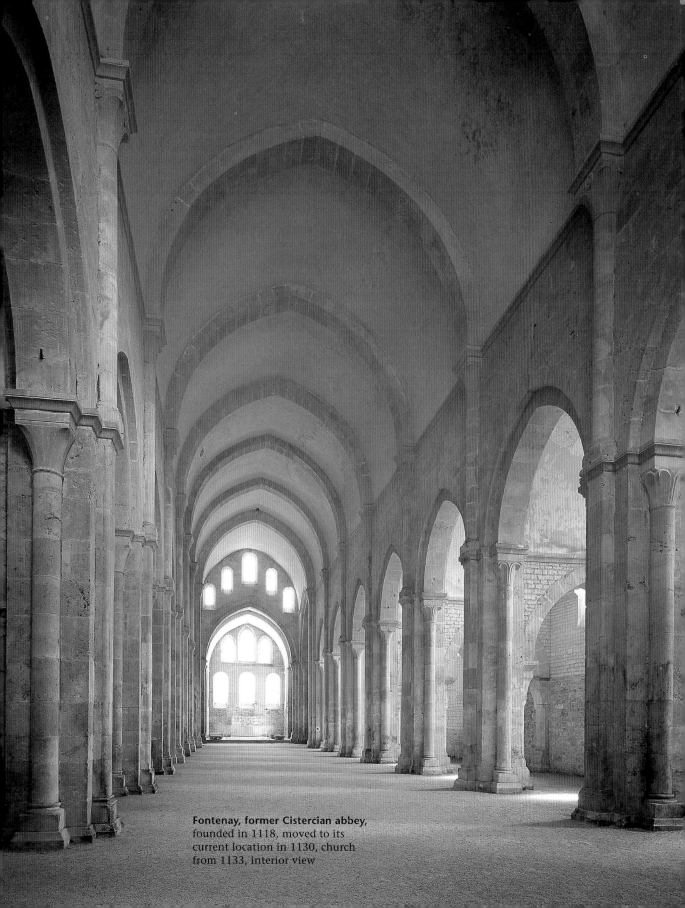

Fontenay, former Cistercian abbey,
founded in 1118, moved to its
current location in 1130, church
from 1133, interior view

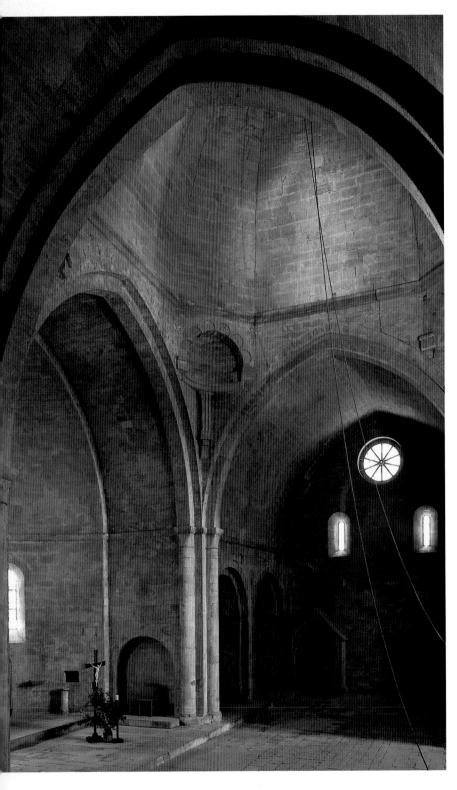

vaillon founded the monastery of Sénanque. Its church bears the characteristic Cistercian touch, but is a southern French variant. The chapels are semicircular, like the apse, and are squared off on the outside. In conjunction with the partially basilican cross-section, this modifies the lighting and therefore the impact of the church. In addition Sénanque has a crossing tower, though a modest one.

One of the best known Cistercian complexes in Germany is Maulbronn, dating from the second half of the twelfth century. Here, too, the floor plan of the church follows the Cistercian pattern, but in contrast with the ten-bay nave, the transept is merely a narrow passageway with side chapels. The tall basilican cross-section echoes the churches of the Hirsau school (see p. 57). The nave originally had a flat roof, while the choir and chapels were no doubt ribvaulted.

The atrium in Maulbronn is a marvelous early Gothic achievement, resembling in some ways the choir of Pontigny. With the introduction of the rib vault, whose every structural element required continuous support all the way from the floor, the earlier level of simplicity in design could no longer be maintained. This, along with the Cistercians' increasing prosperity and their growing number of monasteries, made strict adherence to their ideals more challenging.

Sénanque, former Cistercian abbey, abbey church, from 1150, view into the crossing

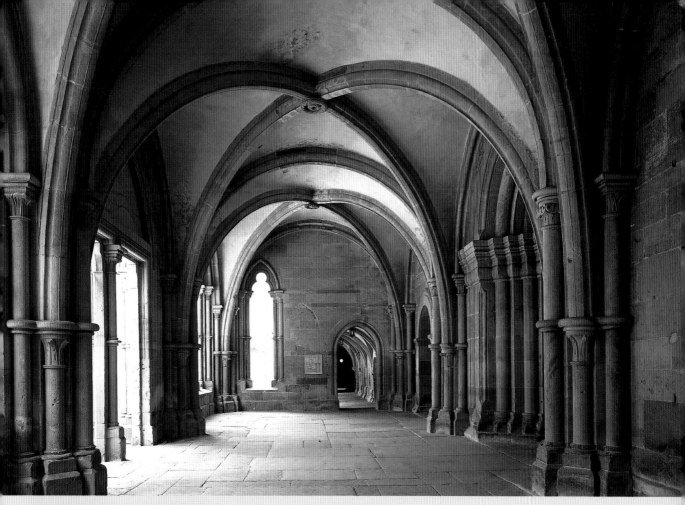

Maulbronn, former Cistercian abbey, second half of the twelfth century, interior view (above); former Cistercian abbey church, view of the nave (below left); view of the entire complex (below). Maulbronn is a German World Heritage Site.

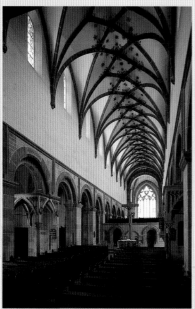

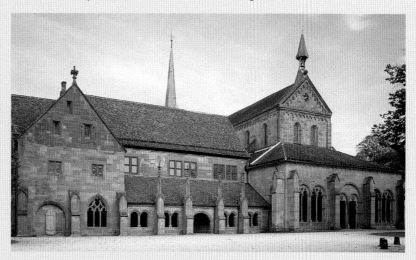

Crusades and Orders of Knights

To call the Crusades the darkest chapter in Church history, as is often done, is no overstatement. Still, it should be noted that the participants, as devout Christians, were convinced that God was on their side and that they were doing the right thing. Even a holy man such as Bernard of Clairvaux, the great preacher of the Second Crusade, glorified it as "an exquisite invention" of the Lord, through which "He admitted into His service murderers,

thieves, adulterers, liars, and many other criminals, affording them an opportunity for salvation." The act of going on a crusade was viewed as a liturgical exercise akin to a pilgrimage, and it was popular to frame it in words borrowed from pilgimage.

Crusader and pilgrim of St Jacques, Autun, cathedral, detail of the tympanum

Schematic map of the city of Jerusalem, codex, c. 1170–1180

The Crusades were in fact armed pilgrimages, a mass religious movement in which all social classes took part, women included. Many participants saw in the Crusades an opportunity to escape from poverty and life's difficulties. During the second half of the eleventh century, the regions growing fastest in population and experiencing the worst famines and epidemics provided the bulk of the troops for the First Crusade. The first groups to set out were mobs with no military organization. They found their first victims long before they reached Palestine, in the diocesan cities along the Rhine. There they massacred and plundered many Jewish communities in a bloody prelude to the eastern Crusades.

The "Holy Wars" in the East were aimed at reconquering Christian places, especially Palestine, and to protect Christendom from real and imagined enemies of the faith. The Church spearheaded this movement and promoted it aggressively. In addition to other privileges, all Crusaders were accorded indulgences so as to remove any doubt about the justification of their venture. In *Lexicon of the Middle Ages*, J. Riley-Smith writes "The Turkish conquest of Byzantine Asia Minor and the plea for help by Emperor Alexius I Comnenus in 1094 furnished the provocation for the first of the Crusades. Possibly as early as 1089, Pope Urban II was conceiving a plan for winning volunteers to the defense of Byzantium ..."

J. Le Goff, however, emphasizes that "the Crusades were launched on papal initiative." It is important to understand that the Church took greater and greater steps during the eleventh century to direct military activities and set them on a certain course. The power politics of Pope Gregory VII (1073–1085), who already had his own plans for a campaign to the Holy Land, can also be seen in this light. The indulgences, especially, which he promised to those who fought for his cause against Emperor Alexius I seem a clear link with the concept of the Crusades.

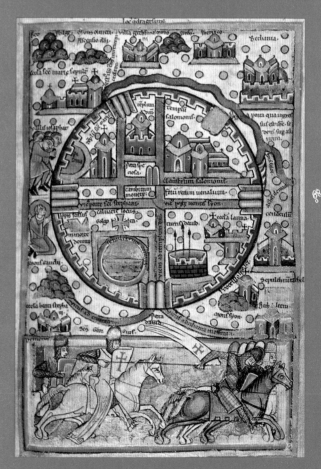

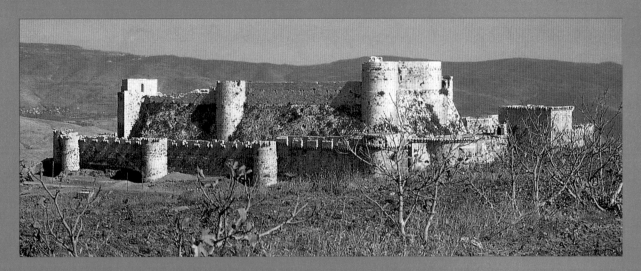

The Crusades affected knighthood in particularly tangible ways. Secular battles over power and possession diminished. The Peace of God movement suffered an attempted coup by the Church, and was given a new objective. This concerned "abandoning the garter of secular knighthood" in favor of the crusade (Baudry de Dol). Many knights now saw themselves as champions of God. At root, this pious idea of God's Army was a Christian restatement of feudalism, in which Christ himself (in the person of the pope) was the ranking lord of a hijacked vassalage (Rainer C. Schwinges). When the Knights Templar emerged in the 1220s, they were not only the first clerical order of knights, but also, in addition to the Hospitallers of St John and theTeutonic Knights, the most significant.

Since the knightly orders constitute a com-bination of monasticism and chivalry, it should be noted here that these knights subscribed to certain ideals without actually becoming monks. The Crusader orders stood out for their devotion to the Holy War, an ascetic vow of poverty, and vows of obedience and celibacy (the Spanish Order of Santiago being an exception to the latter). They subjected themselves to the juris-diction of the church. The knightly orders were a kind of standing army for the crusader states and the Iberian Empire (*Reconquista*), with large castles serving as bases.

The course of the eastern Crusades cannot even be briefly summed up here. Altogether there were seven different campaigns, stretching out over a period of almost 200 years. The First Crusade began in 1096, the Seventh in 1270. In 1291, Acre (now a port city in Israel), the last

Krak des chevaliers, castle of the Hospitallers of St John in Syria, mid-twelfth century

Returning crusader with his wife, Nancy (France), sculpture on the tomb of Count Hugues de Vaude-mont, beginning of the twelfth century

bastion of Christianity, was captured by the Mamelukes of Egypt.

Opinions differ regard-ing the final analysis of the Crusades, but they are widely and predomi-nantly viewed in a nega-tive light. Jacques Le Goff comments: "Of the three stated or known ob-jectives the originators of the Crusades set for themselves, none was achieved. The first and most vital was to conquer the holy places of Jerusalem; they were held for hardly a century." The second goal, to come to the aid of the Byzantines, culminated in the bloody capture of Constantinople by the Westerners. And the third, to unite Chris-tendom against the infidels, Le Goff sees as a failure. Hans Wollschläger puts it concisely and bluntly: "What was the final result? Over 22 million dead. What else is there to say?"

Romanesque Religious Architecture

Typical Architectural Forms and Regional Characteristics

The religious architecture of the eleventh and twelfth centuries is generally referred to as Romanesque (the Gothic began in France in the mid-twelfth century). It manifests itself in different traditions across the landscapes of Europe, but common to all Romanesque architecture is its additive principle of composition. Blocky elements such as nave, side-aisles, transept, apses, crossing towers, and west facade towers are clustered together, yet each remains complete and clearly defined. There are also typical decorative motifs which commonly include low rows of blind arches (Lombard arcades or corbel tables), dwarf galleries, and larger story-high blind arcades that hint at the interior structure within and make the thick walls required by the apse vaulting appear less massive. Yet all of these decorative elements cling to the wall without disrupting its silhouette.

In eleventh-century France, religious architecture developed mainly in monastic churches under the influence of Cluny, and builders strove to realize

Saint-Juste-de-Valcabrère, end of the twelfth century, view from the northeast (in the background the Pyrenee Mountains)

the potential of stone vaulting in basilica design.

In the Germanic regions of the Holy Roman Empire, on the other hand, religious architecture became an important means for expressing imperial power. This gave rise to western choirs as well as additional towers at the east end of churches. In effect, the builders dispensed entirely with nave and transept vaulting to concentrate instead on other spatial and structural features.

Architecture and Landscape

One characteristic of Romanesque religious building is its organization into blocks of increasing height that culminate in massive towers. This draws attention to the architecture and lends itself to the selection of exposed sites in order to maximize the effect. Thus we often find the cathedrals and monastic churches of the eleventh century on hilltops or where the land slopes steeply. This is also why subterranean crypts so often appear near rivers and even on rocky heights. From these spots the buildings signaled the power of the Church and the king, as well as providing an enticing destination for pilgrims.

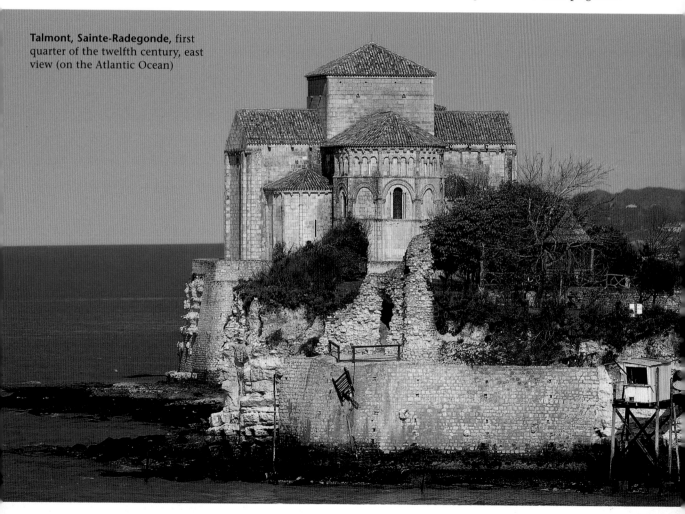

Talmont, Sainte-Radegonde, first quarter of the twelfth century, east view (on the Atlantic Ocean)

Variation of Stone

Due to the disappearance of colors and furnishings over the ages, Romanesque architecture is mainly experienced through its massive stonework. Openings seem as though they have been carved out of the walls, spaces and structures are clearly defined and tower to considerable heights. This imparts a solemn austerity, dignity, and grandeur to Romanesque monuments. Each building element is easy to discern. In Gothic architecture, the orderly arrangement of flying buttresses, statues in niches, crockets, and pierced parapets, creates such a shimmering mirage that the masonry is often overlooked. Romanesque design, on the other hand, manifests itself in the masonry, where one encounters carefully worked slabs and blocks. The Cistercians and Cluniacs were masters of this craft, and their superb stonework remains a testament to their aesthetic. Where decoration was employed, it was directly related to the architecture itself. Blind structures and Lombard arcades add relief to the walls, while inlays and horizontal bands of alternating colors, floral and figural friezes, and reliefs draw attention to the choir, chapels, or nave walls. These decorative elements, however, always serve merely to accent the overall form.

Issoire, Saint-Paul, begun c. 1130, detail of the wall

dels for painting and other art forms are found in sources from Antiquity and in illuminated manuscripts. Preserved remnants show that paint was primarily used to accentuate the structural elements. Narrative images, such as those conserved under later images in Reichenau-Oberzell, Schwarzrheindorf, and Berzé-la-Ville, are rather the exception for nave decoration. Richly painted chapels, crypts, and apses are more common, and these convey to us a sense of medieval taste in color as well as that era's world of imagery and imagination.

Colored Interiors

The interior spaces of Romanesque structures are usually unpainted, and the starkness of the bare stone makes them appear grave and solemn. This appearance plays a role in our concept of medieval architecture, although we know from plaster and paint residues that, originally, things were different. Such evidence has become rare, but was found frequently during the nineteenth century, when attempts were made to replace the losses with historic reconstructions. In the twentieth century, especially in Germany, a period of renewed purism and aversion for historicism reversed this trend, and much of the old, original work was lost when the later layers of color were removed.

Nonetheless, it is known that almost everywhere, the interiors and frequently even the exteriors of Romanesque buildings were coated with plaster. Mo-

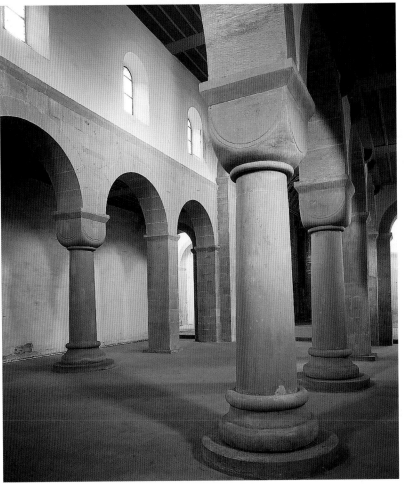

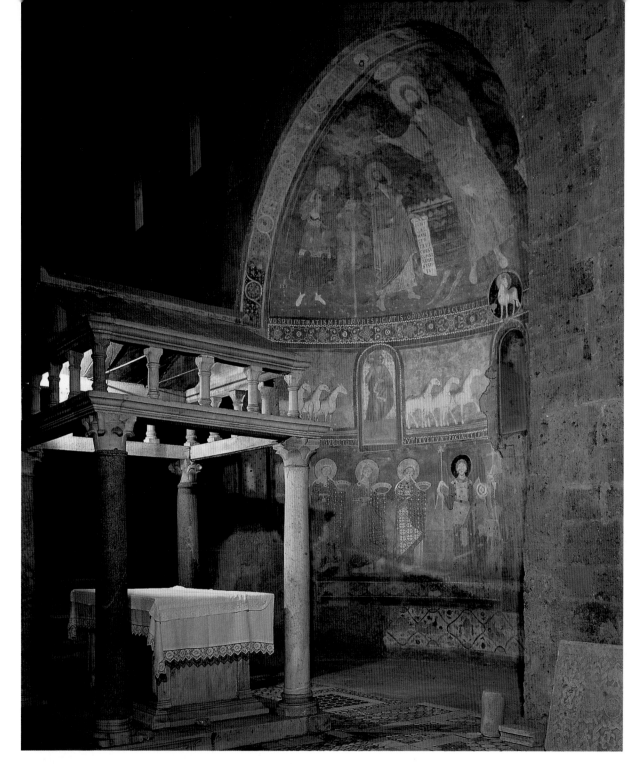

P. 44 above: **Schwarzrheindorf, St Maria and St Klemens,** c. 1180, view of the upper church seen from the lower church, heavenly Jerusalem and Christ in Glory

P. 44 below: **Kleinkomburg, former abbey church of St Ägidius,** twelfth century. Its present state is typical of our modern concept of medieval architecture.

Castel San Elia di Nepi, St Anastasius Basilica, interior view with frecoes of the apse, c. 1100

Germany

Ottonian Architecture at Hildesheim and Gernrode

When the German Empire re-stabilized under Otto the Great in the second half of the tenth century, it had yet to develop a true Ottonian style and its architecture was still based on Carolingian tradition. Its typical church was a three-aisled, flat-ceilinged, cruciform basilica with an enclosed semicircular choir. While builders in France were working on barrel-vaulted basilica design, the emphasis in Ger-man-speaking areas was on the block groupings at the east and west ends, and especially on the exterior ornamentation.

The oldest large-scale building from this era is probably the abbey church of St Cyriakus, Gernrode, sponsored by margrave Gero in 961. Its tall, box-shaped nave has three major zones: arcades whose supports alternate between columns and piers (the "Rhenish" alternating pier system), an unvaulted gallery, and small windows not yet showing any clear-cut relationship to the gallery and arcades. Here a new sense of space becomes apparent, whose focus no longer concerns wall decoration and directionless centrally planned buildings, as in Carolingian times. St Cyriakus' nave has a noticably square emphasis that, if still unrefined, generates a sense of purpose and rhythm.

Between about 1010 and 1033, Bishop Bernward of Hildesheim had the abbey church of St Michael (formerly Benedictine) built. With this church, Ottonian architecture reached its zenith. St Michael's is a basilica with two transepts, two choirs,

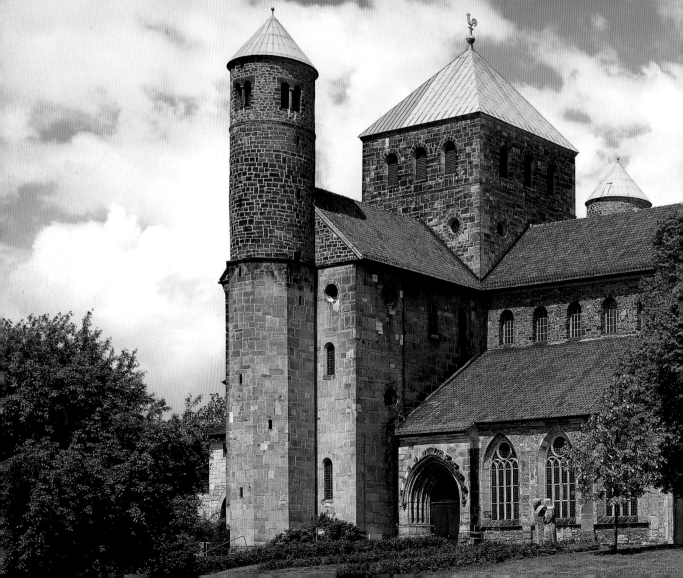

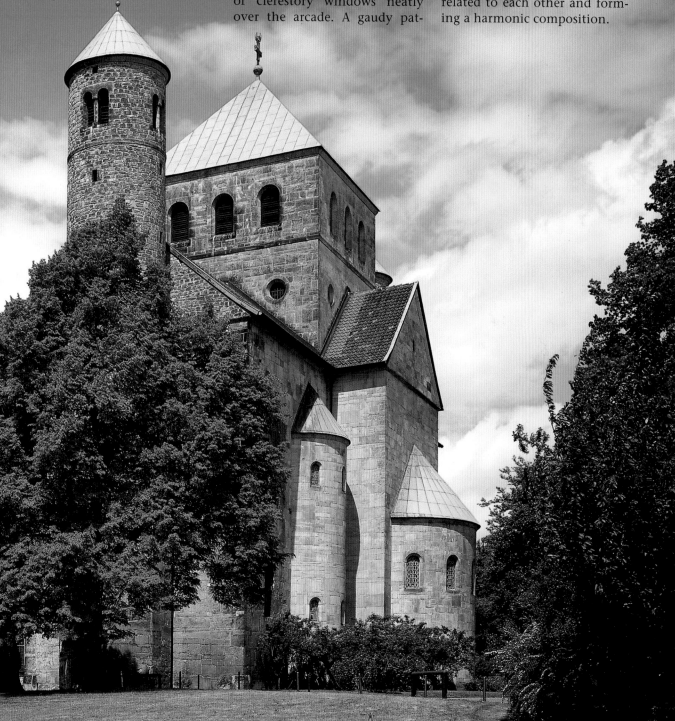

Hildsheim, St Michael, 1010–1033, southeast view

P. 48: **Gernrode, former abbatial church of St Cyriakus,** begun 961, nave facing east

P. 49: **Hildsheim, St Michael,** nave facing east

and a quadratic formalism in the nave. A pier-column-column-pier alternation pattern (the "Saxon" alternating pier scheme) articulates this modular approach. The nave dispenses with a gallery, placing instead a row of clerestory windows neatly over the arcade. A gaudy pattern of alternating bands highlights the arches. Even more striking than the interior space are the Ottonian masons' additive proceedings on the building's exterior: all its features are positioned as distinct elements, yet related to each other and forming a harmonic composition.

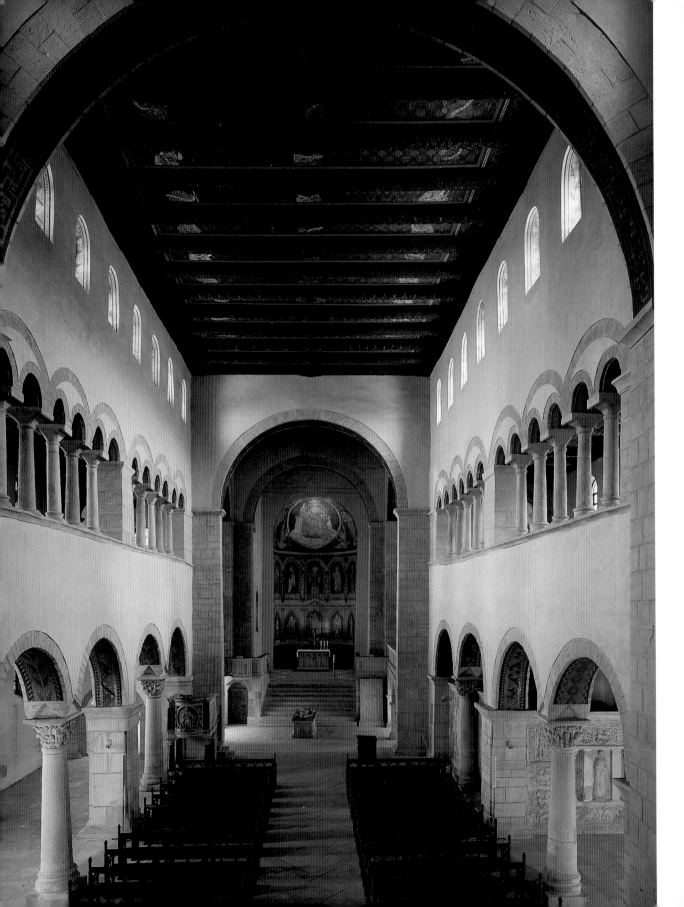

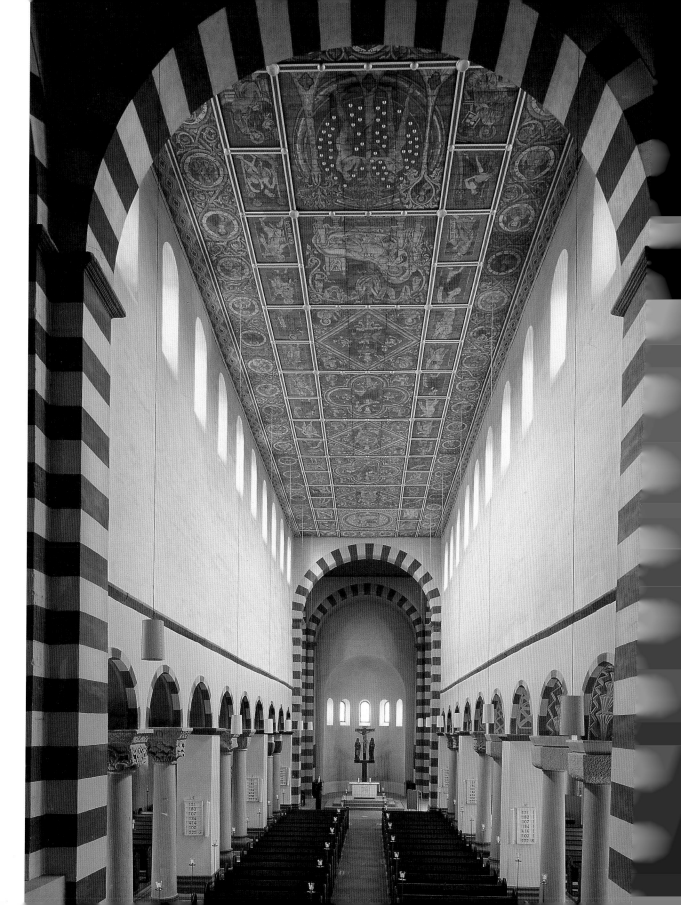

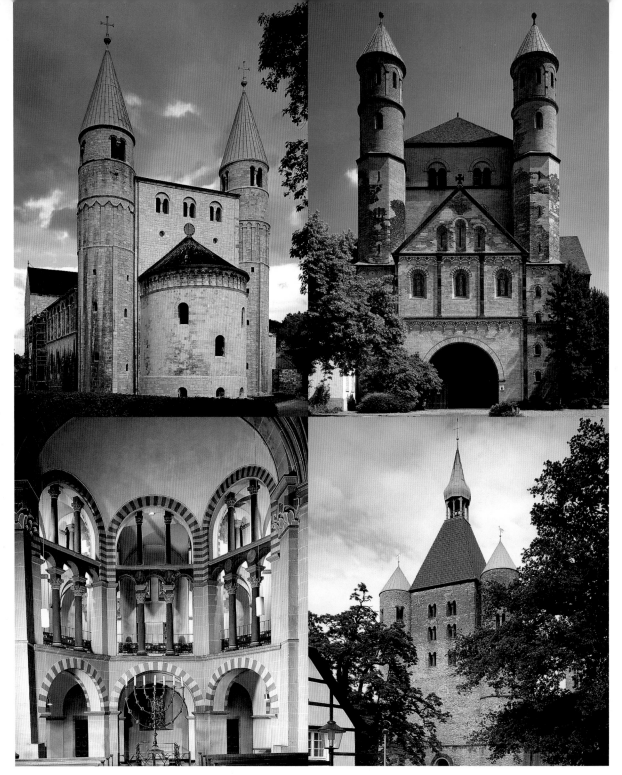

Above: **Gernrode, St Cyriakus,** first half of the twelfth century, west end

Below: **Essen Cathedral,** mid-eleventh century, west apse imitating Aix-la-Chapelle

Above: **Cologne, St Pantaleon,** late tenth century, westwork

Below: **Freckenhorst, St Bonifacius Parish Church,** c. 1090, westwork

The Cathedrals of the Salian Emperors

The first of the Salian emperors, Conrad II, ascended the throne in 1027. The next century saw the German empire's rise to supremacy in Europe, as well as the fundamental dispute over the relationship between worldly and spiritual powers (Investiture Controversy). The resulting open rivalry between papacy and monarchy found its resolution in the "Pilgrimage to Canossa" in 1077 and later in the Concordat of Worms in 1122.

Immediately after his coronation, Conrad began construction of the cathedral in Speyer, the "Metropolis Germaniae." The cathedral is the largest Romanesque building, "a true monument to the international standing of the German Empire." Four German emperors and two empresses repose in the crypt at Speyer. The cathedral has been destroyed and rebuilt several times. After all the reconstruction, expansion, and restoration, the only original sections are the crypt, the towers flanking the choir, and parts of the nave, which is based on a square module. After the first consecration in 1061, the choir and the transept were modified to their present dimensions. The type of construction—a cruciform basilica with towers and apse—is derived from Ottonian tradition, but has an updated nave design. Vaulting in stone was proving successful in contemporary Burgundy, whose protectorate had been secured by Conrad in 1027 (Cluny II, Chapaize, Tournus). At Speyer, the alternating pier

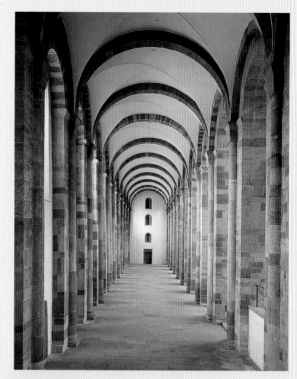

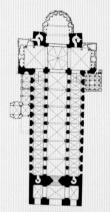

Speyer, St Mary and St Stephen Cathedral, 1027/1030–1061, northern aisle (left); floor plan and hall crypt (below)

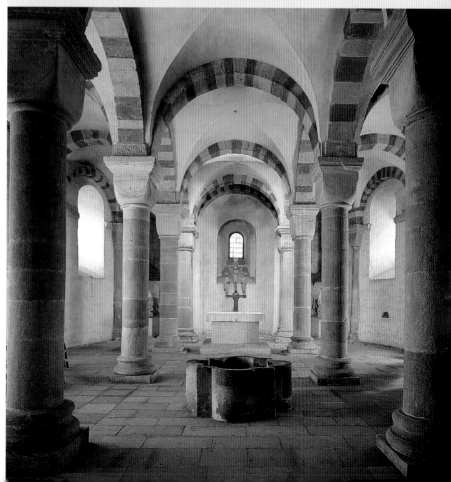

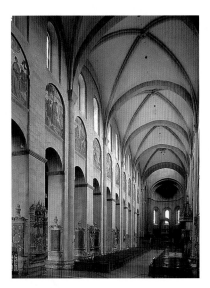

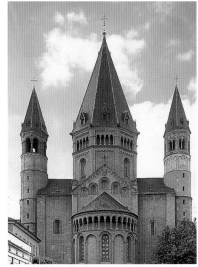

arches. The windows protrude from the center of the major arcade supporting the vault to align them with the nested nave arcade. (The westwork is an addition from Staufen times.) This method of vaulting a wide nave, which had its origins in crypts and was already being applied in pre-Romanesque times, inspired numerous successors throughout German-speaking regions, for example in Maria Laach, Ebersbach, Cologne, St Georg, Knechtsteden, and elsewhere).

Mainz, St Martin and St Stephen Cathedral, 1081–1137, nave facing the east (above left); east view (above right)

system with responds on the nave elevation, the unusually thick walls, and the vaulted altar area all suggest that Conrad's ambitious cathedral project was being readied for a barrel vault. Speyer's nave, however, is 14 meters (46 ft) wide—a span that would not be successfully barrel-vaulted for another century (at Cluny III). Emperor Henry IV ultimately gave Speyer a groin vault. The church's most impressive feature is its exterior east end, where dwarf galleries, blind arches and windows set off the artistic arrangement of towers upon towers.

The cathedral in Mainz was also renovated under Henry IV, between 1081 and 1137. As at Speyer, Mainz is a three-aisled basilica with piers. The nave originally had groin vaults in all three aisles, with semicircular responds carrying the transverse

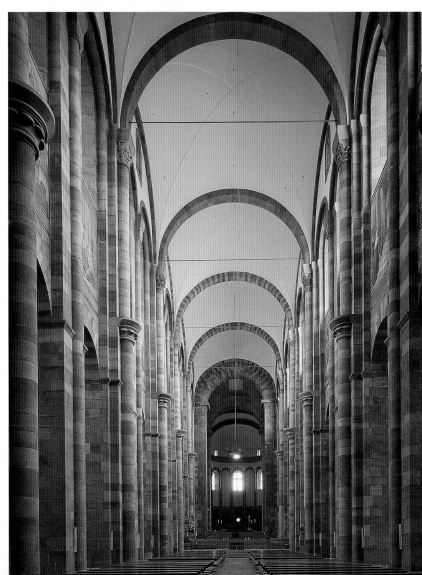

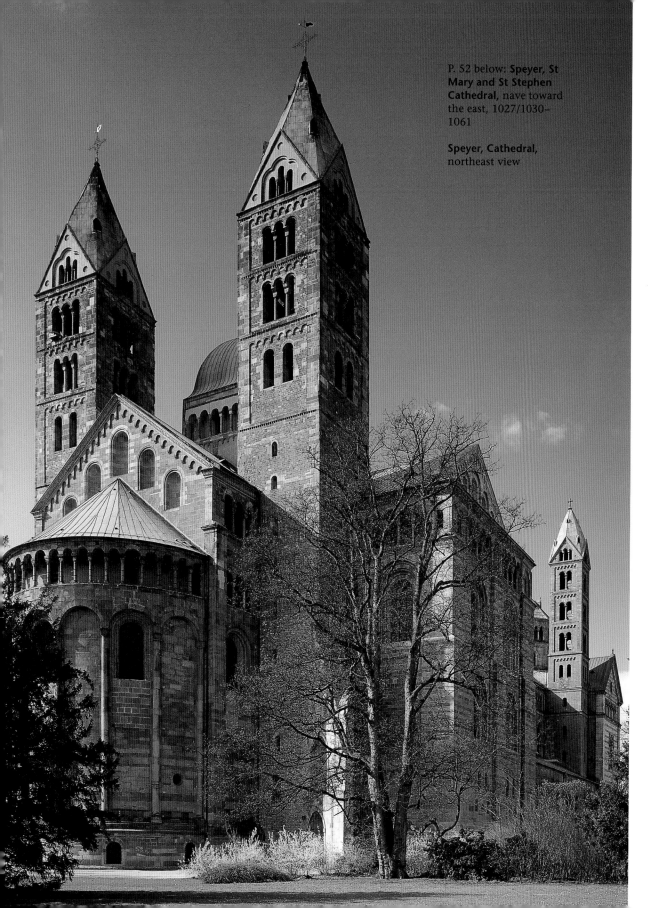

P. 52 below: **Speyer, St Mary and St Stephen Cathedral,** nave toward the east, 1027/1030– 1061

Speyer, Cathedral, northeast view

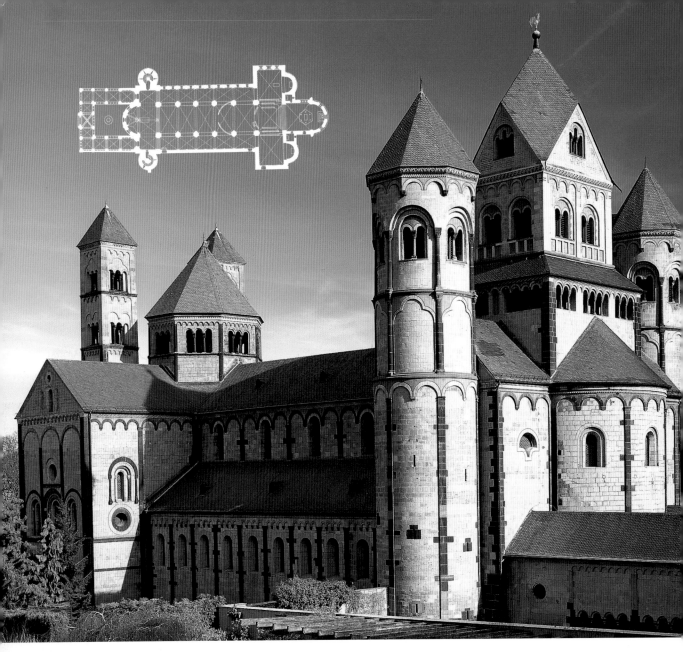

Cologne and its Surroundings

One of the most important archbishoprics of the German empire in the eleventh century was Cologne. It was here that the Rhine School of architecture developed, which came into being with St Maria im Kapitol, its main work. As with many of Cologne's churches, this one was severely damaged in World War II and is now essentially a reconstruction. Around the middle of the eleventh century a building with an unusual floor plan emerged on this site. A triconch choir was attached to a three-aisled nave, resulting in transept arms that mimicked the form of the apse. This was extraordinary enough, but its unorthodox effect was heightened by a further new idea: The usual ambulatory formed by the side-aisles now continued all the way along the perimeter of the three conches. Since each conch had two barrel-vaulted choir bays, a small four-bay,

chapel-like space was formed in the angle between the apses. This resulted in a continuous, uniform choir area with a pendentive dome at the center. The roots of this design can be sought both in centrally-planned churches and in the early choir ambulatory at St Martin, Tours. The nave, originally flat-ceilinged, is now rib-vaulted. On the exterior, the partially-exposed course of the foundation makes the crypt recognizable. This typically Salian exposed foundation is surmounted by an arrangement of half-columns and pilasters.

The same unorthodox east-end design was adopted for the churches of Gross-St-Martin (1150–1172) and at Sankt Aposteln (Holy Apostles; nave with flat ceiling, 1020/1030, choir from the third quarter of the twelfth century), but without the ambulatories. In these two buildings, the triconch is combined either with a massive square crossing tower, or with flanking choir towers and a polygonal dome tower over the crossing. There is also a decorative program with two-story blind arcades and dwarf galleries, producing a subdivided profile and a chiaroscuro effect. This configuration was also adopted for a new choir at St Gereon, to replace the one Archbishop Anno had added in 1067/1069 to an earlier centrally-planned building dating from Antiquity.

P. 54: **Maria Laach, Benedictine Abbey church,** 1156 or 1177 (east choir), northwest view, floor plan

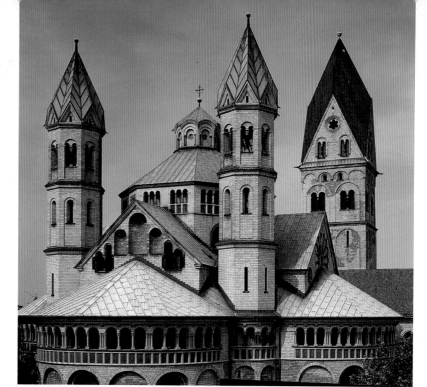

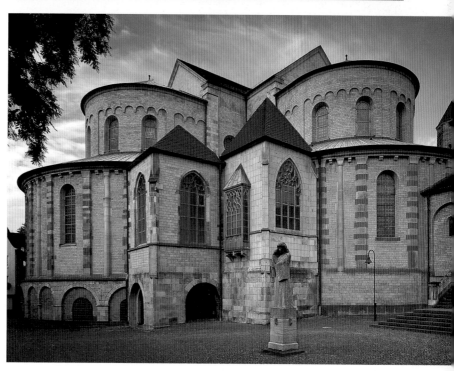

Above: **Cologne, St Aposteln,** first third of the eleventh century, east part from 1192, northeast view

Below: **Cologne, St Maria im Kapitol,** 1040–1049 and 1065, triconch choir, northeast view

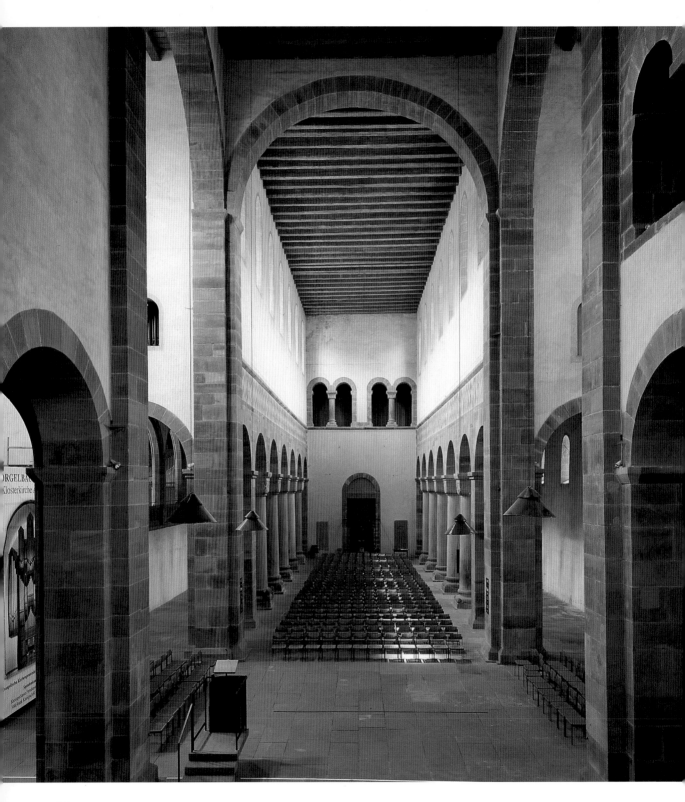

The Hirsau School

The monastery in Hirsau, sponsored by Count Adalbert II of Calw, gained recognition after Abbot Wilhelm took office there. He led it to become an intellectual and spiritual center in Germany as well as one of Church politics. By 1075 Wilhelm was able to liberate the monastery from the patron's personal control, and in 1079 he implemented the stringent rules set forth in the Cluniac reform (see pp. 30–31). Between 1082 and 1091—about the same time as construction was beginning at Cluny III—he built an enormous new church, of which the ground plan and some exterior wall sections survive. This first project of the Hirsau school was a three-aisled colonnaded basilica preceded by a paradise with a total length of 110 meters (360 ft). The crossing square provided the base unit of measurement for the construction (the module). The transept arms had apses projecting eastward, and the enclosed crossing had a square choir bay. The nave arcades resumed again east of the crossing, the side-aisles becoming at that point side-choirs adjacent to the main one. The latter's east wall had three recessed altar spaces, over which hung a choir balcony. The cruciform crossing piers marking the west side of the choir were presumably linked by a screen that shielded the chorus minor from the nave, where the lay brothers worshipped. The *chorus maior*, or *chorus psallentium*, was located in the crossing. In the western

P. 56: **Alpirsbach, former Benedictine abbey, abbey church of St Benedict,** 1099–1125, nave

Calw-Hirsau, so-called Owl Tower: north tower of a facade that once had twin towers, early twelfth century

block, rectangular bands with a checkerboard pattern framed the nave arcades; aligned with these arches, high in the walls above, were clerestory windows. The obsession with vaulting that so occupied eleventh-century French masons had no impact in Hirsau. Instead, the formal elements were derived from the upper-Rhine architecture of Salian times. A twin-towered facade followed in the early twelfth century, and the northern tower, called the Owl Tower, still stands today, with its tall blind arches and three levels of dou-

ble-arched windows. The best-preserved example of Hirsau architecture is the church at the former Benedictine abbey of Alpirsbach (1099–1125), while the former monastic church of Paulinzella (1105–1115), which also followed the Hirsau model, survives today as a lovely ruin in Thüringen. The Hirsau spirit can also be found in Baiersbronn-Klosterreichenbach (1082–1085), where the former monastic church is a scaled-down variant with nave hall, rudimentary transept, vaulted choir, and semicircular apses.

The Archbishopric of Magdeburg

Having established the archbishopric of Magdeburg in about 950, Otto the Great arranged in 955 to build the new cathedral in the Carolingian tradition, as a columnar basilica (now destroyed). Gernrode and Hildesheim (see pp. 48–49) were the next milestones in this Saxon tradition. Later examples of the type are the collegiate churches of St Servatius in Quedlinburg, the Benedictine abbey of Königslutter, and the cathedral in Halberstadt. St Servatius was built from 1070 to 1129 on the foundation walls of a previous (tenth- to early eleventh-century) church, and is the burial place of Emperor Henry I and his wife, Matilda. Above the ground-level crypt is a choir with three apses in echelon and a transept that projects only slightly. Moving westward, we find a three-aisled nave with the Saxon alternating pier system, followed by a two-story westwork that opens inward and is flanked by twin towers. Also worthy of mention is the ornamentation on the capitals and friezes.

Königslutter is the resting place of another emperor, Lothar III, and is located near his family seat of Supplinburg. The church's barrel-vaulted eastern sections were begun in 1135, and included a square choir bay with side-aisles and three apses, and transept arms that also included apses. Later, an originally flat-ceilinged, three-aisled nave and galleried westwork were added, followed by a cloister in the late

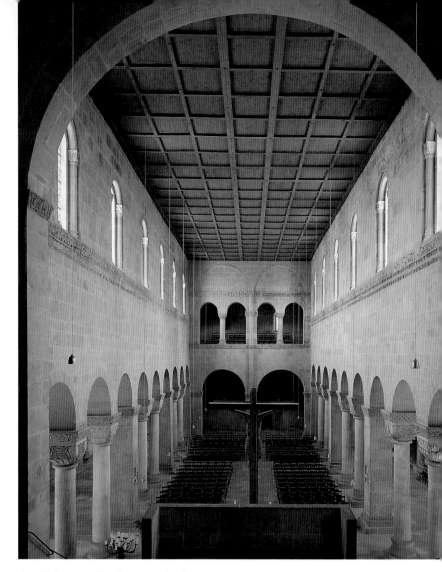

Quedlinburg, collegiate church of St Servatius, 1070–1129, nave facing west

Königslutter, former Benedictine abbey church of St Peter and St Paul, c. 1135–end-twelfth century, east view

twelfth century. Here, too, we find eye-catching ornamentation.

The cathedral in Halberstadt is certainly comparable to Königslutter. Begun in 1140, however, it is broader, has more squat proportions and largely dispenses with decoration.

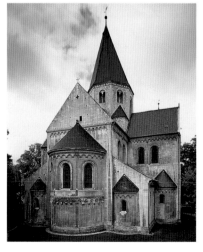

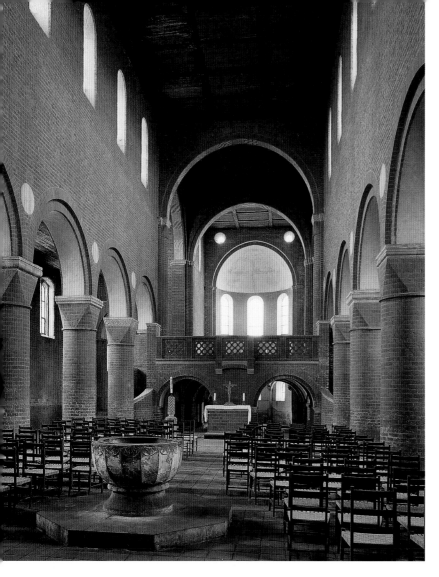

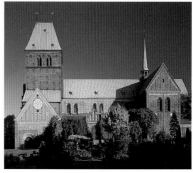

The Archbishopric of Hamburg

The twelfth-century architecture of the Hamburg archbishopric was subject to the influence of the Welf [or Guelph] Duke Henry (the Lion). The center of his realm was Brunswick, whose cathedral was completely rebuilt from 1173 to 1195. This cruciform basilica, based on the square module, equipped with heavy, unstructured arcades, a barely-perceptible alternating pier system, a small clerestory and a transverse arched barrel vault that was already an anachronism at the end of the twelfth century.

Farther to the north, brick was the preferred building material owing to a lack of suitable stone quarries. The former Premonstratensian (or Norbertine) collegiate church in Jerichow is in brick, as is St Mary and St John the Evangelist in Ratzeburg. Here their current effect may be deceptive in that the walls originally may well have been plastered and painted. Ratzeburg is a building from the time between 1160/1170 and 1215/1220—a cruciform basilica with a tall transept, a three-part choir, and a westwork surmounted by a massive tower. Jerichow is also a flat-ceilinged columnar basilica (begun after 1144). In the tradition of two Benedictine abbey churches that are a good century older—Hersfeld and Limburg an der Haardt—it has a tall, projecting transept, a long choir, and three apses. One encounters this configuration throughout the eleventh century in German-speaking areas. The crypt extends to the western edge of the transept, elevating the crossing and main choir onto a sort of bridge that overlooks the nave.

Southern Upper Rhine and Alsace

Alsace belonged to the heartland of the Staufen emperors, who had displaced the Welfs [Guelphs] in 1152. Quite a few large religious buildings were erected here during the second half of the twelfth century, and because of the proximity to France, all have rib vaults. Characteristic of these buildings is the warm, gold tone of the sandstone used in their construction and the rich, increasingly articulate arrangement of sharply-steepled tower clusters to the east and west. Mauersmünster and Murbach, both from the second quarter of the twelfth century, provide especially beautiful examples of this one-atop-the-other arrangement of progressively tall structural elements. Corbel tables frame the win-

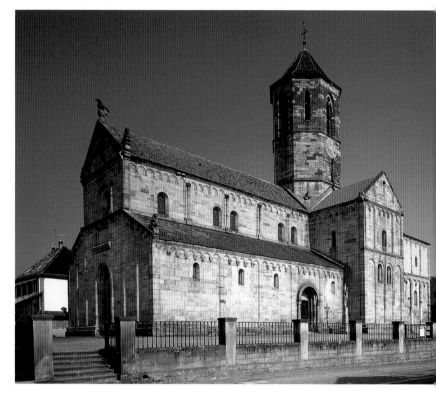

Rosheim/Alsace, parish church of Sts Peter and Paul, third quarter of the twelfth century, southwest view

P. 61: **Murbach/Alsace, former abbey church,** eastern part, around 1130

Basel, former St Mary Cathedral, today a protestant church, after 1185, interior view toward the east

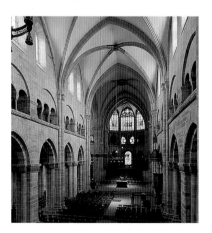

dows, form galleries on the facade, and run along the gable ends that ascend, in basilical organization, to the towers.

The parish church of Sts Peter and Paul in Rosheim, a beautiful basilica with a transept, an apse, and alternating piers, has a rather static appearance in spite of its massive polygonal tower and the typical blind decorative elements. The interior has a stocky, almost crude feel that is also characteristic of Alsatian churches.

The two diocesan cities along the upper Rhine were Strasbourg and Basel. In Strasbourg there was an enormous cathedral from sometime after 1015, a three-aisled basilica with twin-towered westwork, transept, and a slightly stilted apse—a layout similar to that of Old St. Peter's in Rome. During the twelfth century, Strasbourg burned four times, the last occasion being in 1176. It was rebuilt over the original foundation; the eastern sections are late Romanesque, the nave and towers Gothic. In Basel, a new cathedral likewise arose after 1185, the old one having burned. This building, too, has a twin-towered facade, a three-aisled nave with alternating piers for the square rib vaults, and a slightly projecting transept. What is uncommon for the region is its ambulatory choir, which lacks chapels because of the sloping terrain. These two sites were very influential in the upper Rhine, their most famous successor being the Freiburg cathedral.

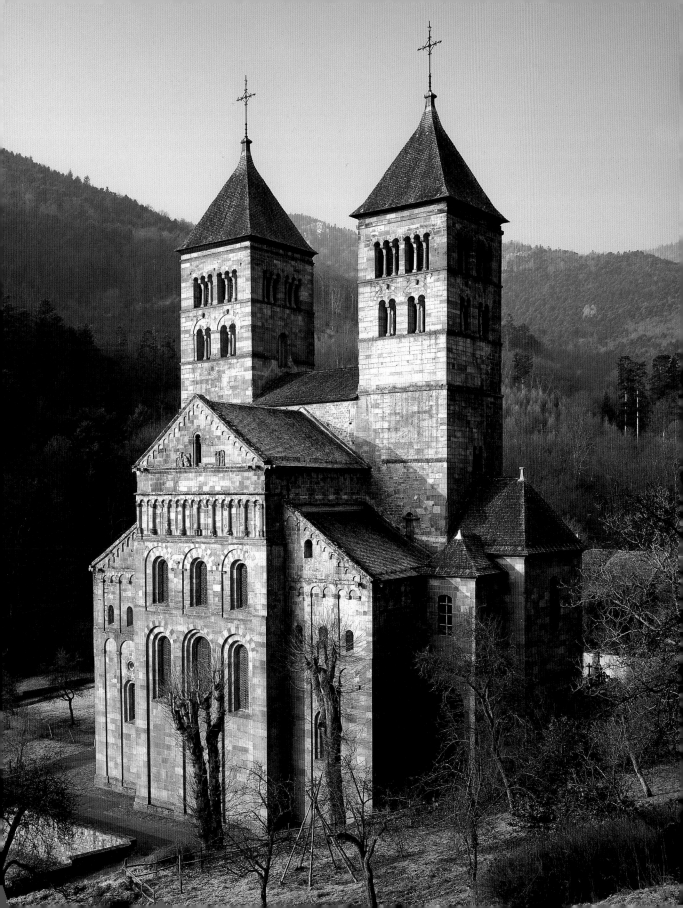

Italy

Northern Italy

The medieval history of northern and central Italy is tied to that of the Frankish or alternatively, German Empire through Charlemagne's conquest of Lombardy and his promise of protection for the Papal States. After the Investiture Controversy (see p. 51), the cities of northern Italy gained increasing political independence, and the early and powerful presence of the Adriatic merchants opened the country to architectural, social, political and religious innovations. The outstanding and most beautiful example of this is San Marco in Venice. Begun in 1063 according to the floor plan of the Church of the Apos-

Venice, San Marco, begun 1063, mosaic ornamentation in the interior of the church

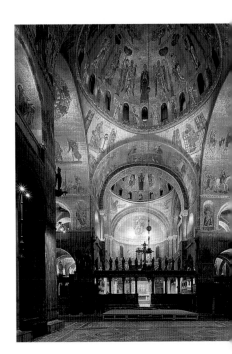

Milan, San Ambrogio, ninth to the twelfth centuries, atrium and west view, ground plan

tles in Byzantium, it has fascinating decorative mosaics on the interior and a facade that opens itself out to the city. However, as churches go, San Marco remained, like Venice itself, an anomaly.

Under the direction of the Lombard builders, a northern Italian school of church design emerged, nurtured from a variety of different sources. These included the transeptless, richly-colored Ravenna-type basilica of the fifth and sixth centuries, as well as the galleried basilica with alternating piers that came to fruition after 1040 in Normandy (Jumièges), although without the twin-towered facade. At the same time, there were conscious reversions to elements of the structure of Old

Ravenna, baptistry of the Orthodox Christians, fifth and sixth centuries, decorative mosaics in church interior

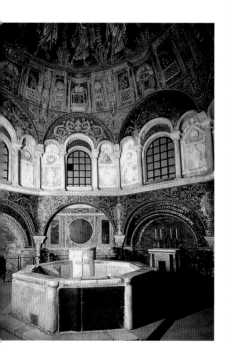

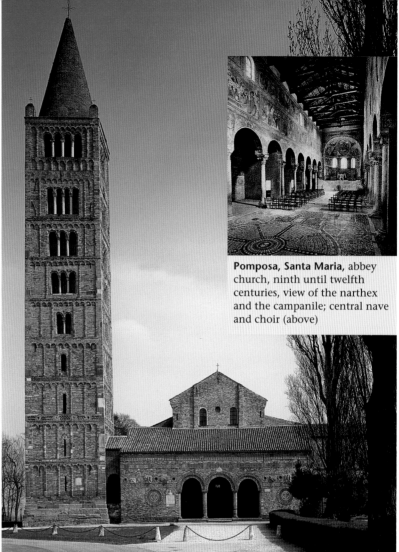

Pomposa, Santa Maria, abbey church, ninth until twelfth centuries, view of the narthex and the campanile; central nave and choir (above)

St Peter's. The Lombard school—among whose initial projects were Santa Maria in Valle at Cividale and Aquileia Cathedral—channeled this cultural heritage of its workforce into development of enriched decoration and breaking up the external walls. The motifs employed—galleries, blind arcades, corbel tables, and pilasters—are themselves inspired by Byzantine forms. These found an active following in Germany and France owing to the steady en-

couragement of the building trade by the Lombard kings.

A truly lovely example of Lombard architecture can be seen in Pomposa, where an extensive monastery complex evolved between the ninth and eleventh centuries. It is no coincidence that the triumphal arch motif on the narthex and the impressive nine-story campanile are reminiscent of Old St Peter's in Rome. This monastic church, consecrated in 1036, is a three-aisled, colonnaded basi-

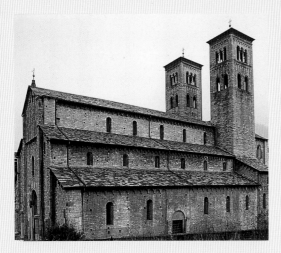

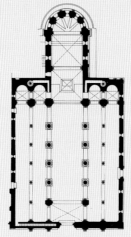

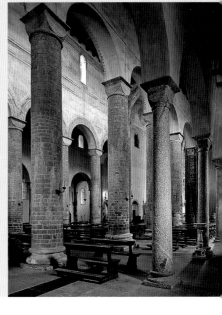

Como, Benedictine abbey church of S Abbondio, 1027–1095, exterior, southwest view; ground plan; interior of the colonnaded basilica

lica without a transept. It has exposed roofbeams, three apses, and rich wall painting akin to that in Ravenna. The ornamentation program of the campanile is typical of the Lombards, with its stories marked off by corbel tables on lesenes and its windows that increase in both number and width with each ascending story.

One of the largest and most important churches in northern Italy is the monastic church of San Ambrogio in Milan (see p. 62). This site was continually under construction, expansion, or repair from the year 386 onward. The first building on this site was a transeptless basilica built by [St] Ambrosius to house relics of the martyrs Protasius and Gervasius. The choir and crypt date from the ninth century, as does the campanile, which again refers back to Old St Peter's. The floor plan remains similar to that of Pomposa, but

Above: **Verona, S Zeno Maggiore,** 1023–1035, western facade

P. 65 above: **Modena Cathedral,** begun 1099, western facade

P. 65 below: **Parma, cathedral,** western facade, campanile, and baptistry

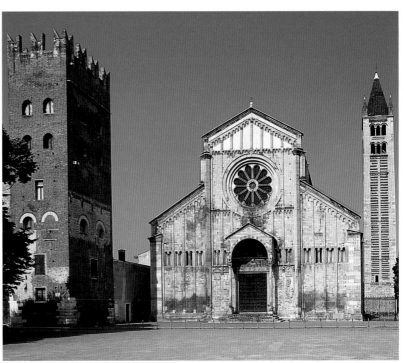

64

the nave includes alternating piers, galleries and a late-twelfth-century rib vault. The original design certainly included a clerestory and a flat or exposed-timber ceiling, and possibly diaphragm arches. The western facade is well known, with its doubled triumphal arch motif completing the atrium arcade and its particularly beautiful campanile.

By the end of the eleventh century, the Lombard style of architecture had spread far and wide. The church of S Abbondio in Como, begun in 1027, became the main church of a Benedictine monastery in 1095. Its five-aisle construction and twin towers recall the architectural customs of Cluny, to which Como had ties. Here we can see how the facades were becoming progressively more open. The west ends of the cathedrals in Modena and Parma, both begun around 1100, and San Michele in Pavia (the coronation church of the Lombard kings), are built with walkways behind double and triple openings, or continuous arcades. They can be found one above the other on several levels, accenting gable pitches and apses, and taking the insubstantial facade to a momentary high point. Another common motif is the two-tier framing of the portal by a deep baldachin with columns on reclining lions under a kind of gallery or loggia under a shallow gable.

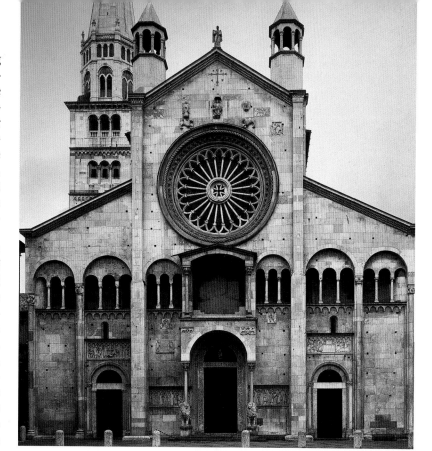

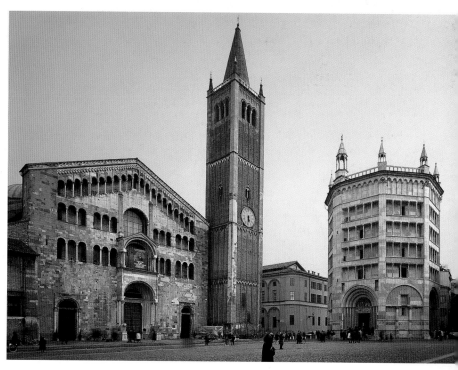

Tuscany and Rome

Situated south of Lombardy along the Tyrrhenian Sea was Tuscany, followed by the Papal States; and on the Adriatic side were Romagna and the Duchy of Spoleto. One of the principal Romanesque churches of Tuscany is San Miniato al Monte in Florence, from the second half of the eleventh century (illus. p. 67). There, the contemporary concept of space and will to order can be seen clearly. Once again we find a colonnaded, transeptless basilica, an apse in the east and a nave with open roof trusses, and an alternating pier system articulated with diaphragm arches at the major piers. This arrangement places San Miniato firmly within the Lombard tradition.

The spatial effect, however, is altogether different: The interior walls of this stunning church are clad in marble with a fine, almost exclusively geo-

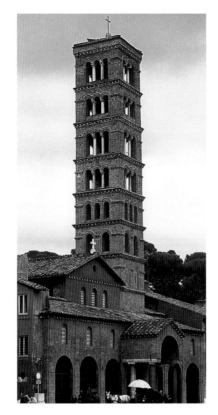

Rome, Santa Maria in Cosmedin,
c. 1200, northwest view

metric pattern that highlights architectural elements such as arches, windows and apses, or simulates ledges, all producing a sacred space with triumphant character. The colors are generally limited to gray and white, with a yellowish sandstone hue used for capitals and horizontal moldings. The only show of colors is in the apse mosaic, which shows the enthroned Christ, and on the back wall of the altar between the crypt exits.

The same formal principle provides the basis for the facade, which repeats not only

the color and pattern of the inlaid marble and the contrast between marble and colorful mosaic, but also the five-arch motif seen in the blind arcade of the apse and in the entrances to the apsidioles. The detailed planning of this crescendo effect left nothing to chance and it still retains its impact today.

The motifs of two-tone marble sheathing and blind arches became common in Tuscany. Frequently they were variations on the San Miniato model, and some churches were given spectacular striped facades, including San Giovanni Fuorcivitas, Pistoia. The unvaulted, colonnaded basilica with richly decorated apses endured as a building form in Rome as well. On the exterior, a shallow five- or seven-arched porch became popular, in which the Tuscan model was transformed into an open, roofed entryway that hid the actual facade.

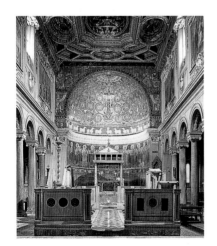

Rome, Santa Marie in Cosmedin,
c. 1200, interior view

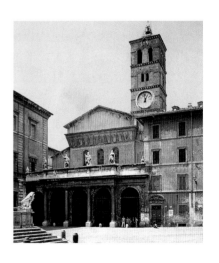

Rome, Santa Maria in Trastevere,
c. 1148, west view

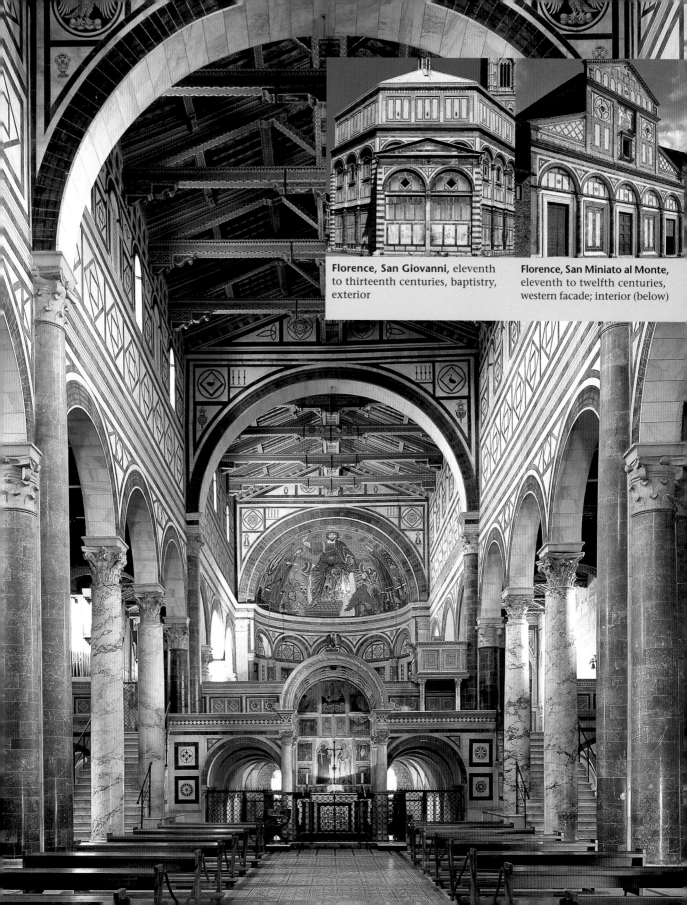

Florence, San Giovanni, eleventh to thirteenth centuries, baptistry, exterior

Florence, San Miniato al Monte, eleventh to twelfth centuries, western facade; interior (below)

Pisa

It is certainly no accident that the two powerful port cities of Pisa and Venice began construction of their cathedrals at the same time (1063), although they used two completely different approaches as suited their needs. Each of these enormous buildings is a unique expression of its time and context. Pisa's cathedral has a five-aisled nave with a flat ceiling that is unusually high for Italy; a tall, three-aisled transept, forechoir and apse; and a domed crossing. Although the nave has galleries, they do not have the vertical elements seen in Milan or Modena. A baptistry to the north (begun with the cathedral) was abandoned at the beginning of the twelfth century when the basilica was extended westward and a new baptistry was erected further along that west axis. At the time, the archbishop of Pisa was also patriarch of the newly formed Kingdom of Jerusalem; so the similarity of the Pisa setting to that of the Temple Mount (between the Dome of the Rock and the basilica of the al-Aqsa mosque) may not be coincidental. The exteriors of the cathedral, baptistry, and campanile (the famous Leaning Tower of Pisa) are the most accomplished examples of Tuscan facade design and insubstantiality. Narrow walkways fenced behind arcades cover the facades, relieving them of any heaviness and, as a matter of fact, of nearly all substance. The walls are visible, though, and are covered in marble inlay. The effect of these groupings of seemingly fragile structures is to relieve the overall ensemble of some of its monumentality.

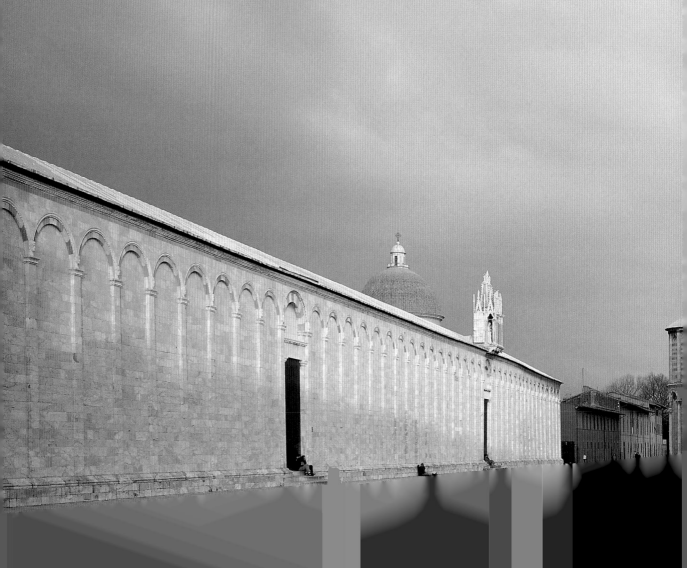

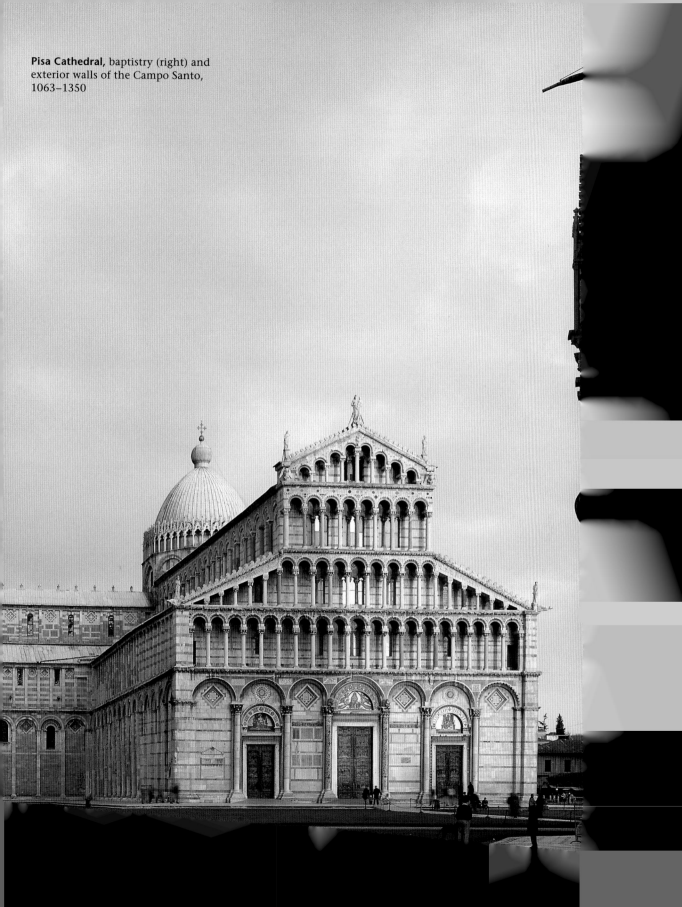

Pisa Cathedral, baptistry (right) and exterior walls of the Campo Santo, 1063–1350

Apulia

In 1087, the Normans (who, between 1041 and 1063, had conquered Apulia followed by Calabria and Sicily), stole the relics of St Nicholas from Myra. From 1089 (until its consecration in 1197!), a three-aisled basilica was under construction in the ruins of the former catapan's palace (the abandoned seat of the former Byzantine governor), which were to some extent incorporated into the church. Sections of the original building still stand today; from the exterior, the eastern sections are easily recognizable as having secular origins. The nave piers, western towers, and west facade survive from the original construction. The facade displays the motifs of the double-arched blind arcade and the bifora, and on the external nave wall are the deep blind arcades that would be adopted by later churches. A diaphragm arch was added between the pier pairs at the middle of the nave and at its eastern end. Again, the nave elevation corresponds to that seen in Jumièges and northern Italy (Modena, Milan, Piacenza), but without the rhythm and verticality produced by responds and square module—although this may have been due to limitations imposed by the existing structure. The gables with lion pedestals that frame the portals are also reminiscent of northern Italy. The present appearance of the building is the result of a restoration which removed significant Baroque modifications inside and out.

The integration of Italian and Lombard schemes at San Nicola was so successful that it spawned a whole generation of Romanesque churches in Apulia. The cathedrals of Trani (begun 1098), Bari (begun 1160 or 1171), Bitonto (begun 1175) and others are unmistakeably derived from this important church.

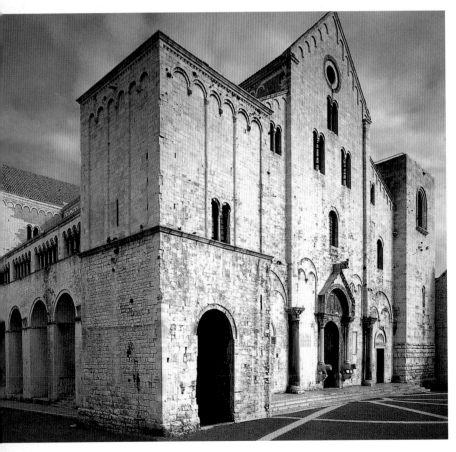

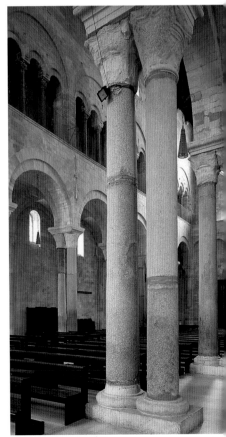

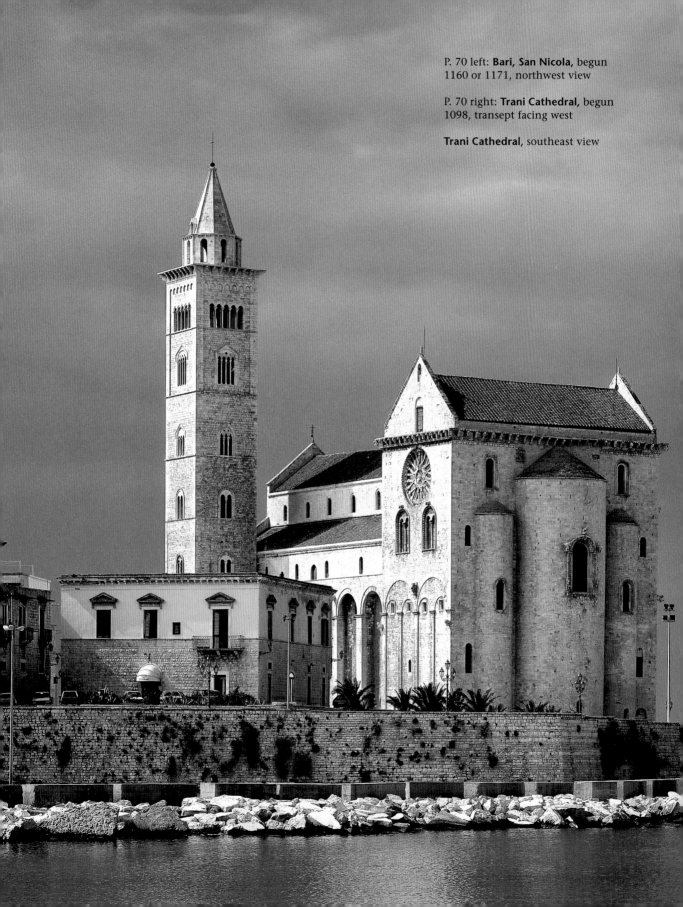

P. 70 left: **Bari, San Nicola,** begun 1160 or 1171, northwest view

P. 70 right: **Trani Cathedral,** begun 1098, transept facing west

Trani Cathedral, southeast view

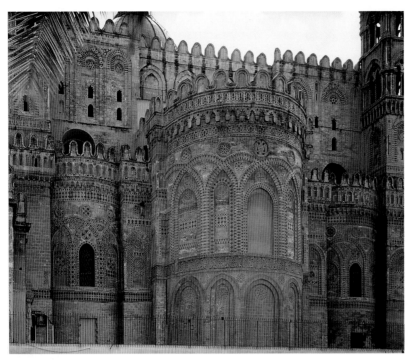

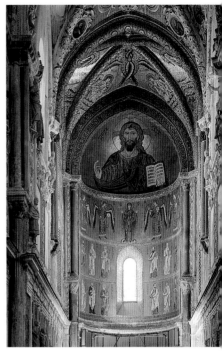

Sicily

Between 1061 and 1091, the Normans conquered Sicily, displacing the Arabs who had invaded and ruled during the years 827–878. They formed the second kingdom in Italy, which in 1130 became part of the kingdom of Naples and Sicily founded by Roger II. As they had in Apulia, the newly Christianized Normans tolerated the culture of their predecessors, allowing the Islamic and Byzantine influences to leave their mark on the newly emerging religious architecture there. The main city was Palermo, where in 1130 Roger had a palace and splendid chapel built for himself (completed 1143). It was a typical European Romanesque layout—a three-aisled cruciform church with a triple apse—but incorporated arches and a stalactitic ceiling of Islamic derivation with rich Byzantine-style mosaics covering every other surface. The chapel became the archetype for churches in Palermo during the twelfth century.

The cathedral in Palermo was begun in 1069, and after several alterations, what remains of the original are mainly the exterior surfaces of the east end and the nave walls. The overlapping blind arcades, interlaced patterns, and simulated battlement walkways must be of Islamic inspiration, although this type of decoration was taken up in England as well (see Castle Acre, p. 92).

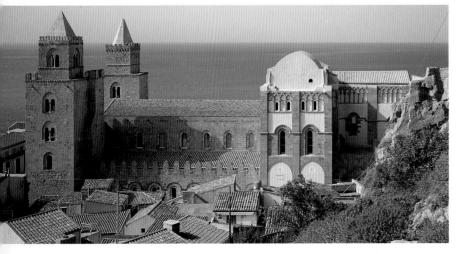

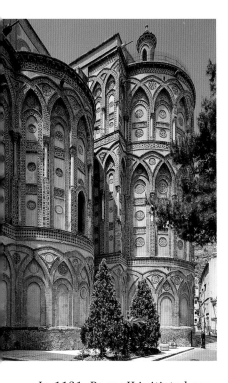

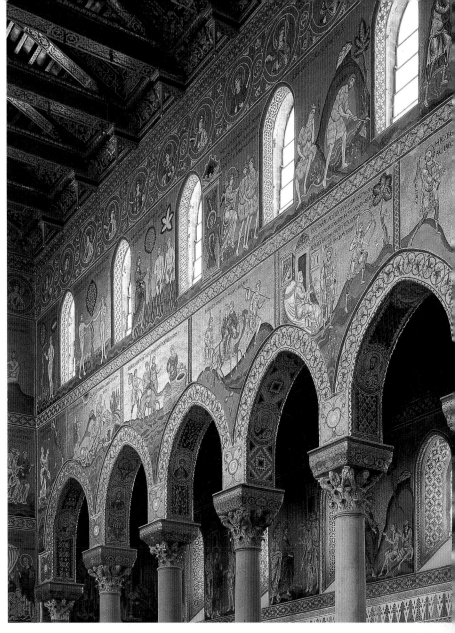

In 1131, Roger II initiated construction of a cathedral in Cefalù, designating it as his burial place. The imposing three-bay Benedictine choir, tall transept and massive west towers display clearly Norman traits (i. e. the arcaded wall passage at attic level, and the intention to vault). The rich mosaics date to 1148, indicating when the eastern sections of the church were completed. The profile of the arch on the east wall of the nave reveals the original plan for vaulting that would have towered over the eastern sections. Instead, William I finished the cathedral with an existing low, columned basilica.

Another royally established building is the former monastery in Monreale (now a cathedral), begun next to the palace there in 1174. It has an impressive interior that, with the exception of the ceiling, is a restatement of the Capella Palatina in Palermo. The exterior, especially in the east, was decorated in what had become the characteristic Norman-Sicilian style. Monreale was completed in 1189, at approximately the same time as the very similar cathedral of Palermo.

Monreale, cathedral, 1174–1189, wall of the nave (above); southeast view of choir (above left)

P. 72 above left: **Palermo, cathedral,** 1069–1090, east view

P. 72 above right: **Cefalù, cathedral, choir** mosaics, 1148

P. 72 below: **Cefalù, cathedral,** begun 1131, south view

France

Burgundy

In the Swiss towns of Romain-môtier and Payerne there are two monastic churches, dating from the 1030s and 1040s respectively, whose patrons had close ties with Burgundy. Romainmôtier now has a rib vault in place of the original barrel over its nave, while Payerne has retained its barrel vault over the nave with responds carrying the transverse arches. The tops of the clerestory windows cut into the spring of the barrel. Both churches belong to the context of Tournus (see pp. 76–77) and Chapaize, demonstrating that the stone vault, which had previously been used almost exclusively in crypts, could now be carried over the nave. Burgun-dy—perhaps Cluny II—must have been one of the starting points for these endeavors. Stone barrel vaults dating almost this far back can also be seen in Languedoc and Catalonia.

St Benignus has been venerated in Dijon since the fifth century. A missionary in Burgundy during the third century, he suffered a marty's death. In 989, William of Volpiano (962–1031) became abbot at the monastery on the site of Benignus' grave, and between 1001 and 1018 he constructed the church of St Bénigne over an earlier sixth-century building. William's new basilica had a five-aisled, flat-ceilinged nave, nearly 100 meters (328 ft) long and possibly with galleries, a west transept with semicircular apse, and a short east transept. The latter had two small apses flanking a middle one that was formed by two semicircular colonnades. Behind this screen of columns was a wider three-story rotunda containing three concentric rings of columns, and attached to this in the east was a chapel dedicated to St Mary that connected the rotunda to St Benignus' original burial chamber. This entire transept and choir area had a crypt of the same footprint under it. The rotunda probably had its origins in the Pantheon of Rome. By the nineteenth century, only its crypt level had survived, and the upper stories were reconstructed according to the tastes of that time. Eight columns surround the center, which has an oculus in the dome of the top story. The next ring of 16 columns

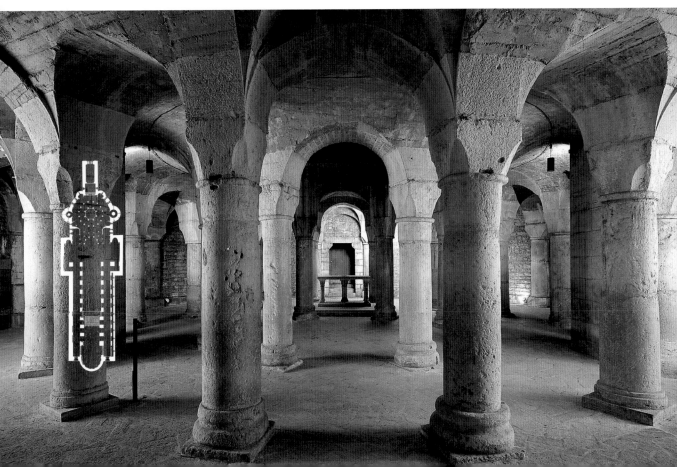

separates two ambulatories, and the third ring of 24 half-columns is engaged in the exterior wall. There are indications that this church provided the inspiration for the Romanesque cathedral in Nevers.

At the end of the fifth century, St Deodatus (Didier) erected an oratorium in honor of St Vorelius (Vorles) in Châtillon-sur-Seine. It was replaced during Carolingian times with a building that was in turn followed by the present-day church of St-Vorles, built c. 1000. Behind its westwork-like facade is a three-aisled nave with drum piers that becomes five-aisled in the eastern bays. To this is attached a five-bay non-projecting transept followed by a square choir-bay and semicircular apse. The present-day additions probably replace the apsidal chapels of a staggered choir along the lines of Cluny II. The nave appears to owe its design to the same church. If so, its current rib vaulting would have replaced a barrel with windows at the base; the rib vaults of the side-aisles are original. Typical for that era, the exterior displays flat lesenes linked with Lombard corbel tables.

In 1030, a benefactor built the former monastic church of St-Nazaire in Bourbon-Lancy, a flat-ceilinged church with piers, a large clerestory and side-aisle windows, but no galleries. This is one of the very few fully preserved large-scale churches in Burgundy. Its box-like transept also has a flat ceiling, while the five-bay staggered choir is again modeled on Cluny II.

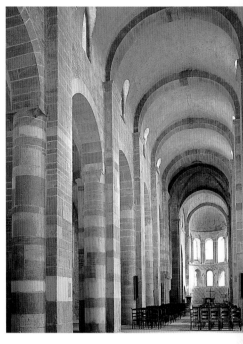

Payerne, former abbey church, c. 1040/1050, nave looking east

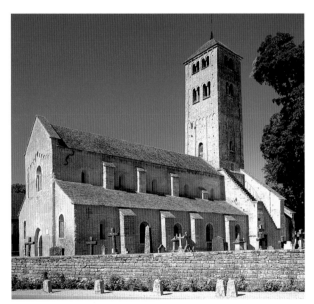

P. 74: **Dijon, abbey church of St-Bénigne,** from 1001, view into the rotunda

Chapaize, former priorate church of St-Martin, c. 1030, exterior view from the southwest

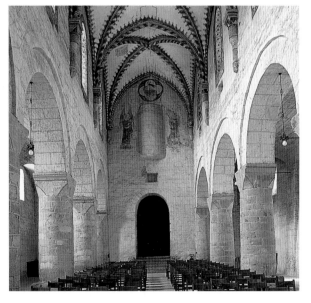

Romainmôtier, former abbey church St-Pierre-et-St-Paul, c. 1030/1040, nave facing west

St Philibert, Tournus, and the Problem of the Vault in the Eleventh Century

The complex and entangled story of the building of St Philibert is a history lesson in ninth- through twelfth-century church construction. It begins with a small monastery church dedicated to St Valerianus and a relocated monastic community. The Norman incursions had driven the monks of St-Philibert-de-Grandlieu to move from the Atlantic coast to Tournus, and

they brought with them not only the relics of St Philibert, but their church-building experience as well. In around 875, they built an unvaulted basilica (similar to the nave at Bourbon-Lancy) with a rectangular ambulatory crypt from which galleries led to rectangular or apsidal chapels, all facing east. This was destroyed and plundered, and in 950 a reconstruction began,

probably concentrating mainly on the choir and establishing the floor plan that persists in the east sections today. The three- or five-aisled nave might have incorporated the old walls or foundation. Accounts tell of a devastating fire in around 1007/1008 and a consecration in 1019, presumably following repairs. Somewhere between 1020 and 1030, work began on a nave

Chapaize, former priory church of St Martin, c. 1030, nave with massive pillars and barrel vaulting

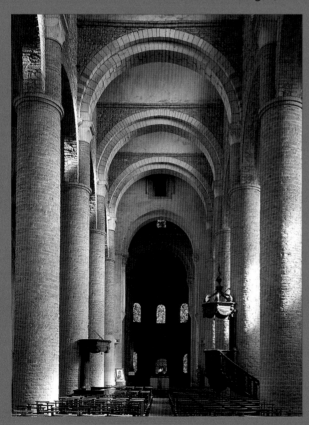

Tournus, former abbey church of St Philibert, central nave with its transverse arches and groin vaulting, 1040–1050 and 1070–1080

Barrel vault without clerestory

Barrel vault with intersecting minor vaults

Barrel vault on clerestory

Pointed barrel vault on clerestory

Groin vault

Cross vault

extension the same width as the 950 choir (thus narrower than the present nave, which to all appearances, it was intended to join. This new extension had three aisles and massive drum piers, which were doubtless intended to carry a central vault. Its central bays are square; those in the side-aisle are rectangular. After three bays, the builders reached the old west wall, where they apparently had a change of plans. Instead of continuing the narrower nave design, they

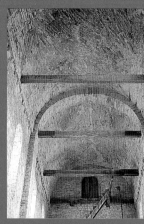

Tournus, former abbey church of St Philibert, vault of the upper level of the narthex, c. 1070

tried to adapt the vaulting concept to the older and wider side-aisles.

About the same time as the Tournus construction, the church of St Martin was built in the neighboring priory of Chapaize, where it still stands today. St Martin's vaulting bays are rectangular in the nave and square in the side-aisles, and it has small windows that cut up into the spring of the barrel (later rebuilt as a pointed barrel).

This development may have emboldened the monks in Tournus to try the Chapaize design in their own church. So they deployed five pairs of drum piers that supported semicircular arcades as well as the diaphragm arches stilted on short half columns with capitals. In all likelihood this was covered by a barrel vault with windows cutting into its spring. The crossing tower windows hint at the height of this barrel, since they now look into the nave. The narrower nave extension became the basement for a narthex whose center aisle got a groin vault, for which the imposts were set visibly deeper, while its side-aisles received transverse barrel vaults. The nave and narthex basement might have been completed around 1050 or 1060. Soon

Tournus, former abbey church of St Philibert, nave and west towers seen from the southeast, c. 1020

afterward came the upper floor of the narthex, a light, airy space with a successful barrel vault atop large clerestory windows. But the nave width turned out to be too great to span with a barrel vault, and it was probably removed when cracks appeared, since there is no evidence of a collapse. Around 1070/1080, in order to retain a stone vault, the builders duplicated the transverse barrels of the narthex basement's side-aisles over the nave. Evidently regarded as a compromise aesthetically, this solution was not repeated elsewhere.

In about 1130, after the collapse of its initial barrel vault, the Cluny III builders managed to span its 14-meter/16-ft-wide nave with a pointed barrel vault above a triforium and an impeccable clerestory. In 1144, St-Denis in Paris got an early Gothic rib vault that perfectly accommodated the new conceptions of space. Meanwhile, in Germany (Speyer and others) and Burgundy (Vézelay, etc), builders had recognized even before 1100 the advantages of groin vaults, whose arched bays made room for large windows. This, however, was only one aspect of the Gothic conception of space. The characteristically Gothic decorative emphases and breaking-up of the shell around a space could not be achieved with the groin vault.

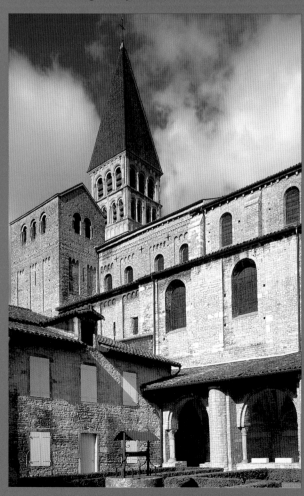

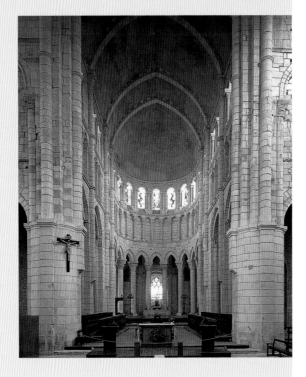

La-Charité-sur-Loire, former priory church of Ste-Croix-Notre-Dame, 1056–1107, interior view of the choir (right), north-east view (below)

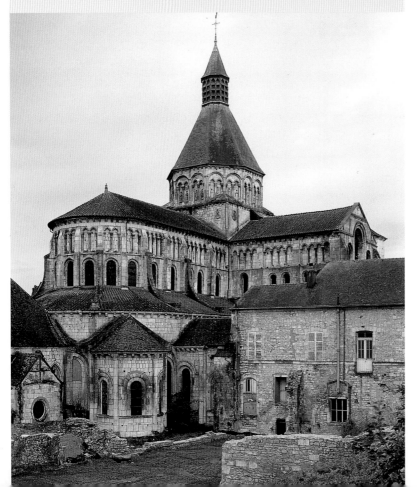

Predecessors of Cluny III

In 1049, the ambitious and clever Hugh of Semur ascended the abbot's throne at Cluny. However, it was not until 1088/1089 that he began construction of the third church, which leads us to assume it was decades in the planning. It seems as though he tested various spatial and structural configurations for Cluny III at several locations.

The earliest large-scale vaulted churches in Burgundy belonged to the Tournus group, of which only Payerne remains fully intact.

After the experience gained at Tournus and Payerne, St Etienne in Nevers represents the next stage in the development of large scale church projects. Endowed in 1063 by Guillaume I de Nevers and placed under the control of Cluny, it was completed in 1097. The builders succeeded in giving St Etienne a barrel vault with transverse arches over a nave with a three-level program: arcades on cruciform piers, galleries with segmental vaults, and a clerestory that does not cut into the barrel. Again we find semicircular responds that run from the floor up to the arches in the barrel. Moving past the tall, barrel-vaulted transept, we come to a three-level choir with ambulatory and three chapels. An octagonal tower crowns the crossing. Yet, despite the successful vaulting, this design also proved unsatisfactory.

The Count of Nevers had already endowed a monastery church in 1056 on the banks of the Loire near Nevers. La Charité-sur-Loire was another mem-

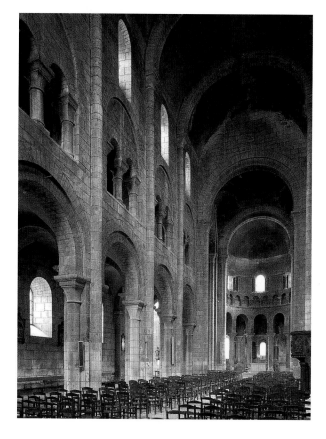

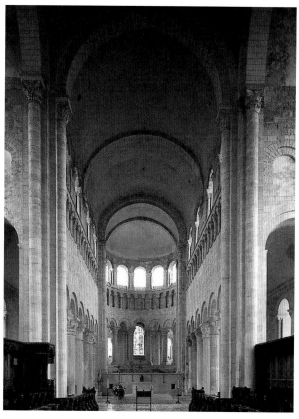

Nevers, former abbey church of St Etienne,
1063–1097, central nave and choir

St-Benoît-sur-Loire, former abbey church of St-Benoît,
c. 1070/1080–mid-twelfth century, choir

ber of the Cluny family. It was built with a seven-bay staggered choir, a tall, narrow transept, and, like Payerne, a colonnade around the inner choir and a two-level clerestory in the main apse. In these respects, La Charité owes its design to Cluny II, although at 122 meters/400 feet long its nave was longer and had ten bays. The galleried basilica design must have proved unsuitable for a five-aisle structure. Because the nave arcade was already considerably higher than for a three-aisle plan, the total height would have become unmanageable if a gallery level

were added. So it was decided to put in a triforium, which would be significantly lower than a gallery without substantially weakening the wall. It appears as though this church was the first attempt at a vaulted five-aisle basilica with triforium (and responds); in addition, it had groin-vaulted outer aisles and segmental vaults over the inner ones).

During the construction of Cluny III, the middle three apsidioles of the original staggered choir were replaced by an ambulatory with radiating chapels, which was consecrated in 1135. St-Benoît-sur-Loire was another

monastery with ties to Cluny. When its abbot, Guillaume, began renovating the church there in 1070/1080, it appears he was influenced by the construction at La Charité. Above a crypt he built a choir and ambulatory with only two radiating chapels and a deep, barrel-vaulted, long choir. The elevation detail takes after those of La Charité and Nevers. On either side of the choir head are chapels topped with towers, which give the effect of a second transept. Thus this choir directly anticipates Cluny III in both floor plan and elevation.

Successors to Cluny III

The third abbey church at Cluny was begun in 1088/1089 under the leadership of Hugo von Semur and consecrated in 1131/1132. Although Hugo led Cluny for a remarkable tenure of sixty years, he died in 1109 and did not see his extraordinary plans fully realized. It consisted of a five-aisled nave of eleven bays (73.75 meters/ 242 feet), a first transept with east apses (also 73.75 meters/ 242 feet), two antechoir bays the width of the nave, a second transept with four additional east apses, and a choir ambulatory with five radiating chapels. The overall length was a monumental 187.31 meters/614 feet! The elevation was in three tiers, with a blind triforium and clerestory, each having three arches per bay, rising above slender, pointed arcades. The compound piers had fluted semicolumns facing into the nave that carried the ribs of the pointed barrel, giving the space a measured rhythm and accenting the vertical elements. Square and octagonal towers rose above both crossings, the west facade, and the arms of the larger transept. The original, rounded barrel over the nave collapsed in 1125 and was replaced with a pointed one, which is obviously more stable structurally and was employed frequently in subsequent projects.

When this in every aspect matchless church was completed, Gothic forms had already begun to establish themselves in Normandy and England. At St Denis in 1144, Abbot Suger created an initial Early Gothic monastic church. Despite this, the Cluny III design formed the basis for many other churches in Burgundy.

The former monastic church of Notre Dame in Paray-le-Monial was built parallel to Cluny III, by the same builder, Abbot Hugo, as a "pocket edition" of its neighbor. Having merely a three-bay, three-aisle nave, a five-bay transept, and a choir ambulatory with three chapels, it appears minuscule in comparison with its model. Their close kinship can be seen in the details of the elevation, but is limited to these. The tremendous sense of space and the slender elegance of Cluny III are absent here. This elegance of a celebratory space, the subtle *chiaroscuro* of the wall mouldings, spread rather to St Lazare in Autun,

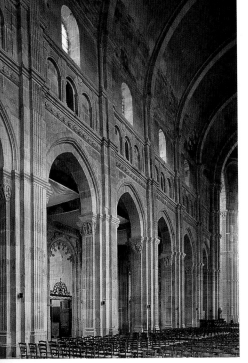

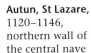

Autun, St Lazare, 1120–1146, northern wall of the central nave

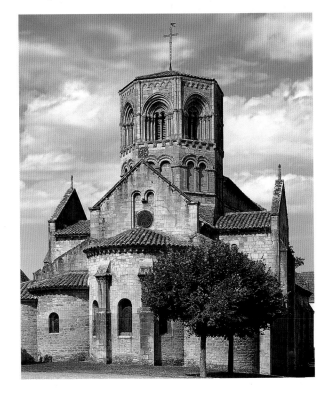

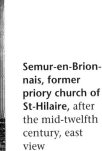

Semur-en-Brionnais, former priory church of St-Hilaire, after the mid-twelfth century, east view

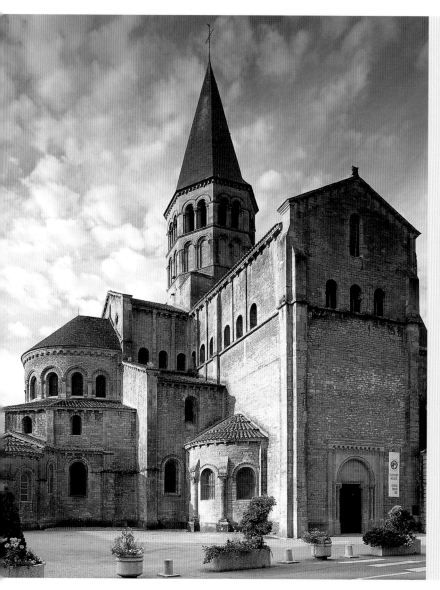

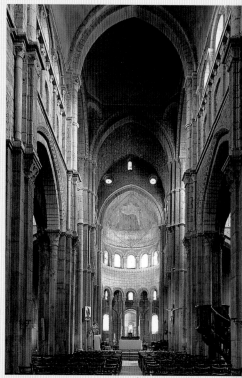

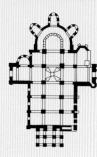

Paray-le-Monial, former monastic church of Notre-Dame, first half of the eleventh century, northeast view; nave and choir; ground plan

even though that church was given a (subsequently altered) staggered choir instead of an ambulatory. St Lazare is the work of Bishop Etienne de Bagé, an ardent follower of the *Cluniazensis Ecclesia*, who began work on St Lazare in 1120.

Other successors of Cluny III are St Andoche in Saulieu, also started by Bishop de Bagé; St Hilaire in Semur-en-Brionnais, the family seat of Cluny's Abbot Hugh, where he himself endowed a church in 1120/1130; Notre Dame in Beaune, the canons' collegiate church begun in 1125/1130; and the cathedral at Chalon-sur-Saône—though perhaps only recognizable as such after its nineteenth-century restoration. The barrel-vaulted galleried basilica of Nevers had hardly any following. Though the Italian gallery basilicas did borrow its concept, they did not adopt its vaulting. Meanwhile, in England and Normandy, rib vaulting and clerestories with wall passages were developing in galleried naves.

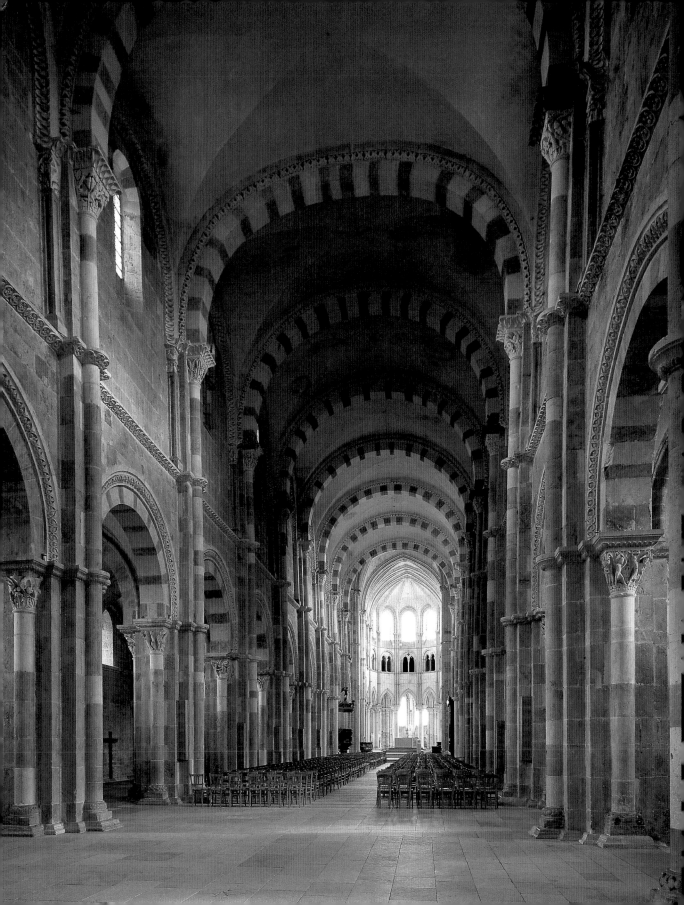

Vézelay

At the time Cluny III was nearing completion, the monastery of Ste-Madeleine in Vézelay, which was founded slightly earlier than Cluny and under similar conditions, had a Carolingian nave and a High Romanesque choir. Vézelay's possession of the relics of Mary Magdalene guaranteed its importance and appeal, making it a wealthy and popular pilgrimage destination. In 1120, the nave burned down, with reconstruction beginning soon afterward. There are records of consecrations in 1132 and in 1145/1151. The reconstruction was certainly inspired by the Cluny project. With 13 bays, Vézelay's nave and narthex surpass Cluny III in length. A three-bay transept provides the transition to the choir (1104) and crypt. After a fire in 1165 devastated the east end, the builders decided to build a new choir in the form of an ambulatory and radiating chapels.

All the nave's structural elements are of a refined perfection that recalls Cluny III, although—perhaps deliberately—the overall impression is rather different. The elevation is composed of the nave arcade and clerestory; both the nave and side-aisles have groin vaults between massive transverse arches that are colored with alternating bands. Square side-aisle bays accompany wide, rectangular nave bays, which was an uncommon form for Burgundy and France in general. Some well-known exceptions are Anzy-le-Duc (second half of the twelfth century), with bays that are square in the nave and rectangular in the side-aisles as a result of changes to the original vault design; and two churches modeled on Vézelay, St-Lazare in Avallon and Ste-Marie in Pontaubert. In German-speaking areas on the other hand, we find many examples of fully groin-vaulted basilicas (consider for example Speyer), which for the most part follow a square schematism.

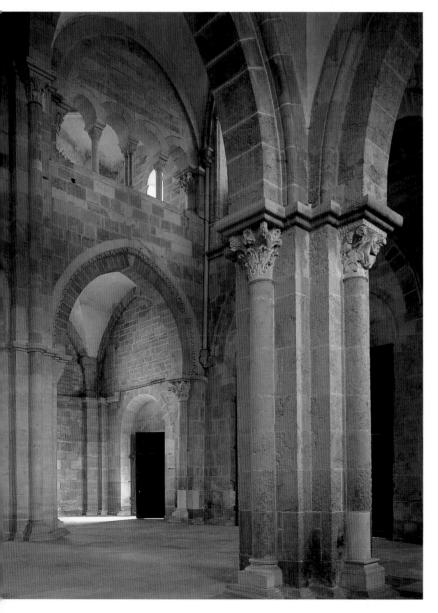

Vézelay, Ste-Madeleine, after 1120, nave facing east with Gothic choir (p. 82); southwest view of narthex (left)

Northern France

Several churches dating from the early eleventh century—the time of Cluny II's vaulting—still stand in northern France. They have flat or wooden barrel ceilings, since stone barrel vaulting imposed obvious restrictions on the width of the nave that the region's builders would not accept. The nave of Montier-en-Der, from c. 1000—the choir is Early Gothic—is the oldest remaining example of these. It has compact arcades under the tall twin openings of a vaulted(!) gallery, and large windows above a smooth wall area. The complete lack of vertical divisions is reminiscent of St Cyriakus in Gernrode (see p. 48), but here the effect is heavier and bulkier.

At Ste-Gertrude in Nivelles, galleries were dispensed with in the nave. Instead, the arches of the extraordinarily tall arcade extend almost up to the clerestory. This device gives the space a much taller and more

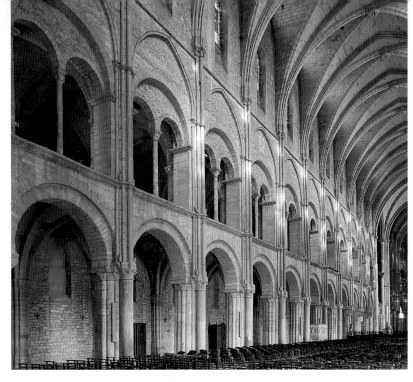

slender appearance without diminishing its monumentality. Three diaphragm arches, one at either end of the nave and one in the middle, lend definition to the area.

In 1005, construction on St-Remi in Reims began under Abbot Airard. This is another

Above: **Reims, St-Rémi,** 1005–mid-eleventh century, wall of the central nave

example of a gallery church, not substantially different in proportion from Montier-en-Der, but incomparably more slender, graceful, and structurally differentiated. The nave extends across 13 bays. The narrow transept has side-aisles and galleries as well as eastern apses. The result is a space with a transparency and complexity that had not been seen before. This might be what was envisioned for the presumably five-aisled Romanesque cathedral that was planned for Orléans, but which in the end had to yield to the Gothic. Gothic additions at Reims [St-Remi] include the responds in the nave, the pointed blind arches over the galleries, the vault, and the choir with ambulatory.

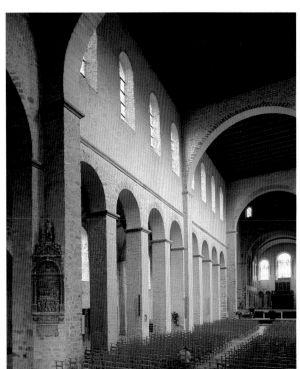

Nivelles, Ste-Gertrude-et-St-Pierre, c. 1000–1046, wall of the central nave

Normandy

The monastery church of Notre-Dame in Bernay was begun around 1015. When its original staggered choir was damaged in a tower collapse and rebuilt on the model of an earlier example in Lessays, the completely unvaulted nave was left intact. Its elevation is in three zones, with the solids and the voids vertically aligned. Above the nave arcade, the triforium has shallow niches alternating with stilted-arched double openings, and above these are large clerestory windows. In all likelihood, the choir and transept had the same elevation, but with stone vaulting replacing the clerestory. Thus Bernay demonstrates the options of the time: vaulting without clerestory or clerestory without vaulting. This connundrum kept the architects of Normandy busy for a century until they finally discovered the possibilities of rib-vaulting. In the interim it was variously resolved in Burgundy with the "Tournus solution" (a barrel vault with small

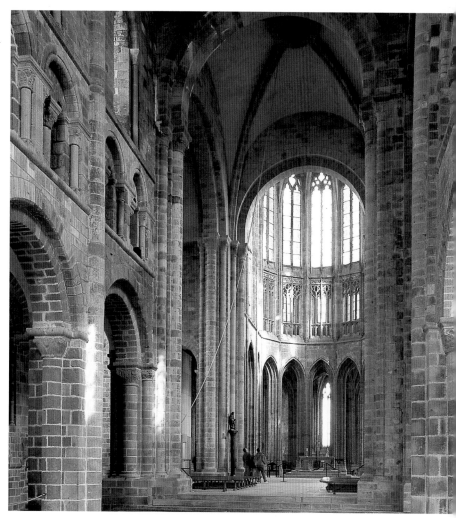

Mont-St-Michel, former monastic church of St-Michel, c. 1035 and following years, Romanesque transept and Gothic choir

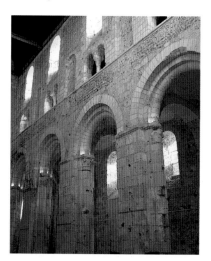

Bernay, former church of Notre-Dame, c. 1015 and following years, wall of the central nave

windows at the foot), then later the "Nevers solution" (barrel vault over galleries) or the "Cluny III solution" (a pointed barrel vault over triforium).

The abbey church of Notre Dame in Jumièges, 1040–1067, has a three-aisled nave with arcades, vaulted galleries with three-light openings in framing arches, and a clerestory. Here we encounter a further important developmental step. The compound piers have semicircular responds facing into the nave; between them are drum piers. Thus Jumièges has alternating supports like Speyer I (begun 1027), which was designed for a barrel vault. This

together with the gallery vaulting might hint at a plan for vaulting at Jumièges. In any case, the responds changed the look of the interior, and the nave no longer has the box-like quality of northern French, early Burgundian, and many German and Italian examples. The responds and arches provided a vertical counterbalance to the previously dominant horizontals. They merged the elements of the interior, articulating them into sections, and added a greater sense of height to the nave. At Jumièges, this effect was certainly deliberate, since the nave is only 24 meters/ 79 feet high (Cluny III was 29.5 meters/97 feet). Attached to this nave were projecting transepts and a vaulted choir with ambulatory and radiating

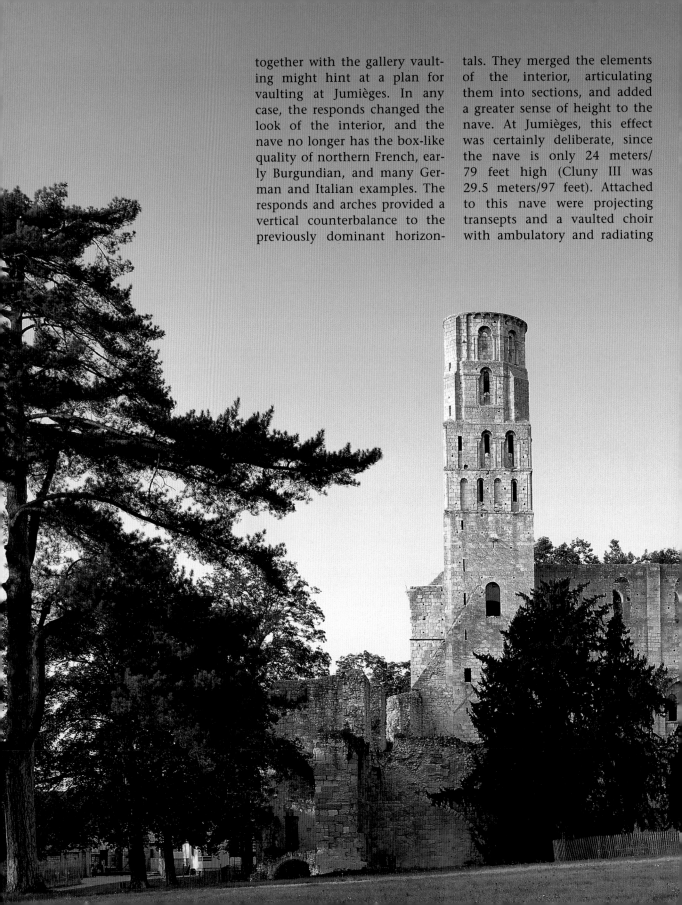

chapels, of which the foundations survive. On the surviving western wall of the transept a supplementary wall layer can be seen on the inner side. This is a later addition that may have been intended to facilitate a barrel vault by reducing the interior span and increasing the outer supports. However, because a wall passage was included at window level, we can

pinpoint the origin of this feature. The main choir appears to have had a barrel vault with transverse arches over the arcade and galleries.

As early as 1023, the choir of a new chuch had been started on Mont-St-Michel. It was built over an underground crypt with a polygonal floor plan, forgoing chapels because of the terrain. As at Jumièges, the choir was

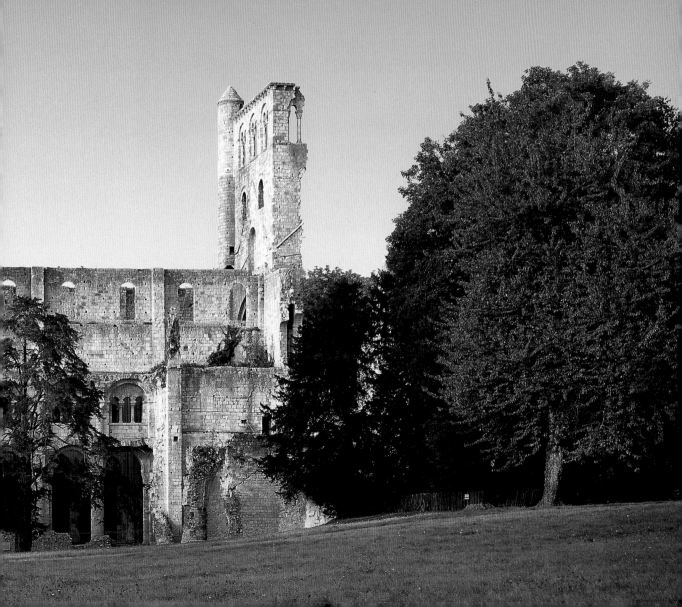

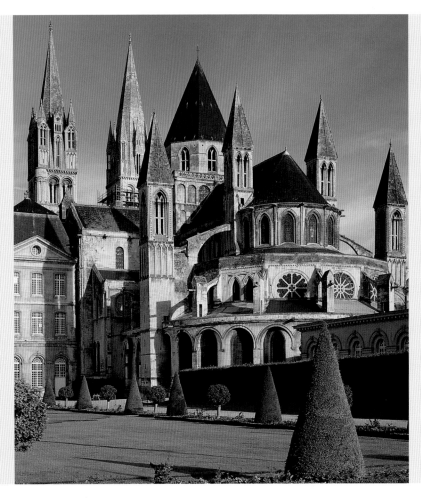

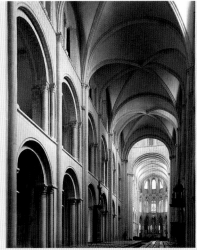

Caen, former abbey church of St-Etienne, 1060–1065, northeast view; ribbed vaulting; ground plan

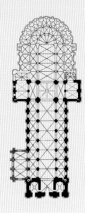

lower than the nave and had a barrel vault, although it lacked transverse arches and its bays contained single, rather than doubled arches and windows. The three-level galleried nave (illus. p. 85) from around 1055 has no alternating piers. Like the slightly earlier barrel-vaulted nave of Payerne, Mont-St-Michel has responds on each pier, and like Speyer I, it has a tall blind arch in each bay. Because of that, its bays are rectangular, and its arrangement is tighter and more consistent. It may be that the stone vaulting

was successful here, although the collapses in 1094 and 1103 should be noted.

By order of William the Conqueror and his wife Matilda, the construction of the abbey churches of St-Etienne and Ste-Trinité began at Caen in approximately 1060/1065. Their ensuing decades-long rivalry brought Norman architecture to its fulfillment. Both churches, like Jumièges, have the familiar massive twin-towered facade. The naves have three aisles and a three-tier elevation. Because of the similarity between Ceri-

sy-la-Forêt and Ste-Trinité, it can be assumed that St-Etienne also originally had a staggered choir of the same type that Bernay once possessed. The double-walled structure of the clerestory, which finds its origins in the transept at Jumièges, was perfected at St-Etienne and Ste-Trinité, where it can be seen in the nave, transept and presumably the choir of both churches. Apparently the choir and transept at St-Etienne displayed the same three-zone elevation as the nave—arcades, galleries with high twin open-

ings and a clerestory with wall-passage and an opening in front of the window—and were flat-ceilinged. Only the apse was vaulted, at the expense of a clerestory. From about 1070 onward, the nave was under construction. Like Jumièges, it had alternating supports that corresponded to a pattern of transverse ribs (or the transverse arches of an intended barrel vault). The galleries have segmental vaults, which likewise indicates an intention to vault the nave. When this idea was abandoned on account of the span, the clerestory was redesigned. It was given a passageway with three arches opening onto the nave, a motif that was often repeated afterward. This established a hitherto untried method for opening up the upper wall surface.

In contrast, Ste-Trinité probably had a barrel-vaulted choir with small windows over a blind arcade, which would have corresponded to a similarly barrel-vaulted nave with a short triforium and small clerestory. But the nave, completed in 1075/1085, combined a ground level arcade and a blind triforium with a clerestory and wall passage. Perhaps it was thought that a barrel vault might be achieved by dispensing with the galleries. This method of vaulting is found in 1120/1130 at St-Etienne: a rib vault which, owing to the alternating piers, is in six sections. As a consequence of the mid-section transverse ribs, the clerestory with passageway took on an asymmetrical form.

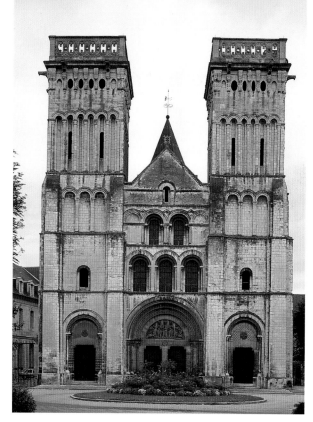

Caen, former monastic church of Ste-Trinité, double-towered western facade; c. 1060/1065– c. 1120

Cerisy-la-Fôret, former priory church of St-Vigor, c. 1080/ 1085, choir with apse, transept, crossing tower, and two bays of the nave

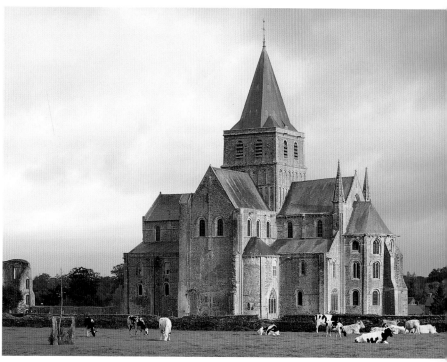

England

Any attempt to classify a style into early, high and late periods, as is customary on the European continent, must take into account the fact that in England, the Romanesque—and here that means French Romanesque—was generally not assimilated until after the conquest of the island by William II of Normandy, who asserted his claim to the English throne by force of arms on October 14, 1066 at the Battle of Hastings. This pivotal campaign is depicted on the Bayeux Tapestry, an embroidery more than 70 meters/230 feet long and only 50 cm/20 in wide, with multi-character scene sequences accompanied by commentaria in the margins.

Until this invasion, English religious building remained entirely Anglo-Saxon in tradition: Smaller spaces were joined together; the old was retained and would be expanded either by joining it to other existing structures or by the addition of new sections. Cnut had come to England in 1013 as leader of the Danish invasion; as King Cnut the Great, he made the island the center of his northern kingdom from 1016 onward. He left behind, however, barely any architectural testimonial to his time. This changed, gradually at first, under his successor Edward the Confessor, who reigned from 1042. Edward had grown up in exile in Normandy, and was therefore familiar with the French churches of the time, especially the Norman ones. From 1045/1050 he had the old buildings of St Peter's Abbey in Westminster (London) taken down and began a monumental new construction.

Robert Champart, abbot of Jumièges, became bishop of London in 1044. Excavations at Westminster reveal a triple-aisled nave, twelve bays long and articulated with an emphatic alternating pier system. There was a twin-towered facade at the west end and, to the east, a slightly projecting double-bay transept and an unvaulted staggered choir of five chapels. Although the choir plan demonstrates its kinship with those of Bernay and Cluny II, neither of these had alternating piers in the nave (these would only emerge somewhat later, at Jumièges). Thus it seems likely that the nave elevations were also similar, and that Westminster Abbey would have had a galleried nave with a basilican cross-section that was, like Jumièges, intended to carry a stone vault. There may have been other pre-1066 buildings besides Westminster Abbey that took after French architecture, but no known examples did more than import the sculptural forms found on French nave walls. After 1066, when Duke William ascended the English throne as King William I, the secular nobility as well as the clerical leadership underwent a radical Normanization. Abbot Lanfranc from St-Etienne in Caen became Archbishop of Canterbury. He united the English Church and reformed its monastery system.

From about 1070/1080 until the early Gothic renovation of Canterbury Cathedral, Westminster Abbey would remain the mandatory prototype for large-scale religious buildings in England—the earliest of these being Battle Abbey, consecrated in 1094. Regrettably, we have only the floor plan for Canterbury, which was built between 1070 and 1089 under Abbot Lanfranc. Yet its nave cannot have differed greatly from that of St-Etienne in Caen, which was also built by Lanfranc. St-Etienne had major arcades and galleries as well as a triple-arched clerestory wall passage. However it looks as though vaulting plans were abandoned at Canterbury. From about 1070–

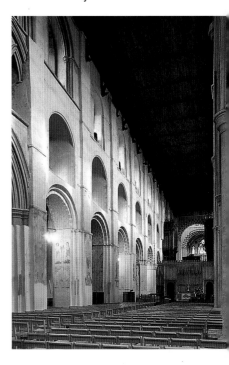

Former monastic church of St Albans (cathedral since 1877), view of the central nave

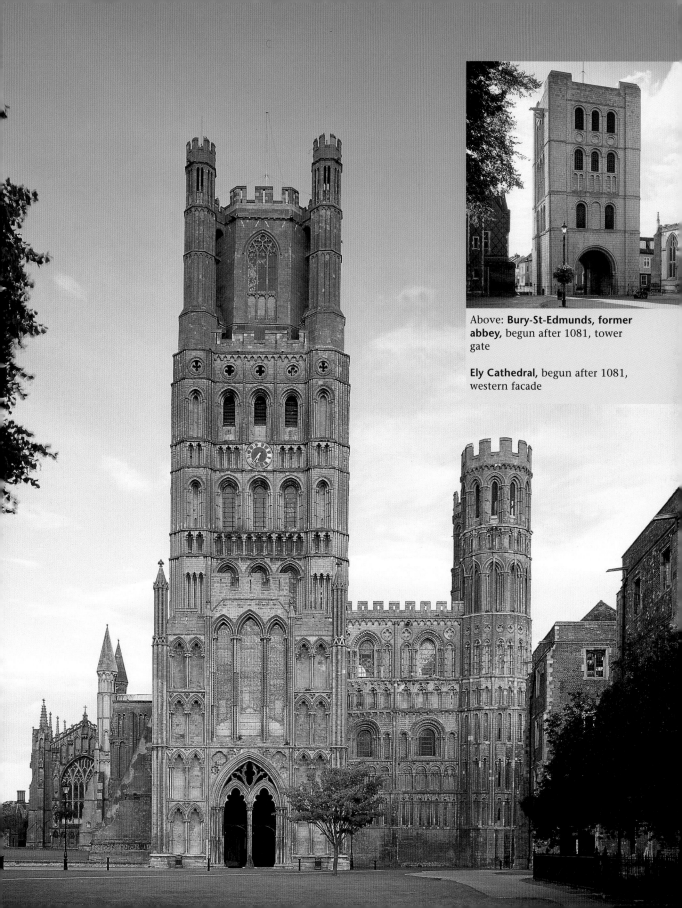

Above: **Bury-St-Edmunds, former abbey,** begun after 1081, tower gate

Ely Cathedral, begun after 1081, western facade

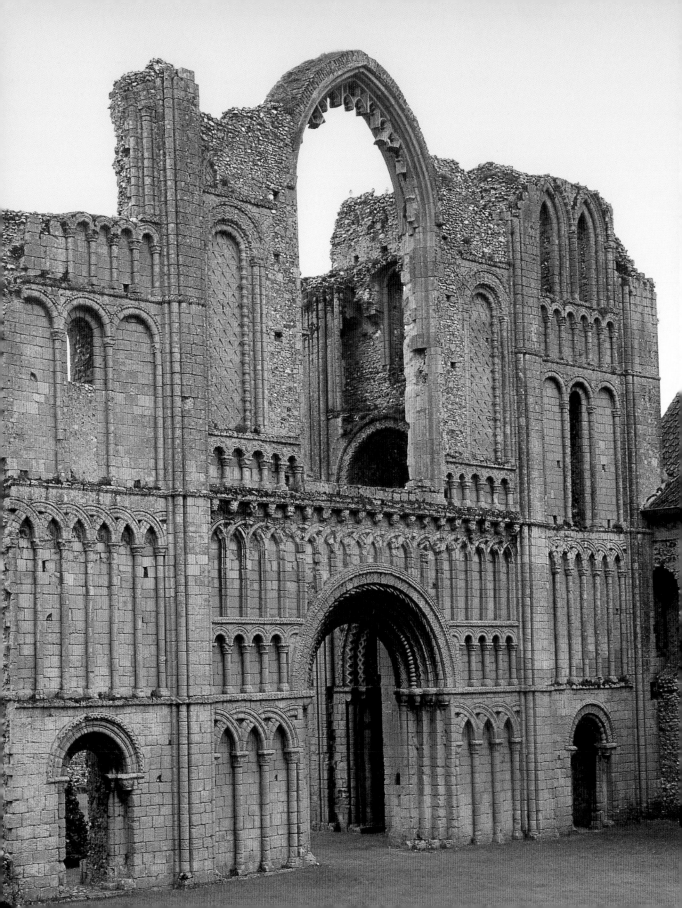

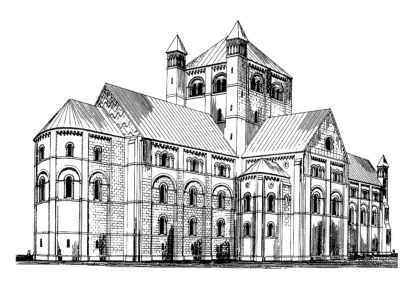

transept with semicircular apses, and a four-bay long choir with an ambulatory and radiating chapels. At the west end, a projecting transept passed through apsidal chapels to connect with octagonal towers at each end. At the center of this transept, a massive square tower was set directly over the nave. Only the central tower still stands today, but the west facade of Ely Cathedral gives us some idea of the overall look of Bury (illus. p. 91).

1073, the cathedral had local competition in the abbey church of St Augustine, which was being built under Abbot Scotland (formerly of Mont-St-Michel). St Augustine's, too, was a galleried basilica, but it surpassed the cathedral by three bays and had a more modern ambulatory with three radiating chapels. The third building modeled on St-Etienne was Lincoln Cathedral, begun in 1073/1074 and consecrated in 1092. It weathered the Gothic era about as poorly as Rochester Cathedral, begun in 1080.

The monastic church of St Albans (a cathedral since 1877) is at least partially preserved. It was built by the monk Paul from Caen, who became abbot in 1077, using bricks from Roman times that had been gathered over decades. Here we find the earliest preserved structure of Anglo-Norman construction. And in fact, it is closely related to St-Etienne, even though the building material made certain concessions unavoidable. But an even closer likeness to the St-Etienne structural program can be found in the transept of Winchester Cathedral, which was begun in 1079 and is still virtually unaltered. This monumental 164-meter/538 foot-long building enriched the established church design of the day by introducing a continuous ambulatory, which made it possible for the gallery level to extend into the transept. The influence of the pilgrimage churches may also be felt in the paired square towers on the transept ends and choir.

This configuration propagated itself at the cathedrals of Hereford (from 1080), Worcester (from 1084), Gloucester (from 1089), and others, all of which followed the now established style. Several major abbey churches came from the same period, but most are now destroyed. However, much can be learned from what remains of the abbey church of Bury-St-Edmunds, the monastery built over the grave of St Edmund. Here, too, was a three-aisled galleried basilica, a two-aisled

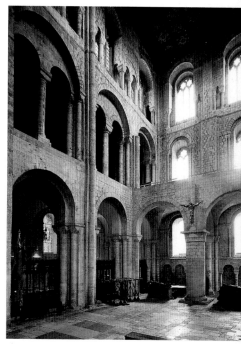

Winchester Cathedral,
view of the interior: northern transept

Above left: **York Cathedral,** begun c. 1079(?), Thomas of Bayeux-building, reconstruction from the northeast

P. 92: **Castle Acre, former Cluniac priory church,** begun 1089, western facade

The structure at Ely, however, is more advanced and more richly ornamented. Ely also began as a monastery, which in about 1080 was one of the last to fall into Norman hands after its Anglo-Saxon monks put up fierce resistance. In 1081, the new abbot, Simeon, began construction of a new church there, a three-aisled galleried basilica with alternating piers, a transept with an ambulatory and chapels, and a long choir. Only the central aisle of the choir ended at one time in a semicircular apse. Similar to earlier buildings, the nave elevation consisted of a major arcade with nested soffits, a double-arched gallery, and a clerestory with a triple-arched wall passage, arranged together in a 6:5:4 proportion. As was true in Burgundy and Normandy, ex-

perimentation with stone barrel vaults in England continued until the monumental barrel vaulting of the clerestory at St-Etienne in Nevers—and presumably the rib vaulting of St-Etienne in Caen—were successful. Worcester and Gloucester Cathedrals are two examples of these attempts, but unfortunately their upper stories are lost. However, a reliable representation can be seen at two of their former dependents, the priory churches of Tewkesbury and Pershore. In the choir of these buildings, the major arcade supports a gallery with segmental vaults, above which is a triforium with tiny windows and a barrel-vaulted wall passage. In the nave, a similar triforium is set directly over a much taller major arcade. This explains the strange proportions of the nave

in Gloucester today, which was given a Gothic clerestory and rib vault. In Worcester and Gloucester, it was not until 1120 that knowledge of rib vaulting made a stone vault possible, which explains why the large-scale projects begun at the end of the eleventh and during the first two decades of the twelfth centuries maintained the traditional nave elevation. These include Durham Cathedral (begun 1093), Norwich Cathedral (begun 1096), Southwell Cathedral (begun 1108), and lastly Peterborough Cathedral (begun 1118). The frequently made assertion that Durham Cathedral was in 1093 the first to receive a rib vault, does not hold up. Meanwhile, the exteriors, especially the towers and west facades, were being embellished with row upon row of blind arcades decorated in rich detail and superimposed over each other, introducing the motif of the pointed arch.

An especially lovely example of "Norman" facade decoration is Castle Acre, the ruin of a Cluniac priory begun in 1089 (illus. p. 92). Here the English builders are already beginning to show their originality, while remaining close to the standard French floor plans and nave elevations. They abstain from figurative sculpture and concentrate almost entirely on column and arch motifs, which they assemble into multiple variations on the blind arcade.

The Late Romanesque began around 1135 in England, manifesting itself essentially in the

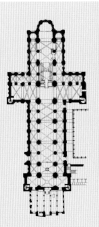

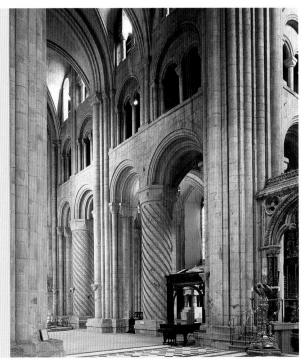

Durham Cathedral, begun 1093, wall of the central nave; ground plan

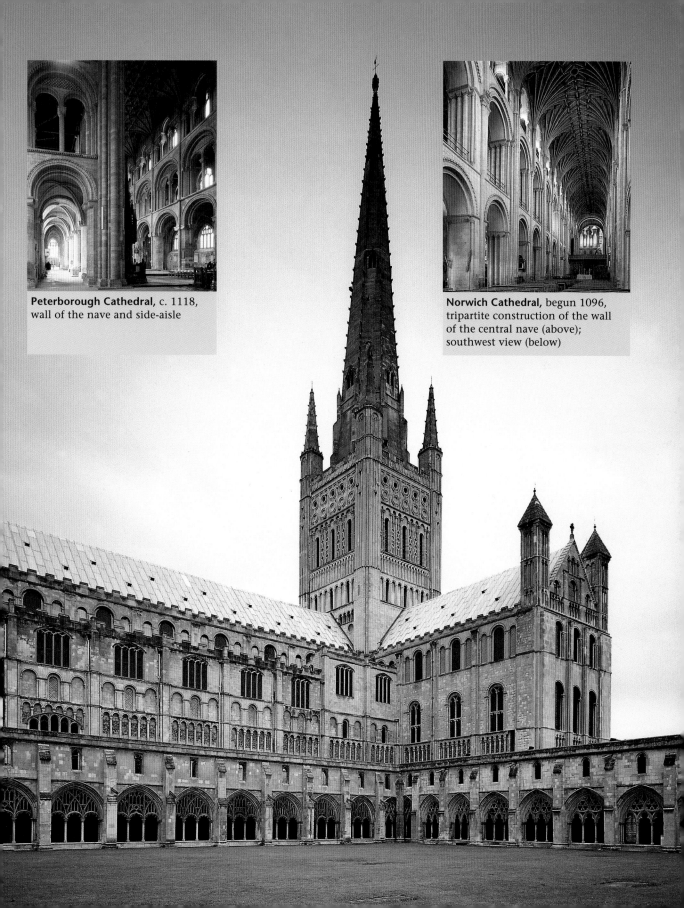

Peterborough Cathedral, c. 1118,
wall of the nave and side-aisle

Norwich Cathedral, begun 1096,
tripartite construction of the wall
of the central nave (above);
southwest view (below)

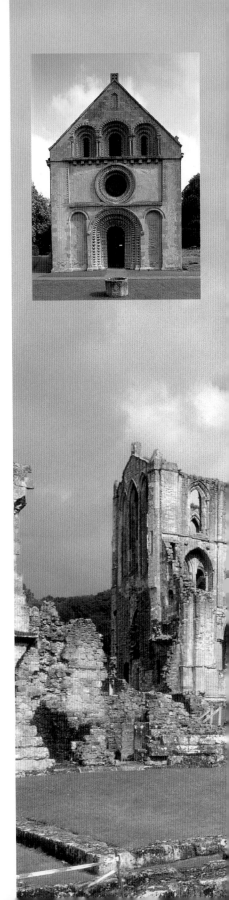

decorative embellishment of existing structures. After the "building fever" that had blanketed the island with large-scale buildings during the last decades of the eleventh century, the immediate needs had been met. During the second half of the twelfth century, however, several smaller parish churches were built with abundantly decorated facades or portals. Some examples of these are Iffley, Patrixbourne, Kilpeck, and the former Augustinian priory church at Oxford. It is interesting to note that west facade of Iffley, from the last third of the twelfth century, is decorated exclusively in geometric patterns that frame the openings in several bands, while the two late-twelfth-century portals at Patrixbourne and Barfreston are closely comparable with contemporary Burgundian sculpture. In a parallel development, the Templars, one of the internationally organized knightly orders, had already begun introducing the Gothic into England with their London churches from as early as 1160.

From about 1120, the Cistercians began founding daughter monasteries in rapid succession on the island. Their monastic complexes followed the same principles laid out during the founding years of the order in Burgundy. As in Burgundy, nearly all of England's Cistercian monasteries have been destroyed, although picturesque ruins surviving at many spots allow us to see their layouts, with the typical transept chapels and rectangular choirs. The

Patrixbourne, Romanesque church, last third of the twelfth century, detail of the archivolts (below)

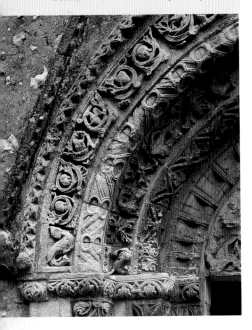

elevations and large parts of the monastic complexes are frequently recognizable. Incidentally, the structural formulae, as in Germany, did not always follow those of the Cistercian mother churches (arcades and windowless pointed barrel vaults). The English Cistercian churches are two- or even three-storied and might have had either flat ceilings or wooden barrels. Like their colleagues on the continent, the English Cistercians began loosening their strict canon in around 1200, tolerating richer structures and, of course, choir ambulatories.

Two famous and scenically delightful examples are Fountains Abbey (founded 1135, illus. p. 33) and Rievaulx Abbey (founded 1132), whose massive two-story columned basilica still has many noticeably Cistercian features. Although it is an abbey church, Rievaulx's three-aisled, richly structured gallery elevation has the character of a cathedral.

P. 96 right: **Iffley, Romanesque church**, last third of the twelfth century, western facade

Rievaulx Abbey, former Cistercian monastery, founded 1132, exterior view of the ruins of the monastic church

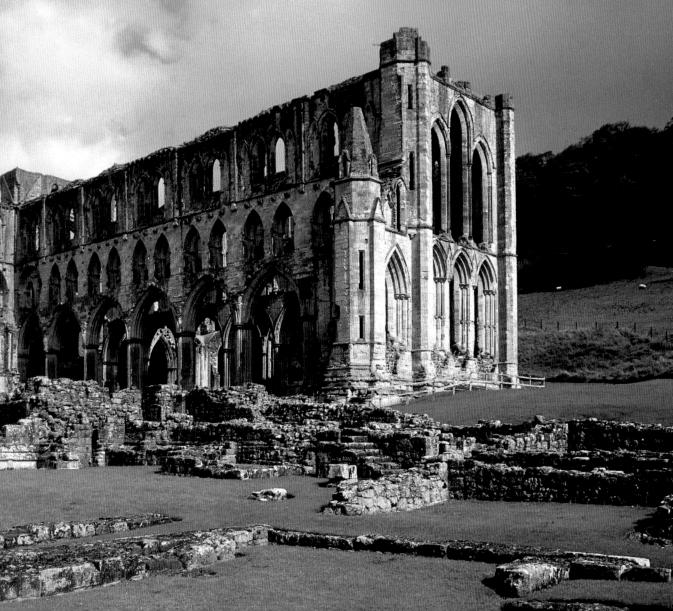

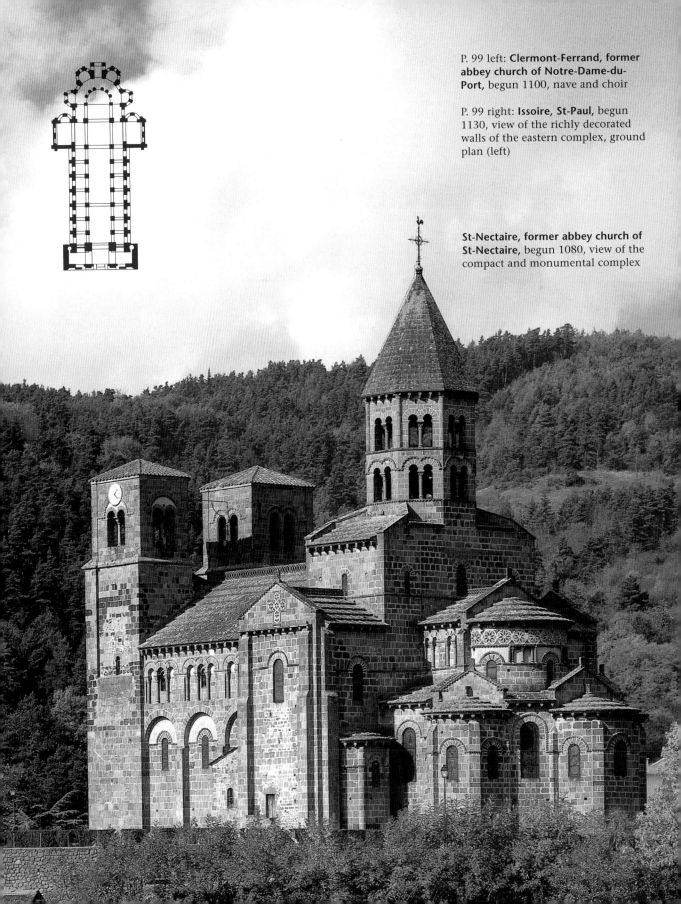

P. 99 left: **Clermont-Ferrand, former abbey church of Notre-Dame-du-Port,** begun 1100, nave and choir

P. 99 right: **Issoire, St-Paul,** begun 1130, view of the richly decorated walls of the eastern complex, ground plan (left)

St-Nectaire, former abbey church of St-Nectaire, begun 1080, view of the compact and monumental complex

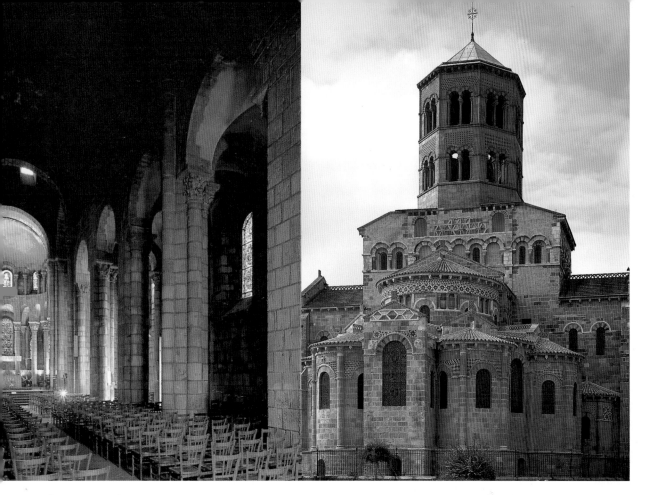

Other Regions of France

Auvergne

From the late eleventh century, a group of monastic churches emerged in Auvergne that assimilated many aspects of the pilgrimage churches and St-Etienne in Nevers, without giving up their own identity. The most significant churches of this group are St-Nectaire (from 1080 onward), Notre-Dame-du-Port in Clermont-Ferrand (from 1100 onward), St Austremoine in Orcival (early twelfth century), and St Paul in Issoire (1130 onward). Common to all these churches is a low choir with an ambulatory and four radiating chapels, and a deep choir bay; a five-bay transept with three taller middle bays; and a three-aisled nave. The naves have major arcades, galleries, and a windowless barrel vault. The low gallery openings do not allow nearly as much light into the interior as in the pilgrimage churches.

It is surprising to note the deliberate lack of responds and transverse arches in the nave, since they are employed in the side-aisles. The interior spaces in Auvergne appear to result from an effort to create a unique look there, and this building conception is even more evident on the exterior. The subtly pyramidal composition of the masses is especially clear from the east. From the chapels encircling the compact ambulatory rises the clerestory of the choir, which is approximately the same height as the transept arms. At the crossing, a raised section with shallow lean-to roofs leads to the culmination of this complex structure: an octagonal crossing tower enriched with blind arcades and windows.

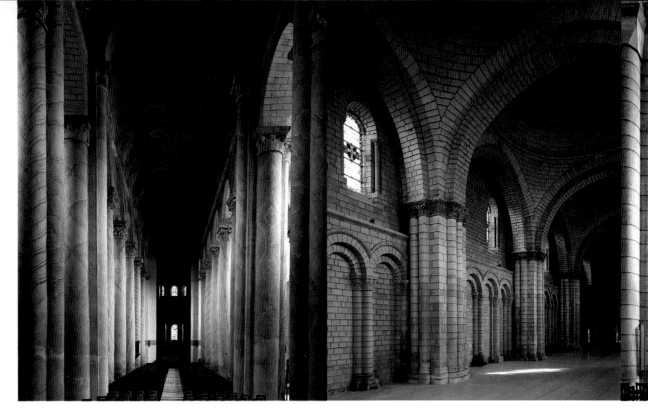

Western France

The Romanesque is exemplified in western France essentially through two building types, the hall church and the domed church. St-Savin-sur-Gartempe was built from about 1060, and its east end was completed around 1085. This section differs only in detail from the monastic churches of Auvergne, but the nave is a hall, with the groin vaults of the two side-aisles at the same height as the nave barrel. Similarly, the nave and aisles are almost equal in width. Only the western bays of the nave have transverse arches, whose continuation is reflected in the pier design. Moving eastward, the ribless barrel is carried on columns, imparting continuity rather than rhythm to the space. Another example of a hall church is Notre-Dame-

la-Grande in Poitiers (c. 1130/1150), although, like a vaulted basilica, its nave is distinctly broader and higher than the side-aisles and is articulated with responds. This gives it an altogether different interior effect than St-Savin.

Perhaps the best-lit interior is found in the hall church of Notre-Dame in Cunault. Construction began around 1100/1110 on the choir and ambulatory, which have an unmistakable similarity to the neighboring monastery church of Fontevrault. The fourth bay of the choir was meant to connect to a five-aisled hall with side-aisles of equal height. If this project had been finished as planned, it would have produced one of the most unusual churches of the Romanesque period, but in the end the nave

was redesigned with only three aisles.

At the beginning of the twelfth century, a new architectural form—the dome—appeared in western France, possibly imported from the Orient by way of Venice. The earliest building from this group is the monastic church of Fontevrault, whose east end was consecrated in 1119. This consists of a choir with ambulatory and chapels, and a five-bay transept with apses. What was likely the initial plan for a three-aisled nave was abandoned in favor of a single-passage nave whose four bays are vaulted with domes on pendentives. The nave of the cathedral at Angoulême, begun around 1120/1130, repeats this design but sets a dome onto a drum with windows in place of Fontevrault's traditional cros-

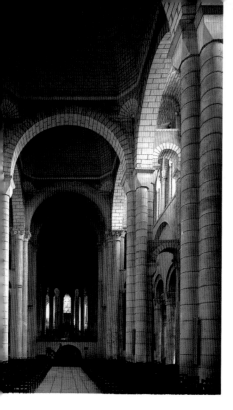

P. 100 left: **St-Savin-sur-Gartempe,** view through the columned nave into the old choir with ambulatory

P. 100 right: **Fontevrault, monastic church,** founded 1110, domed nave of the former monastic church

Left: **Poitiers, St-Hilaire,** first half of the eleventh century and c. 1130 onward, nave looking east with two-story lower sections of the inner side-aisles

Angoulême, Cathedral of St-Pierre, begun c. 1120, dome vault, view of the richly decorated facade

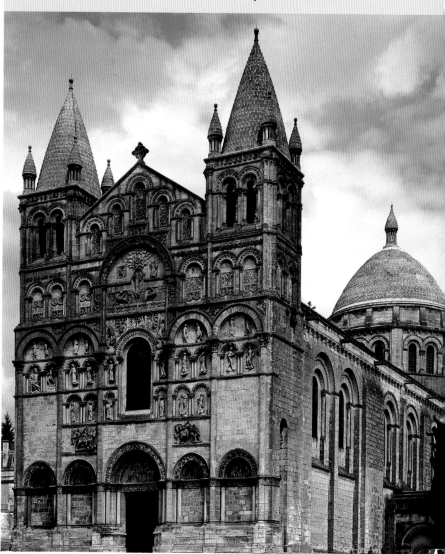

sing tower. Finally, St-Front in Périgueux reveals itself as a definite offshoot of San Marco in Venice (1063–1094). It has a cruciform central plan composed of five domes on square bays, which, as at S Marco, are separated by massive piers containing vaulted passages. Three of the bays have eastern apses attached, reminiscent of a choir and transept, but to the west, instead of a nave, there is simply one more bay.

The hall and domed churches come together in hybrid form at St-Hilaire in Poitiers, from the first half of the eleventh century. In this five-aisled plan, the side-aisles equal the nave in height but vary in width; octagonal domes on small squinches crown the nave.

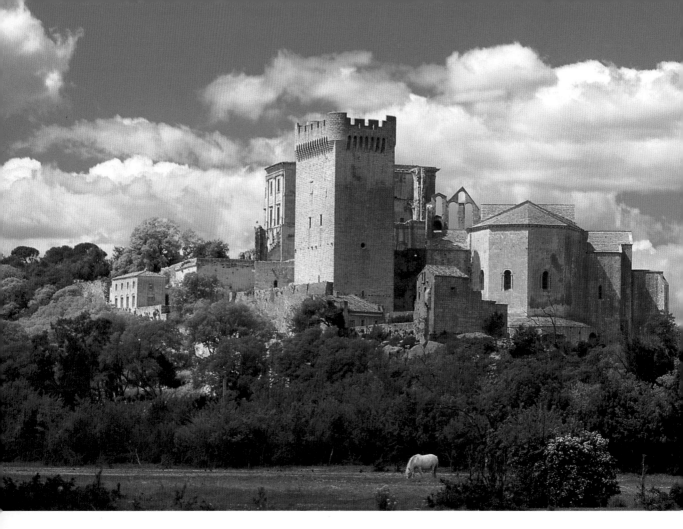

Provence

With the abbacy of Maiolus
(Maieul de Forcalquier, 954–994)
Cluny's influence extended into
southern France, naturally car-
rying the Burgundian building
style with it. During the tenth
and eleventh centuries, reli-
gious architecture was under the
exclusive leadership of Cluny,
which, toward the end of the
tenth century, began to stimu-
late the development of barrel-
vaulted hall churches. In the
Roussillon area especially, the
barrel-vaulted single-passage nave
developed as a regionally specif-
ic type. The pilgrimage churches

also had an effect on the archi-
tecture of the south.

By the end of the eleventh
century, religious building ac-
tivities had come to a near
standstill in the regions east of
the Rhône. Not until 1103 did
the consecration of the cathe-
dral in Aix-en-Provence take
place, whose nave had been re-
novated as a barrel-vaulted hall
with great apsidal niches in the
walls. This was the definitive
style here for more than a cen-
tury. Barrel-vaulted basilicas were
the exception for this era, and
rib vaulting only appeared after
1200. The choice of the single-

passage nave caused a revival of
the stand-alone apse, since a
choir with ambulatories would
also have demanded a multi-
aisled nave.

For this reason, there are only
a few choir ambulatories from
that era. Typical interiors of Ro-
manesque Provence are dark
and devoid of decoration (two
aspects which complement each
other well). The earliest real
sculptural programs emerged on
the exterior, around portals and
in cloisters (Arles and St-Gilles,
among others).

One of the most impressive
examples of late Romanesque

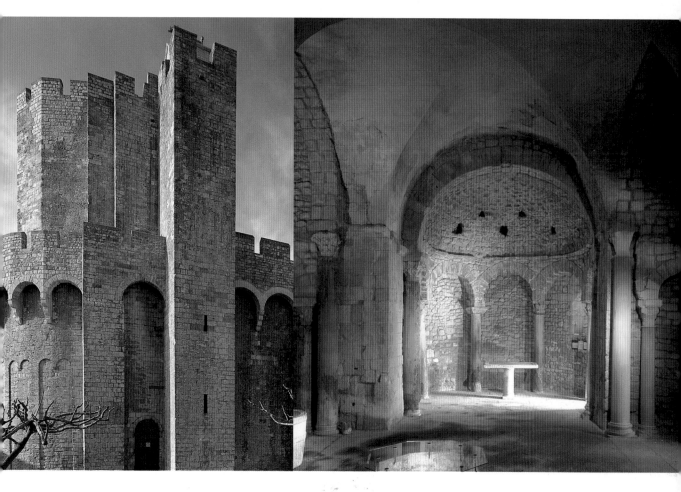

church construction is the monastic church of Montmajour, whose massive basement crypt and east end were consecrated in the year 1153. Its single nave has two of the five bays originally planned, and the east end was rebuilt in 1190/1200 after a collapse. The pilgrimage church of Les-Saintes-Maries-de-la-Mer is of the same type; it was later converted into a fortified church. A principal work of late Provençal Romanesque is St-Gabriel, an enchanting chapel not far from Tarascon. It, too, has the typically dark, single nave with high and broad blind arches on the side walls; though the west facade's arches and gables are masterfully staggered above and behind each other. All the architectural elements are accompanied by finely detailed antique reliefs which beautifully heighten the effect of the simple forms.

The centrally-planned churches in Vénasque, Montmajour and Rieux-Minervois constitute their own category, which no doubt trace back to the late Antique baptistries of fifth- and sixth-century Aix-en-Provence, Fréjus, and Riez.

P. 102: **Montmajour, former monastic church of Notre-Dame,** c. 1140–1153 and 1160, view from afar over the entire complex

Above left: **Les-Saintes-Maries-de-la-Mer, pilgimage church of St Mary,** c. 1170/1180 and 1200, view from the southwest

Above right: **Venasque, the "baptisterium,"** eleventh century, view of the interior with the octagonal baptismal fountain and the altar in the east apsis

Medieval Pilgrimage Roads

In *The Golden Legend*, the thirteenth-century collected lives of the saints, the Dominican Jacobus de Voragine gives an account of the followers of the apostle James bringing his headless body to the coast of Galicia in A. D. 44. After many difficulties, they interred him there in a marble tomb, which was apparently lost to memory during the Moors' conquest of the Iberian peninsula. It is certainly no accident that its rediscovery came during the time of the *Reconquista*, or reconquest by Charlemagne. An angel is said to have appeared to the hermit

Pelagius in the year 813 and indicated the site of the tomb, whereupon the bishop of Iria Flavia (now Padrón) ordered exacavations and actually struck upon the tomb. In spite of this miraculous occurrence, the Christian army was not able to liberate Spain for the time being. It appears, though, that the precious bones were successfully transferred to Santiago de Compostela during the second half of the ninth century. This was a part of the Gothic empire that the Moors had not been able to conquer, and it was to become the *Reconquista*'s launching point.

The way there was not finally open to pilgrims until the year 1000, though the ninth century saw four major routes established across France on which pilgrims travelling from the north and east would converge. They were known as the Via Tolosana, which came across from Switzerland and the Ligurian coast by way of St-Gilles-du-Gard, St-Guilhem-le-Désert, and Toulouse; the parallel Via Podiensis, which led from Le Puy via Conques and Moissac; the Via Lemovicensis, which began in Vézelay and passed through Limoges and Périgueux to join up with the Via Podiensis in Ostabat, near Roncesvalles; and finally the Via

Turonensis, which came down from the English Channel via Tours, Poitiers, Saintes, and Bordeaux, likewise meeting up with the others in Ostabat. The Via Tolosana joined the other three in Puenta la Reina, and from here all pilgrims trekked westward through Navarre and Asturia. In a short time the apostle James' grave became one of the three most important pilgrimage sites in all of Christendom, alongside those of the Redeemer in Jerusalem and the apostle Peter in Rome. James, the patron saint of Spain, came to be the intercessor for the poor. Countless monasteries emerged along the pilgrim routes, providing

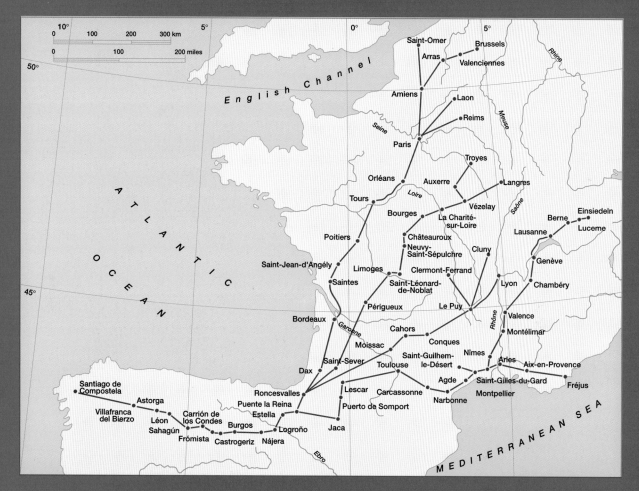

Map labels (north to south, as shown):

English Channel

Saint-Omer · Brussels · Arras · Valenciennes · Amiens · Laon · Reims · Paris · Troyes · Orléans · Auxerre · Langres · Tours · Loire · Vézelay · Bourges · La Charité-sur-Loire · Berne · Einsiedeln · Poitiers · Châteauroux · Lausanne · Luceme · Neuvy-Saint-Sépulchre · Cluny · Saint-Jean-d'Angély · Limoges · Clermont-Ferrand · Genève · Saintes · Saint-Léonard-de-Noblat · Lyon · Chambéry · Périgueux · Le Puy · Bordeaux · Garonne · Cahors · Valence · Montélimar · Moissac · Conques · Nîmes · Saint-Sever · Saint-Guilhem-le-Désert · Arles · Aix-en-Provence · Dax · Toulouse · Agde · Saint-Gilles-du-Gard · Fréjus · Santiago de Compostela · Roncesvalles · Lescar · Carcassonne · Montpellier · Astorga · Puente la Reina · Puerto de Somport · Narbonne · Villafranca del Bierzo · Estella · Léon · Carrión de los Condes · Sahagún · Burgos · Logroño · Jaca · Frómista · Castrogeriz · Nájera · Ebro

ATLANTIC OCEAN · MEDITERRANEAN SEA · Seine · Meuse · Rhine · Saône · Rhône

hostels, hospitals, and all the facilities necessary for outfitting and supporting the pilgrims. And the more monasteries there were along the way, the more saints could be called upon for assistance in pursuing the perilous and arduous journey. The huge processions of worn-out and ragged pilgrims constituted not only a source of revenue, but also a never-ending challenge for the monasteries, as well as an enormous burden for all who lived along the routes.

The great **pilgrimage routes** to Santiago de Compostela

Left: **Representation of a pilgrim** from S Juan de Ortega

P. 104: **Le Puy** with the chapel St-Michel-d'Aiguille and the Romanesque cathedral (right)

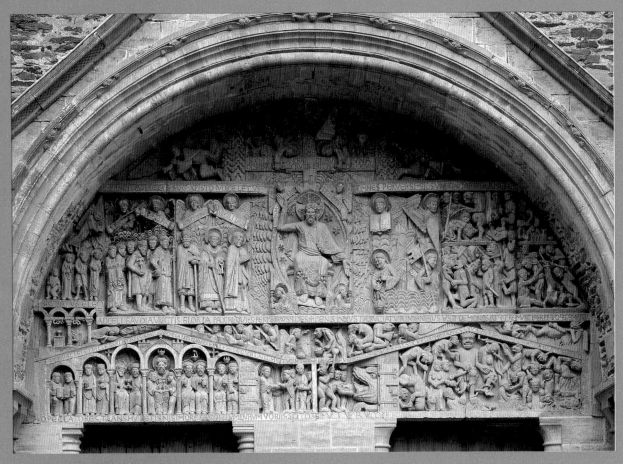

Characteristics of the Major Pilgrimage Churches

The term "pilgrimage church" is closely associated with the St James pilgrimage to Santiago and the four major routes that crossed France in a southwesterly direction. There were five pilgrimage churches, each dedicated to a different saint: St-Martin (patron saint of France) in Tours on the Via Turonensis, St-Martial in Limoges on the Via Lemovicensis, Ste-Foy in Conques on the Via Podiensis, St-Sernin in Toulouse on the Via Tolosana, and finally

St James the Elder in Santiago de Compostela. Statues of the saints were venerated in their respective churches and their tombs were sought out for all manner of supplication. Rich figural sculpture on the portals depicted events from their lives alongside scenes from Revelation. With the exception of Conques, these churches were among the largest and most spacious religious buildings of their time. St-Martial is now lost, and little more than

the foundations of St-Martin are recognizable at Tours. Begun in 1000, it was the first of the big five. Here we encounter for the first time a fully-fledged ambulatory with five radiating chapels (compare the simpler ambulatories at St-Philibert-de-Grandlieu and Tournus). The ambulatory itself continued west into the transept, passing two east-facing apses on each arm, and continuing around its gable ends into a three- or five-aisled

nave with a twin-towered facade. This layout facilitated multiple altar stations as well as an uninterrupted circulation of pilgrims around St Martin's tomb without disturbing the religious activities inside the choir screen. There is unfor-

Conques-en-Rouergue, former abbey church of Ste-Foy, western portal, tympanum, second quarter of the twelfth century (above), view of the village and Ste-Foy from the southeast (p. 107)

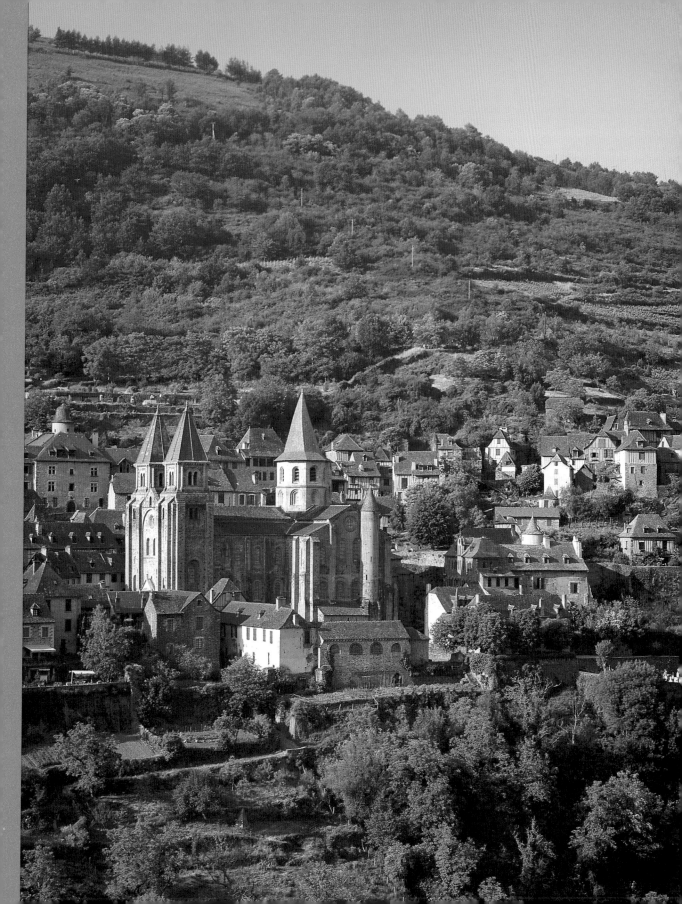

multipartite and complicated construct both inside and out. Around the three-story choir (arcade, windowless gallery, clerestory) runs a groin-vaulted ambulatory. The graduated east-facing apses on the transept demonstrate the transition from staggered choir to choir with ambulatory. A transept clerestory was dispensed with; in its stead the transept and nave were given ribbed barrel vaults, as shown by the responds on the piers.

tunately no record of the interior elevation at St-Martin. The church demonstrably belongs with the pilgrimage group, and this allows us to presume that it would have had arcades and galleries like the others, but in view of its early date we must assume it had a flat ceiling.

Did it also possess a clerestory? A look back to St-Remi in Reims (p. 84) leaves the question open.

Begun nearly simultaneously, St-Remi is also a three-aisled galleried basilica whose three-aisled transept has east-facing apses and a later choir ambulatory. Ultimately, the barrel-vaulting

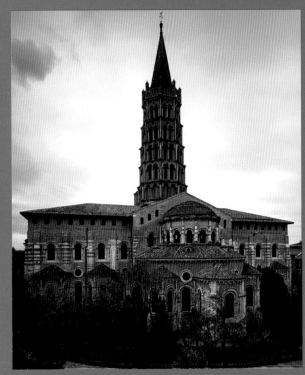

Toulouse, St-Sernin, 1080–mid-twelfth century, view of the choir, transept, and crossing tower

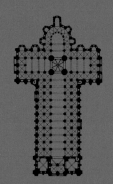

Toulouse, St-Sernin ground plan

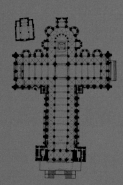

Santiago de Compostela ground plan

of the broad nave would have forced abandonment of the clerestory. Half a century later, around 1050, construction began at Conques and was not completed for over 80 years. Ste-Foy, with five nave bays (as opposed to ten!) and only three ambulatory chapels, is the smallest church of the group. The oldest section is the choir—a

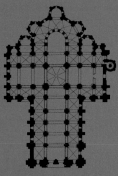

Conques, Ste-Foy ground plan

Santiago de Compostela, cathedral, 1075–1125, nave and view of the crossing (below); Pórtico de la Gloria, central portal and entrance to, sculpted by Master Mateo (active between 1168 to 1188, right)

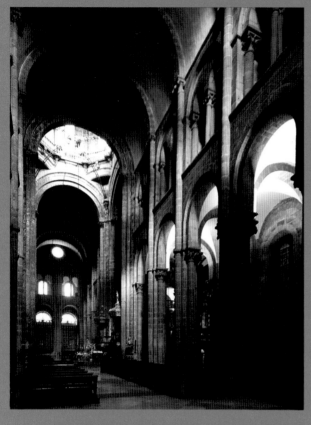

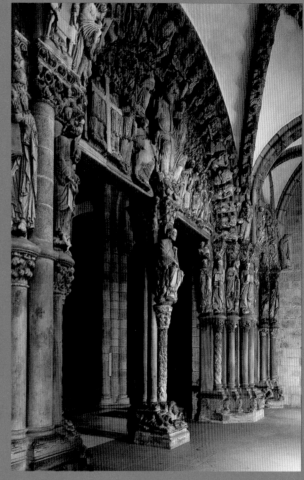

St-Sernin in Toulouse, begun in 1080, is the consummate pilgrimage church. In a perfect replication of Tours, its nave elevation consists of arcades, galleries with large windows, and a barrel vault whose ribs spring from semicircular responds. The massive crossing piers support a five-story octagonal tower. As at Conques, the choir elevation has three levels, but the gallery is no longer dark. St-Sernin is consistent and perfect down to the details and distinguishes itself through its lively arrangement and decoration.

The last of the five pilgrimage churches, and the pilgrims' final goal, was Santiago. It was begun in 1075, slightly earlier than St-Sernin, but complications bedeviled the construction and the choir chapels could not be consecrated until 1105. The choir and transept differ little from the others in the group. The nave has three aisles and is noticeably shorter because of its narrower bays, which also vary in width. Yet Santiago is an impressive building. It has a two-level elevation in the nave and transept—arcades and galleries—and is even more richly decorated and structured than St-Sernin. The three-tier program of the choir is maintained here as well. The crossing is crowned by an octagonal tower that far surpasses Conques in height and richness; this and the pair of west facade towers make the church visible from afar.

Lastly, common to all these churches is an enlarged crypt containing the saint's grave, which is the pilgrims' ultimate destination. Sumptuous shrines made of gold and silver and studded with jewels held the mortal remains of the saints. In the light of countless candles, they took on an air of mystery for the pilgrim. The seated figure of Ste Foy from Conques, enthroned and covered in gold, is a good example.

Spain

Catalonia

During the early eleventh century, the counts of Barcelona gradually succeeded in expelling the Moors from Catalonia, and a new era of church construction began there. One of the most important patrons was Count Oliva Cabreta of Besalú and Cerdaña, a learned and well-traveled clergyman who was abbot first at St-Michel-de-Cuxa in the Roussillon, then at Sta María in Ripoll before becoming bishop of Vic in 1018. At St-Michel, he had the existing tenth-century building expanded with a twin-towered west facade and a choir reminiscent of those at St-Philibert-de-Grandlieu and at Tournus I, making it a forerunner of the choir with ambulatory. At Ripoll there was a five-aisled church from the late ninth century. To this he added a projecting transept and increased the number of east-facing apses from five to seven (consecration in 1032). The church has been overly restored in the meantime, but appears to owe its original design to the Constantinian basilica, Old St Peter's.

In 1022, his little monastery church of S Pere de Rodes was consecrated. To the east of the nave is a projecting transept

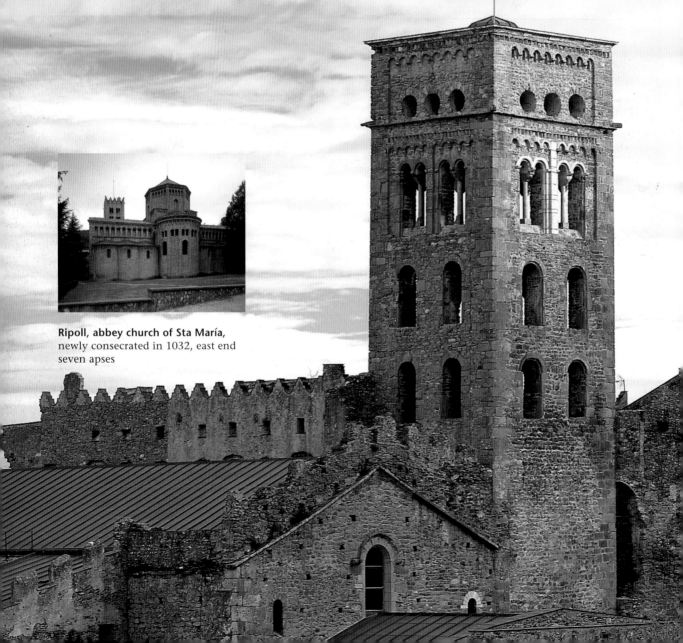

Ripoll, abbey church of Sta María, newly consecrated in 1032, east end seven apses

and three-apse choir; at the west end is an older vestibule. An ambulatory is separated from the main apse by a subsequently added wall, into which the arcade openings are cut. The nave has a ribbed barrel, which is supported at its springing by the quadrant vaults of the side-aisles. The square piers have a column attached to each side and set on a tall plinth; the column facing the nave has a

second one above it that accomodates the corresponding transverse arch of the barrel. A good hundred years later at Fontenay, Bernard of Clairvaux would repeat this same motif on a monumental scale along with that of the single-story, windowless nave.

S Pere was built shortly after the vaulting of Cluny II. It is among the oldest preserved vaulted buildings of the Middle

Ages, blending French, Asturian, and Mozarabic traditions. In 1046, not long before he died, Oliva Cabreta began construction on S Miguel de Fluviá, a sister church to S Pere. As in Burgundy, the builders here were experimenting with barrel vaulting. Apparently it was the crypts that essentially determined the vaulting form. In France and Catalonia, most crypts consist of barrel-vaulted pas-

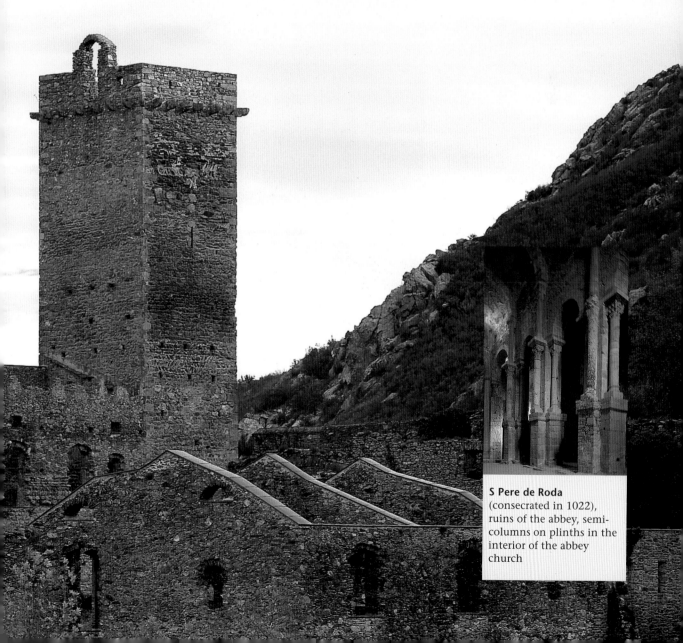

S Pere de Roda
(consecrated in 1022), ruins of the abbey, semi-columns on plinths in the interior of the abbey church

sageways and tunnels, or alternatively of narrow, multi-aisled halls. In German-speaking areas, on the other hand, crypts accommodated not only saints' tombs, but also those of emperors. They were built as spacious hall crypts, to which various kinds of groin-vaulting were suited. After the collapse of the nave barrel at Speyer, the groin vault found equal favor alongside the flat ceiling in Germany.

In 1040, Bishop Eribald of Urgel consecrated a church sponsored eleven years earlier by Bremund of Ausona. S Vicente in Cardona Castle has an exceptionally clear-cut and consistently structured floor plan and elevation. It is composed of a single-bay narthex, a three-aisled nave three bays long, a transept, antechoir, and apses. In contrast to Oliva Cabreta's works, this is not a pseudo-basilica (i. e. one without clerestory); above the offset arcades open the windows of a clerestory that is covered by a barrel vault with transverse arches. S Vicente corresponds both chronologically and developmentally with the narthex basement at Tournus: three narrow, groin-vaulted, side-aisle bays flank the square nave bays. Thus what had been abandoned at Tournus—the barrel vaulting of the nave—was by 1040 meeting with success in Cardona, although on a nave width of little more than four meters (13 ft). What's more, the barrel here is set over a perfect clerestory, and the piers are already set to accommodate the responds for the transverse arches. As at Speyer I

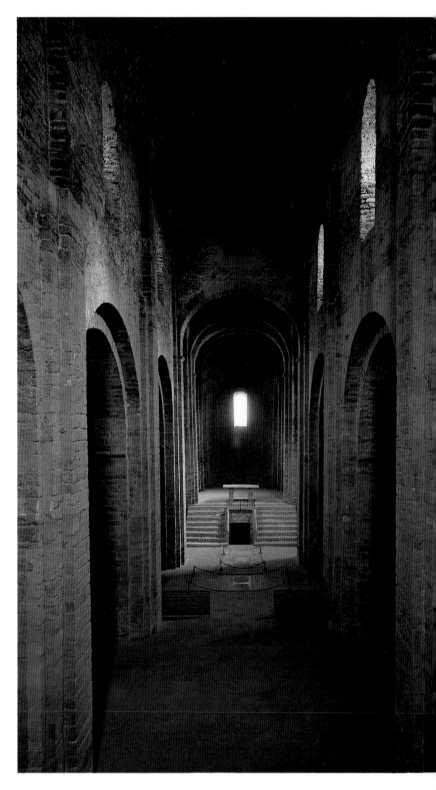

and Mont-St-Michel, we find shallow shaft moldings on the upper wall of each bay. Religious architecture, particularly stone vaulting, was quite the theme in eleventh-century Europe! Between 1080 and around 1100, the monastery church of Sta María in Vilabertrán emerged as a close relative of S Vicente, though with quadrant arches replacing the groin vaults of the side-aisles. An example of Late Romanesque construction is the cathedral of La Seu d'Urgell, begun in 1175. This building demonstrates how the arrangement and decoration of buildings became richer at the end of the eleventh and during the twelfth century, while the now-established building layouts were maintained. Finally, a comparison of exteriors shows that here, as well, the Lombard motifs were appearing in Spain, beginning at S Pere and later becoming varied. The form and decoration of towers and east ends had hardly differed during the first half of the eleventh century from those in northern Italy or France.

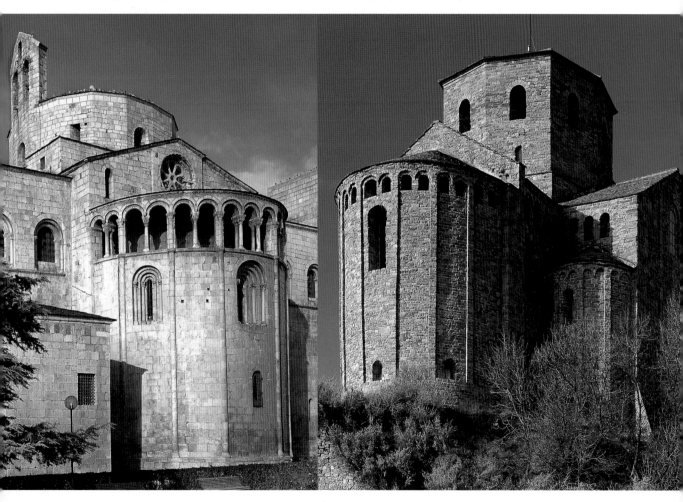

Above: **La Seu d'Urgell, cathedral**, from 1175, east view

P. 112 and above: **Cardona, S. Vicenç**, 1020–c. 1040, nave with choir, view from the northeast

113

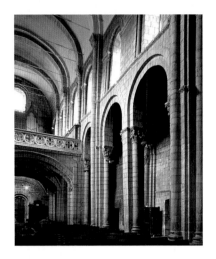

Frómista and León

After the pilgrim routes converged in Puenta La Reina, it was a long trek west to St James' grave at Santiago in Galicia. Along the way, the stopovers followed in close succession. Among them are the cathedral of Burgos, which has been renovated in the Gothic style, and S Martín in Frómista, which is preserved, albeit severely restored. Built during the second half of the eleventh century, S Martín is another instance of the three-aisled pseudo-basilica with a non-projecting transept, a three-apsed staggered choir, and an octagonal crossing tower. Apart from lovely sculpted capitals, the interior is without decoration; the beauty of the space is in its proportions, arrangement, and flawless masonry. Moving westward, we come to S Lorenzo de Sahagún, a beautiful, richly structured twelfth-century brick construction; and the church of S Isidoro in León. The latter, consecrated in 1149, is a three-aisled basilica with a five-bay transept and three-apsed staggered choir. Two remarkable aspects are the varying depths of its bays and its distinctive alternating piers, which do not seem to have been intended for a barrel vault. In the second quarter of the twelfth century, builders here were already considering rib-vaulting on the Norman model. Even in westernmost Europe one encounters French and Catalonian building forms.

León, S Isidoro, dedicated 1149, interior view toward the west, ground plan

Right and
p. 115: **Frómista, S Martín,** before 1066(?)–1100 on, southwest view, interior view, ground plan

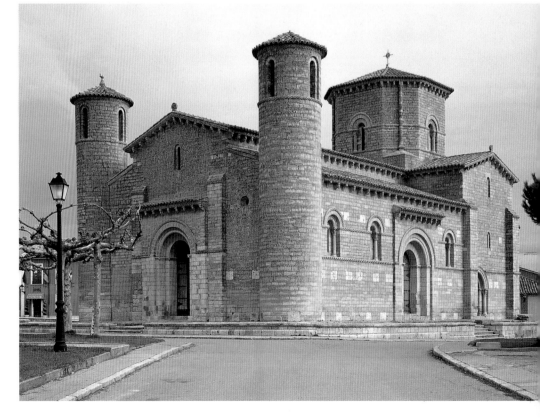

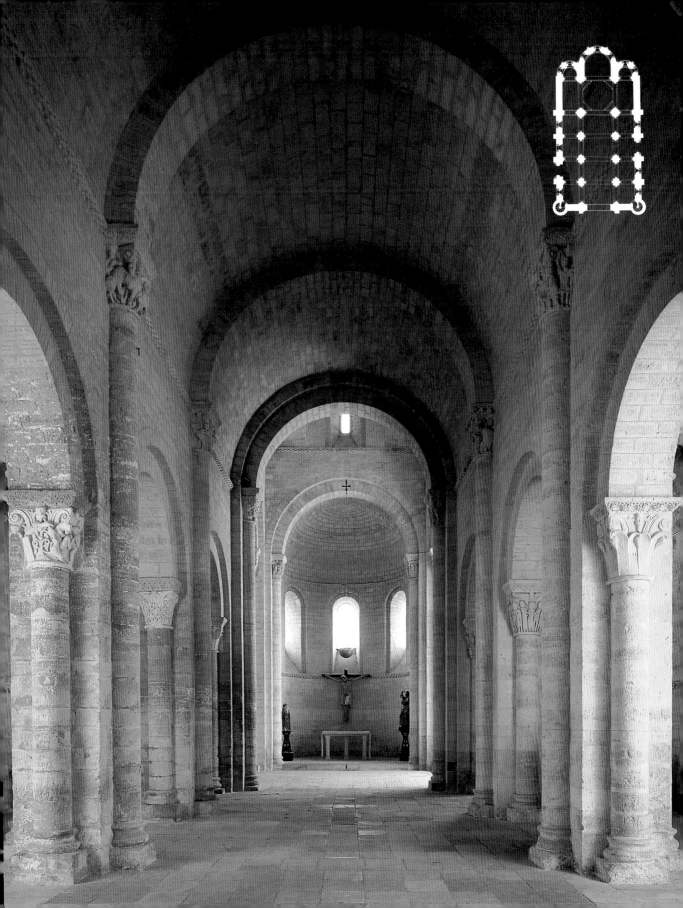

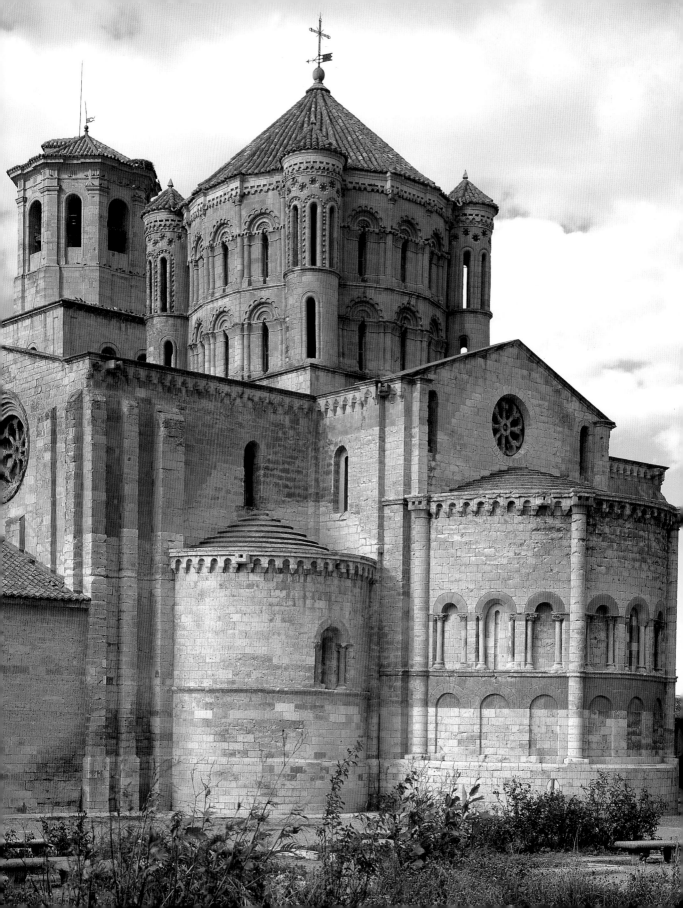

Domed Buildings

The region between Duero and Tajo was heavily disputed between Christians and Moors for three centuries. Not until the Spanish crown took Toledo in 1085 did the area become repopulated. Another good half-century went by before three large-scale religious structures were begun there between 1145/1150 and 1160. These marked the beginning of what in a European context would be the Late Castilian Romanesque: the Old Cathedral of Salamanca (1145/1150–1289), the Cathedral of Zamora (1151–1173), and the collegiate church of Sta María la Mayor in Toro (1160–c. 1240). Common to all three were (originally) a three-aisled basilical nave, a slightly projecting transept with a square crossing, and a three-apse choir. Thus far, they follow the example of Cardona, also in their dimensions. But while Toro has pointed barrel vaults throughout, the naves at Salamanca and Zamora have rib vaults between bulky transverse arches. The transept vaulting at Zamora shows that at least here the initial plan was for a pointed barrel. However the piers in both these cathedrals are configured for rib vaults. All three have a massive drum cupola over the crossing that rests on penditives and has a sixteen-part vault—over a single clerestory at Zamora, and over a double clerestory at Salamanca and Toro.

Zamora, cathedral, 1151–1171 crossing tower from the inside

P. 116: **Toro, collegiate church of Sta María la Mayor,** begun 1160, view from the south

Salamanca, Old Cathedral, before mid-twelfth–early thirteenth century, interior of the nave

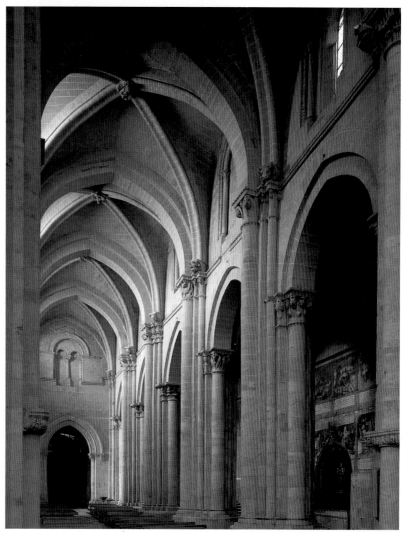

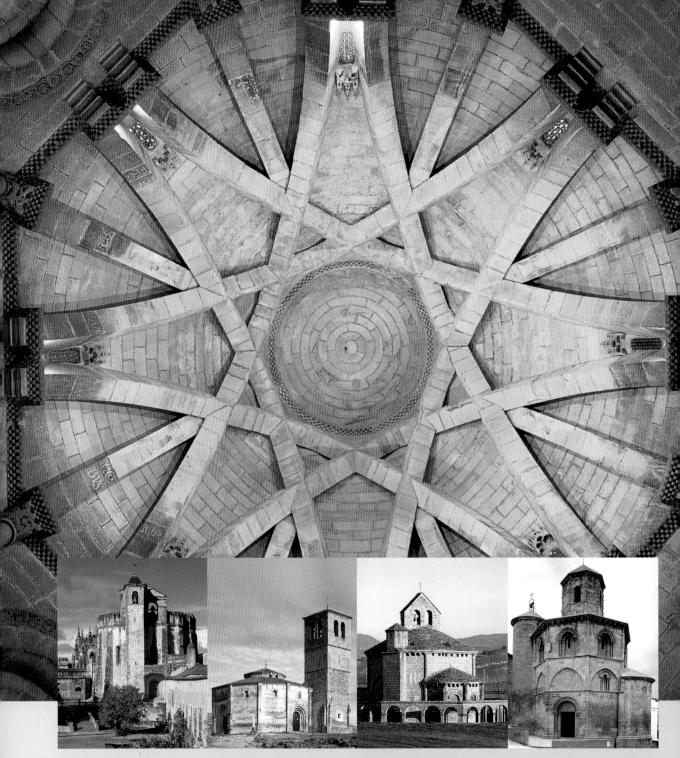

Tomar, Church of the Knights Templar, late twelfth century

Segovia, Vera Cruz, dedicated 1208

Eunate, circular building early thirteenth century

Torres del Río, Church of the Holy Sepulcher, exterior view and interior of dome (above)

Circular Structures and Early Cistercian Architecture

The knightly orders were founded beginning in the early twelfth century with the aim of reconquering the Holy Land and Moorish Spain. Though actually formed in France, they were internationally organized, and this comes out in the motifs they employed in their architecture. One of the largest churches of the these orders was built by the Knights Templar from c. 1165/1170 in Tomar. It consists of a sixteen-sided ring crowned with battlements, and a two-level octagonal chapel composed of slender arches on richly molded piers and a wall of narrow windows. The evolving ambulatory is covered with an annular vault, and the central space is domed. The structure presumably takes after the Church of the Holy Sepulcher in Jerusalem. As a matter of fact they do not look very similar, but medieval notions of copying were more conceptual than visual. A comparable building is the Church of Vera Cruz (or Holy Cross) in Segovia, probably built by the Order of Canons of the Holy Sepulcher, and consecrated in 1208. Here, a circular design is combined with a three-apsed Benedictine (or staggered) choir in the east, giving orientation to the structure. A similar but more intricate vault and an elaborate exterior decoration program characterize the Church of the Holy Sepulcher in Torres del Río, whose plan is an octagon with two opposing apses.

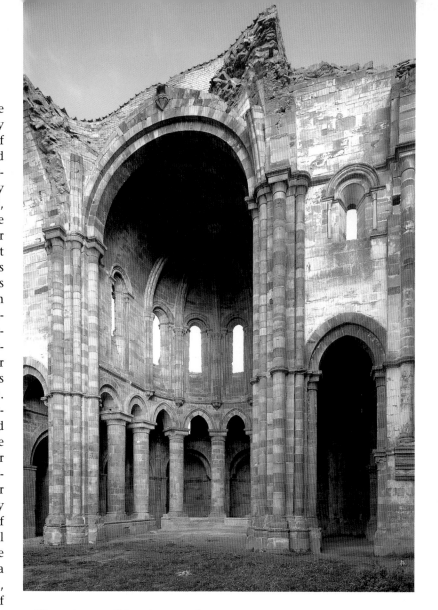

Cistercian proliferation on the Iberian peninsula increased steadily after about 1170/1180. Their earliest complex was at Moreruela, where a church begun in 1168 is today a picturesque ruin. It shows a relaxation of the strict formula of rectangular choirs from earlier decades. The cruciform structure had a high transept and an ambulatory with radiating chapels. In this it is quite similar to

Moreruela, former Cistercian church, from 1168, interior view of the ruins of the choir area

the choir at Pontigny, which was renovated soon afterward (1186) and may have had Spanish inspiration. But while Pontigny has rib vaulting throughout, at Moreruela the choir, transept, and possibly even the nave still used barrel vaults; only its crossing had a rib vault.

Scandinavia

From the eighth century, the Norsemen (Vikings) ruled Scandinavia. From there, Norwegians went on to occupy Iceland and Greenland, Danes took large areas of England, and Swedes advanced into Russia, founding the proto empire of Novgorod and Kiev. With versatile ships they sailed to the west coasts of France and Spain, penetrating into the interior via rivers to maraud and plunder the hinterland. King Arnulf finally beat the Norse near Leuven in 891, whereupon they settled down in Normandy, which was elevated to a dukedom and would later become the heartland of Norman religious architecture. From here they con-

quered Apulia (from 1041), Sicily (from 1061), and England (1066), forging mighty kingdoms in those places. Beginning in the ninth century, missionaries coming out of northern Germany spread Christianity into Denmark. This took until the year 1000 in Norway and until 1150 in southwest Finland. A regular diocese has existed there since 1276. While in Normandy the evolution of religious architecture in stone set in as early as the year 1000—with St Pierre in Jumièges and a little later at the monastic church of Bernay—the first stone or brick churches don't appear in the Scandinavian motherland until the end of the eleventh century. These took their inspiration from the cathe-

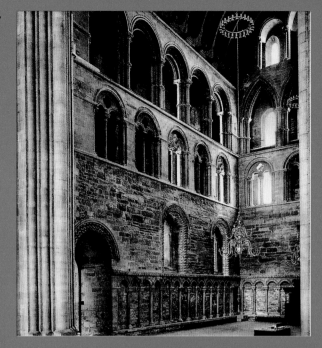

Trondheim, cathedral, three-level design of the northern transept arm

drals of the lower Rhine and from Anglo-Norman religious architecture. Denmark, evangelized since late Carolingian times, nevertheless has no buildings of note from the eleventh or early twelfth centuries. In 1150 the cathedral at Viborg in Jutland was completed, a sister church to Lund (thus part of the Speyer family). Today only the crypt survives under the neo-Romanesque structure of 1864/1874. The cathedral in Ribe was begun c. 1150/1170 as a three-aisled, galleried basilica with west towers; it underwent a design change and after 1250 was finished with an Early Gothic clerestory and sexpartite rib vault. Some

Romanesque building forms remain at the cathedral in Århus in Jutland, built between 1200 and 1250 and greatly modified in the Gothic style after 1400. Worthy of note is the fortified church from c. 1170/1190 in Kalundborg in Seeland—a centrally planned structure around a square core three bays deep, with a polygonal apse plus choir bay projecting from each side. These apses have stocky polygonal towers while a square one accentuates the center. Also from this time are the multi-level circular churches, of which seven are left (four of them in Bornholm). They were meant to serve religious as well as defensive purposes.

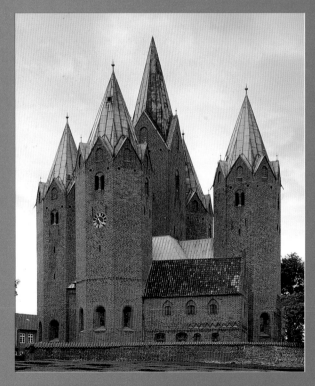

Kalundborg, fortress church For Frue Kirk, after 1160, east view

In Sweden, a royal court at Sigtuna, Uppland, became the first diocesan town in 1100, and had a small fieldstone church. Husaby in Västergotland was also a former royal estate. Here a larger stone building replaced a wooden stave church from c.1020, but is no longer standing. Similarly, at Skara, Västergotland, only the crypt endures from the late-eleventh and twelfth-century structure. The oldest partially extant cathedral in Sweden might be Gamla Uppsala, in Alt-Uppsala, of which the long choir and crossing still stand. The cathedral of Lund was begun in 1110 (on what was then Danish territory), although its east end was not consecrated until 1145. A spacious hall

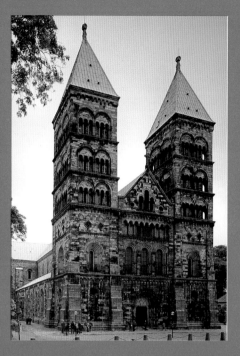

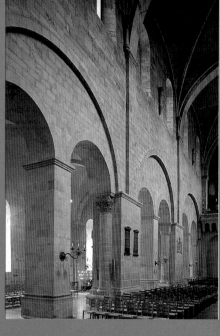

crypt underpins the semicircular choir and the three-bay transept, onto which adjoins a three-aisled basilical nave with alternating piers and rib vaults. Like Speyer, Lund possesses a lively relief on the exterior as well as two square western towers. The oldest preserved church in Scandinavia is the Cathedral of Nidaros in Trondheim, Norway. At 102 meters (335 ft) overall, it is also the largest. This transept basilica was already begun in the eleventh century and has a steepled rotunda containing the tomb of St Olaf attached to its square-ended choir. Galleries, arcaded passageways in the clerestory and along the transept gable windows, and zigzag ornamentation on the windows and

Lund (Sweden), cathedral, exterior view from the northwest (left); south wall of the nave (right)

Lund, cathedral, northern transept, east wall (east end consecrated 1145)

arches all point clearly to English influence. In 1130, the church in Stavanger was begun. It has typically English drum piers, as does the cathedral in Hamar, which is now a ruin. Besides these large-scale buildings, Norway has many small stone churches from the era after 1100. As early as the 1140s, the Cistercians were spreading into Scandinavia. Two daughter monasteries of Clairvaux were founded there in 1143: Alvastra in Östergotland and Nydala in Småland. Both were soon able to found their own daughter monasteries, Alvastra's Varnhem, Västergotland, in 1150 and Nydala's Roma, Gotland, in 1164. The monastery of Solo in Seeland was founded in 1161.

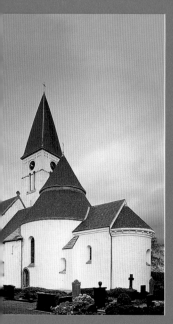

Valleberga, only preserved circular church in southern Sweden, twelfth century

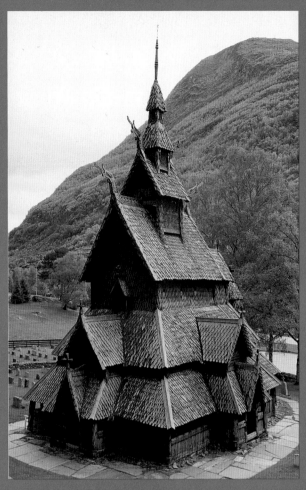

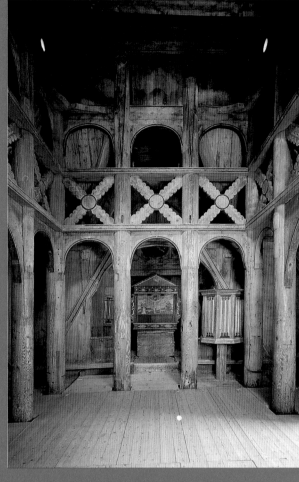

Norwegian Stave Churches

Like their brothers in France, the Normans back in the homeland "invented" their own architectural style, one that corresponded with their boatbuilding skills. They built hundreds of wooden stave churches during the eleventh and twelfth centuries, mostly in Norway. Today only 25 remain. Their walls consist of upright planks between cylindrical corner posts that run up into the roof framing. They took the structural elements from the religious architecture of western and southern Europe—aisles, arches on drum piers, wooden barrel vaults, stacked and towered roofs—and adapted them to wooden construction. However, their combination of structural elements and dimensions is truly original. The most impressive examples of these stave churches are found at Urnes (c. 1060), Lom (eleventh century, modified 1630), and Borgund (c. 1150). A comparison between Urnes and Borgund shows an evolution from the simple to the complex, an enhancement of decoration, and a refinement of proportions. Urnes is an orderly structure, whose silhouette develops in four stages and dispenses with ornamentation except for a low ridge decoration and some superb carved panels on the walls. At Borgund, on the other hand, one can distinguish six zones. The church has small, transept-like three-level gable ells projecting from each side; beautiful carvings adorning the portals and gables; and rune inscriptions. These all make the structure appear less monumental, allowing instead its elegance and virtuosity to come across. The elevation of the centrally-planned interior is patterned after the multi-level nave walls of stone churches.

Borgund, stave church, c. 1150, exterior and interior

P. 123: **Urnes, stave church**, c. 1160, exterior view with fjord panorama

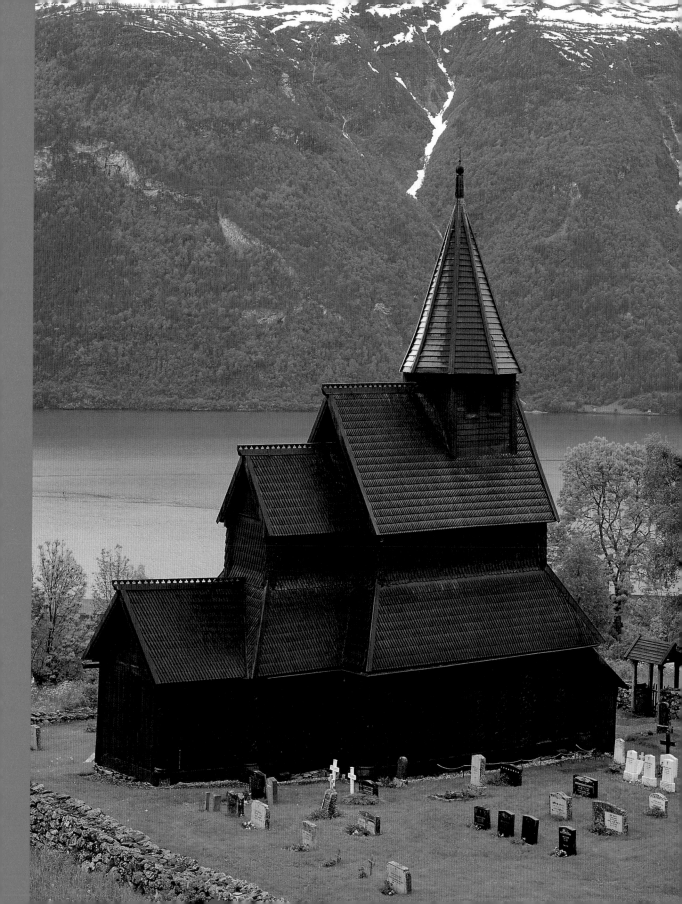

Secular Romanesque Architecture

Not surprisingly, the secular architecture of this era is preserved to a much lesser degree than the religious. It falls into two general categories: urban and rural. City buildings included residential townhouses, tower blocks, and palaces as well as city halls, gates, and walls. In the country were palaces, castles, and donjons. There were also purely functional structures such as bridges. Wherever residential buildings were securely behind city or castle walls, they developed facades with portals, symmetrical window arrangements, and series of double-arched windows or arcades; the main floors had open halls and occasionally, as in the Palazzo della Ragione in Milan, niches with equestrian statues or saints. Semicircular towers flanked gates and walls, which were crowned with a variety of battlements and parapet walkways. The castles of the twelfth and early thirteenth centuries were in many cases still situated on high ground, and their form was dictated by the landscape. They were frequently centered around a donjon which served as both a sign of sovereignty and as a final point of retreat. Beginning around 1200, castles located on open ground began to appear sporadically, one of the better-known being the Louvre of Philip Augustus (Philip II) in Paris. These now took on square, rectangular, and sometimes triangular form; in other words they were becoming regularized. The structures built by Frederick II in southern Italy are exemplary specimens of clear and well-ordered architecture whose appearance was certainly designed to complement the beauty of the surrounding landscape.

Loarre, castle complex,
eleventh–thirteenth century

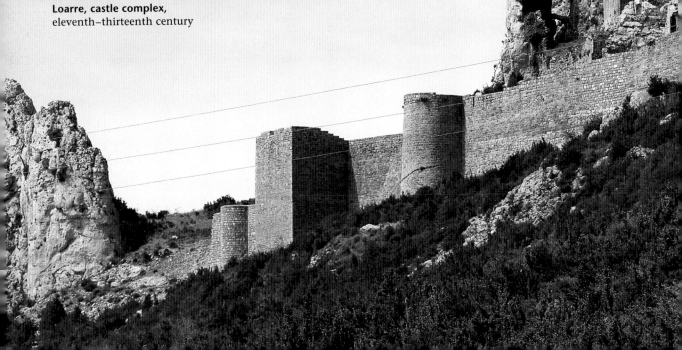

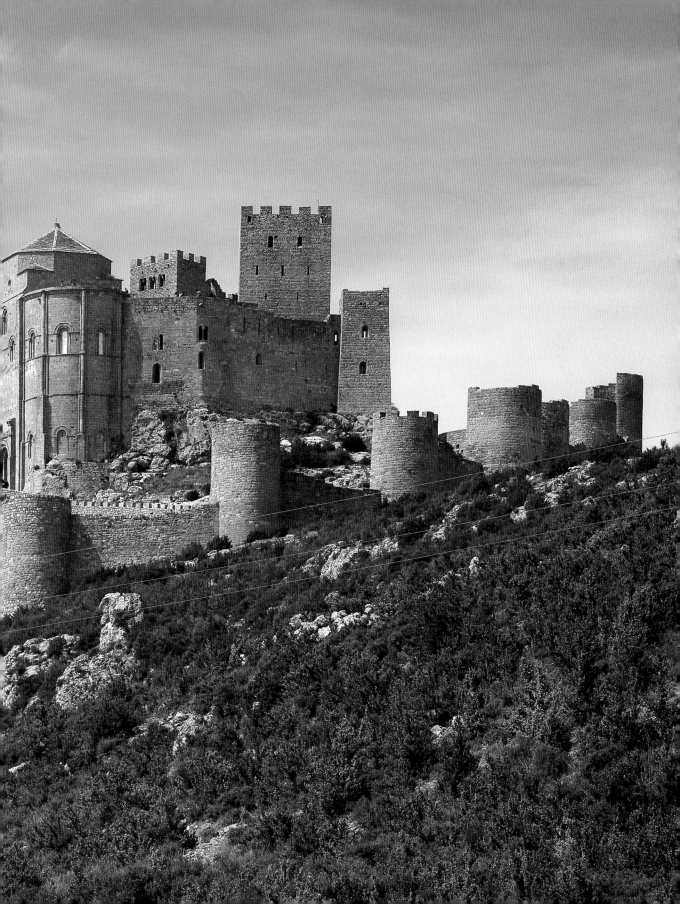

The German Imperial Palatinates of Goslar and Gelnhausen

The German kings and emperors of the Early and High Middle Ages did not rule from a single capital city as the French did. Instead they traveled throughout their enormous territories in Germany, Italy, Switzerland, Burgundy, and Lotharingia, visiting the different centers of their empire at regular intervals. Royal and regional assemblies were conducted at these times: justice was administered, local disputes settled, and envoys were received. Also at these centers, armies were raised, secular and religious festivals were celebrated, and local provisions were collected and stored. Increasingly, an appointed official (a member of the governmental household), administered, represented, and defended the royal or imperial prerogative. Thus a new kind of building emerged—the Palatinate. Early architectural types and

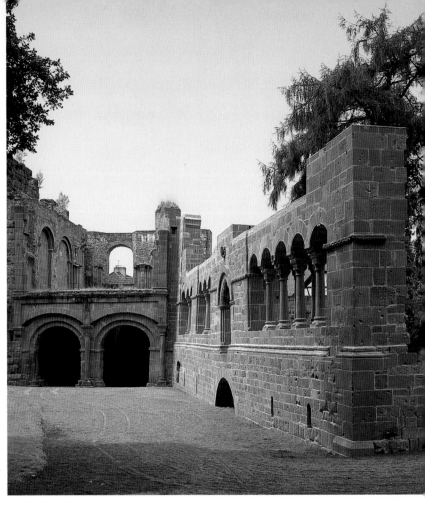

Gelnhausen, ruins of the imperial Palatinate, second half of the twelfth century, palace, gatehouse with chapel and tower; wall detail (above left)

motifs show a merging of Roman, Byzantine, and Germanic models. The earliest Palatinates come from Merovingian times (Quiery, Bodman); the best known are those of Charlemagne, found in Aachen, Ingelheim, Nijmegen, and elsewhere. Later as the structures varied there were water castles, such as at Kaiserslautern, Kaiserswerth, and Gelnhausen; and hilltop castles such as Wimpfen and Trifels. They were often part of a city or market, as in Frankfurt. Little is known today of the appearance, interior makeup, or

décor of these buildings. After the mid-thirteenth century, when the emperors chose to take up fixed residence (Prague, Vienna), the Palatinates were disposed of and either dismanteled or allowed to fall into neglect. They have not been well researched either individually or as a type, and are rarely mentioned in the sources. Because of this, construction dates are widely unknown. Only Rahewin mentions the Palatinates, praising among the deeds of Frederick I his generosity in restoring and refurbishing them.

126

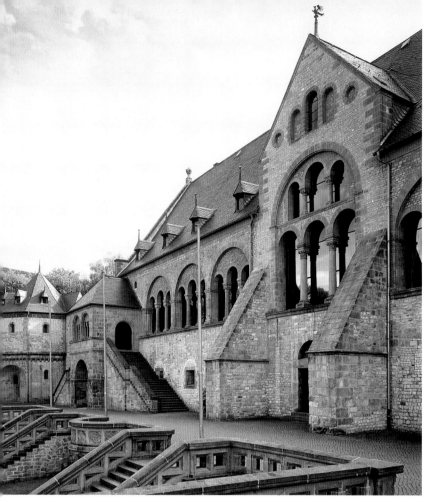

midpoint is accentuated by the transept portal and windows in two tiers. The palace took up an entire side of the courtyard, and may have been absolutely symmetrical. This, too, was presumably a mark of sovereignty. The paired stairways in front of the main entrance are an accurate reconstruction.

The Palatinate and city of Gelnhausen were founded by Frederick I on the main trade route between Frankfurt and Leipzig. The Palatinate is a castle built in water on 18,000–20,000 pilings. In spite of long neglect, the layout has been preserved: a ring wall of rabbeted rusticated stone, a two-aisled gatehouse with an overhead chapel, a tower, and the palace, which is situated nearly perpendicular to the gatehouse. Foundations have been discovered east of the palace from another building, as well as a round tower, and the servants' housing.

Goslar, former imperial Palatinate, eleventh to thirteenth centuries, so-called "imperial house" (reconstruction to its present form, 1868–1879); design of the reconstruction: imperial domain with the imperial house, chapels and church

One complex from the time of Henry III (1039–1056) is the Palatinate in Goslar, whose extensively restored and reconstructed palace is preserved. Its elongated floor plan is intersected mid-way by a transept which emphasizes the imperial throne. At each end is a residential building with an adjacent chapel. A continuous row of triple-arched windows defines the courtyard facade, whose

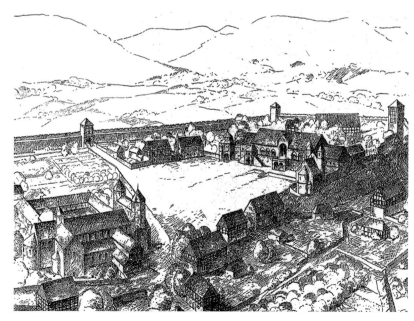

From Motte to Donjon

Today, a motte is generally understood to be either a naturally occurring or artificially constructed hill, or else a rocky outcrop set off by artificial trenches, atop which sits a fortified residence. Mottes were common all over Europe during the Middle Ages. At first they contained buildings made from wood, earth, and stones. They were often ringed with an excavated moat (sometimes filled with water) that provided added protection for the complex. Most mottes were probably set within a courtyard protected by a palisade or earthwork, and seem to have formed a last refuge at the center. It can also be assumed that mottes were seen early on as a symbol of sovereignty. The famous Bayeux Tapestry provides contemporary illustrations of the mottes at Hastings, Dol, Dinan, Rennes, and Bayeux. In England there are well-researched examples from the late eleventh and early twelfth centuries of mottes with wooden towers.

At Langeais shortly before the year 1000, Foulques Nerra, Count of Anjou, built a rectangular stone tower reinforced with buttresses. This is the oldest surviving donjon on French soil. The new design was extremely successful and proliferated quickly (often as part of a motte). Known in England as a keep and in Germany as a *bergfried* (hilltop haven), the tower would be situated at the highest point in the castle complex. Shell keeps appear from the late eleventh century; these are fortified ring walls of stone that surround the plateau of a motte. A very well-preserved example is the early twelfth-century buttressed shell keep at Gisors.

Around 1170, Henry II Plantagenet had an octagonal donjon erected at its center, superbly crowning the concentric ring walls. Provins, too, has an octagonal donjon from the early twelfth century. Donjons were now developing new forms: circular with round wall towers in Houdan (first quarter of the twelfth century), quatrefoil in Etampes (1130/1150), and round at both Châteaudun (early twelfth century) and the Louvre (approximately 1200).

Stone keeps are known in England from about 1070 onward, starting with the rectangular tower at Chepstow built for William Fitz Osborne and followed soon afterward by the White Tower. More complex floor plans begin to emerge in England during the twelfth century.

Construction of the motte in Hastings, detail from the Bayeux Tapestry

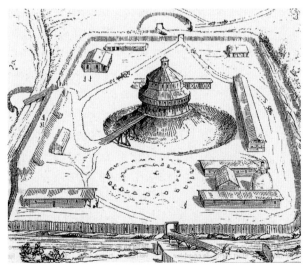

The **motte "la Tusque"** near Ste-Eulalie d'Ambarès, reconstruction according to Viollet le Duc

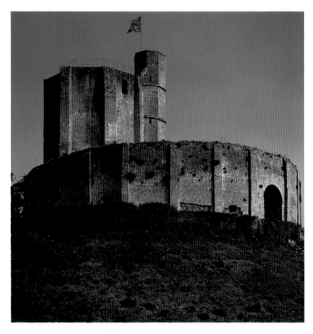

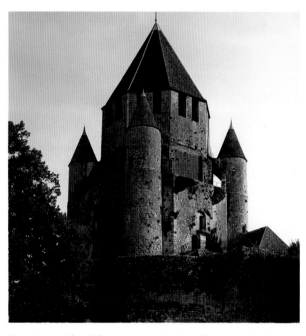

Gisors, castle: shell keep of the early twelfth century, donjon c. 1170

Below: **Conisborough, circular donjon,** reinforced by turrets, twelfth century

Provins, castle with octagonal donjon, early twelfth century

Below: **Houdan, donjon,** first quarter of the twelfth century

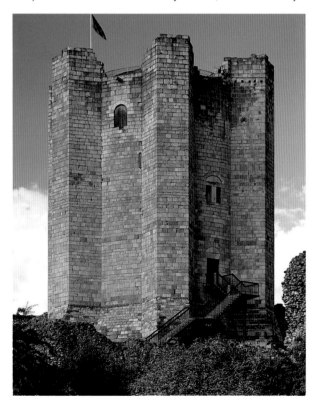

Knighthood and Courtly Life

"In its origins and proliferation, knighthood is a European phenomenon. Its sense of common purpose derives essentially from Germanic and Carolingian roots. Although it took on various national forms, these, nonetheless, maintained a strong resemblance to one another and (with certain modifications over time) remained valid throughout the Middle Ages and beyond" (Josef Fleckenstein). By the High

Middle Ages, the institution of knighthood was leaving its mark on society and culture, but toward the end of the Middle Ages, its power to shape society was superseded with the rise of the bourgeoisie.

We have gained our concept of a knight's appearance from countless images and descriptions. After the Bayeux Tapestry, the predominant visual "narrative source" for us is the depictions we find on tombstone epitaphs. Anselm hands down a description in the *Vita metrica* of Archbishop Adalbert II of Mainz: "... astride his steed, a tall helm on his head, girt with a mighty sword, protected by shield and armor ..." On his helmet and shield he carried his identifying crest, which made him known to all in the community and on the battlefield. The sources tell us that at least as early as the eleventh century, the knight was generally accompanied by a squire, who helped him don his ever more elaborate armor. Later accounts tell of the knight typically having three horses; a palfrey and a destrier for himself (for riding and battle), and another for his squire, who also carried the suit of armor. In some cases, there was even a fourth horse or other pack animal to carry additional gear.

From around the eleventh century, a knight would obtain the means to outfit himself with horses, gear and liegemen through a royal fief (a manor whose associated tenant farmers owed provisions and/or service), which he secured with a pledge of fealty and

Left: **Loches**, castle from the twelfth/thirteenth century

Right: **Fighting knight**, leaf from a *speculum virginum*, c. 1200, Hanover, Kestner Museum

service. This feudal system institutionalized the medieval power structure. Its origins lie in Carolingian France, where extensive conquest and defense of lands resulted in the formation of a warrior and ministerial nobility that was granted land in compensation for its services, at first for life, then later as inheritable fiefdoms. At the top of this feudal pyramid stood the king, whose power, like that of the other nobility, was based largely on the extent of his holdings. Like any other member of feudal society, he was at once lord and vassal, for according to the principle of Divine Right incorporated into the title of king and emperor from the time of Charlemagne onward, he himself was a liegeman to God.

Bartering of goods formed the basis of economic life. Castles, noble residences, and monasteries were self-contained economic entities that produced and processed products for their own

needs. At Palatinates, on the other hand, tributes were collected and administered. It was here and at the monasteries that supply inventories intended for large groups or for the outfitting of troops were first developed. Specialized craftsmen who produced necessities for general use were rare. Only with the major increases in agriculture and settlement—beginning in the eleventh century and reaching their height in the thirteenth—did the middle class develop (along with trade and cities) as a social complement to knighthood. Therefore, along with the obligations of a vassal, a knight had administrative functions and, at smaller manors, farm-related and technical duties.

The fraternity of knights and their dependents represented for the king one of his greatest resources of power. After the Church had bound itself closely to the Carolingian nobility through the institution of the Divine Right

of kings, it was a natural progression to draw the knights more tightly into the Church's sphere of influence, and to place the institution of knighthood—which was originally or-

tion; and keeping the peace. Given the prevalent feuding among the nobility, this peace was not easily achieved, however, and only the crusade movement was able to resolve this

Germanic notions of battle, bravery, and honor with the notions of peace and salvation for the soul. This was successful in promoting the crusades and at the same time

Bayeux Tapestry, 1077 and 1082, details: battle at a motte (above); the oath between Harold and William (below); height 50 cm/20 in, length more than 70 m/210 ft

ganized around military service and retained its pre-Christian Germanic ideas even after Christianization—into a clerical or sacred context that would redefine it. This was achieved through sword blessing and knighting ceremonies that subjected a knight to the same demands placed upon kings: defense of the Church; its servants, widows, orphans, and all others in need of protec-

problem decisively by setting a worthy cause before the knights. When he promulgated the First Crusade at Clermont in 1095, Urban II said: "Now will they become knights, who before were only robbers; now shall they rightfully do battle against barbarians, who before did battle against brother and cousin." The Church legitimized the war by linking the traditional

created the conditions for synthesizing a new moral and social code for knights that merged their socially and economically very heterogeneous group into a true community.

Just as monasteries were the centers of education, the center of this chivalric culture was the court. In times of peace, activities such as hunting (particularly falconry) and combat practice were taken up for

physical exercise; poetry and homage to ladies were also practiced in expression of the charitable duties incumbent upon knighthood. The moral code that regulated encounters between knights and ladies at court presented an opportunity for the knights to prove their valor and honor in terms of their Christian as well as their military principles.

131

Plains and Hilltop Castles

Castles are a typical phenomenon of the European landscape. While those in the south and west adopted regular ground plans from 1200 onward, the northern complexes retained more irregular layouts. Especially in France, the tenth and eleventh centuries left behind numerous castles situated on high promontories. They are composed of several concentric ring walls with pointed archways surrounding a central area containing a donjon as well as residential and service buildings. Flanking towers were added to the walls and especially the gates from the early thirteenth century. At this time, too, plains castles were emerging whose irregular ring walls were enclosed within water-filled moats. After about 1200, the flatland complexes and sometimes also the hilltop installations started to take on regular

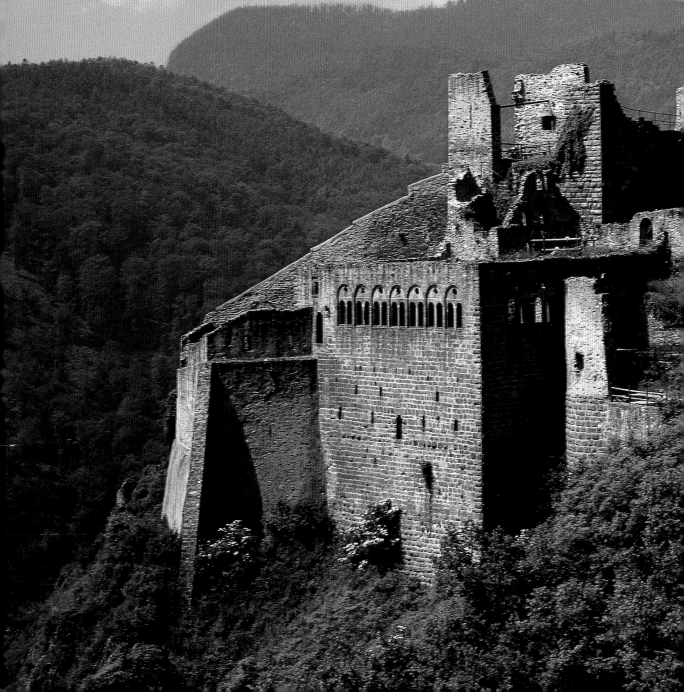

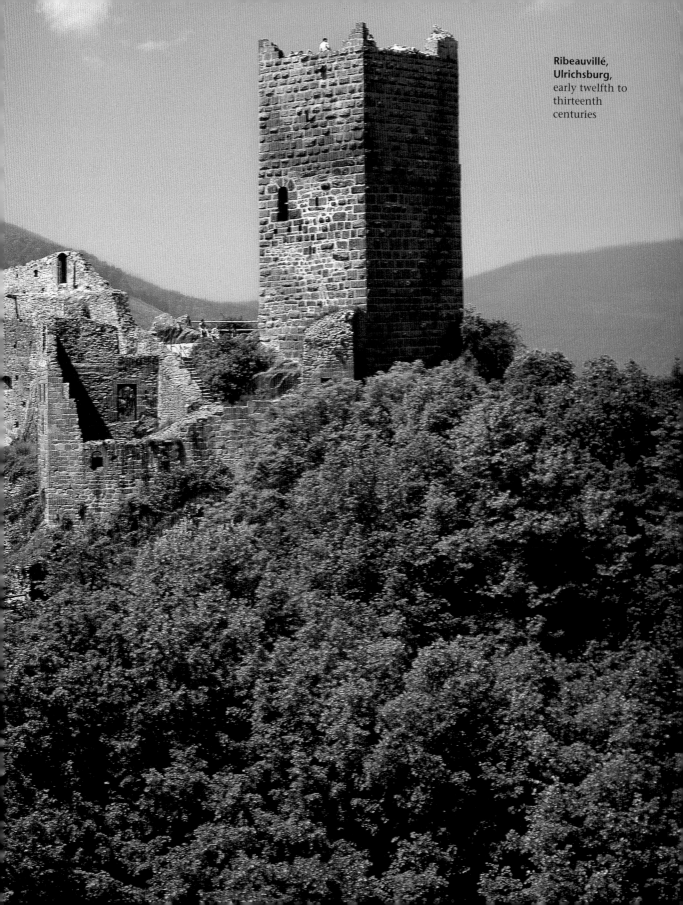

**Ribeauvillé,
Ulrichsburg,**
early twelfth to
thirteenth
centuries

forms. Initially rectangular and later square, all of these complexes had the donjon and three circular towers at the corners. The first constructions of this type are the Louvre and the castle at Druyes-les-Belles-Fontaines, whose owners were cousins—Philip II Augustus and Pierre de Courtenay. This type of layout remained current into the Late Middle Ages.

From the second quarter of the thirteenth century in Italy, Frederick II built royal residences with a strict mathematical regularity. Without exception, their locations were chosen for the beauty of the landscape. Examples are Castel Maniace in Syracuse from the 1230s, Castel Ursino in Catania, and Castel del Monte. Before the twelfth century, castles in German-speaking areas had been purely functional buildings. Then during Staufen times, they were enhanced for the first time by adding more comfortable residential buildings and ceremonial spaces. These were grouped together and surrounded by defensive walls with high towers. Typical of the Staufen era is the rabetted rustication of the towers and principal structures.

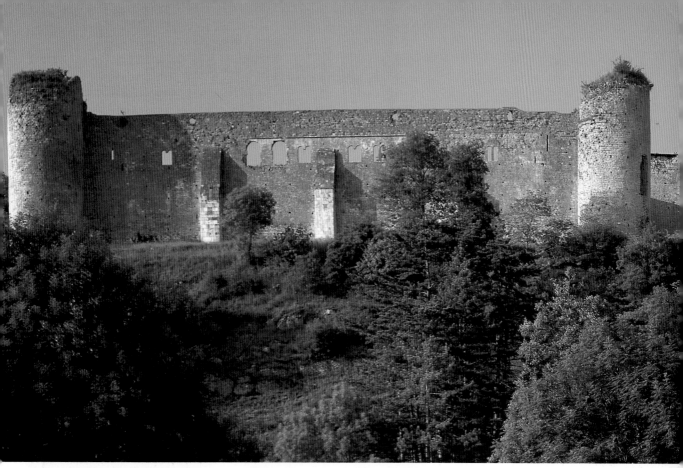

Druyes-les-Belles-Fontaines, castle, begun c. 1200

Far left: **Ruins of Trifels castle near Annweiler,** "the most elegant Staufen fortress" served as a temporary depot for the crown jewels; oriole window of the chapel

Left: **Landsberg in Alsacia, castle ruins,** palace with chapel oriole

P. 134: **Büdingen, water castle**

Townhouses

Church buildings often retained the same purpose over long periods of time and could frequently rely for survival on their being viewed as consecrated historical assets. Not so for residential structures, which were much more liable to destruction through violence, improvements, change of use, or simply the ravages of time. Indeed the cities of the eleventh and twelfth centuries featured very few stone buildings. Timber-framed houses were much more the rule, and these would regularly burn to the ground in the countless fires of the time. Among the surviving examples of townhouses are residential towers, which had a small footprint but could reach up to seven stories in height. They differed little from the donjons found in the countryside (examples are found in Italy, France, and Germany). There were mid-sized houses with pitched roofs and lovely windowed gable ends, and prestigious palaces that might belong to a bishop, a major monastery (e. g. Cluny, Sens, and Auxerre), or could, like a Palatinate, represent a governor. The nobility continued to live almost exclusively in castles or in the rural centers of their holdings for quite some time, while the townspeople only gradually began to increase in prominence and affluence during the thirteenth century.

Orderly arrangements of bifora, not unlike the gallery openings in churches, characterized the townhouses of the High Middle Ages; at times they had aligned sequences of windows with rhythmically varied lintels and arches. In many cases the palaces have galleries and/or arched porticoes at the street-level, presumably designed to serve the commercial activities of the building (illus. below and on p. 137).

The White Tower in London

Beginning in 1077, William the Conqueror had three large defensive complexes built along the Thames: Baynard's Castle, Montfichet Castle, and on the north bank in London, the fortress that is today known as the White Tower. It lies within the Roman city walls and was built as a defensive point at the city's river access. More particularly, it permitted the Norman

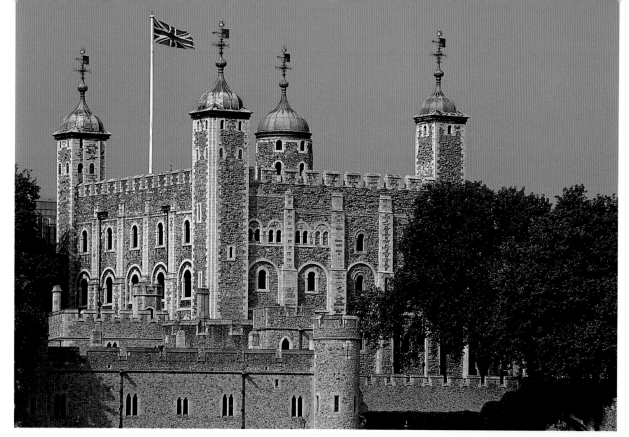

S. 136:
Regensburg, "Baumburger Turm", residential tower, third quarter of the thirteenth century (left)

Milan, Palazzo della Ragione, first half of the thirteenth century (right)

London, The White Tower, after c. 1078, fortress, city palace and governmental seat of William the Conqueror

St-Antonin, Granolhet city palace, second quarter of the twelfth century, street front

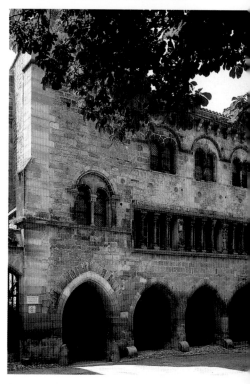

conquerors to keep the Anglo-Saxons in check, meaning it was initially a symbol of foreign rule. Over a long period of time it has served as a royal palace, infamous state prison, mint, treasury, observatory, and state archive; thus in these capacities it has been central to English kingship.

The history of its construction is comparatively simple; the oldest section is the actual White Tower, a free-standing, roughly square donjon that was originally surrounded by a moat. Completed in 1097, at 27 meters/89 feet high, it remains England's tallest secular stone structure since Roman times. After the fashion of France's larger donjons, the tower has four stories of three rooms each. An unusual aspect, however, is the three-aisled, barrel-vaulted chapel, which is developmentally on a par with the monastery churches at Jumièges and Caen. Two other comparable defensive structures in England are the keeps at Rochester and Colchester.

The Rural and Municipal World in the High Middle Ages

The social distinction between knights and peasantry followed the formation of a professional military cavalry based on land ownership and fiefdom. Starting with the tenth/eleventh century, we see increasing mention of *milites* and *rustici* in legal sources. The meaning of the Middle High German word *gebure* was changing as well: Originally used to designate a fellow occupant of one's house or a fellow villager, it changed in meaning to denote a peasant, a person who works the land. "The alienation of the peasant from military service finds its deeper meaning in the … intensification of agriculture, which created an economy that now required his continuous presence on the farm, making him less and less available for military campaigns" (W. Rösener).

One of the most significant characteristics of farming during the High Middle Ages was the dependency of farmers on feudal lords. Only a relatively small stratum of so-called yeomen was directly answerable to the king or prince. Because of this, historians trying to give a picture of rural medieval life speak of farming conditions in a system in which power is derived from land ownership, which in turn affected economic, political, and social factors. In other words, land ownership entitled one to exercise dominion over people. The feudal lord did not cultivate the land himself, but left it to the dependant farmer to use in return for socage or contributions. The demands of the feudal lords were usually high as they had expensive lifestyles. Correspondingly, their peasant farmers led a harsh existence.

Several groups can be distinguished among these serfs: those who held farms; those without a house of their own, who

Portal medalions representing the months, c. 1140, Paris, St-Denis

Oxen pulling a plough, from Herrad von Landsberg, *Hortus deliciarum*, twelfth century

lived and worked on the estates as servants; and finally the day-laborers with their own small farmsteads. The social and economic differences both among these groups and within that group who worked their own farmsteads were considerable. There were big and small farmers; among the former, some managed to

St-Denis c. 1000, the town and its palisades

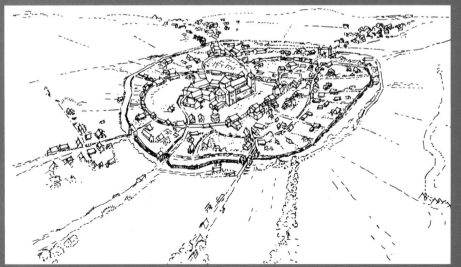

138

Vintage, month of September image, sculpture by Benedetto Antelami, late twelfth century, Parma, baptistery

advance into certain posts in the service of their lords. The feudal lords exercised sweeping authority over their serfs, including judicial power. They regulated and supervised almost every aspect of life—right down to enforcing a dress code. Simply put, land ownership was synonymous with authority and power.

For the majority of the rural working population, simplicity and scarcity were the general rule for all areas of their lives, from living conditions to level of education. Almost none of them could read. What little news of civilization they heard, came to them by way of the parish priest. Christianity for these peasants still incorporated elements of old folk beliefs, and thereby retained a touch of the magical. Processions of supplication and the worship of saints played a major role.

Up until the eleventh century it is not so easy to distinguish town from country. Until then, towns were simply larger villages: centers of commercial production, trade, and administration. Their inhabitants had no particular legal status and most of them were just as dependent as the rural serfs. This situation changed over the course of the eleventh and twelfth centuries, due in large part to the town *ministerials*. These administrators of the town's sovereign rule— in the capacity of toll collectors and coin minters—formed the upper economic and political strata of the townspeople, together with wealthy merchants who were in some cases also ministerials. The growing self-confidence of these groups and their desire to partake in power and possession led to struggle

for emancipation. "The result of these contests is the municipality, the joining together of townspeople into a political corporation that acts in unison and enters into a contractual relationship with the Stadtherr, assuming for itself an increasing share of his rights" (H. Bookmann). The founding of numerous new towns during the thirteenth century in which the inhabitants constituted from the outset a community of "free" citizens underscores the increasing importance of towns and municipal ways of life in Western Europe.

Medieval city c. 1300, reconstruction based on contemporary documents and archaeological excavations (painting by Jörg Müller)

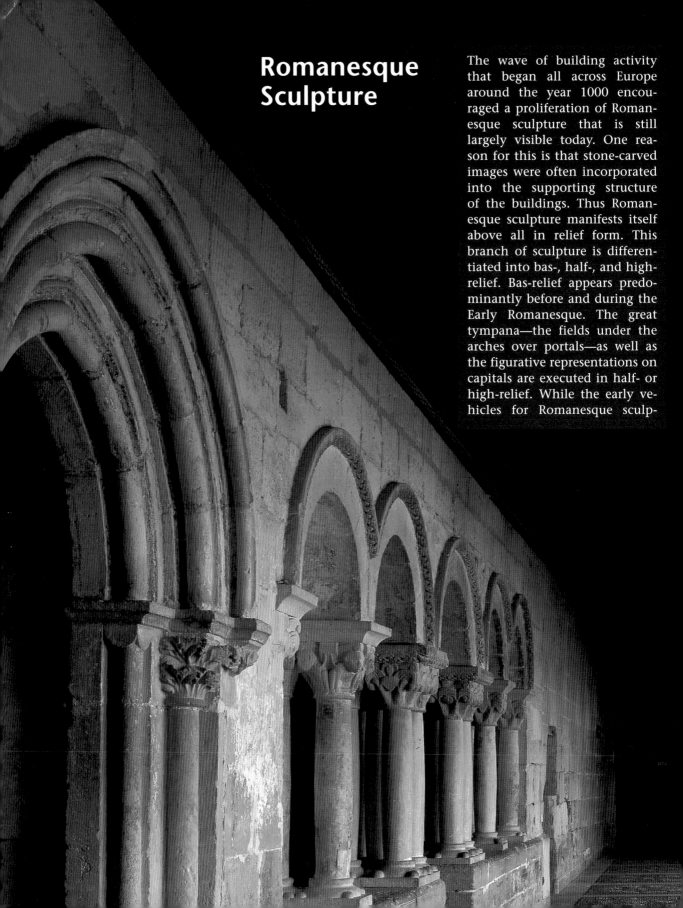

Romanesque Sculpture

The wave of building activity that began all across Europe around the year 1000 encouraged a proliferation of Romanesque sculpture that is still largely visible today. One reason for this is that stone-carved images were often incorporated into the supporting structure of the buildings. Thus Romanesque sculpture manifests itself above all in relief form. This branch of sculpture is differentiated into bas-, half-, and high-relief. Bas-relief appears predominantly before and during the Early Romanesque. The great tympana—the fields under the arches over portals—as well as the figurative representations on capitals are executed in half- or high-relief. While the early vehicles for Romanesque sculp-

ture were relatively simple architectural elements, the tympanum ultimately became the central and most prominent locus for the sculptor's art. Added to this were the richly draped sculpted figures that soon began to accompany the portals.

Capitals are rather special vehicles for sculptural imagery. They form the upper extremity of the columns that support the vaulting, which symbolically represents the cosmos and God's heavenly realm. As the transition between support and load, the capital remains bound to the terrestrial, while presenting itself to the cosmic sphere. This locus is the key to the repetitive symbolic content of the Romanesque capital, which is often difficult to decipher today.

Sto Domingo de Silos,
cloister, twelfth century

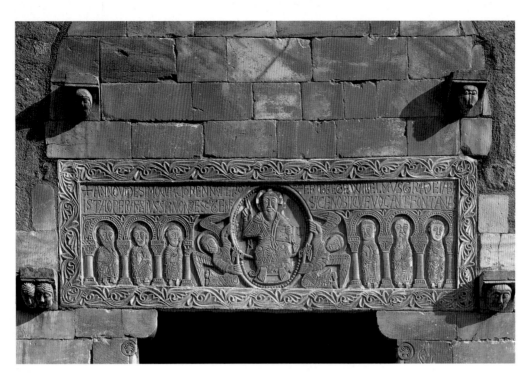

France

The lintel over the portal at St-Genis-des-Fontaines in the Roussillon is thought to be the product of a Pyrenean workshop. Its inscribed date of c. 1019–1020 makes it the earliest work of the French Romanesque. Executed in the facetted "chipcarving" technique, it shows Christ enthroned between six apostles. Their silhouette-like integration into an arcade shows an already very close relationship between architecture and the figure. Here we are probably looking at a full-scale sculptural interpretation of the minor, applied arts.

The Eastern Pyrenees
The St-Genis lintel is part of a group of similar eastern Pyrenean works that appear at various locations in the Roussillon. The rapid ascendancy of the monastery of St-Michel-de-Cuxa added further and lasting momentum to sculptural activity throughout the region. Evidence of this can be found in the decoration of the church of Notre-Dame at the former priory of Serrabone, northeast of the Massif de Canigou (illus. p. 144). The south gallery here, and above all the singers' gallery hold special prominence in this region's Romanesque sculpture. Built around 1150, the two-bay-deep gallery now spans the nave with three arches. Its red and white marble stands in noble contrast to the otherwise modest interior. The west side is covered in continuous reliefs, with symbols of the four Evangelists in the spandrels. The figurative representations under the corner volutes of the capitals consist largely of grotesque animals interposed with human faces.

Both the singer's gallery sculptures and the carved capitals of the south gallery display high quality carving. The work here is believed to be that of two masters who were also involved in sculpting the cloister at St-Michel-de-Cuxa. Some scholars even debate whether the entire singer's gallery might have been executed in the Pyrenean workshop mentioned above, and transported to Serrabone in pieces. That could well apply to other locations, as well, where the sculptural style closely matches that of Cuxa. In any case, the sculpture on the singers' gallery marks a peak in the High Romanesque sculptor's art in the Roussillon region.

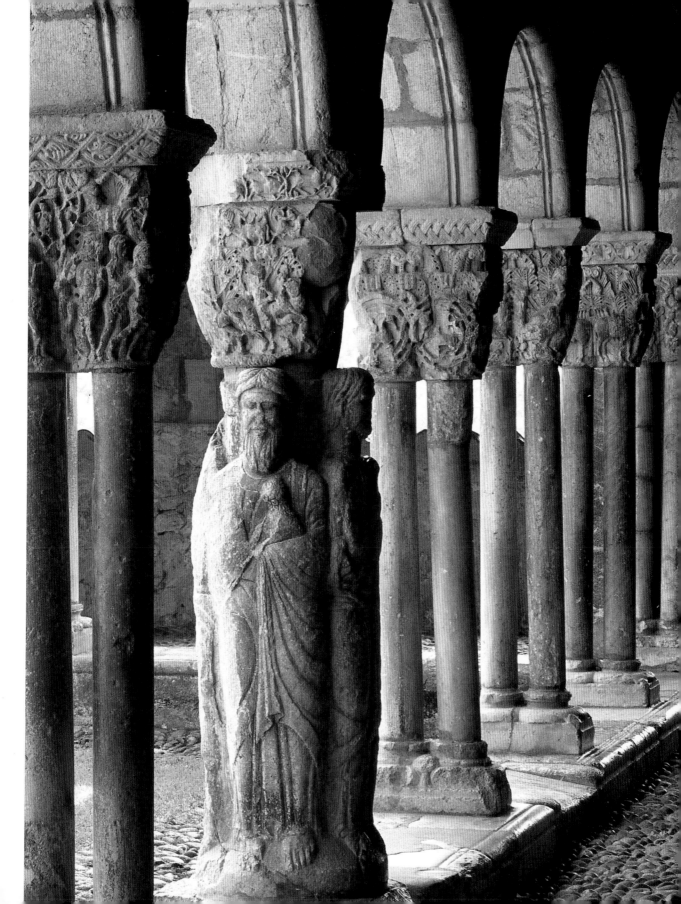

Toulouse and Moissac

The three great cloisters of Toulouse placed it at the center of southwestern French Romanesque. While all three unfortunately fell victim to the French Revolution, the collegiate church of St-Sernin, which next to Cluny III is the largest religious structure of the Romanesque in France, remained intact. It is also one of the great pilgrimage churches along the route to Santiago de Compostela (see pp. 106 ff.). At the cusp of the eleventh and twelfth centuries, the imagery at this church generated a movement that was exceedingly innovative in its artistic development and involved the participation of at least three stylistically distinct workshops.

The most important portal at St-Sernin is the Porte Miègeville of the southern side-aisle; it was presumably completed in time

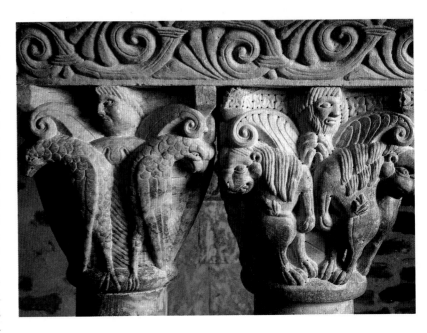

for the church's consecration in 1118. Along with Spanish examples in León and Santiago de Compostela, it is one of the first portals in which all the fundamental elements of portal composition are combined in one

Serrabone, former priory Notre-Dame, double capital of the choir gallery (above) and the choir gallery (below), after the mid-twelfth century. Originally located in the west of the church, it was only moved to its present position in the nave in the seventeenth and the nineteenth century.

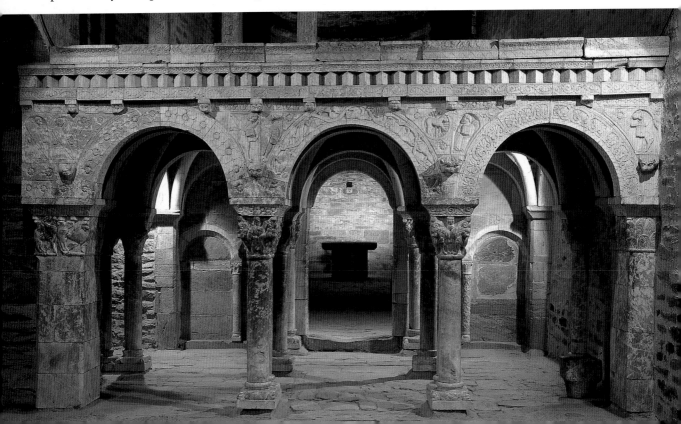

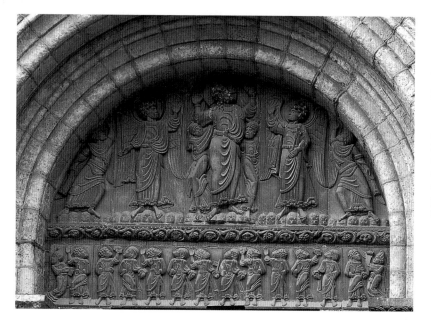

cohesive ensemble. The program of the portal, which focuses on the Ascension of Christ, is equally cohesive. At the center of the tympanum we see Christ being carried heavenward by two angels. Beneath him stand the apostles, their heads turned to look upward. Flanking the tympanum are large reliefs of the apostles Peter and James who greet the pilgrim and refer to the Via Tolosana.

Perhaps the most impressive portal, and the most artistically significant, is the south portal of the former abbey church of St-Pierre in Moissac. Its tympanum depicts the Revelation of St John. At the center sits

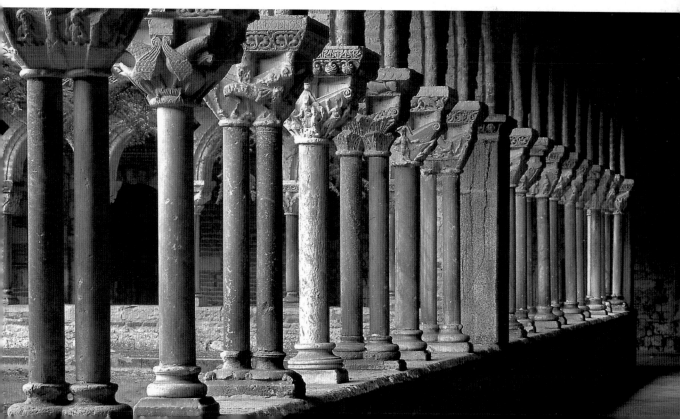

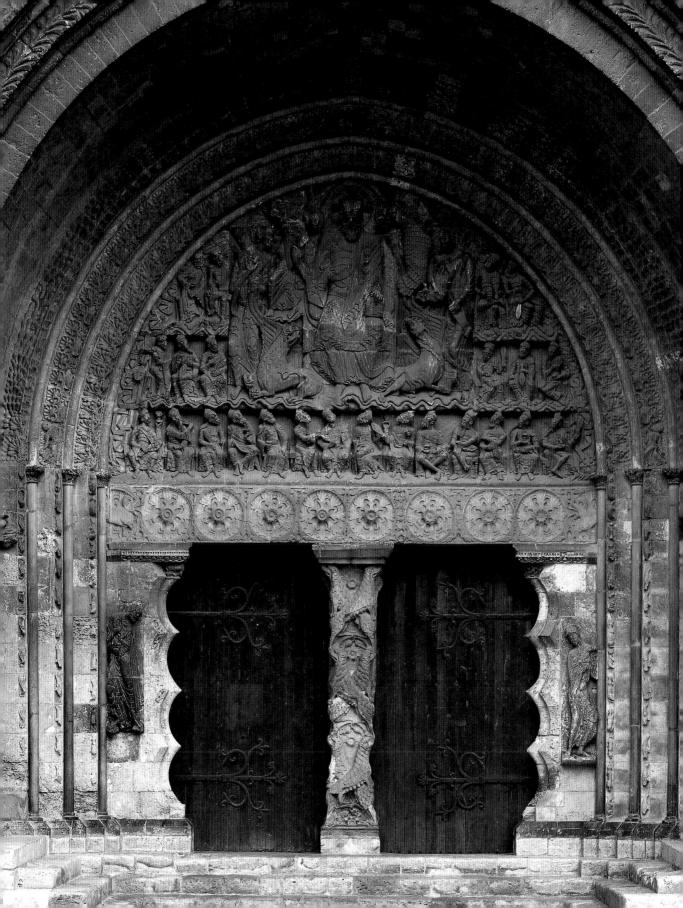

Christ, crowned, majestic, and aloof on his throne. Around him are angels and beasts of the Apocalypse, the twenty-four elders, and the "glassy sea." At the perimeter of the tympanum is a meander that sprouts from the mouths of beasts. The tympanum and lintel are supported by massive jamb piers that are scalloped on their inner edges. From an artistic standpoint, the trumeau is the centerpiece of the Moissac sculptural program. The carvings on its outer face show pairs of lions set one atop the other, while on the left and right side appear the apostle Paul and the prophet Jeremiah, respectively. The slender elegance of the latter is especially remarkable, and is clearly the inspiration for the Isaiah found at Souillac.

The reliefs in the portal atrium are each organized within a double arcade topped by friezes. On the right are scenes from the life of Christ; on the left the story of Lazarus and Dives is set with the condemnation of Avaritia and Luxuria (illus. p. 162). Here the association of greed with unchastity ("luxuria") constitutes a criticism of a new and growing social stratum that was on the verge of freeing itself from feudal dependency by engaging in commerce of money and goods. Unchastity was seen as a sensual complement to the commercial pursuit of profit. Together they formed the basis of a new individual freedom which not only countered the influence of the Church, but was also unsettling to the religious and moral foundations of medieval feudal society. Also at St-Pierre in Moissac, the cloister, which we gather from its inscription was finished in the year 1100, is not only the largest and most richly decorated cloister still in existence; it is also the first to depict Biblical stories and other scenes on its capitals.

P. 146 and left:
Moissac, former abbey church of St-Pierre, southern portal (p. 146), southern portal, east side of the trumeau: the Prophet Jeremiah (left), 1120–1135

Soulliac, former abbey church of Ste-Marie, relief on the interior west wall: the Prophet Isaiah, 1120–1135

147

Gerlanus, Gofridus and the "Master of Cabestany"

For a long time people assumed that artists in the Middle Ages withheld their names on purpose because their works were supposed to serve the glory of God alone. Hundreds of artists' signatures have been preserved, however, which contradicts this misconception. If, despite this, most artists remain unknown, this is due on one hand to inadequate records, and on the other to the fact that sculptors, for instance, only gradually managed to emerge from their roles as simple stonemasons. Thus it is especially appealing to see at St-Philibert in Tournus the earliest depiction of an individual artist in the history of Western art. The relief on the Gerlanus arch shows a man with hammer, the very same Gerlanus who left his name in an inscription on this archway.

Of the sculptors' names that have been handed down to us, it is striking that the majority come out of France and especially Italy. These are areas where the economic and political conditions had experienced a considerable upturn. This suggests that the clerical and secular patrons were well aware and in fact proud to have engaged an important master or acclaimed workshop. Historically speaking, an artists could not attain this kind of fame until the advent of growing towns and rising bourgeoisie. This was a time when artists were developing a sense of self-confidence and pride in their ability and the quality of their work, and getting recognition from society. Many of their signatures speak of this. Nonetheless, one should not lose sight of the fact that the name inscribed on a work, with the addition of the word "fecit"—made (this)—is often merely that of the client and not of the actual sculptor. Furthermore, the artisan's name would take second place to that of the master who ran the whole workshop.

In cases where no name has been handed down, but works are recognized

Above: **Tournus, former abbey church of St-Philibert,** Gerlanus arch: a man holding a hammer, second quarter of the eleventh century

Left and below: **Chauvigny, former collegiate church of St-Pierre,** capitals from the ambulatory: Adoration of the Magi with a signature (left); the devil shows his altar with the symbol of death (below), second half of the twelfth century

as belonging together in a stylistic group, art historians have established a cognomen to identify his oeuvre. The "Master of Cabestany," for instance, is named after a small village near Perpignan in the south of France. The local church there had a tympanum which is comparable in style to a series of works spread over a wide area. This artist's figures always have a large head with flat forehead; a long, powerful nose; and slanted, almond-shaped eyes. Relatively large

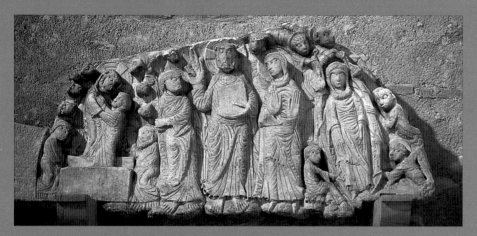

hands with long fingers, and garments classicizing folds are other characteristics of his style, although no reference to Antiquity may be intended. In this master, we have one of the most prolific and fascinating artistic personalities of the entire Romanesque period, one whose works can be found all the way from Tuscany to the Roussillon and into Catalonia. Art-historical literature views him as a peripatetic sculptor who first came from Tuscany and created most of his works in the Roussillon. The great mystery surrounding the artist's identity has recently given rise to the notion that this could be a case of a heretic who worked in the land of the Cathars during the great heresy of the last quarter of the twelfth century.

Geographical place names are not the only criterion used to identify outstanding works of anonymous artists. The scene or circumstance depicted in a work can also be used to generate a cognomen, as can particular subjects or even certain motifs. For example in the case of the "Master of Doña Sancha" (see pp. 168–169), the name comes from the person for whom he sculpted a sarcophagus.

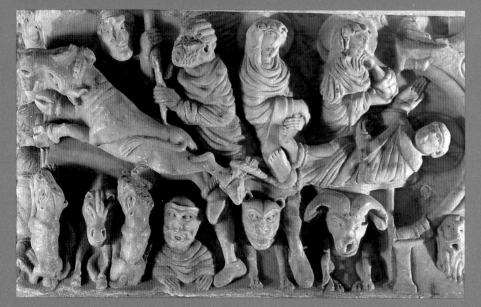

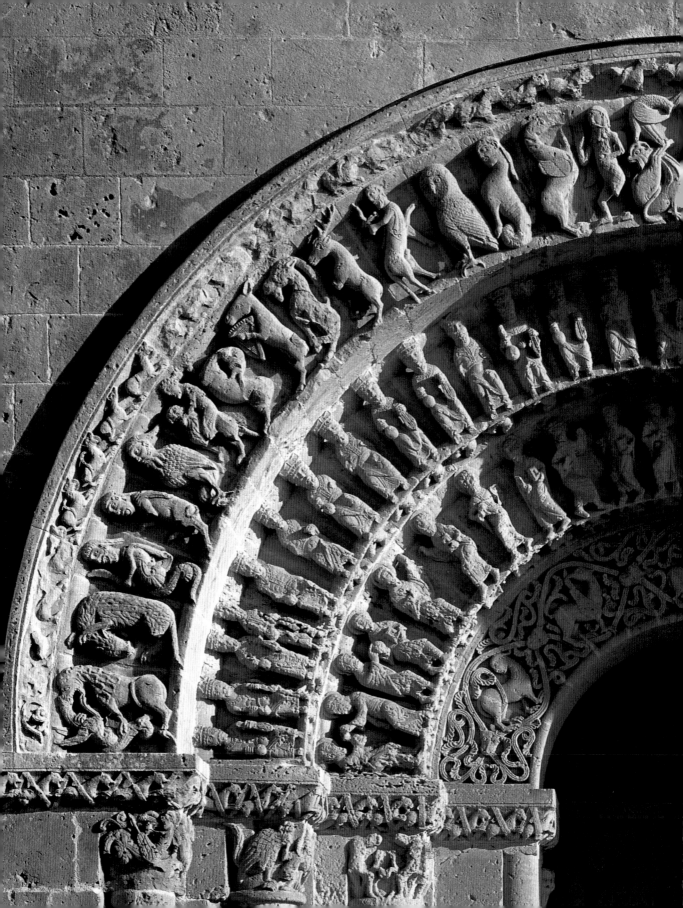

Western France

The West of France is home to the majority of Romanesque religious architecture. A characteristic feature of its facade and portal arrangements is the lack of a tympanum. Furthermore, the facades at Angoulême, for instance, or at Poitiers, exhibit a full wall of decoration, whereas the sculptural appointments of other portals are restricted to the archivolts. The three-level facade of the former collegiate church of Notre-Dame-la-Grande in Poitiers is emphatically designed around a vertical axis formed by its portal, window and mandorla, and accompanied by corner towers. In contrast, the horizontal arrangement is inconsistent with the architecture. While the portal and its flanking blind arcades follow a multi-aisle architectural layout, the upper story has a two-level register of figures set in arcades that resembles the decoration on the side of a sarcophagus. The iconographical program starts above the portals with scenes from the Old Testament and the birth of Christ. Above that we see the twelve apostles, seated in the lower register and standing in the upper one. The facade is dominated by the mandorla, in which Christ appears encircled by the Evangelist symbols. Here the Late Romanesque transition from the Old Testament to the New is made the central theme. The portal archivolts are crowded with carved decoration.

Even more articulate than Poitiers is the sculptural treatment of the archivolts at Aulnay and Saintes. The three outer arches of the south transept portal at St-Pierre in Aulnay are composed of small figures that are joined together so they radiate from a center point while forming the supporting structure of the arch.

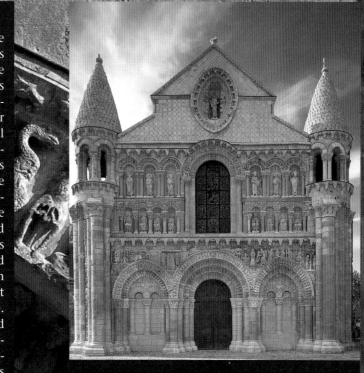

Above: **Poitiers, former collegiate church Notre-Dame-la-Grande,** west facade, c. mid-twelfth century

Right: **Saintes, former abbey church of Ste-Marie-des-Dames,** west facade, archivolts of the portal, second third of the twelfth century

Aulnay-de-Saintogne, former collegiate church of St-Pierre-de-la-Tour, portal of the south transept, from 1130

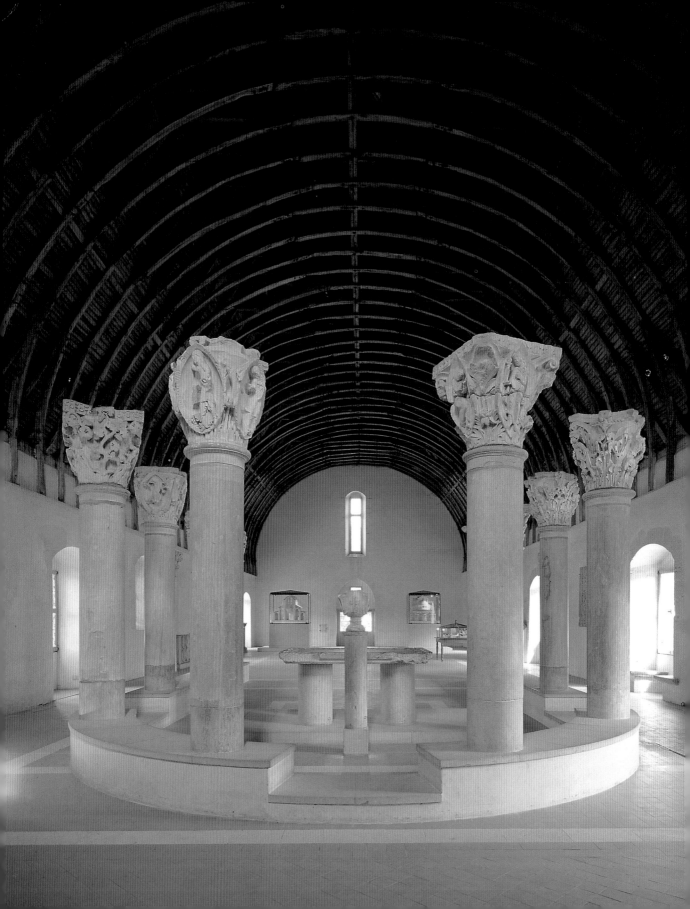

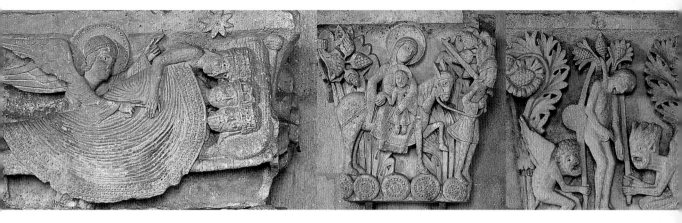

P. 152: **Cluny, former monastery of St-Pierre-et-St-Paul,** the grain loft, upper story with wooden barrel vault. The surviving fragments from the monastery church have been exhibited here since 1949; the most significant are the eight capitals of the choir, restored by K. J. Conant to their original sequence.

Autun, Cathedral of St-Lazare, capitals: Dream of the Magi (left); Flight into Egypt (center); Suicide of Judas (right), 1120–1130, Autun, Musée de la salle capitulaire

Burgundy

Burgundy, the land between the Saône and Loire Rivers, long enjoyed secure borders and inner stability, which was particularly conducive to the development of this French Romanesque artistic landscape. For it was here that monasticism revitalized itself at an early period. The largest and most powerful monastery in the Occident emerged in Cluny, and it had a major influence on Romanesque art. In the west portal of the abbey of St-Fortunat in Charlieu, Christ appears for the first time in the form of the *maiestas Domini* ("Glory of God," illus. p. 154). This would later be transformed into the Last Judgement. Against the backdrop of the dispute between pope and emperor over dominion in western Europe, this was seen as an expression of imperial title as adopted from Antiquity.

The pilgrimage town of Vézelay was more than just the origin of one of the four major pilgrimage routes to Santiago de Compostela. After Bernard of Clairvaux invoked the Second Crusade at Vézelay in 1146, it also became the staging point where the crusading knights of Europe congregated before marching off to the Holy Land. The portal of its church of Ste-Madeleine (illus. p. 155) narrates the apostles being sent out on their mission to proselytize the world. At the center, Christ sits enthroned inside the mandorla. Under his outstretched arms, the disciples sit and absorb the Holy Spirit while the peoples of the world await conversion in the cells around the perimeter. Surrounded by the signs of the zodiac and representations of the different months, the theme takes on quasi-cosmic dimensions. It is quite reasonable to see this highly ambitious conception in the context of crusade preparations in the year 1146.

The extraordinary impact of Romanesque sculpture is also demonstrated in the figural capitals found in Burgundy. Some of the most touching work can be seen on the capitals done by Master Gislebertus of Autun, who left us his name in the tympanum at St-Lazare. Both here and in the capitals, his carved images are extremely expressive in their portrayal of human feelings, hopes, and fears (illus. above). The Three Magi lie together under one blanket; only two are asleep, because the third has been awakened by the delicate touch of an angel who is showing him the star. In the scene of the flight to Egypt, Mary is seated on a donkey and turns to face us, presenting her child. Based on the archetype of the enthroned Madonna with Child, the mystical motif of the *sedes sapientiae,* she lays her arm protectively over the child in a scene rich in human depth and empathy.

153

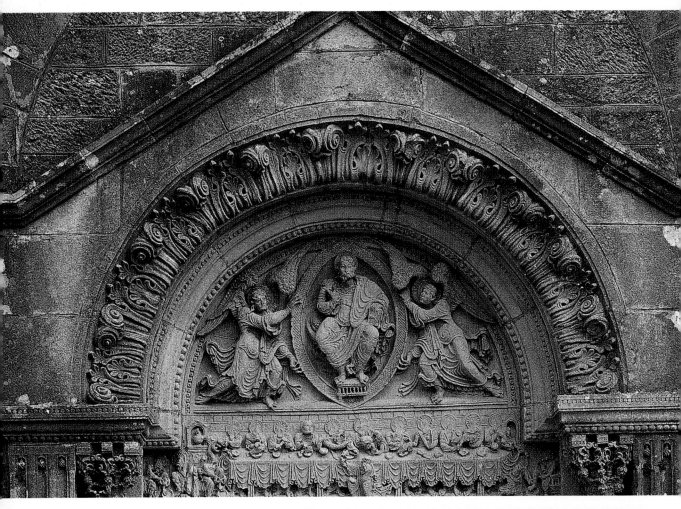

St-Julien-de-Jonzy, church of St-Julien, tympanum and lintel of the west portal, mid-twelfth century

Charlieu, former priory church of St-Fortunat, tympanum of the west portal, late eleventh century

P. 155: Vézelay, former abbey church of Ste-Madeleine, main portal, in the tympanum: the miracle of Pentecost, 1125–1130

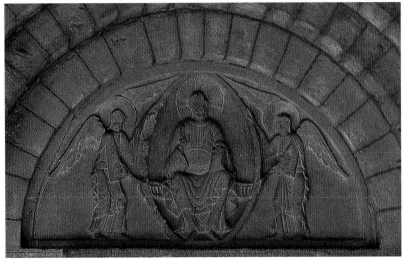

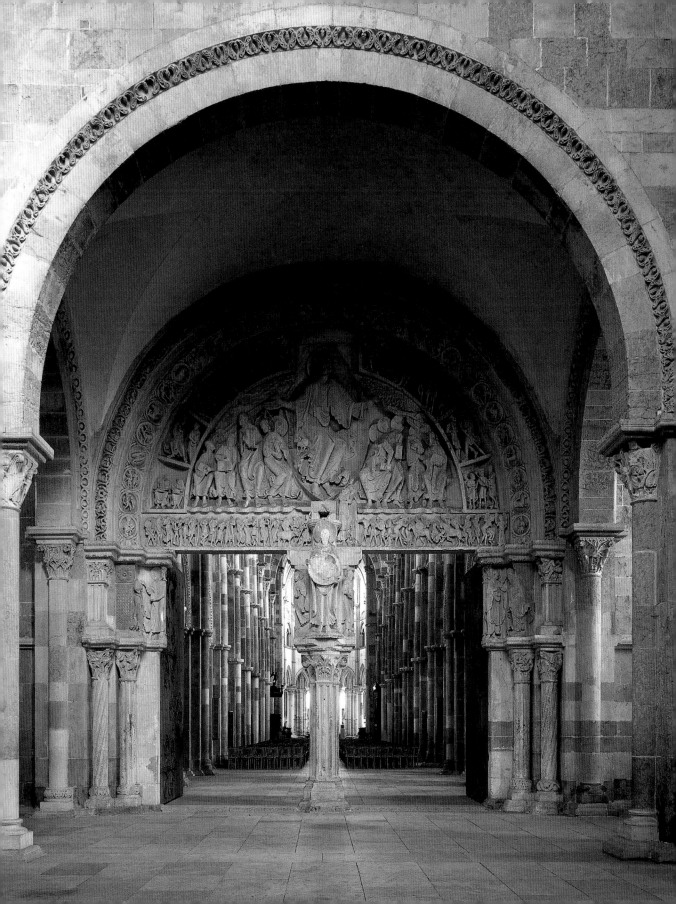

Death of a pope seated on the toilet. This sculpture gives a crass example of unexpected death, which can even surprise a pope. Semur-en-Brionnais, detail of the tympanum of the west portal, twelfth century

Angel present at a benificent death, Elne, tomb stone from the Cathedral of Ste-Eulalie

Below: **Death and burial of a monk,** illuminated scene from a French manuscript of the eleventh century, Troyes, Bibliothèque municipale, Ms 2273

Image and Meaning

The image that people in the Middle Ages had of the world in which they lived was permeated by fears and symbolic meanings. No object, no event was just as it appeared. Everything extended in some way or another into the here-after, whether sacred or demonic. Just as the sacred could manifest itself in almost anything that was accessible to human senses, so could the devil. And it was often difficult for ordinary people to distinguish whether they were confronting Good or Evil, since God was free to appear to them in any form He chose. Thus there were symbols and references everywhere that were based on a particularly medieval worldview. Because they understood everything as part of a fabric of inter-woven affinities, people in the Middle Ages were constantly relating what they saw to the supernatural world and a higher truth. These references were rarely straightforward, as they could be interpreted differently at any time according to the circumstances in which they appeared. That said, however, there were certain elements that were regularly associated with the same theme. The bright blue of the sapphire (for instance) and the bright blue of the sky were so connected that this stone became a symbol for the heavens, although this meaning could also be expanded or altered.

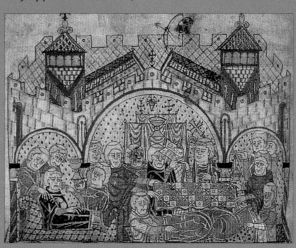

Christianized, this was a specifically medieval way of thinking. Its core, which was reduced to the mere associative linking of manifestations, is reflected in the *Physiologus* ("natural history"), a kind of early lexicon of the animal kingdom as presented in Romanesque art. The animals' characteristics are associated in naïve allegorical fashion with examples of the Christian way of life or with Christ himself. The *Physiologus* supposedly originated around A. D. 200 and was always undergoing expansion and editing. Today it is one of our most important sources for understanding medieval imagery.

156

Death and Fear of Death

Stern and terrifying were the things that medieval believers beheld on entering the house of God. There, they would be confronted with something they could hardly imagine—the end of the world. For out of ages past, the threat of the Old Testament's God of vengeance was still very real, and people were filled with the profound fear that a sudden death might leave them without time to repent for their sins and have them forgiven. Even the pope could be taken by death in the most humiliating place—sitting on the toilet (illus. opp. left). While his soul (depicted as a child) exits his body through his mouth and is accompanied to Hell by three horned devils, the papal throne is left abandoned.

In an era of high infant and child mortality, and in the face of numerous diseases and epidemics and an average life expectancy of only 35 years, death was a powerful and ubiquitous companion to life. Thus people in the Middle Ages were left no choice but to contemplate their whole life from the perspective of death. The drastic consequences of a life without atonement were portrayed in the many Last Judgement depictions found on the portals of churches being built at the time. Here, much space was devoted to descriptions of Hell's punishments. When people unfamiliar with this new style of imagery went to enter the churches at (say) Autun, or Conques-en-Rouergue, they were confronted with scenarios that were almost too menacing for them to bear. At the Last Judgement, souls would be weighed to determine into which of the two hereafters they would go. This could be so vividly and naturalistically portrayed, that a viewer could hardly avoid taking a frightened look at his own life. Such a scenario is shown on a narrative relief at Moissac, where the soul of a greedy rich man is claimed by devils (illus. left). In contrast, one does find depictions of people who died in a state of grace, for example on a memorial

The tortured soul of a dying rich man, Moissac, former abbey church of St-Pierre, vestibule of the south portal, detail of the west wall, 1120–1135

Soul of a saint ascending to heaven, Riesenbeck in Tecklenburg, St Calixtus, tomb of Reinhildis, c. 1130/1135

slab in Elne, in the Roussillon (illus. p. 156 top right). Here the *gisant*, the simultaneously prone and standing body of the dead person, is shown being led up to heaven by two angels. Thus the deceased is portrayed as neither dead nor alive. Philippe Ariès sees in him the depiction of a "fortunate one."

157

The Last Judgement:
Heaven, Hell, Purgatory

The fear of death was a deep-seated religious fear. Since life was supposed to continue in the hereafter according to the two-world doctrine, death could not mean the end of life. This meant every mortal was burdened by the depressing uncertainty of not knowing whether they were worthy of heavenly mercy and thus of redemption, or if they would burn unsaved in Hell. At the end of all time, on Doomsday, judgement would be made. This Last Judgement scenario often found its place in the tympana over the portals of church entrance facades. The tymapanum, jambs, and archivolts constitute an area of sculptural representation that is one of the most important inventions of Romanesque art. Here the throne of God (the New Testament's Judge of the World) appears always in the center of the Last Judgement. About him are a host of the blessed and saved on one side, while opposite them the hellish torments of the damned are depicted, often quite starkly. For according to Matthew's vision of Judgement Day,

in which Christ gathers sheep on his right and goats on his left (Matt. 25:33), the judge makes gestures pointing to both sides, parting the

hereafter into paradise on his right and inferno on his left. Out of this came the division of this world into good and evil, a theme which not only dominated Medieval art, but has remained culturally relevant to the present day. It was

indeed the end of time that was conjured up in the Last Judgement on these tympana. And anyone who walked through these portals was aware of their sins and had a foreboding of what was in store for them. Especially impressive, for example,

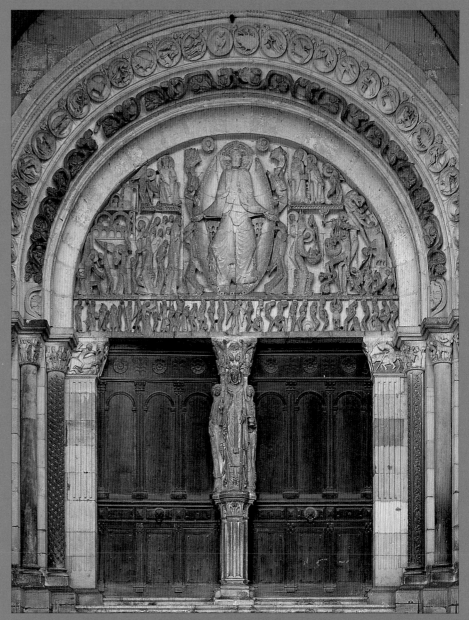

Autun, Cathedral of St-Lazare, main portal, tympanum: The Last Judgement, 1130–1145

is the depiction at Autun in Burgundy, where the elongation of the figures pushes them to an almost fleshless corporeality. Additionally, the drama of the weighing of souls could hardly be more intense, with Good and Evil confronting each other to measure and compete over souls at the scale. The fleshless, grotesque devils depict an end of the world where there is no turning back and it is too late to repent. The depiction of Hell itself leaves no room for speculation, as we see at Conques-en-Rouergue. Yawning from the gates of Hell are the jaws of a leviathan that devours the damned. In the background, the Devil is holding his own hellish court. While folk beliefs had long accepted Purgatory, the theological concept did not come about until the twelfth and thirteenth centuries. Purgatory imagines a "third place" (Luther) in the hereafter, between Heaven and Hell, where sinners are purified by a cleansing fire. Connected to this idea was the hope that all was not decided upon death, giving those who were not eternally damned the chance of a future between their death and the Last Judgement, during which they might prove their worth. What's more, this testing period could be shortened by both the prayers of the living and the intercession of the saints. Thus people's suffering in Purgatory was not without hope, because it worked towards their salvation.

According to St John, on Judgement Day the dead will all be awakened and judged; the good will go to Heaven and the wicked to Hell. But the Early Church recognized the efficacy of praying for the dead, and Isidore of Seville interpreted Matthew 12:32 as a direct reference to purging by fire.

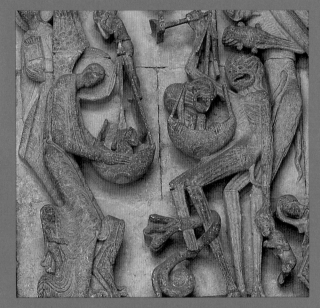

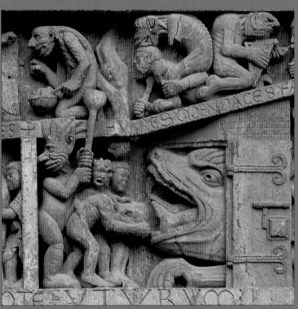

Developing from these early witnesses, the idea of Purgatory assumes an individual or "particular" judgement and adds the concepts of Limbo (a neutral waiting area for unbaptized dead children) and Purgatory, where the mildly sinful suffer for their sins before ascending, purified, to heaven.

Above: Autun, Cathedral of St-Lazare, main portal, tympanum: **The Last Judgement, the weighing of the souls**, 1130–1145 (detail)

Left: Conques-en-Rouergue, abbey church of Ste-Foy, tympanum of the west portal: **The damned are pushed into the gorge of hell**, second quarter of the twelfth century

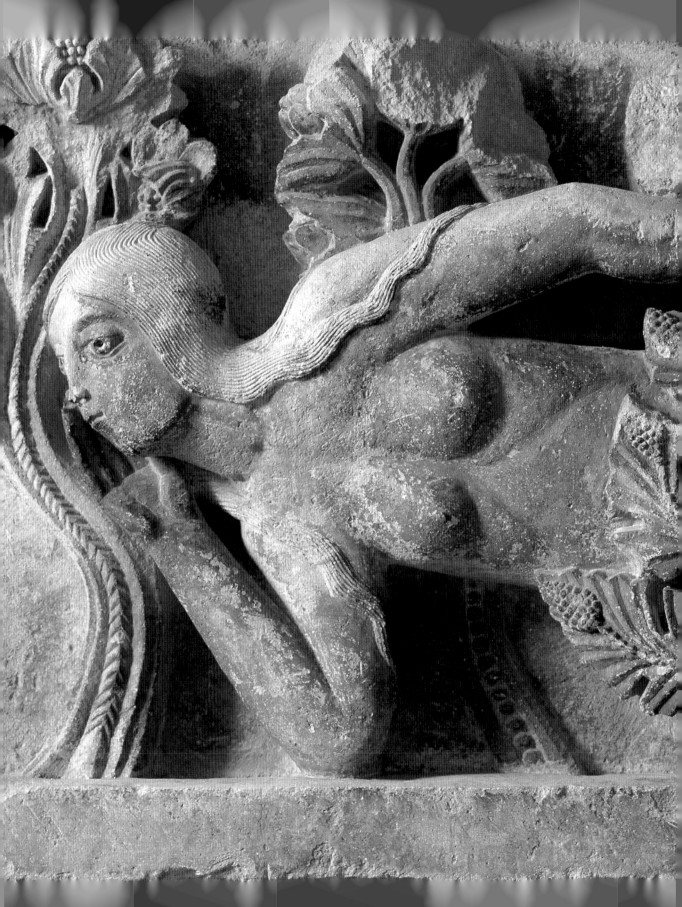

Sex and Sin
The demonization of sexuality

Considering the religious and moral condemnation of all things carnal, Romanesque sculptors devoted a lot of space to depicting the naked human form. For them the proscription of the body turned out to be a rather ambivalent contrivance which they placed at conspicuous places in the architecture. An especially famous example is the Luxuria at Moissac, whose naked body is impressively modeled. Her sensuality, heightened by her long wavy hair, makes her a veritable image of female voluptuousness. A grotesque devil grasps her by the arm, either for a mistress or as a victim to be punished. To remind people that she is reprehensible, two snakes, the omnipresent embodiment of evil, have sunk their teeth into her breasts. Even in their very weathered condition, these figures retain the dramatic menace they held for the contemporary viewer back then.

If genitals themselves are displayed in an image, their demonization is achieved through gross distortion. In the Spanish town of Frómista, a phallus-man and a vulva-woman demonstrate the damnable. Kilpeck, in England, has an unusual and to us puzzling vulva-woman who is believed to be modeled after Spanish examples. This grotesque and very foreshortened figure from the middle of the twelfth century seems more demonic than female. Her arms reach around from behind her legs and her hands hold open her vulva for display.

Such depictions go back to the stone age and their name "Sheela-na-gig" means "ugly as sin." In Romanesque Europe, they bear witness to obsessions that were not confined to monks. Connected with the vulva was the fear of being devoured by beasts and demons, and the demon's gullet was the entrance into the inferno of Hell, which was repeatedly associated with the "mouth of the vulva." The terror posed by a wicked world and and the subconscious awareness of the opening through which one

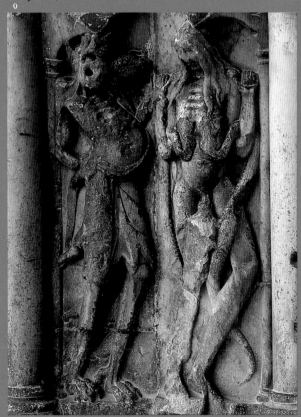

Left: **Moissac, former abbey church of St-Pierre**, west wall of the vestibule of the south portal, detail: The Devil and Luxuria, 1120–1135

Above right: **Frómista, S Martin**, console figure: phallus-man, c. 1088/1190

Above: **Kilpeck, St Mary**, console figure, "Sheela-na-gig," mid-twelfth century

P. 160/161: **Autun, Cathedral of St-Lazare**, Eve from the lintel of the former northern transept portal, c. 1130, Autun, Musée Rolin

entered it heightened fear to the point that anything sexual could only be seen as demonic. Thus since the vulva was the pinnacle of male desire, but subject to female autonomy, it must have been almost inevitable that a deep-seated fear of the vulva would develop, and is manifested in these images of being devoured.

Alongside this nearly archetypal menace we find aspects of morality and death. The tympanum of the Puerta de las Platerías (portal of the silversmiths) in Santiago de Compostela displays a woman holding a skull in her lap. The message in this image remains elusive to this day. So far she has been interpreted as an "adulteress with the fleshless head of her lover." But she has also been presented as Eve in the role of the "mother of death." Her physically sensual appearance, however, with long, flowing hair and transparent gown, make it apparent that this warning against wickedness could also be a temptation.

The pilgrims who were presented with all this were tossed back and forth between anguish and terror. The effect

Aulnay-de-Saintonge, former abbey church of St-Pierre-de-la-Tour, capital: demon and snaring tendrils, early twelfth century

of these supposedly apotropaic demons in stone can hardly be ascertained. Just as these images were meant to condemn everything sexual, so the experienced sculptor gave himself free reign to fantasize in his persuasive depictions of evil. As a result, sculpture produced more invitations to than condemnations of evil, which, nonetheless, was supposed to be shunned forever. The famous Eve of Autun stands as

testimony to this (illus. p. 160/161). Her sensuality and seductiveness are unique in Romanesque art. Just like the snake itself, she winds her way through the Garden of Eden. As she whispers to Adam (now lost) to do what she has already done, her left hand grasps the apple being offered by the clawed hand of the seducer. The exaggerated turn of her upper body towards the viewer clearly heightens the presence of her femininity.

This Eve constitutes the high point of an extremely fantasy-rich era of European art in which sculpture was turned into an exciting language of imagery by artists who were in no way nameless (see, for example, p. 148 and p. 153).

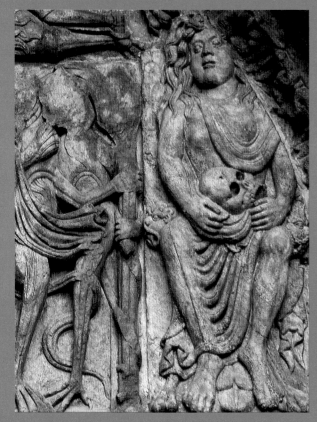

Santiago de Compostela, cathedral, Puerta de las Platerías, left tympanum: adultress or original sin, second decade of the twelfth century

Late Romanesque Sculpture in Provence

Among the major works of Romanesque Provence are two portal arrangements that are patterned after ancient Roman triumphal arches. This inspiration comes as no surprise, as the region has many examples preserved from that era. The most significant belongs to the former abbey church of St-Gilles-du-Gard, in a facade which is unique for the Romanesque period. It is organized into three widely spaced portals flanked by corner towers. In addition to adopting elements of the Roman triumphal arch, the sculptural program here borrows from Roman theater architecture, an example of which is the more or less intact stage backdrop at Orange. A complex, multi-figural biblical presentation extends across the entire St-Gilles facade at several depths and includes the very first complete Passion cycle. The most extensive in medieval sculpture, the cycle is presented in a frieze that runs full-length at the level of the doorway lintels. Below it stand life-sized figures, some of which can be identified as apostles.

The portal at St-Trophime in Arles stands out from its otherwise bare facade. Its design revisits a single triumphal arch type from Antiquity, as does the one preserved in nearby St-Rémy. In the tympanum sits an enthroned Christ in a mandorla, surrounded by the Evangelist symbols. Here, again, the iconographical program refers to the Last Judgement, accompanied by scenes of the Fall, the Chosen People, and the Passion of the Damned. On either side, the portal is flanked by representations of the church's patron, St Trophime, and of the

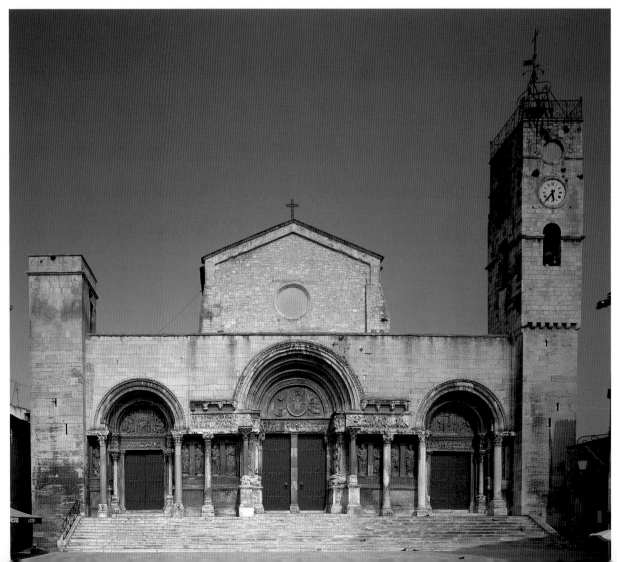

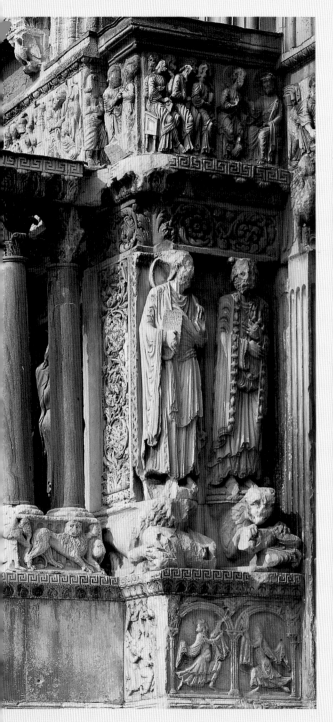

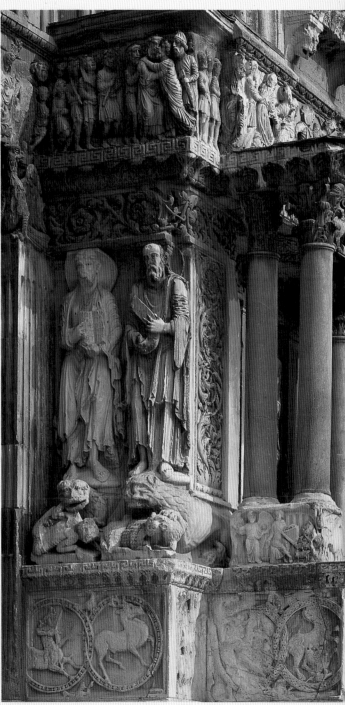

P. 164 and above: **St-Gilles-du-Gard, former abbey church of St-Gilles,** west facade, second half of the twelfth century

West facade, main portal, north jamb: St James the Elder and St Paul (left), St John and St Peter (right)

stoning of St Stephen, relics of whom were housed in Arles. The very cohesive portal structure is tightly bound visually by the monotonous series of figures that stand at the height of the lintels. Additionally, the jamb figures of the apostles come across stiff and almost column-like, giving rise to speculation that they are stylistically indebted to the early Gothic sculpture of Chartres.

The monastery of St-Trophime possesses the most sculpture-rich cloister in all of Provence. Only the north and south wings are (Late) Romanesque. In these, each of the paired columns forms its own capital, which is then joined to its mate through an impost block set atop the two. The entire height of the capital is devoted to the figures, while the ornamentation, as with the portal, is kept separate and assumes an independent role as a frame or border. The idea of Christian salvation comes to the fore in the scenes on these figural capitals, with themes ranging from Christ's childhood to the events of the Passion.

In the Romanesque sculpture of Provence we find clear indications of lively interaction with Italy. For instance, the inspiration for the lion caryatids of the columns and pilasters of St-Gilles appears to have come from the Lion Portal in Modena (illus. p. 172). Furthermore, one capital in the cloister at St. Trophime has been recognized as an early work by Benedetto Antelami, one of the great masters of the Italian Romanesque.

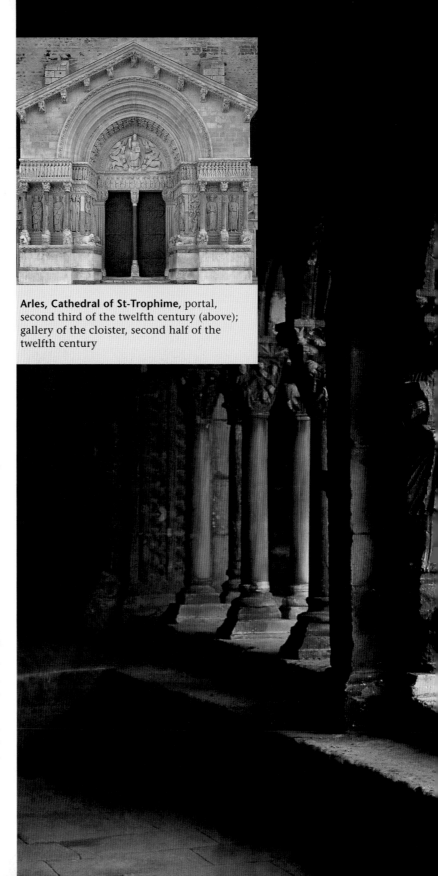

Arles, Cathedral of St-Trophime, portal, second third of the twelfth century (above); gallery of the cloister, second half of the twelfth century

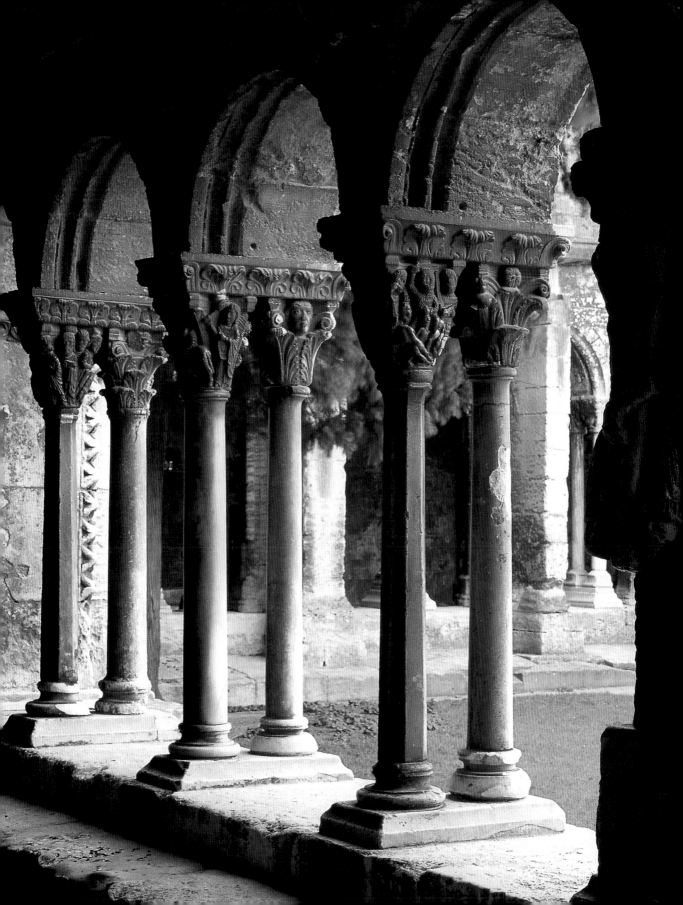

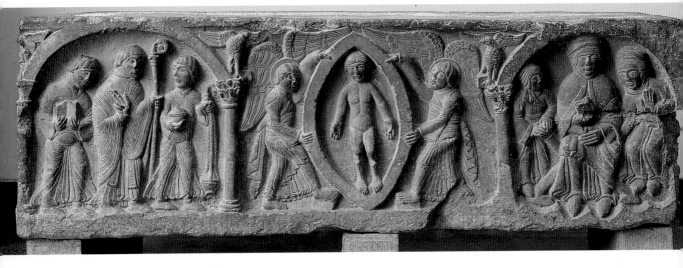

Spain

By the end of the eleventh century, the royal families of León, Castilia, and Aragón, with their close dynastic connections, had already built several important churches with significant architectural sculpture. Along with S Martin de Frómista (begun 1066), were Sta Maria in Iguácel (1072), S Isidoro de Dueñas (after 1073), S Isidoro in León (after 1072), the cathedral of S Pedro in Jaca (c. 1085), and S Pedro de Loarre (after 1080). Frómista, in northern Spain,

Above: **Jaca, S Salvador and S Ginés,** sarcophagus of the infanta Doña Sancha, main side, c. 1100

Frómista, S Martin, capitals of semi-columns on the pillars separating the nave from the side-aisles, 1066/1085–1090

was located on one of the most important pilgrimage routes to Santiago de Compostela. The region's earliest original production of carved imagery began to establish itself here in this courtly and artistic environment around the year 1070. Only recently have art historians recognized in these artistic developments a new beginning that marked the liberation of the early Spanish Romanesque from its supposed dependency on that of France.

In addition to architectural sculpture, the Spanish Roman-

esque boasts some notable non-architectural works. Among them is the sarcophagus of Doña Sancha, daughter of King Ramiro I and widow of the Count of Toulouse. She died in 1097, and the sarcophagus was housed in the convent of Sta Cruz de la Serós, near Jaca. Under the arcades of its main side are scenes from Doña Sancha's life. On the right she is shown between two nuns or servants; on the left is a scene from her funeral. In between, two angels present her soul within a mandorla as a symbol

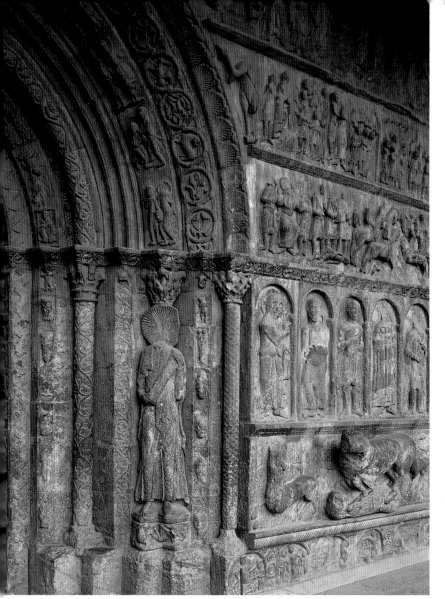

displays scenes from the lives and martyrdoms of the apostles Peter and Paul; it is supported by jamb figures of the two saints. The facade is extraordinarily rich with figures, its six registers underpinned by a plinth carved in relief. The two upper registers contain symbolic representations of the Church militant and triumphant. The blind arcades on the left depict King David with his musicians. On the right, Jesus appears blessing various people, among them presumably Count Oliva Cabreta of Besalú and Cerdaña, his son, and Abbot Oliva. The lower register contains demonic scenes. On the whole, the portal presents a triumphal structure deriving from the triumphal arches of Antiquity as found in Carolingian book illustration. At Santiago de Compostela, the objective of many pilgrimage routes across Europe, construction was begun on a costly cathedral in the year 1077/1078 (illus. p. 109). The sculptural decoration was carried out under the direction of a "Master" Bernard, whose workshop employed 50 stone carvers, and who was aided by a certain "conscientious Robert."

of the expectation of her salvation. While writings identify the artist as the "Master of Doña Sancha" on account of the work's pleasing, naive simplicity, the back side reveals a jousting scene by the hand of different master.

Sculptural architecture took hold all over Europe around the middle of the twelfth century. In Spain, it was the preferred artistic medium. It is perhaps for this reason that the most comprehensive iconographical program is found on the west facade of the abbey church in Catalonian Ripoll. Regrettably, the sculptures there were partially destroyed in an 1835 fire. Without a tympanum, the portal is framed in seven nested arches resting on columns and pilasters. Leaves, tendrils, or animal figures adorn the archivolts. Only the third archivolt

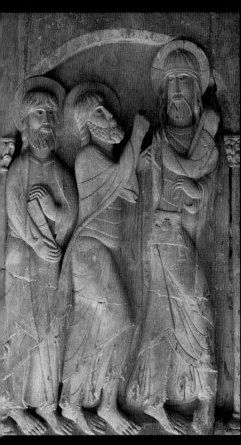

Santo Domingo de Silós

The capitals and relief-work piers in the cloister of the monastery of Santo Domingo de Silós, near Burgos, contain some of the most splendidly carved images of the Romanesque. Consisting of two stories, the lower gallery alone took almost a quarter century to complete in its final form. The most appealing sculptural work of its double capitals is found in the east and north wings. The reliefs include scenes from the death and resurrection of Christ, be-

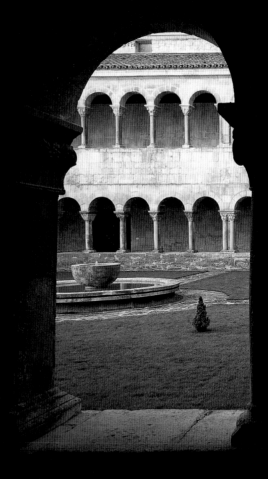

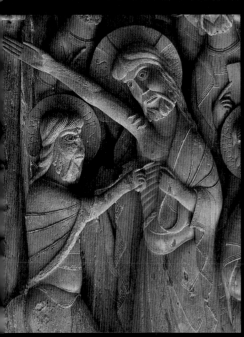

ginning with the Descent from the Cross.

This is followed by the Burial, into which aspects of the Resurrection are integrated. In three other reliefs we see Christ as a Santiago pilgrim with the disciples in Emmaus, the Ascension, and Pêntecost. In the doubting Thomas scene, faith is renewed by the physical experience of touching the wound of the Risen One. Here a historically new level of perception is addressed, in contrast to faith, which had formed in the lay environment of the monastery. In response, the sculptor has placed Paul in the very center of the composition, someone who neither witnessed the event nor ever met Christ in the flesh, but who is seen as a model of exemplary faith.

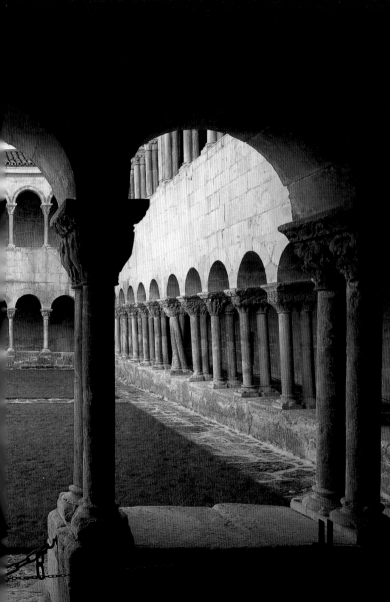

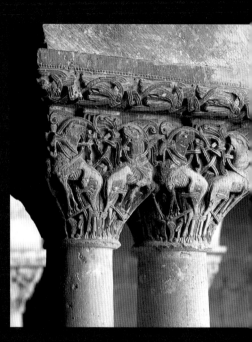

Silós, abbey Sto Domingo,
cloister, mid-twelfth century, capital
(above)

Relief on the corner pillar: Christ as a
Santiago pilgrim with the disciples in
Emmaus (see p. 170 top)
Relief on the corner pillar: Doubting
Thomas touches Christ's wounds
(detail, see p. 170 top)

171

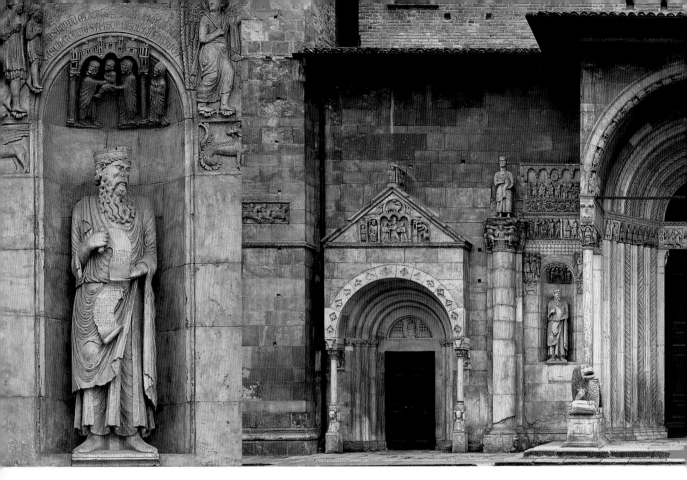

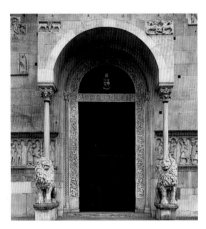

Fidenza, cathedral, end of the twelfth century, portals: baldachin supported by lions, side portals (below); and niche statue of David (left)

Modena, Cathedral of S Geminiano, lion portal, early twelfth century

Italy

Northern Italy

Though connected with the blossoming of architecture, the Romanesque sculpture of Italy, more conspicuously than elsewhere, serves a liturgical program in church decoration.

The early architectural sculpture on the facade of S Maria in Pomposa (illus. pp. 174–175) exhibits powerful decorative elements composed of variations in color or setting of the bricks, as well as animal forms and abstracting braided patterns. A certain Master Mazulo signed this work on a stone tablet countersunk in the side wall (unfortunately without putting

a date). He and his workers are presumed to have come from Ravenna. The fact that most of the Italian artists of the Romanesque era are known to us by name today is due in no small part to the notion of prestige characteristic of the northern Italian cities. They early on began to adorn themselves with the names of those artists whose craftsmanship rose above the level of mere tradesmen.

Just such a person, Master Wiligelmus, went to work in 1099 under cathedral architect Lanfranco on the cathedral in Modena. What would later become the prevalent portal composition is thought to trace

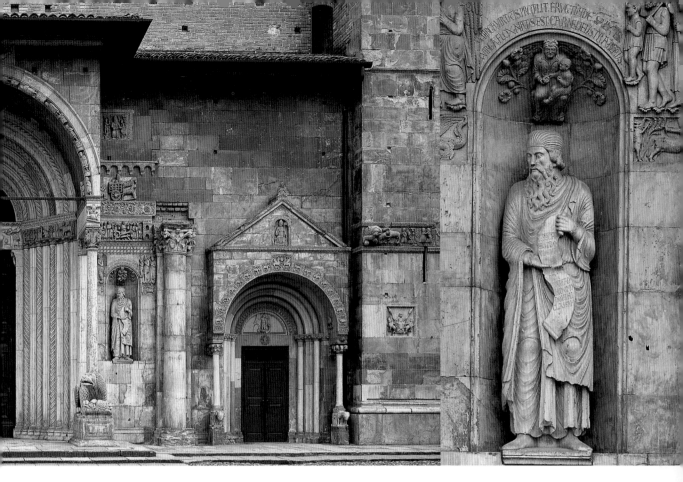

Above: **Parma, cathedral,** Benedetto Antelami, Descent from the Cross, 1178, high-relief, marble, height 110 cm/43.5 in, width 230 cm/ 90.5 in

Fidenza, cathedral, portal, niche statue of Ezechiel (right); the two statues are attributed to Benedetto Antelami

back to their conception here, with its columns resting on antique lions that may well be spolia from a Roman ruin.

On the portal of this church one encounters a series of carved images that are associated with one of the greatest sculptors of the Italian High Romanesque, Benedetto Antelami, and his workshop. In particular, the two statues of prophets that flank the center portal are attributed to him. These are rare Romanesque examples of free-standing sculpture. Before this, one of his domains was Parma, where he is credited with the design of the baptistry. His most important surviving work, however, is a relief depicting the Descent from the

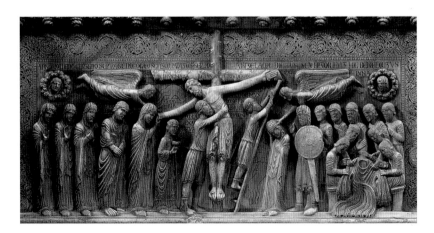

173

Cross, because it includes a detailed signature in which we come face-to-face with him as the artist. His extensive body of work found numerous imitators in Italy, even influencing artists like Nicola Pisano and Arnolfo di Cambio.

Several sculptors worked on the outstanding baptismal font at S Frediano in Lucca, among them one Master Roberto, whose signature is passed down to us on the rim of the bowl. In the center of the richly carved font

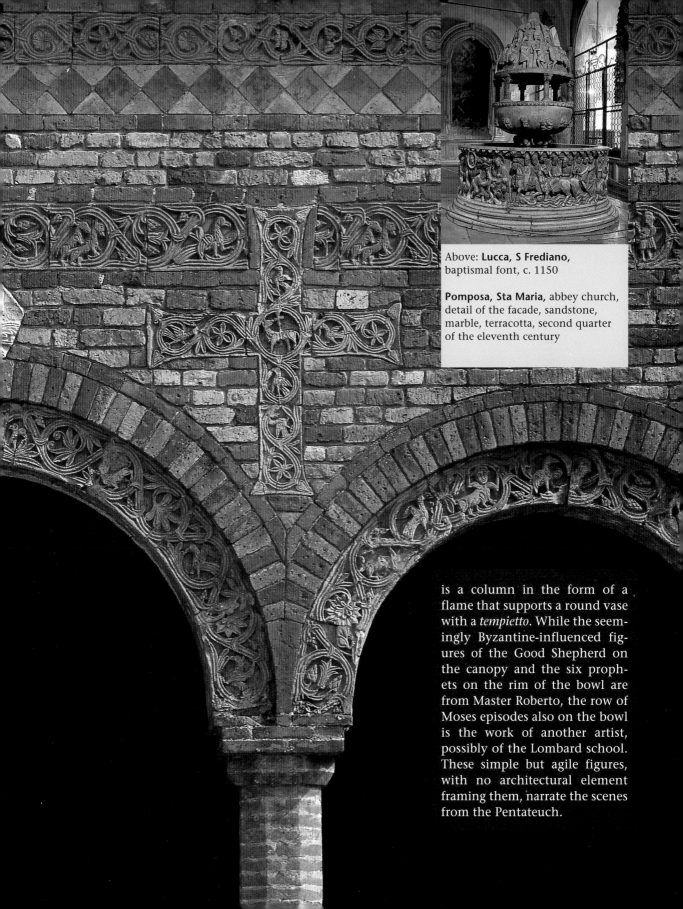

Above: **Lucca, S Frediano,** baptismal font, c. 1150

Pomposa, Sta Maria, abbey church, detail of the facade, sandstone, marble, terracotta, second quarter of the eleventh century

is a column in the form of a flame that supports a round vase with a *tempietto*. While the seemingly Byzantine-influenced figures of the Good Shepherd on the canopy and the six prophets on the rim of the bowl are from Master Roberto, the row of Moses episodes also on the bowl is the work of another artist, possibly of the Lombard school. These simple but agile figures, with no architectural element framing them, narrate the scenes from the Pentateuch.

Central and Southern Italy

From the beginning of the twelfth into the fourteenth century, the Cosmati family of artists excelled, particularly in mosaic work. Their name goes back to a succession of Roman sculptor families that carried the name Cosmas and often signed and dated their works. Mellini and Vassaletto were the two other major artistic family names of the time. Father and son Vassaletto are known to be the masters of one of the grandest and best-preserved Romanesque cloisters, that of St John Lateran (S Giovanni in Laterano). Built between 1215 and 1232, it has arcades whose double columns are worked in a great variety of forms, and in many cases covered with delicate mosaics. Where the passageway opens into the courtyard, the flanking columns stand atop pedestals with crouching lions. The smaller but more richly appointed cloister at S Paulo fuori le mura was likewise built by the Vassaletto family between 1205 and 1241.

Apulia, standing on the threshold between Orient and Occident, spawned a wealth of art from the eleventh century onward. After architecture, the most notable work here was church furniture. The throne of Bishop Elia at S Nicola in Bari is of the highest quality. Its seat is supported by free-standing carved Atlas figures at the corners, with a center figure who merely assists with one hand. In his other hand he holds a staff, identifying him as a pilgrim. This figure is seen as a reference to the pilgrimage to S Nicola, which constituted an important "prop" for the newly established prestige of Bari and Bishop Elia. While art historians suggest a date in the third quarter of the twelfth century, the throne had traditionally been thought to originate from just before 1105.

An outstanding Romanesque ambo, the forerunner of the

Rome, S Giovanni in Laterano, gallery of the cloister with lions supporting columns flanking the passage, detail of a column ornamented with mosaics (above), executed by Vassaletto father and son, 1215–1232

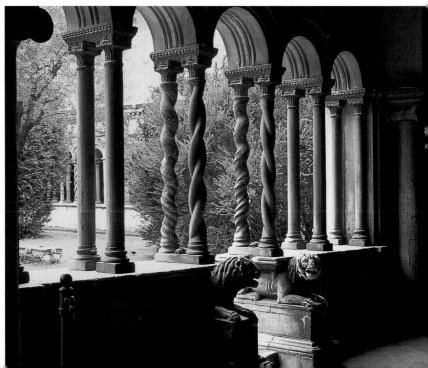

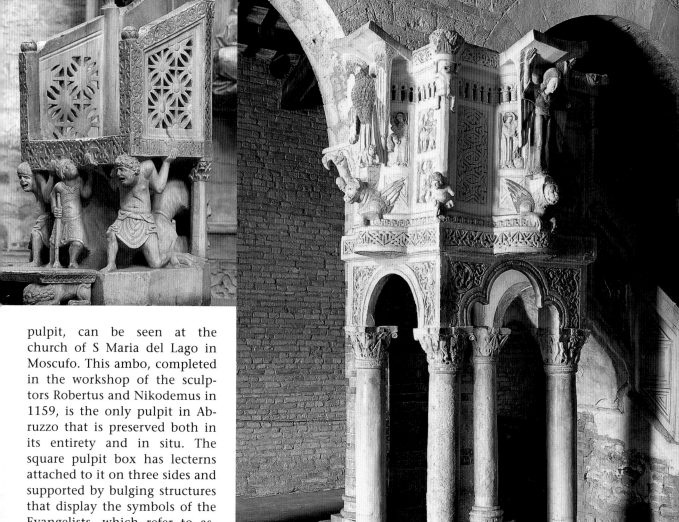

pulpit, can be seen at the church of S Maria del Lago in Moscufo. This ambo, completed in the workshop of the sculptors Robertus and Nikodemus in 1159, is the only pulpit in Abruzzo that is preserved both in its entirety and in situ. The square pulpit box has lecterns attached to it on three sides and supported by bulging structures that display the symbols of the Evangelists, which refer to aspects of the liturgy. Along with depictions from the Old and New Testaments, one of the corner pillars has an astonishingly early and direct adaptation of a classical figure, in the form of the *spinario* (boy pulling a thorn from his foot). Such quotations from Antiquity did not really become common until the Renaissance. Meanwhile, the sides of the staircase display a fast-paced narrative depicting the story of Jonah.

Above left: **Bari, S Nicola,** throne of Elijah, marble, end of the eleventh century or early twelfth century

Moscufo, S Maria del Lago, ambo, created by the workshops of the masters Roberto and Nicodemo, 1159

Germany

Germany does not possess the same quantity of Romanesque sculpture one finds in the Mediterranean countries. Where it did appear early on, it was mostly in the form of small works in metal or stone furnishings for churches. Beginning in the eleventh century, however, good quality sculpture did develop in the Rhineland. This came about due to the technical skill available in the region and its direct access to then-extant vestiges of works from Antiquity.

Carved into the face of a cliff near Horn is a relief depicting the Descent from the Cross. It is one of the most unusual pieces of Romanesque sculpture ever produced. Located on the site of an ancient heathen cult center, the work was executed around the year 1130 and was presumably meant as a setting for Easter celebration games. Heinrich von Werl, Bishop of Paderborn, had a replica of the holy sites of Jerusalem and a cave-like chapel hewn out of this cliff face, which were consecrated in 1115. About the same time, a "Sepulcrum Domini," or a replica of Christ's grave in Jerusalem, was built in Gernrode. Furnished with a richly decorated west wall that was often described as a sermon in stone, and including a grave chamber, the structure served to receive the body of Christ when it was taken down from the cross during Good Friday services.

During the Early Romanesque era, churches and crypts were reserved exclusively for the interment of martyrs and saints. Later on, the right of burial was extended to secular and clerical princes. This brought about the creation of tomb slabs finished in stone or bronze that would cover a grave or *tumba* sunk into the floor of a church. This was the most significant type of Medieval tomb. In the crossing of the cathedral at Merseburg is the bronze tomb slab of Rudolf of Swabia, who fell in 1080. This may be the earliest preserved figural example of its type. The tomb slab of Reinhildis in the village church of

Far left: **Riesenbeck near Tecklenburg, St Calixtus,** tomb of Rheinhildis, sandstone, c. 1130–1135

Left: **Merseburg, former cathedral of St John the Baptist and St Laurence,** tomb slab of Rudolph of Swabia (died 1080), bronze, before 1100

Right: **Gernrode, former abbey church of St Cyriacus,** holy sepulcher, interior of the tomb chamber, Metronius, bishop and martyr, 1100–1130, beginning of the eleventh century

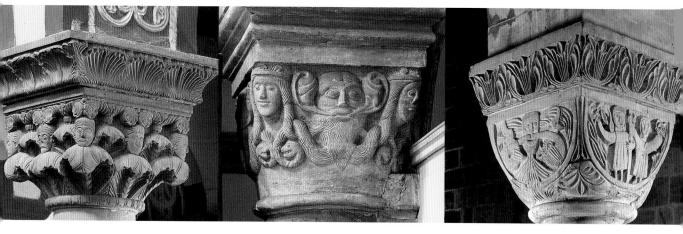

Left: **Hildesheim, former Benedictine abbey church of St Michael,** nave, capital ornated with foliage and heads, before 1186

Center: **Spieskappel, former Premonstratens abbey church of St John,** nave, capital with bearded mask and heads, c. 1200

Right: **Quedlinburg, former abbey church of St Servatius,** nave, cubic capital with figurative decoration, before 1129

Below: **Externsteine near Horn,** carved into cliff, Descent from the Cross, first quarter of the twelfth century. Measuring 5.5 m/18 ft high and 3.5 m/11.5 ft wide, this relief is one of the most unusual sculptures of German Romanesque.

Hörstel-Riesenbeck near Tecklenburg was perhaps originally designed as a sarcophagus cover. This trapezoid-shaped work in sandstone probably dates to around 1135.

Capitals were originally cube-shaped and then were gradually transformed with geometric forms, animal or vegetal designs, and masks or monsters. Wherever they do appear, they clearly reveal the influences of northern Italian sculptors, who were frequently called up to Germany around the year 1100. The self-assurance of sculptors in Germany shows up as well, as evidenced by the signature on the famous Hartmann column in Goslar: HARTMANNUS STATUAM FECIT BASISQUE FIGURAM— "Hartmann made the column and the pedestal figure."

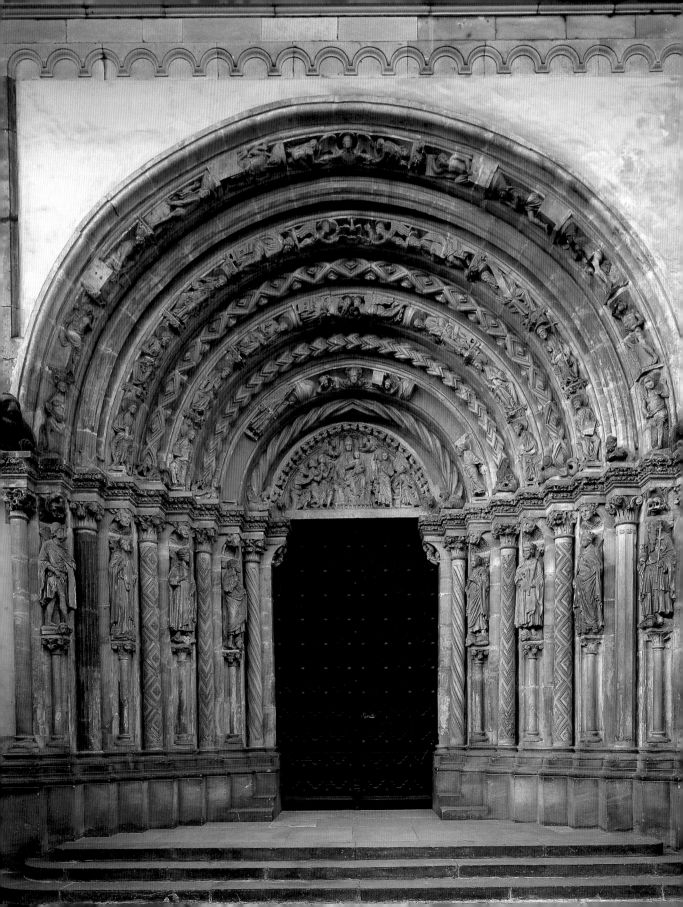

P. 180: **Freiberg, parish church of Unserer Lieben Frauen,** Golden Gate, c. 1230

Left: **Regensburg, former Benedictine abbey church of St Jacob,** north portal, c. 1190

Right: **Basel, Cathedral of Unserer Lieben Frauen,** Gallus Gate, end of twelfth century

Romanesque Portals

The two earliest portals of the German Romanesque seem to be still very much bound to the architecture of triumphal arches from Antiquity. They are the north portal of the former Benedictine abbey church of St Jacob in Regensburg, and the Gallus Gate on the north transept of the Cathedral of Unserer Lieben Frauen in Basel. Thus, at Regensburg, the columned portal is inserted into a display wall on which the actual sculptural program is exhibited. In addition, the tympanum remains underdeveloped. The late twelfth-century Gallus Gate, on the other hand, frequently restored and altered over the years, already

has the appearance of a staggered portal. Some of its sculptures are situated between the columns, and the tympanum is clearly emphasized as a vehicle for imagery. Furthermore, it is framed by a combination of tabernacles and aediculae, in which more sculptures are displayed.

The west portal of the parish church in Freiberg, near Dresden, is one of the most significant portals of the Late Romanesque. Known as the Goldene Pforte (Golden Gate), it is an eight-layer staggered-jamb portal that reveals varied influences in both composition and figural style. These are primarily attributed to the style used in the mid-twelfth century Gothic

cathedrals of the Ile-de-France. In the center of the tympanum, Mary appears enthroned as the Queen of Heaven with the child Jesus. She is accompanied on the left by Joseph and an angel bearing a scepter, and on the right by the Three Kings. Starting with this image and continuing through the entire ensemble, the apotheosis of the Mother of God with the Christ child is made the central theme. In the jambs, the typographical progenitors of Mary and Christ are portrayed: Daniel in the lion's den, the high priest Aaron, Bathsheba and the Queen of Sheba, the Kings Solomon and David, John the Baptist and St John all glorify Mary.

181

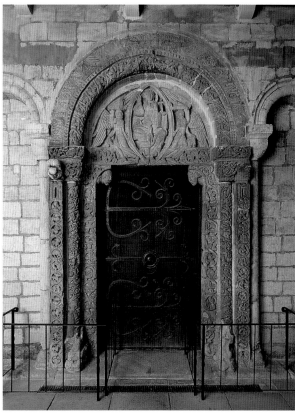

England

Anglo-Saxon culture had been assimilating Celtic and Roman elements into its art since the eighth century. With the Danish invasions and their subsequent Christianization from 1017 under Danish King Cnut, a new religious architecture emerged. Cultural change however did not actually occur until the Norman William the Conqueror took the island in 1066. From this point onward, Romanesque sculpture developed in England through a fusion of indigenous artistic forms with Scandinavian and continental style elements into an Anglo-Norman art form.

The capitals in the crypt of Canterbury Cathedral were constructed between 1100 and 1120 at the latest, and became the models for many more after them. Two such examples are the capitals in the southern transept of the cathedral in Worcester and those at Romsey Abbey, which in turn influenced the cloister capitals at the Benedictine abbey of Reading (founded 1121). These all have common Irish-Anglo-Saxon roots that can be seen, for example, in metalwork and the manuscript illuminations of the famous scriptoria.

In contrast, some of the more splendid English Romanesque portals show a rather more Nor-

man or continental traditon. Among the more outstanding examples is the portal on the southern atrium at the church of St Mary and St Aldhelm in Malmesbury. The lunettes of the atrium sidewalls depict apostles seated in rows of six, above which hover angels carrying banners. While the slightly elongated figures recall Burgundian work of around the year 1130, their carving attains the level of quality found at Autun. The British fondness for rich decoration is apparent in the ornately decorated portals of Ely and Kilpeck. Along with this, Ely displays a peculiarity in the composition of its *Maiestas Domini*, in which the point

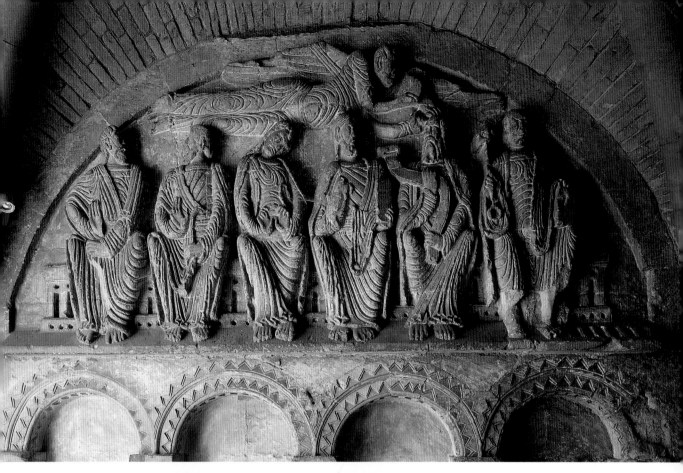

Malmesbury, church of St Mary and St Aldhelm, lunette on one of the side walls of the south portal atrium, c. 1155–1170

Canterbury Cathedral, capitals of the crypt, 1100–1120

P. 182 left: **Kilpeck, church of St Mary and St David,** south portal with beast columns, c. 1140

P. 182 right: **Ely Cathedral,** The Prior's Doorway, before 1139

of the mandorla penetrates the lintel, leaving no room for independent imagery. The richly decorated portal at Kilpeck, flanked by a pair of beast columns, is considered the best-conserved example of a western English school of carving from the second quarter of the twelfth century. Slender pillars with relief serpents frame the limits of the portal zone. These are complemented by richly decorated columns and massive archivolts. It is generally assumed that when the church's benefactor, Oliver de Merlemont, returned from a pilgrimage to Santiago de Compostela, there were artists in the retinue accompanying him who were well-acquainted with continental themes and forms.

The Worshipping of Saints and the Cult of Relics

Being close to God, saints were powerful conveyors of God's grace to ordinary people. The sick and vulnerable put all their hope in the saints, as only they could intercede to gain this grace for the petitioners. If their prayers and petitions were fulfilled, it was seen as a miracle. These procedures and invocations are recorded in numerous miracle narratives, and are among the most impressive testimonies of medieval creation of identity. When word got around that a miracle had occurred at the grave of a saint, where her or his presence was strongest, everyone followed this news, which was seen as proof of God's grace. Since this kind of event would spark the hopes and fantasies of all, it could sometimes result in a major pilgrimage. Such cults, especially when they arose spontaneously, were not entirely unproblematic for the Church, for the uncontrolled veneration of a saint sabotaged the Church's authority as the earthly broker of God's salvation. Therefore, the Church saw to it that those worshipped were adopted into the Canon of Saints—in other words were canonized—in order to maintain central control over the cult. The rapid growth in church buildings during the Romanesque period created a demand for a large number of relics, since no church or altar could be consecrated without a saint's relic as the guarantor of the consecration.

Until the tenth century, the doctrine of the "completely intact body" was widely respected, meaning it was prohibited to remove parts of a saint's

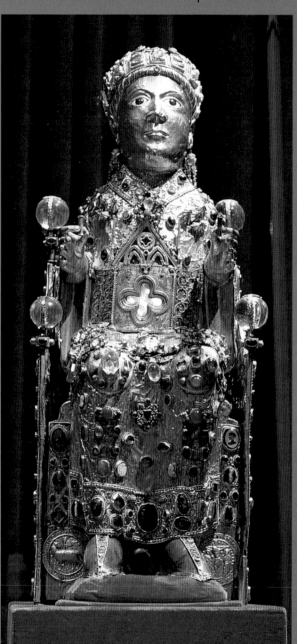

body, with the exception of hair and nails. But the great demand for relics forced a re-thinking of this doctrine. A new notion arose proposing that the saints had been present in each part of their bodies, so it followed that the smallest particle of a bone would now suffice to assure the saint's presence. Consequently, people who had followed the example of Christ during their lifetime were regarded as future saints while still living, and were asked for relics on their deathbeds. Immediately upon death, the corpse was sometimes spontaneously divided up. In addition, relics were quite often stolen and many were counterfeit. These goings-on could hardly be controlled, let alone stopped, by the Church. Therefore anything was seen as fair game as long as it served the faith.

The bigger the pilgrimage, the more powerful the saint to whom it lead. Thus the possession of relics from famous saints carried with it far-reaching political claims to power. Churches and cloisters would do anything to possess the more prominent relics.

Conques-en-Rouergue, former abbey of Ste-Foy, treasury: gold statue of Ste Foy, gold plate on wood, inlaid with precious stones, c. 1100

184

To that end they had sumptuous reliquaries produced which represented not only the power of the relic they contained, but also their own economic power. If the rise of Romanesque architecture brought about the growing demand for relics, the cult of relics themselves provided the occasion for many artistic creations of the Middle Ages.

Early on, this veneration of saints also gave rise to its own type of literature. The hagiography was the story of a saint's life, and found its expression

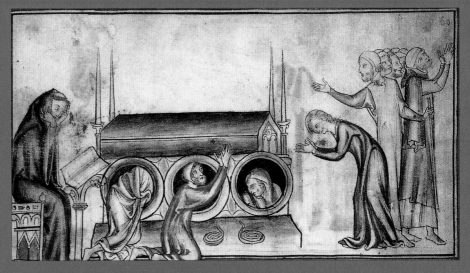

Pilgrims at the coffin of St Edward the Confessor, Westminster, thirteenth century

above all in paintings, both in book illumination as well as wall painting. The legends of the saints are also often found in sculptural form. It was not

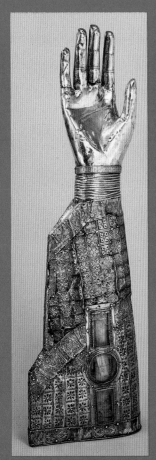

Arm reliquary of St Laurence, sculpture by the Master of the Oswald reliquary at Hildesheim, cedar wood, partially gilt silver, c. 1175, Berlin, Kunstgewerbemuseum

customary, and even prohibited after 1215, to display relics outside of their repositories. The most important and most precious works of art were therefore the reliquaries themselves, and these could take any variety of forms. While the primary characteristic of the

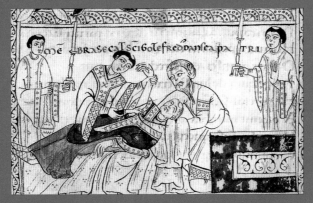

Bishop Gotefredus cuts an arm from the corpse of St Apollonius, 1115, from Donzio, *Vita* of Countess Mathilda of Canossa, Vatican, Biblioteca Vaticana (detail)

reliquary was its use of the most costly materials to emphasize the preciousness of its contents, its form was also supposed to indicate the nature of the relic. The statue portraying the seated figure of St Foy shows whose relics are secured inside. To the faithful viewer, such a figure provides the link between the mundane here-and-now and supernatural reality, which the figure makes accessible through its power to convey divine salvation. There was always a need to have direct contact with the relic. Since touching the actual relics was seldom possible, reliquaries were furnished with windows through which the faithful could make visual contact with the relic and thus be assured of its healing power.

Sculpture in Wood

As a medium, wood was already in wide use by the Middle Ages as it provided the predominant building material in architecture. Its far less frequent use for carving, however, produced a series of quite outstanding examples of Romanesque sculpture. Although woodcarvers would gradually distinguish themselves within the ranks of other craftsmen who worked in wood, as would stone carvers with respect to masons, they were still a long way from being on an equal footing with the other "artistic" trades. For their task was merely to produce a sort of rough draft of a wooden work that would afterwards be primed and then colorfully painted by finishers. Alternatively, gold- and silversmiths might sheath the sculpture in precious metals to give it a splendid exterior that was often then set with jewels. This all resulted in the woodcarver's work being largely covered up. Now, however, many of these sculptures have to a great extent lost their finishes, or had their plating of precious metal removed during restorations over the years. This has revealed that many Romanesque woodcarvers nonetheless aspired to high artistic standards.

The many colorfully painted crucifixes generally portray a living Christ on the cross. Since contemporary emphasis regarding the Passion was placed on

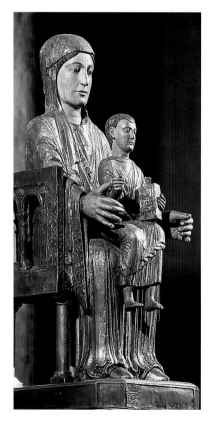

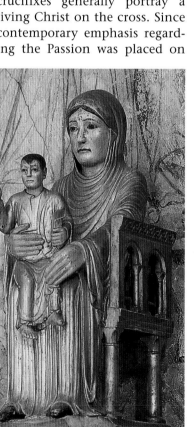

Above: **Cologne, St Maria im Kapitol**, left door wing, detail: Annunciation to the Shepherds, Birth of Christ, The Three Magi before King Herod; Adoration of the Magi, painted wood, total height of the door 4.74 m/ 15.5 ft, width of the door wing 2.26 m/7.4 ft, c. 1065

Far left: **Orcival, Notre-Dame,** enthroned Madonna and Child, wood, silver-plated copper, height 74 cm/29 in, twelfth century

Left: **Tournus, former abbey church of St-Philibert,** enthroned Madonna and Child: "Notre-Dame-la-Brune," painted wood, gilt, restoration in 1860, height 73 cm/28.5 in, second half of the twelfth century

P. 187: **Cologne, St Georg,** crucifix, detail, walnut, height 190 cm/75 in, c. 1070, today in Cologne, Schnütgen-Museum

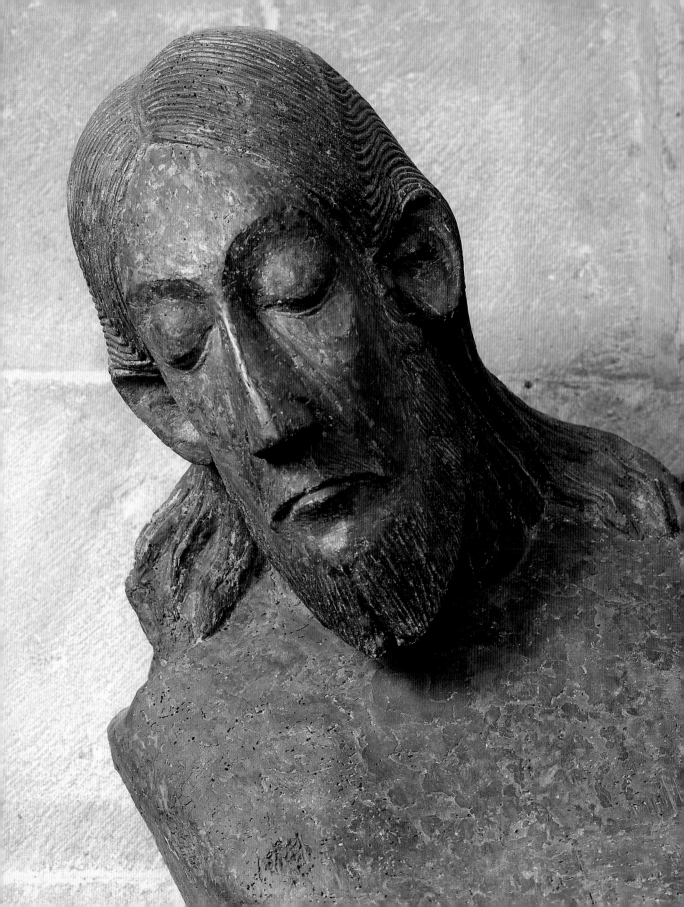

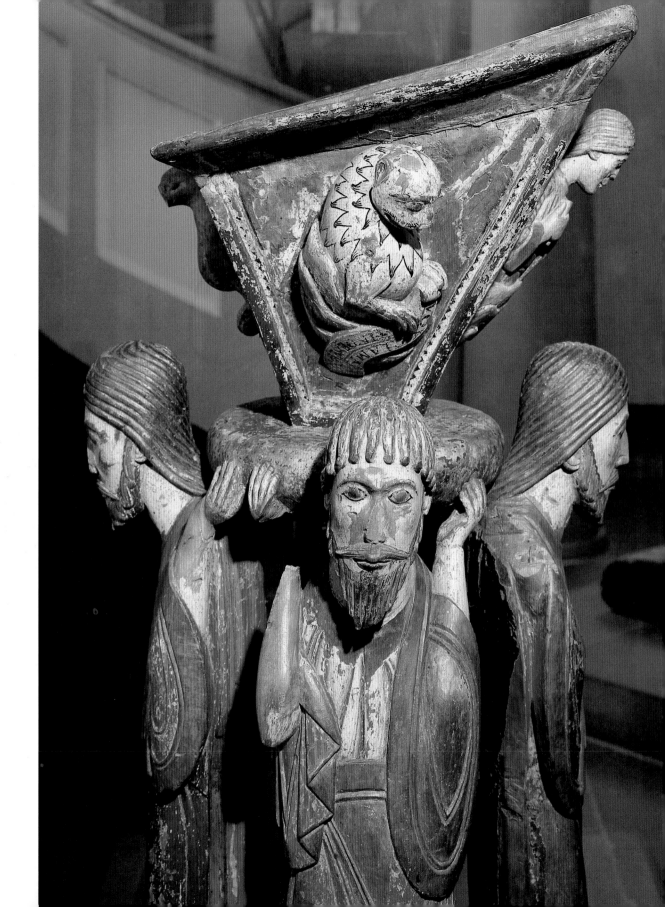

the triumph over death through the Son of God, Christ only rarely appears dead on the cross. Moreover, numerous regional trends led to the emergence of many variations on the Crucifixion. Along with the crucifix, the enthroned Madonna and Child is among the most widely spread wooden works of the Romanesque period. This type, whose hieratic demeanor caused it to be known as the *sedes sapientae*, or "Throne of Wisdom," emerged in the early Middle Ages and is often compared with Byzantine icons. Initially, its element of severity was further accentuated by the Child, who sits or stands on Mary's knees gazing outward. After 1200, this format would gradually relax into one in which the mother turns toward the Child.

Another aspect of church ornamentation that fell in the woodcarver's domain was the composition of the doors, which were often most vividly decorated on the outside. Since the decorative possibilities here were limited to the surface, the representational medium of choice was relief. Where the furnishings of Romanesque churches required more than skilled carpentry (as found in church pews, for example), they demanded considerable sculptural ability on the part of the woodcarver. Particularly in the area of liturgical furnishings, a task might call for high-relief work instead of the more common low-relief. Finally, the famous lectern at the monastery church of Alpirsbach provides an example of a fully free sculptural form, made even more impressive by its colorful finish.

P. 188: Alpirsbach, abbey church, pulpit, detail, painted wood, height 137 cm/54 in, mid-twelfth century, now at the Protestant church of Freudenstadt

Alpirsbach, church bench with rounded woodwork, twelfth century

189

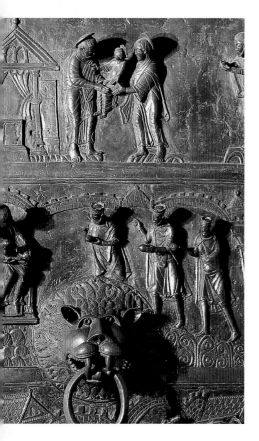

Bronze Work

Bronze, an alloy of copper and either tin or zinc, is the noblest of the base metals. The relative proportions of its components can vary greatly according to period, region, or workshop. With the right mixing ratio, it can be worked to reproduce very fine detail, while at the same time it is very durable and weather-resistant.

During the Middle Ages, bronze was cast using the lost wax process, in which a work is first sculpted in wax, then encased in a layer of clay or earth. This form is then fired, and the wax flows out, leaving a hollow shell into which the molten bronze can be poured. Numerous venting channels permit the air to escape, ensuring that the form is completely filled with molten metal.

The inscription on the lion's head door handle at the cathedral in Trier gives a colorful description of the metamorphosis of a work from one medium into another: "What formed the wax, the fire has taken, and the bronze has given it back to you." If the casting was unsuccessful, the form would have to be completely redone. In order to prevent this, the artists often worked together with experienced bell casters for this step. The names of many bronze casters, artists, and benefactors have come down to us in inscriptions. Among these, we know of a certain Oderisius of Benevento, who created the bronze doors of the Tróia cathedral in Apulia, one of many sets of extremely elaborate Romanesque bronze doors. Among other examples of bronze sculpture are larger works such as baptismal fonts and candlesticks, as well as many smaller ones, including crucifixes and aquamaniles—a type of ewer in a figural form that was used for washing hands at table.

Above: **Hildesheim, cathedral,** the Bernward door of the west portal, door with two wings, decorated with reliefs of Old and New Testament scenes (detail: door knocker), completed 1015

Troiá, cathedral, door of the west portal, Oderisius of Benevento, bronze, 1119, height 3.66 m/12 ft, width 2.05 m/6.7 ft

190

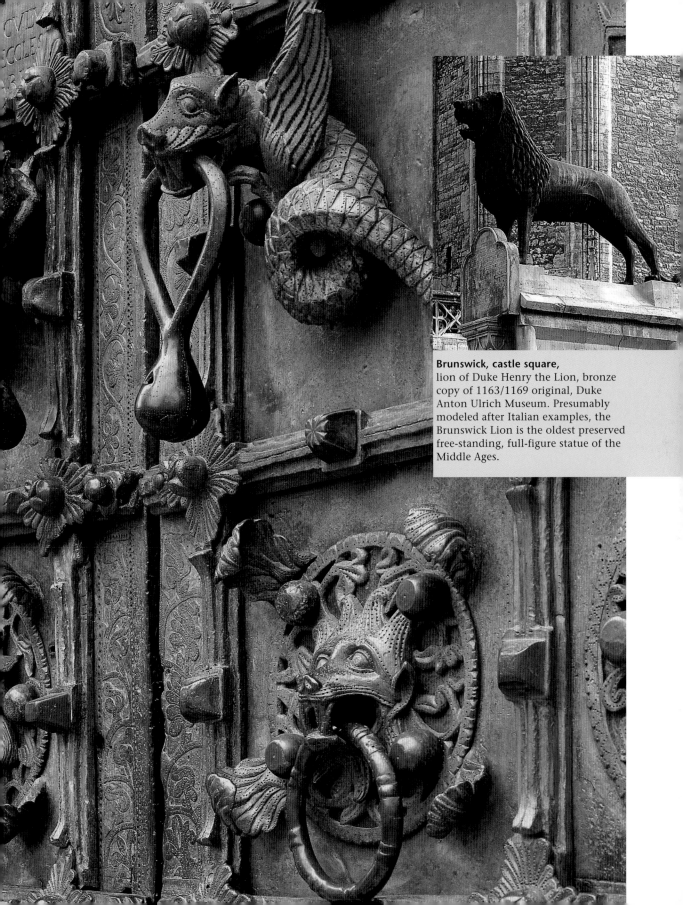

Brunswick, castle square,
lion of Duke Henry the Lion, bronze copy of 1163/1169 original, Duke Anton Ulrich Museum. Presumably modeled after Italian examples, the Brunswick Lion is the oldest preserved free-standing, full-figure statue of the Middle Ages.

Precious Objects

Gold and silver have always been regarded as the most precious of substances. During the Middle Ages, the only things considered more valuable were the relics of martyrs and saints. Because of its rarity, ivory (whether from elephant or walrus tusk) was valued as highly as precious metals. Because these materials were perceived as being of the greatest value, they were the preferred media for repositories of relics. People prized important relics for more than their material value. Possession of such treasures could also bring great renown as well as religious and political power to the owner. After one of Barbarossa's raids in 1162, for example, the relics of the Three Kings came into the possession of the archbishop of Cologne, who had the famous Shrine of the Three Kings made for them. Since the three were considered holy as the first kings who had paid homage to Christ, King of Kings, the possession of their relics provided the most reliable authentication of Christian rule. For the archbishop of Cologne, these relics gave him coronation rights that were less concerned with kingship itself than its consecration. He tried to underscore his endeavor by adding the relics of Charlemagne, in whose canonization he had personally participated during the year 1165. The three crowns symbolizing the Three Kings still appear in Cologne's city crest today.

It was popular to keep relics inside a casket that represented

P. 193:
Domed Reliquary of the Guelf Treasure, wooden core, enamel on copper and gilt, reliefs and figures of morse ivory, varnished base, pedestals cast in bronze and gilt, c. 1175–1180, height 45.5 cm/18 in, width 41 cm/16 in, Berlin, Kunstgewerbemuseum

Cover of an Evangelary, binding done in Maastricht, detail: the eagle of St John Evangelist, c. 1040, Paris, Musée du Louvre

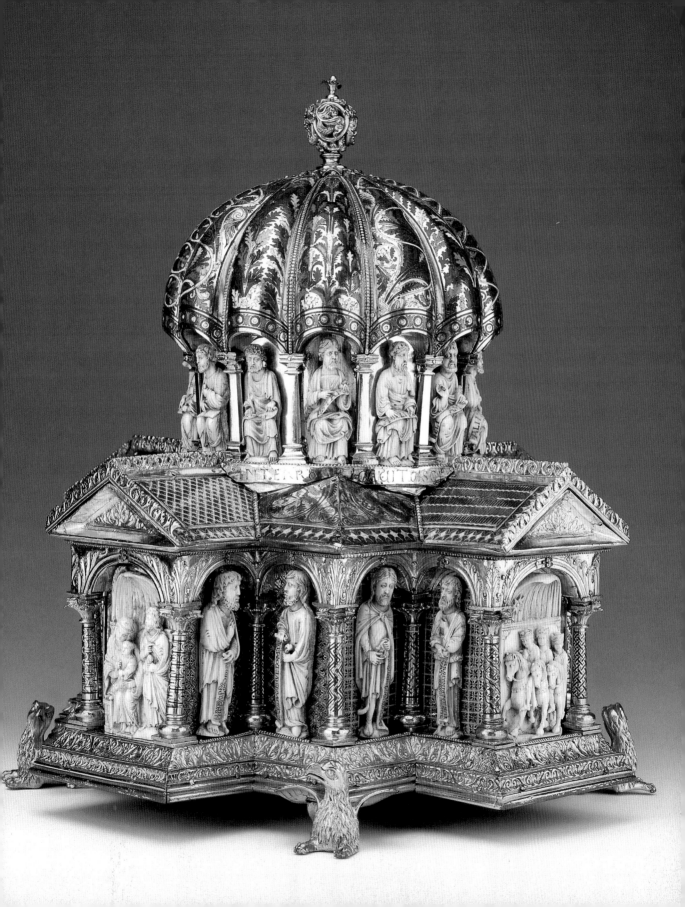

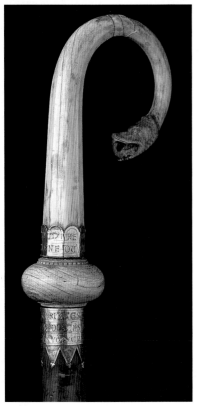

Cassette with a roof-shaped lid, ivory placques, height 10.5 cm/6.7 in, width 17 cm/3.5 in, depth 9 cm/ 3.5 in, Sicily, thirteenth century, Berlin, Museum für islamische Kunst

Crook of St Annon, ivory, height 20 cm/7.9 in, c. 1063, Siegburg, Treasury of St Servatius

P. 195: **Cologne, Shrine of the Three Kings,** oak, gold, gilt silver and copper, enamel and cloisonné, precious and semi-precious stones, ancient gems and cameos, height 1.53 m/43.5 in, width 1.10 m/60 in, c. 1181–c. 1230, Cologne, cathedral

the Heavenly City. The shrine of the Three Kings in Cologne is an outstanding example. Meanwhile, a novel reliquary architecture emerged shortly after 1175 in the workshop of Cologne's Gregory Master. From his crusade of 1172–1173, Henry the Lion had brought back the head of the saint Gregory of Nazianzus, bishop of Constantinople (330–390). A famous repository was created for its safekeeping—the "Domed Reliquary of the Guelph Treasure." This structure has a central plan with two long arms of equal length that intersect at a square, domed crossing. An arcade containing morse ivory carvings surrounds the whole lower story. At the gable ends are scenes from the life of Christ, while the remaining 16 arches contain standing figures. The dome on its drum is composed of 13 niches in which Christ and the apostles are enthroned. Supported on reclining griffins, the reliquary as a whole forms an image of the heavenly Jerusalem.

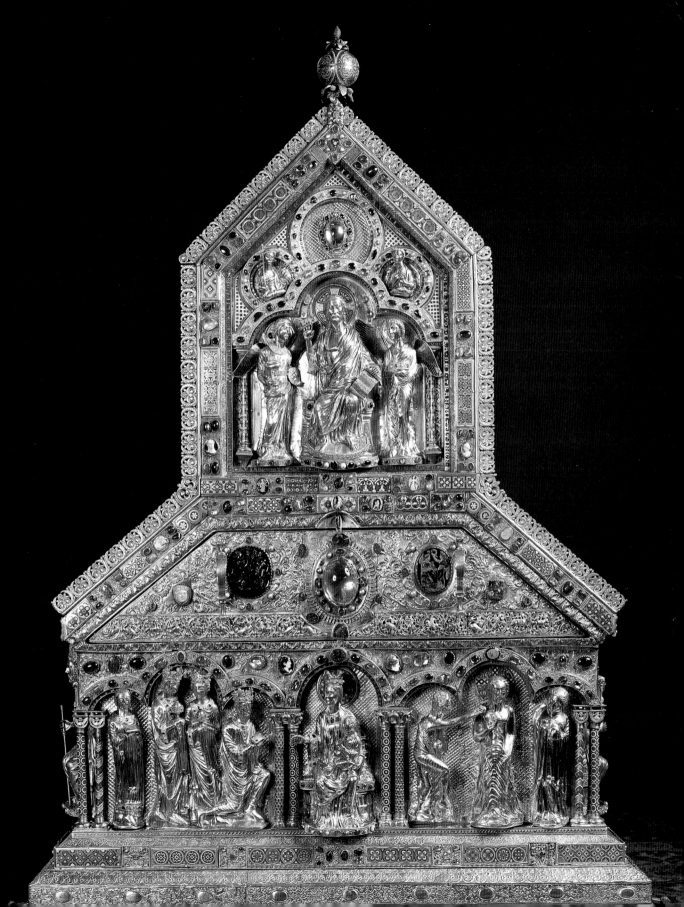

Techniques

The genesis of Roman-esque art involved many very different kinds of crafts, and our knowledge of these comes from more than the works themselves. We have a series of treatises, originating mainly between the eighth and twelfth centuries, that describe many of the craftsmen's techniques. A document by one "Theophilus presbyter," of which three copies survive, is considered the most important work of this nature. Entitled *De diversis artibus* ("On Diverse Arts") it covers the different arts, and one could add "and their techniques" to the title. In three volumes, the medieval author describes in great detail the procedures an artist should follow. The first book is dedicated to the rules of painting and contains precise instructions for producing and applying paints. The

second book covers glass manufacture and the creation of stained glass windows, while the third deals with goldsmithery and working with other metals.

There has been much speculation regarding the author of this first craftsman's handbook. Nowadays there is widespread agreement that the artist monk Roger of Helmarshausen is the man behind the name Theophilus, which would narrow down the time of its conception to between the years of 1107 and 1125. This work is an incredibly valuable source on medieval art, culture, and technology especially because it was copied frequently at the scripto-rium of Helmarshausen for distribution among the workshops of friendly monasteries.

Before ateliers began to appear in the slowly developing and newly emerging towns, monas-teries and royal courts were the centers of artistic production. Medieval scriptoria, for instance, were highly complex writing work-shops in which countless texts were copied and illuminated. These were large rooms in which copyists and miniaturists

Tower of Tavara, scribe at work, Beatus, Apocalypse commentary, 970, Madrid, Archivo histórico nacional, Ms 1240

went about their work, for the most part in silence. Since the mate-rials and tools of the trade, such as quills, tinctures, paper, small wooden panels, and wax were readily flam-mable, no open lamps could be lit. In any case, daylight was indispens-able for the demanding work of writing and painting.

Ink horn, Rhineland, ninth–tenth centuries, Cologne, Schnütgen-Museum

Writing tablet with handle, Cologne, thirteenth cen-tury, Cologne, Römisch-Germanisches Museum and Kölnisches Stadt-museum (joint property)

One of the standard pieces of equipment at the scriptorium was the writing tablet coated with wax. In use since Antiquity, it was inscribed with a stylus and smoothed out again by means of a spatula at the other end of the writing tool. Sometimes these small panels would be hinged together, and because they were made from the wood of the beech tree (in German: Buche) they generated the German word for book (Buch).

At the opposite end of the craft industry from the light, two-dimensional medium of the scribe stood the heavy, three-dimensional material of the bronze worker. Working with bronze was very costly because it required large workshops with massive hearths for smelting the metals. The production of a bronze sculpture began with the making of a model that provided an object for discussion

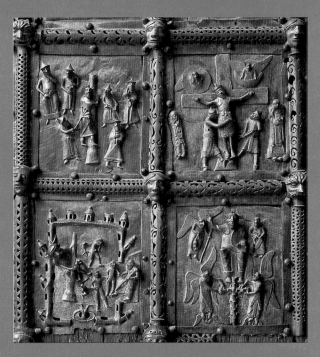

Verona, San Zeno, detail of the west portal with scenes from the Passion, wood with bronze plates, total height of door 4.8 m/15.7 ft, width 3.6 m/11.8 ft, c. 1138

between client and artist. Next the model was executed in wax and encased in a mantel of clay, with small channels left to permit the escape of air and admit the molten bronze. When the clay coat was fired, the wax would flow out, leaving a mold into which the molten metal would be poured. After the mold had cooled down, it was broken off to expose the final figure. This casting technique, known as the lost wax process, was practiced on a large scale throughout the Middle Ages. Its

drawback however was that if the process failed, there was no form for re-casting. This posed a great danger, because massive figures without cavities could easily

rupture or shatter while cooling down. Beeswax was extremely valuable and not available in large quantities, so it could only be used for casting smaller objects. For larger objects such as bells, tallow was used, probably from cattle. Mixed with lard, it provided sufficient firmness as well as the necessary malleability. As the cooled down bronze figures had a very rough surface, they had to be smoothed during the cold work and details had to engraved.

Theophilus devoted an extensive chapter to the casting of bells. The enormous increase in church construction during the Romanesque sparked the wide proliferation of bronze church bells. Hence this artist monk's instructions provided important guidance for disseminating the art of bronze casting. The text points out just how exceedingly steady and practiced a cooperation was required on the part of those involved. It took a very experienced master to bring off this complicated work successfully, one who was good at instructing and managing his people.

Pedestal of a baptismal fountain, Hildesheim, cathedral, c. 1225

Romaneque cross, Soest, St Maria zur Höhe

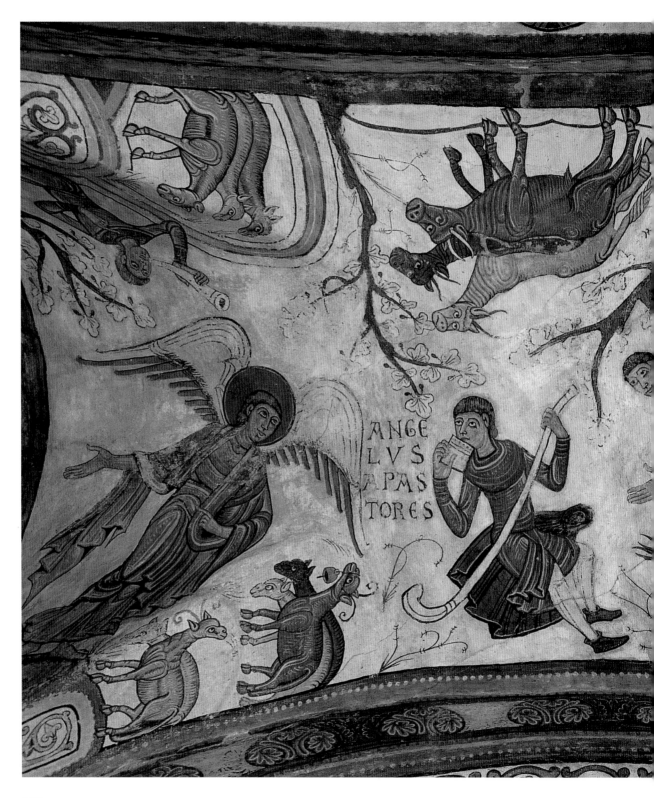

ANGE
LVS
APAS
TORES

198

Romanesque Painting

The high quality of Romanesque painting is evident in more than the monumental wall paintings for which the new churches provided wall space. Quite often, these were based on miniatures contained in illuminated manuscripts. In addition, enamel work and mosaics presented effective pictorial techniques, as did glass painting and tapestries such as the Bayeux Tapestry.

Wall Painting

Placing the advent of Romanesque mural painting at the beginning of the eleventh century does not imply a stylistic break with the pre-Romanesque period. Though no complete large-scale image cycles remain from either Carolingian or Ottonian times, we do have knowledge of the period from written sources, in which the names of clients and even artists occasionally appear. In one such case, Otto III had a painter named Johannes come from Italy to paint the Palace Chapel in Aachen. Accounts of secular painters also exist, such as when Charlemagne or Henry I had their military victories glorified in monumental paintings. More

León, Pantheón de los Reyes, detail: Annunciation to the Shepherds, c. 1180

or less within the scope of Carolingian art are remains of frescoes with scenes from the legend of St Stephen that survive in the crypts of St Germain in Auxerre (855) and San Salvatore in Brescia (early ninth century). From the same period come the large-figure representations of Christ, saints, and patrons at St Benedict in Mals, and from the end of the ninth century, a cycle of David at St Johann in Müstair, to name just a few examples. The church of St Georg in Oberzell, on the island of Reichenau, offers a clear overall impression of church painting in Ottonian times: The upper walls of its nave display a nearly-intact fresco cycle of Christ's miracles from the second half of the tenth century. The earliest examples of influences from wall painting of this pre-Romanesque period come from the German empire that succeeded the Carolingians and Ottonians, and extended into Italy and the kingdom of Burgundy until the end of Staufen rule in the thirteenth century. Though national structures were forming then that still hold today, we can't speak of the art of this period as having an individual national identity. Nevertheless, the geographically-oriented art history that began with the 20th century is a useful aid to research and study in this area.

Mals (South Tyrol), St Benedict (apse), figures of the patrons, c. 880

Reichenau, Oberzell, former abbey church of St Georg, nave facing east with Ottonian wall paintings, c. 980

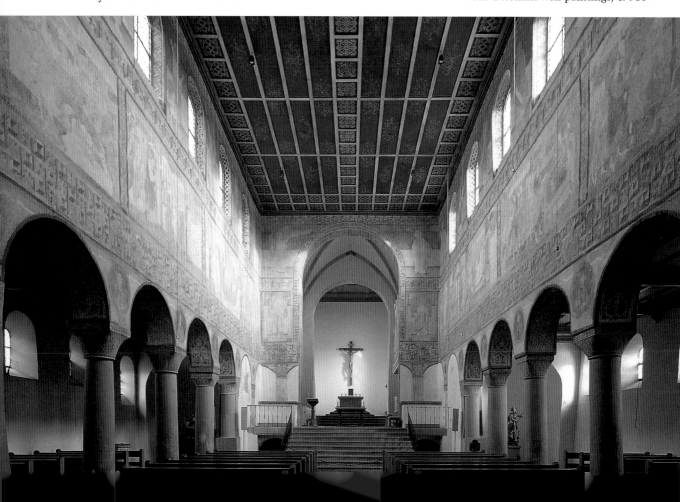

France

Scattered throughout France are several centers of Romanesque wall painting, which can be organized somewhat schematically into four general groups. Murals in western and central France, centered around Tours and featuring fairly soft colors on a light background, are designated "naturalistic" because of their stylistic appearance. In Burgundy and southeastern France we mainly find images on blue backgrounds, while in the Auvergne a third group has darker backgrounds. The fourth, or "Catalonian," group was prevalent in the then predominantly Spanish region of the Roussillon.

Among the most significant of all France's Romanesque wall paintings is the fresco cycle on the barrel vault of St-Savin-sur-Gartempe, east of Poitiers. An example of the "naturalistic" group, the cycle displays a series of thirty-six Old Testament scenes which—with the exception of the first, the heavily damaged creation story—are extraordinarily complete and well preserved. Because the scene sequence does not follow biblical chronology, we may infer that the builders and mural painters of St-Savin were working side by side under considerable time constraints: As soon as a surface meant for painting was completed, the painters went right to work on it. While the work of as many as three distinct hands can be recognized in the paintings, the execution of the cycle demonstrates an overall unity in form and content.

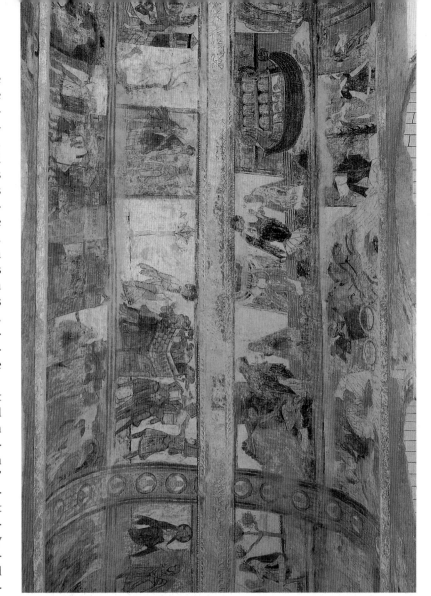

St-Savin-sur-Gartempe, abbey church,
fresco cycle on the vaulting of the central nave, end eleventh century

The artists' predilection for including a myriad of anecdotal details in their paintings allows them to tell us a great deal about daily life in the Middle Ages. The scene depicting the building of the Tower of Babel (see illus. pp. 8 and 100) provides a vivid portrayal of a medieval construction site, where the workers demonstrate the arduous use of their tools, while God the Father punishes their conduct by rendering them incapable of understanding one another's speech.

St-Plancard

The small, central Pyrenean village of St-Plancard, near St-Gaudens, is home to southern France's only double-ender church. Here two apses stand opposite each other, one of which is decorated with murals. There are paintings in the chapel of the south aisle as well. These frescoes have an archaizing and folk-art naïveté to them, and neither their dating nor their art historical classification has led to any conclusive critical or stylistic analysis. Most notably, the figures in the apse frescoes—for example in the Adoration of the Magi, the Crucifixion scene, or the Ascension—use animated hand gestures and are clad in magnificent robes as well. Various art historians have seen parallels here with Coptic paintings, leading them to suspect that the artist might have been trained in Egypt. The frescoes of the choir chapel however show themselves to be the work of a different artist, one whose style differs from that found in any other French Romanesque wall painting. Dating from the middle of the twelfth century, these works (and a following of many less significant ones in the northern Pyrenean valleys) are linked to the painting style of Catalonian Roussillon. Until 1462/1463 the Roussillon was part of Spain, and together with Catalonia, it constituted an important artistic region.

St-Chef

One of the few fully-intact fresco programs can be seen in the convent chapel of the abbey church of St-Chef, located east of Lyon in Dauphiné. The work centers around a Maiestas Domini, and fills the entire vaulted ceiling of the chapel, exploiting the architectural form to deliver its message. The mandorla is in the zenith of the vault, and the figures around the perimeter include Mary flanked by angels to the east and the Heavenly Jerusalem to the west; on the north and south sides additional angels and seraphim as the keepers of Heaven are depicted. The incorporation of the entire surface of the vault to display the work creates a representation of the divine sphere, from which the terrestrial convent receives its blessing and heavenly endorsement.

St-Plancard, St-Jean-Baptiste, two fresco details: the Fall (left), an angel (right), c. 1140

P. 203 : **St-Chef, abbey church,** convent chapel, Maiestas Domini and the Heavenly Jerusalem, c. 1080

P. 204/205: **Berzé-la-Ville, priory church,** Maiestas Domini, c. 1120

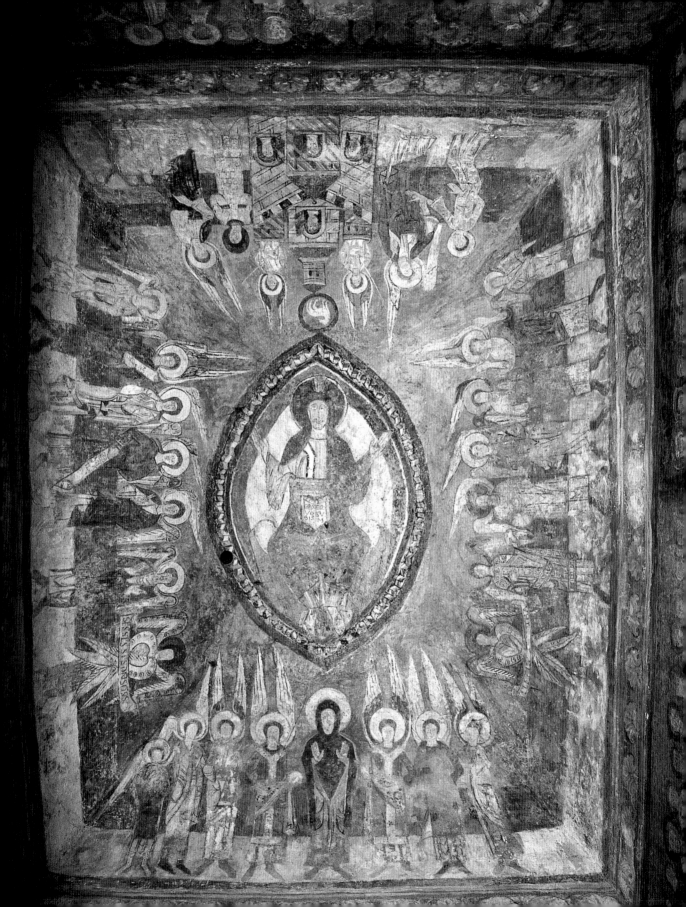

Berzé-la-Ville

In the chapel of Berzé-la-Ville, a priory with close ties to Cluny, several monumental Romanesque paintings survive, which are among the most important in France. Because this small chapel was built or rebuilt by Abbot Hugh (1049–1109) as a personal retreat, the paintings were possibly planned with his input, though probably only completed after his death. It is also possible that one of his successors, either Pons (1109–1122) or Peter the Venerable (1122–1158), had an influence on the content and composition. In the apse vault, which is framed with floral and foliate borders, Christ enthroned appears in a mandorla, signalling speech with his right hand. The apostles are gathered to either side of the mandorla; below the left group and on a smaller scale appear the patrons of the chapel, the deacons St Laurence and St Vincent. Counterbalancing them on the right are St Blaise and an unidentified saintly bishop. Above these, St Paul stands to the left, and to the right St Peter receives a scroll from Christ's hand as in the Early Christian motif from Rome, the *traditio legis,* "conferring the law." The whole may symbolize the ceremonial conferring of the region onto Saints Peter and Paul in the year 910, and thus by association the founding of Cluny, which was dedicated to these saints. The inference that this is an expression of Cluny's loyalty to the pope is supported by St Blaise, whose cult was popular in Rome at the time. Furthermore, his martyrdom is depicted in a niche on the side wall. Most notably, the rendering of the robes indicates an Italo-Byzantine influence that could mean artists from the monastery of Montecassino were called to Berzé.

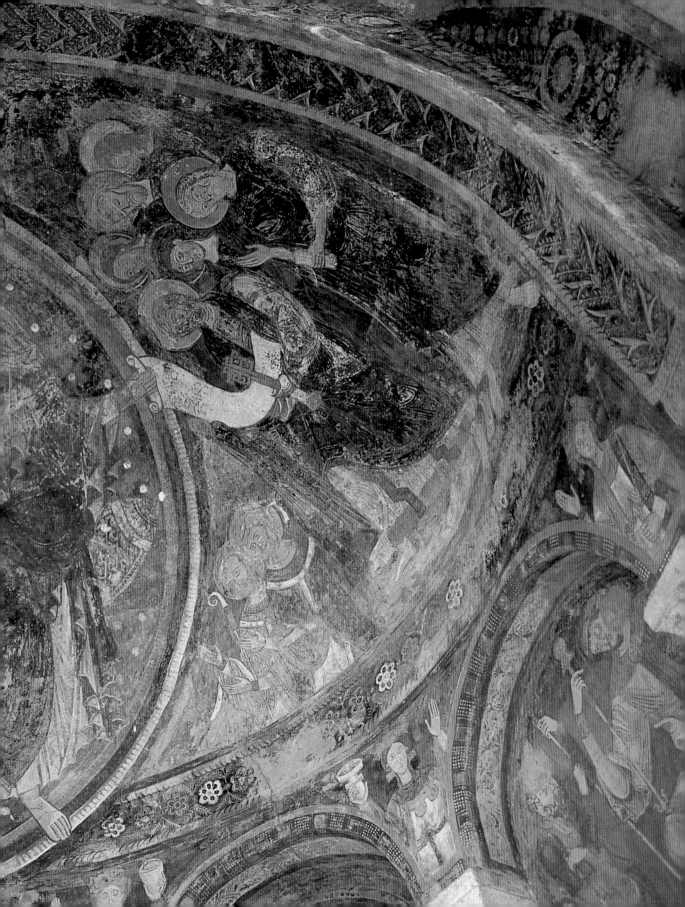

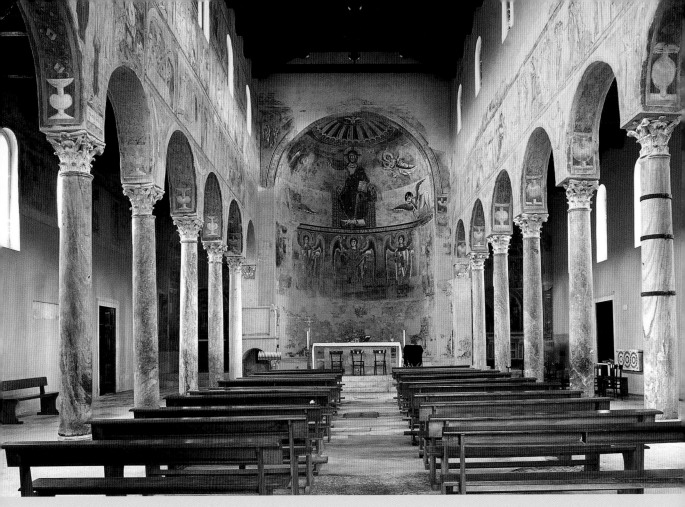

S Angelo in Formis, basilica, interior of the church facing the apse: Maiestas Domini encircled by the symbols of the Evangelists, with angels beneath, 1072–1087

Below: detail of the south wall of the central nave: Meal in the House of Simon (left); The Last Supper (right)

P. 207: **S Angelo in Formis, basilica,** detail of the Last Judgement on the west wall: Descent into Hell, 1072–1089

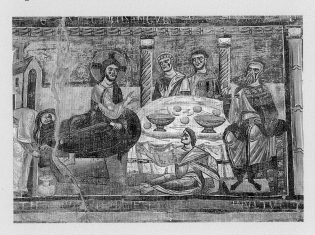

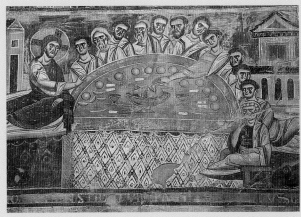

Italy

Romanesque wall painting in Italy had always been influenced by the mosaic schools, which themselves were characterized by Byzantine features. They left a legacy of impressive works in Rome, Ravenna, Venice, and many other cities. This is probably why elements of Romanesque painting styles have been preserved longer in Italy than elsewhere.

S Angelo in Formis

Though not particularly significant in its architecture, the basilica of S Angelo in Formis does house a substantial fresco program. The church was transferred to the control of Abbot Desiderius of Montecassino in 1072, who according to an inscription had it restored. In light of a portrait in the apse showing the abbot with the attributes of a living person, the redecoration with murals was presumably part of this restoration. Thus for the apse frescoes we can assume a date between 1072 and the abbot's death in 1087, although this does not necessarily apply for the rest of the church. Nonetheless, Desiderius is considered the contractor and "spiritus rector" for the entire program.

The main apse presents Christ on a throne surrounded by the symbols of the Evangelists; below are three archangels with Desiderius on the far left and St Benedict on the right. The right side-apse shows a half-length figure of Mary with the Child, while the left side-apse paintings are lost.

The fresco cycle, originally comprising some one hundred images, of which around sixty survive, extends across the church aisle walls and the entire west wall. This monumental product of Montecassino art is a stylistic and iconographical blend of both Byzantine and Western elements. While Byzantine parallels can be found in book illuminations from Montecassino itself, the spatial arrangement of the wall paintings as well as the graphic depictions of figures and their movements indicate the Western orientation of the painters.

Despite the differences in quality, the uniformity of the whole suggests that it is the product of a single workshop comprising several artists, working without interruption according to a coherent plan.

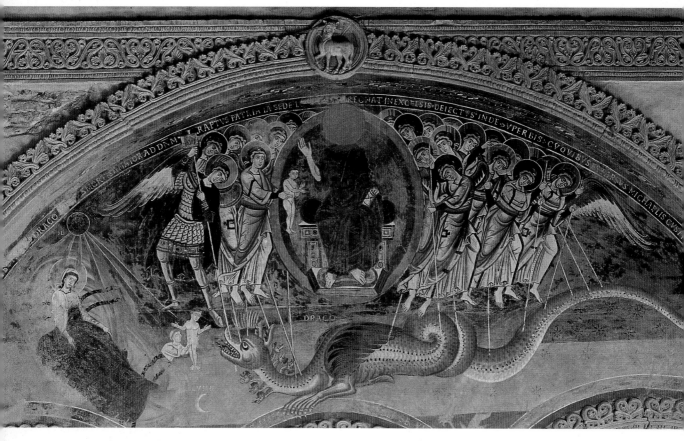

Civate, S Pietro al Monte, east wall of the narthex, the vision of the woman and the dragon, c. 1090

P. 209: **Rome, S Clemente,** lower church: St Clement celebrating mass, c. 1100

S Pietro al Monte, Civate

The murals in the church at Civate, on Lake Como, were probably painted on the initiative of Archbishop Arnolfo dei Capitani of Milan. He had been elected to the position in 1093, but was not immediately confirmed by the pope. Since he has been entombed there since 1096, he is also thought to have been at Civate during the two years prior to his inauguration by Pope Urban II. That the murals in this isolated monastery illustrate stories of the Apocalypse may well reveal some-thing about his mood during his "exile" there. Art historians have distinguished the hands of five different artists who all worked here at the same time, but with differing levels of qual-ity. The painter of the apoca-lyptic battle between the angels was probably the chief master and director of the overall de-coration. This fresco, without question one of the greatest of the Italian Romanesque, pre-sents the twelfth chapter of the Apocalypse (*The Vision of the Woman and the Dragon*). In the center sits Christ enthroned and in a mandorla, while the dragon of the apocalypse ap-pears under him and is battled by the archangel Michael and his host of angels. To his left, the woman of the apocalypse confronts the dragon with her son. The painter is thought to have come from Milan, and is one of the greatest masters of his time. His work here dis-tinguishes itself both through its monumental conception and through its refined technical sophistication.

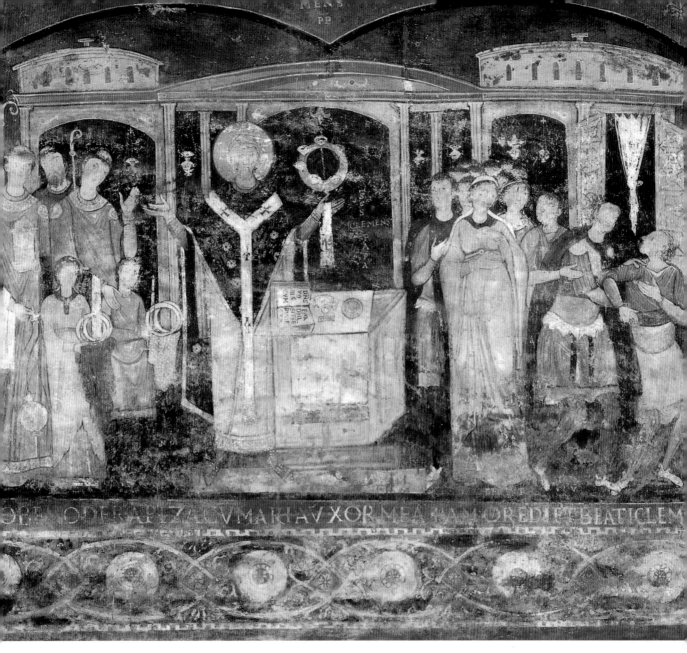

S Clemente, Rome

Dating from around 1100, the four frescoes found in the lower church of S Clemente are among the most important examples of Romanesque painting in Rome. They display scenes from the legend of St Clement, who is said to have been the fourth bishop of Rome. The leg-end of the mass of St Clement tells of a Roman woman named Theodora who had converted to Christianity. Her husband was the city prefect Sisinnius, and a jealous man. When she went to the mass in the catacombs, he followed her so that he could arrest Clement, but instead was himself struck blind and dumb in punishment. On the right side of the painting (above), we see Sisinnius being led out by a servant. One can pick out three stylistically distinct hands at work in the St Clement cycle, with the highest quality work in the mass scene. All three scenes, however, tend to favor antique elements.

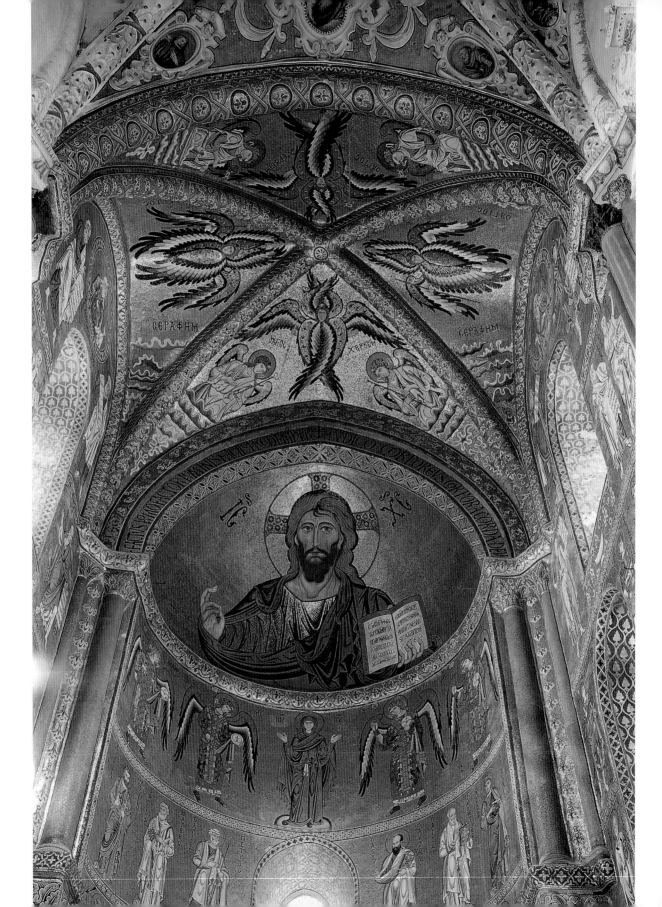

Byzantine Mosaics

In the apse of the basilica at Cefalù, on the north coast of Sicily, is an extraordinary example of Byzantine mosaic work. Prominent masters from Constantinople were enlisted by Roger II for the production of this work, which dates to 1148. The remaining mosaics in the choir were accomplished during the years that followed. The central image of Christ Pantocrater (Ruler of the Universe) appears in the apse calotte in an impressive work that depicts both his divinity and his humanity. While the inscription over the arch indicates the central theme of Christ's divine parentage, the register below the apse vaulting presents the Mother of God as the agent of his incarnation. She is encircled by the four archangels, who hold Christological symbols in their hands. Apart from Cefalù, Ravenna is the primary center of Byzantine mosaic work. Italy derived its long Romanesque tradition from sources such as these.

Although S Marco in Venice was built sometime after 1225, its narthex mosaics are an outstanding example of a typical Late Romanesque Venetian pic-

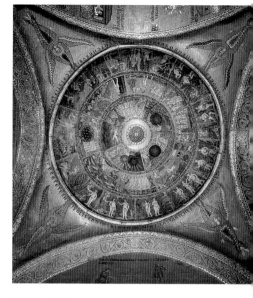

Venice, **S Marco,** mosaics in the narthex: dome with motifs from Genesis, early thirteenth century

Left: **Florence, Baptisterium,** detail of the dome mosaics, from 1225

P. 210: **Cefalù, cathedral,** choir mosaics, 1148

torial language. The first dome, south of the main portal, exhibits the Creation story in trapezoidal scenes forming three concentric rings around a starry disc of heaven at the zenith. While the gold background gives an overall Byzantine effect, the miniature figures of the Creation narrative and the sequencing of its elements are indebted in both form and content to Western styles, such as those found in contemporary book illumination. In this respect, the Creation Dome is seen as a masterpiece of the new Venetian picture style of the early thirteenth century.

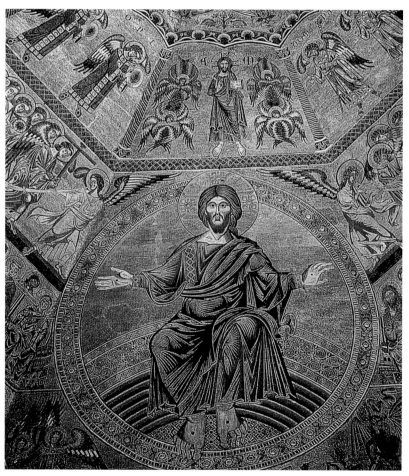

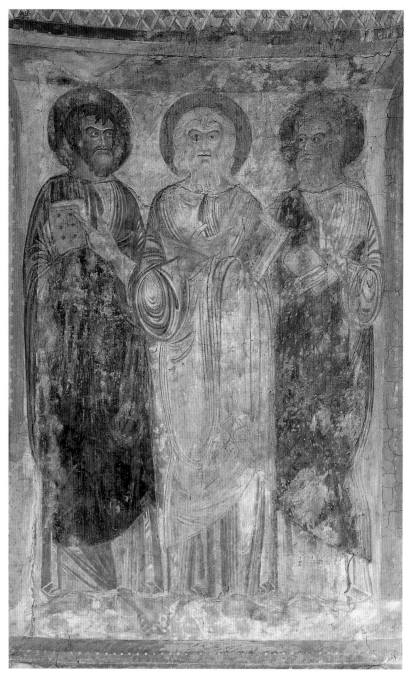

Knechtsteden, former Premonstratensian abbey church of St Maria and St Andreas, a group of three apostles, c. 1170/1180

P. 213: Schwarzrheindorf, St Maria and St Klemens, interior view of the Lower Church; visible is also the Upper Church with its paintings of the Maiestas Domini and Heavenly Jerusalem, c. 1180

Germany

The Ottonian wall painting and book illumination of Reichenau spread its influence into Swabia and the Alpine regions for quite some time—although a decades-long scholarly controversy over the possible existence of a distinctive "Reichenau school" of painting continues unresolved to this day. However, there is no question that Reichenau was an important center of Romanesque painting in German-speaking lands.

Another focal point of this art form was the lower Rhine area. This can be seen in church murals at St Maria or St Pantaleon in Cologne, where the Byzantine art of Italy continued to exercise its influence until approximately 1200.

Another style, and one considered to be more art historically significant, is the "softly flowing style." Its principal works are conserved at the double church of St Maria and St Klemens in Schwarzrheindorf, as well as in the chapter house at Brauweiler. Other works associable with these are the frescoes in the east vaulting over the crossing of cathedral at Essen, and the now destroyed apse paintings of St Gereon in Cologne. Art historians regard Cologne as the point of origin for this style, which, incidentally, is one that demonstrates the high degree of artistic skill necessary for the rendering of theologically complex subjects.

Comparatively little is left of the intensive Ottonian painting production that continued into

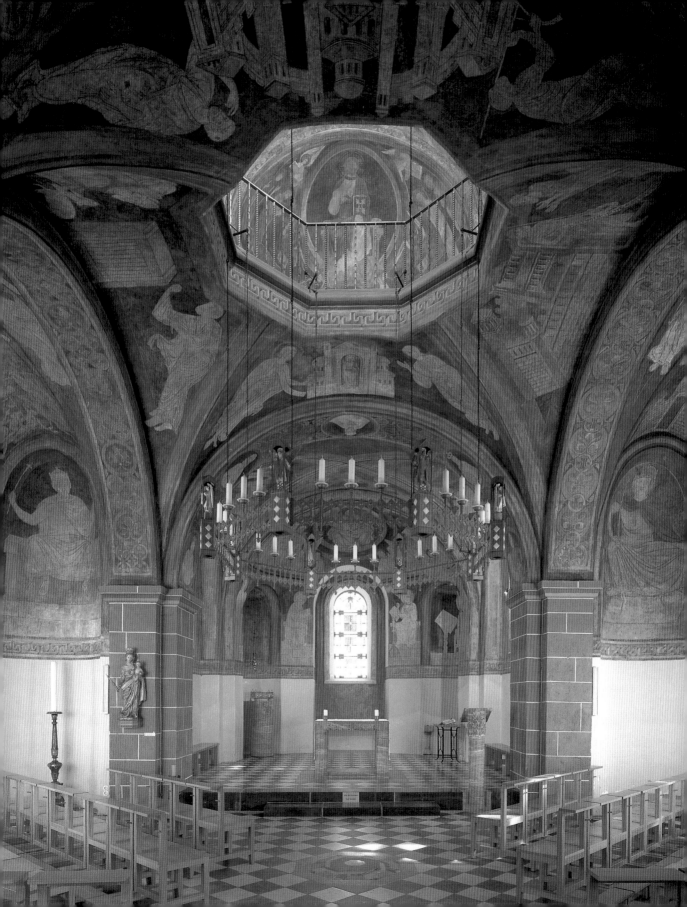

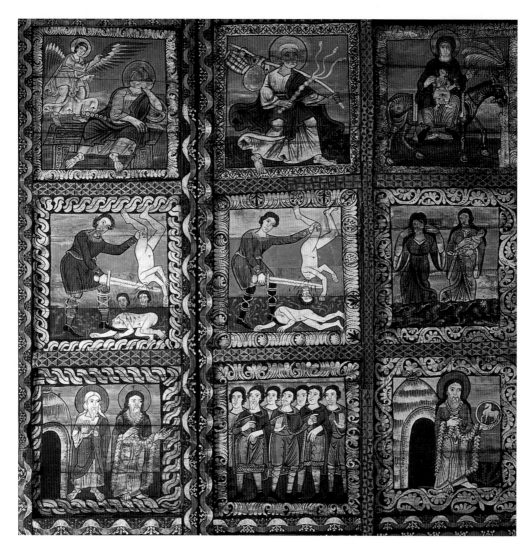

Zillis, St Martin, detail of the painted wood ceiling, c. 1130/ 1140

P. 215:
Hildesheim, St Michael, detail of the painted wood ceiling, third quarter of the thirteenth century

the High Romanesque period in southeastern Germany, especially in Regensburg. What does survive is largely distorted by flawed restoration work. For instance the paintings in the monastery church of Prüfening, which date to 1130, are connected at least in terms of content to those of the All Saints Chapel in the cathedral of Regensburg (c. 1160) and to the rather provincial murals of St Emmeram (c. 1170). In Lower Saxony, too, an early heartland of Romanesque painting, only scattered works survive. One of the most important is the fresco cycle in the private burial church of Bishop Sigwart of Minden (1120–1140), in Idensen near Hanover.

The style of the Idensen work, which dates between 1120 and 1130, is closely related to the artistically very influential painting school of the imperial Benedictine abbey of Helmars-hausen. Here Byzantine and Ottonian stylistic elements were fused with Mosan features. For example, even in the first half of the thirteenth century, we find the painting in Brunswick Cathedral or in the Neuwerk-kirche ("Novum Opus Church") of Goslar still predominantly governed by this Ottonian style.

The only remaining painted wooden ceilings from the Romanesque are at St Michael in

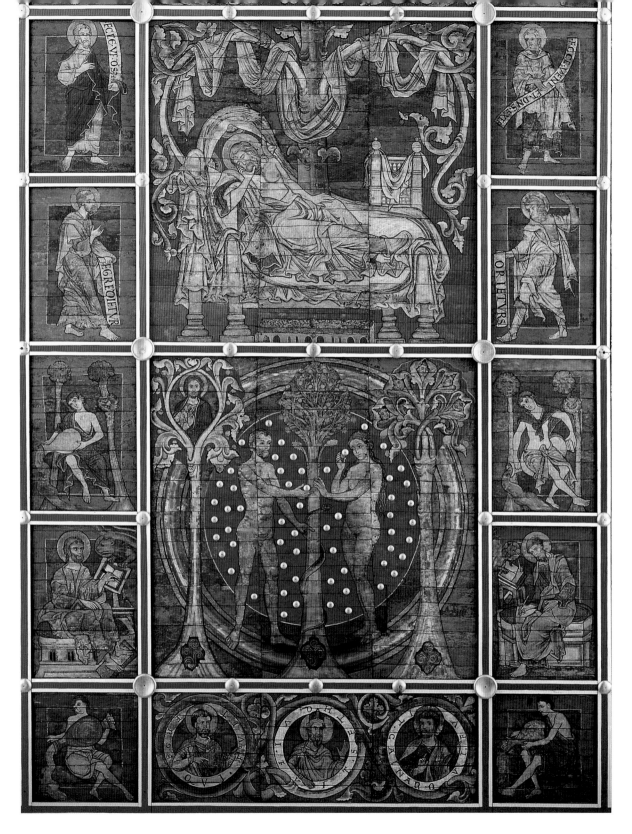

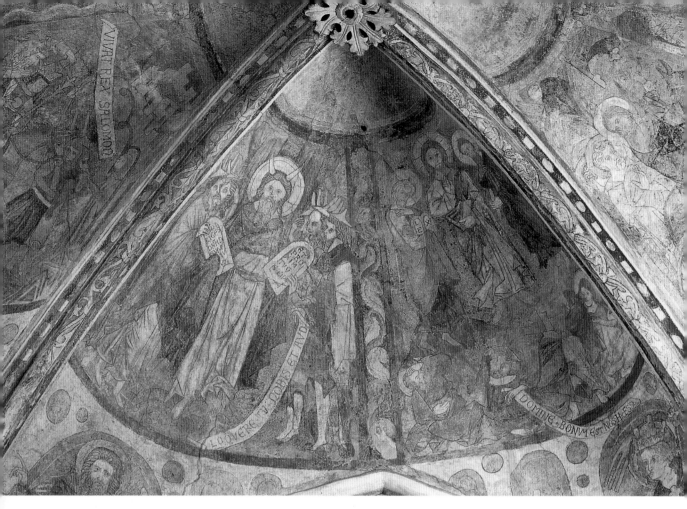

Cologne, St Maria Lyskirchen, Passion scenes, c. 1250

P. 217: **Tahull, St Maria,** "Master of the Last Judgment,"
the battle of David and Goliath, c. 1123,
Barcelona, Museu Nacional d'Art de Catalunya

Hildesheim and at Zillis, in Switzerland (illus. above and p. 215). The older wooden ceiling at St Martin in Zillis now contains only 150 square fields, after part of the ceiling fell victim to a sixteenth-century renovation. The middle squares are painted with numerous scenes from the life and passion of Christ and of St Martin. Around them is a row of fields with sea monster figures representing the external realm of Chaos and the menace it poses to the "world of salvation." At each corner stands an angel named for one of the four winds—together they represent the four corners of the world. The rather simple and rustic style is not connected with the painting at Hildesheim. Though difficult to date, this work likely comes from the third quarter of the twelfth century.

During the thirteenth century, one of the most bizarre stylistic phenomena of late Romanesque painting emerged in Germany. Known as the "jagged" or "zigzag" style, it is primarily characterized by splintering or serrated drapery patterns that take on a life of their own, independent of the body (see above). This style, perceived as both irrational and Mannerist, is thought to have been a specifically German "artistic protest" against the newly emerging Gothic styles.

Spain

Even though Spain's inventory of Romanesque murals is largely confined to the northern parts of the country (particularly Catalonia), what has survived is extraordinarily rich. Compared to other regions, it is easier here to distinguish the hands of many masters and their influences. Considerable efforts have been undertaken since the beginning of the twentieth century to transfer the majority of frescoes from the churches into museums, which has certainly contributed to their preservation.

The Romanesque murals of Spain draw their essential stylistic influences from two different sources. The first is genuinely Iberian and descends from the body of Arabic and Moorish forms, out of which developed a kind of Early Romanesque-Islamic fusion. This style is designated Mozarabic, as it was practiced by the so-called "Mozárabes," the Christians of the area who had been subjugated by the Moors and subsequently assimilated their culture. After the reconquest of the Moorish sections of Spain, the Moors—now in the service of Christianity—developed the "Mudéjar" style, which remained current from the twelfth up to the sixteenth century while taking on aspects of contemporary styles.

Characteristic of Mozarabic painting for instance is the spatially ambiguous, planar composition of its images, with strong background coloring. The figures display a similar planar treatment, and elongated rendering of their heads. An example

León, Pantheón de los Reyes, detail, The Murder of the Children of Bethlehem, c. 1180

P. 219 : **Tahull, S Climente,** Maiestas Domini, c. 1123, Barcelona, Museu Nacional d'Art de Catalunya

were likely finished by local masters.

The source of the other Spanish painting style lies in northern Italy and can be found in the works of the influential "Master of Pedret" and his circle. The frescoes painted for the church of S Quirce de Pedret, north of Figueras, which are now housed in three museums, demonstrate that Byzantin-oriented artists had an impact on the region. The frescoes at S Pietro al Monte in Civate on Lake Como (see pp. 208 and 221) are named as their direct or indirect precursors, and their transmission to Spain in whatever complex ways had probably begun even before the end of the eleventh century. The influence of the Master of Pedret and his workshop remained stylistically formative into the twelfth century, above all in the province of Lleida/Lérida.

Meanwhile, a rather innovative master left behind a remarkable work in the Pantheón de los Reyes in León (see illus. p. 199). This royal tomb, constructed in the atrium of S Isidoro in around 1054/1067, was decorated with frescoes in about 1180 under King Ferdinand II (1157–1188). The painter here presents a rather informal series of biblical stories, with less emphasis on narrative order and more on an almost intuitive representational virtuosity and a sparkling decorative effect. The different levels of quality in these murals invites speculation about the collaboration of a lesser master.

of this can be seen in the depiction of David's combat against Goliath at Sta Maria in Tahull, on the outer wall of the western bay of the south aisle (illus. p. 217). The artist here is known for his principal work as the "Master of the Last Judgement." Compared to the more distinguished "Master of Tahull," to whom only the frescoes of the main apse and presbytery are attributed, the painter of David and Goliath shows himself to be less proficient in this type of work. These artists were presumably from out of town, and after painting the more prominent scenes at the churches of Sta Maria and S Climente in Tahull, they moved on. The remaining sections

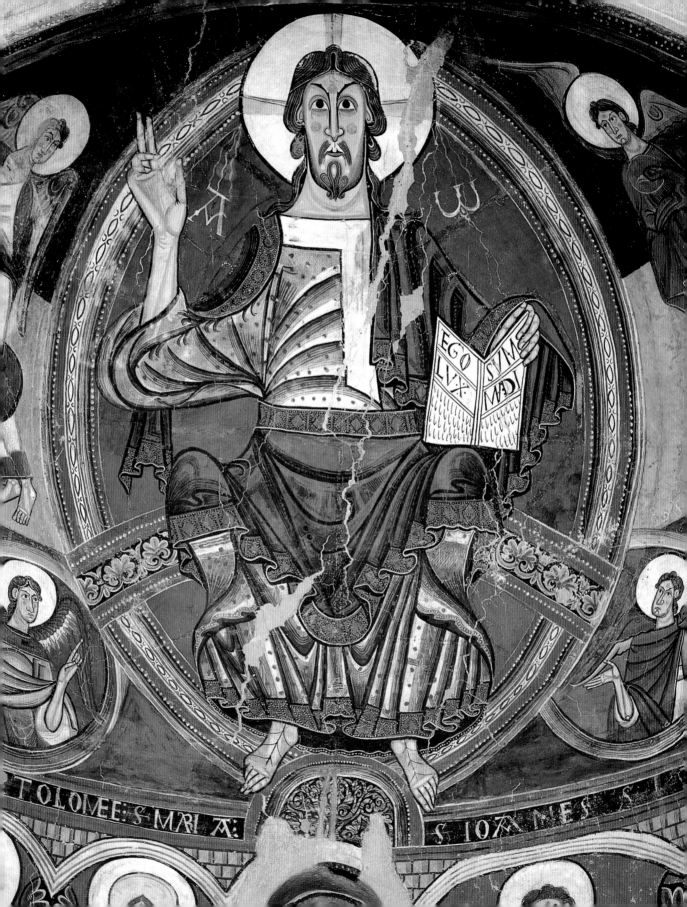

EGO SVM LVX MVDI

TOLOMEE S MARIA S IOANNES

Important Visual Themes

After its origins in the Roman basilica, church architecture underwent a reinterpretation filled with symbolic power. The nave was seen as the "triumphant road of Christianity" that lead to the choir and apse, which were almost always situated in the east, oriented toward the source of Christian salvation. The wall configurations corresponded to an architectural hierarchy whose individual zones had their own signifi-

Christ on a white horse,
Auxerre, cathedral, crypt, c. 1150

Maiestas Mariae, or enthroned Mary,
Soest, St Maria zur Höhe (Our Lady on the Hill), dome, c. 1120

cance. Consequently, the *Maiestas Domini*, Christ in His Majesty, the core theme of Romanesque monumental painting, appears almost exclusively in the calotte of the apse. This motif is derived from several biblical sources which, apart from the Book of Revelation, are found mostly in the vision of Ezekiel (1:44 ff). Enveloped in a glowing, rainbow-colored aura of light and accompanied by the tetramorph, a haloed Christ sits on his heavenly throne holding a book. Depictions showing Christ sitting on a large semicircle while his feet rest on a smaller one are based on Isaiah 66:1: "Heaven is my throne and the earth is my footstool." Another variation can be found in the crypt of the cathedral at Auxerre, where Christ appears astride a white horse in the junction of a cross; he holds a sceptre in his right hand and has the left raised in proclama-

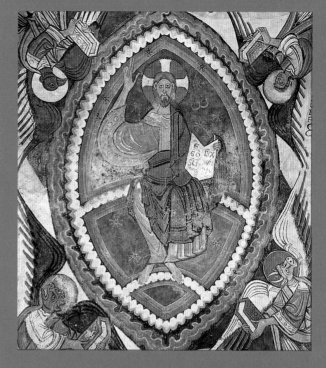

Maiestas Domini, León, Pantheón de los Reyes, c. 1180

tion. Here the theme has been iconographically expanded to that of the triumphant entrance of a ruler. This refers to the Roman motif of the "Adventus Imperator" which

had been built up by medieval rulers into a symbol of their own imperial *gestae* (heroic achievements).

Occupying a position hierarchically below the Maiestas Domini is the enthroned Mary. She is removed from the center and, as at St-Chef (see illus. pp. 203, 221) and in the Church of Our Lady on the Hill in Soest (left), she belongs to the heavenly realm, though not directly at its center. In her status as Mother of God and as an intercessor particularly close to God, she seems to form the connection between heaven and earth. In Soest she is both a titular saint and appears above the altar. Her depiction there holding the scepter follows a type evolved

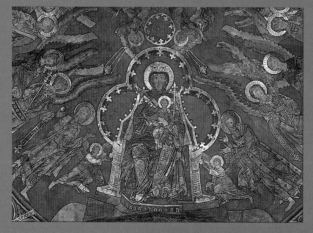

during the Romanesque which presents the enthroned Mary as the *sedes sapientiae*, or the Throne of Wisdom. This allegorical image type alludes to the Old Testament wisdom of Solomon, on whose six-tiered lion throne Mary takes her place. The throne was made of ivory and covered with gold (1st Kings 10:18–20). In the medieval mind, the Mother of God was identified with this throne, and, by sitting herself, became also the throne of the son of God. In medieval depictions she appears with various attributes and biblical companions.

As a symbol of the City of God, the depiction of the Heavenly Jerusalem is given a lot of space in Romanesque wall painting. Described in great detail in the Vision of John (Revelation 21:12–27), the city is also regarded as the New Jerusalem and thus as part of paradise. It could be reached through the Word of God as rep-

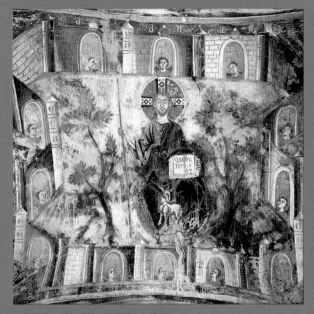

resented in the Maiestas Domini, through the the Lamb of God as the symbol of Christ's sacrifice, and through the intercession of the Mother of God. The depiction of the Heavenly Jerusalem in Civate, for example, shows a haloed Christ with the book of life in his left hand, a golden staff in his right, and the lamb at his feet. The faces of the apostles appear in twelve gates, three for each of the compass points, and the throne is set in the garden of Eden. In this iconograhic combination, the Last Judgement appears to have already taken place. This program of salvation presents itself with singular integrity in the St-Chef vault painting discussed above (p. 203). Underneath the Maiestas Domini in the center stands Mary, surrounded by angels. Along the same axis, the lamb appears over the mandorla and above the Holy Jerusalem, though it is turned 180° due to the incline in the vault (detail right).

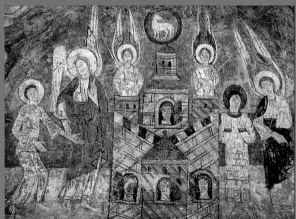

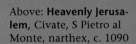

Above: **Heavenly Jerusalem**, Civate, S Pietro al Monte, narthex, c. 1090

Center: **Heavenly Jerusalem**, St-Chef, abbey church, c. 1080

The stoning of St Stephen, Müstair, abbey church of St-Jean, twelfth century

While the the Last Judgement often appears on the inside west wall, together with the abyss of hell, the nave and clerestory walls are reserved mostly for narrative cycles of the Old and New Testament or for scenes from the lives of saints and martyrs' legends. These themes can also be found on both flat wooden and barrel-vaulted church ceilings.

221

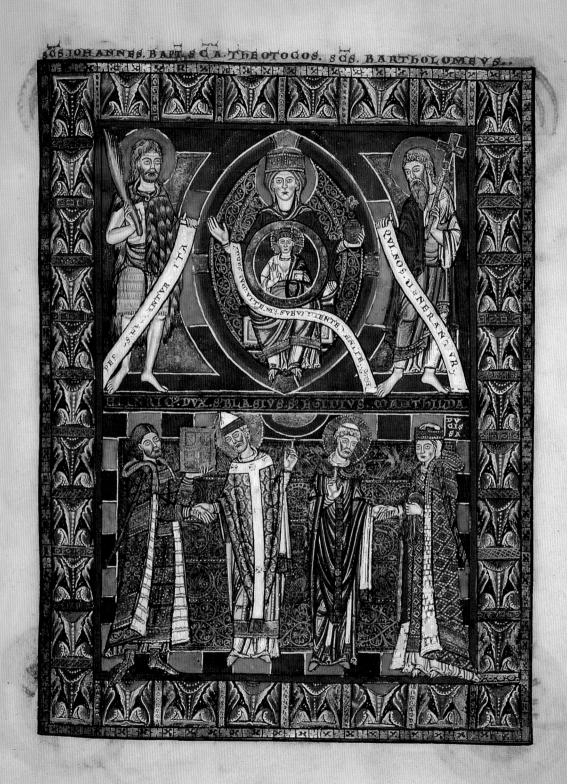

Book Illumination

The flowering of Romanesque book illumination during the eleventh and twelfth centuries was preceded by several significant eras of development in this art form. These go back through the Ottonian, Carolingian, and Late Antique periods, all the way to the time of the Egyptian *Books of the Dead*. Charlemagne's efforts to restore the intellectual prowess of the empire stimulated an increase in the production of handwritten documents. At that time the court scriptorium, generating many marvelous manuscripts, came into its own alongside the monasteries, which until then had been the sole producers of written material. The contribution of the court miniaturists was that they drew on the legacy of Late Antique painting, prompting art historians to speak of a Carolingian renaissance. The revival of monastic life brought on by the tenth-century Cluniac reform (see also pp. 22–25) led not only to the foundation of many new monasteries, but also to a re-evaluation of the book, which was increasingly useful to monks, particularly for reading exegetic literature. Later, the economic rise of towns and the accompanying upsurge of their episcopal schools created a demand for books with specific emphasis on encyclopedic knowledge. Many of these books were richly illustrated. After the reform of the liturgy, books required for the celebration of the mass were particularly sumptuously illuminated.

One of the greatest centers of early twelfth-century book illumination in France was Cluny, whose scriptorium was primarily influenced by Byzantium. At the same time, the painters at the newly founded monastery of Cîteaux were more oriented towards the illumination style of England, where the twelfth century had brought an artistic break with forms from the eleventh. The most important English scriptoria were in Canterbury and Winchester. The phenomenal Romanesque book illumination of the Maas region (in present-day Belgium) sent its influence into Germany, especially into the Rhineland, where between 1140 and 1170 the gifted visionary Hildegard of Bingen created her famous works. From Strasbourg came the *Hortus Deliciarum*, a major encyclopedic volume by Herrad of Landsberg. The original, from the last quarter of the twelfth century, was destroyed in 1870, but partial copies remain. Many works of Swabian book illumination survive in the monasteries of Weingarten and Zwiefalten, where a style formed with influences from England and the Maas region. Bavarian book illumination received its principal stimulus from Salzburg, where, despite some innovations, the Byzantine tradition of Italian Romanesque painting continued to hold sway.

Romanesque lower-case letters from Salzburg, mid-twelfth century. After the introduction of the Carolinian alphabet or lower-case letter toward the end of the eighth century, Western writing was unified.

Book Types

Book production was stepped up enormously during Romanesque times and experienced a previously unknown range of variety. The majority were of a religious nature, with the concentration on books used in the liturgy. First and foremost among these was the Evangelary or Gospel book. This contains the four Gospels in the canonical sequence of Matthew, Mark, Luke, and John. An essential component of the Gospel book is the set of canon tables (concordances of similar readings), which are set in front of the Gospel texts. These are usually organized within arcades under a major arch or pediment. Each Gospel is preceded by an author portrait showing the Evangelist, who is often accompanied by his symbol and set in an architectural frame. Not infrequently, the program would be supplemented with a Maiestas Domini. Among the most prestigious book types, the Gospel book was luxuriously bound. If a book had been owned by a saint, it could even attain the status of a relic and become a cult object.

The Evangelistary, or book of Pericopes, contains the Gospel extracts assigned for the lessons on Sundays and feast days arranged in the order required by the liturgical year. Like the Gospel book, the Evangelistary has canon tables at the beginning, but it may also contain images of feast days, saints and donors.

The most important of the individual liturgical books is the Sacramentary, which contains the canon (consecration of the Host) and prayers for the Mass. Because of the cross-like shape of the large "T" (*Te igitur laudamus*) with which the main text begins, it is embellished with the crucifix (the canon image). By the thirteenth century at the latest, the missal, containing all necessary texts for the Mass, took over the functions of both sacramentary and antiphonal.

The antiphon (from the Greek "sounding in answer") has been in use since as early as the second century, and contains the music and text for the liturgical antiphons. Put into its canonical form by Pope Gregory the Great, it has been known as the Gradual for short since the twelfth century. It is illustrated with scenes from the lives of Christ and Mary, with supplemental images of saints who are particularly important during the ecclesiastical year.

Apart from liturgical books, other religious writings were increasingly being produced for use by the laity. Originally, the psalter, containing the 150 psalms, was mainly used in monasteries for choral office. It evolved during the thirteenth century and, in conjunction with the breviary, came into use by the laity as a prayer book and later as a book of hours. While the psalter was illustrated mostly with narrative scenes from the Bible, the book of hours was often commissioned by wealthy lay people, and typically endowed with opulent illuminations.

There was also a rich culture of encyclopedic books combining secular knowledge from both classical tradition and contemporary perceptions of the world. The body of secular works was expanded by such newly emerging forms such as court epics, accounts of journeys, and romances.

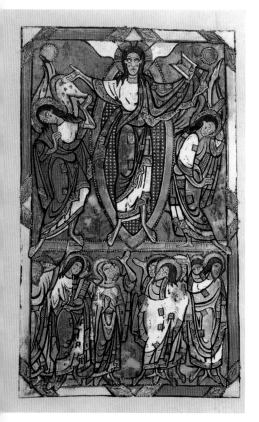

Viri Galilaei—Introitus of the mass for the feast of the Ascension, Sacramentary of St-Etienne in Limoges, c. 1100, 16.5 cm/6.5 in x 27 cm/ 10.6 in, Ms. lat. 9438, fol. 84 v, Paris, Bibliothèque Nationale

P. 226/227:
The apocalyptic riders,
Apocalypse of St-Sever, mid-eleventh century, 36.5 cm/14.4 in x 28 cm/ 11 in, Ms. 8878, fol. 108 v–109, Paris, Bibliothèque Nationale

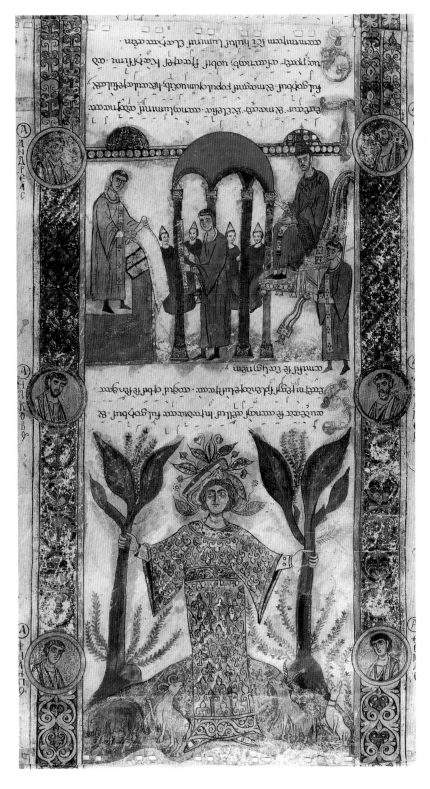

Apocalypses

Even in the Late Antique period, the last book of the New Testament (the Revelation of St John)—which was not recognized by the early Church—existed in illuminated manuscript form. This section had always presented problems for miniaturists, as it was artistically challenging to do justice to the extraordinarily evocative and visionary language of the Apocalypse. An important group of manuscripts with illustra-

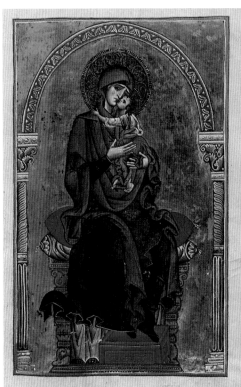

Above: **Mary with the Christ Child,** Sacramentary, Messina, end of twelfth century, painting on parchment, height 31.8 cm/12.5 in, Madrid, Bibl. Nacional

Left: **Dedication of the Easter candles—** Terra, *Exsultet* scroll, c. 1055–1065, length 39 cm/xxx in, length 5.9 m/ 19.4 ft, Ms 1, Bari, cathedral treasury

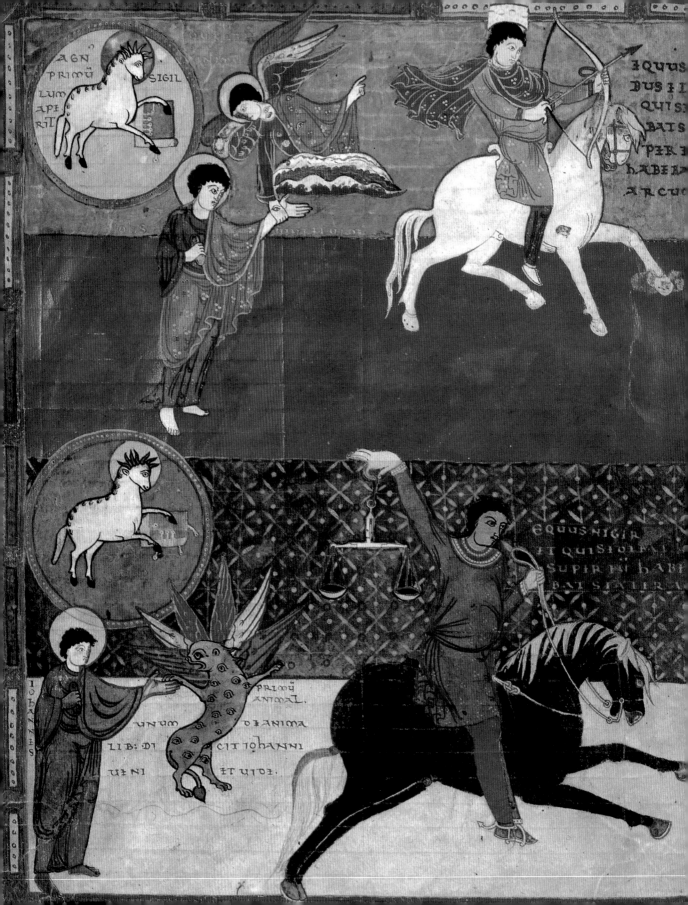

AGN
PRIMU
LUM
APE
RIT

SIGIL

EQUUS
BUS
QUISIBA
BAS
PERE
HABEA
ARCU

IOHANNES

PRIMU
ANIMAL
UNUM DEANIMA
LIB: DI CITIOHANNI
UENI ET UIDE

EQUUS NIGIR
ET QUISIDEBAI
SUPIR EU HABE
BAI STATERA

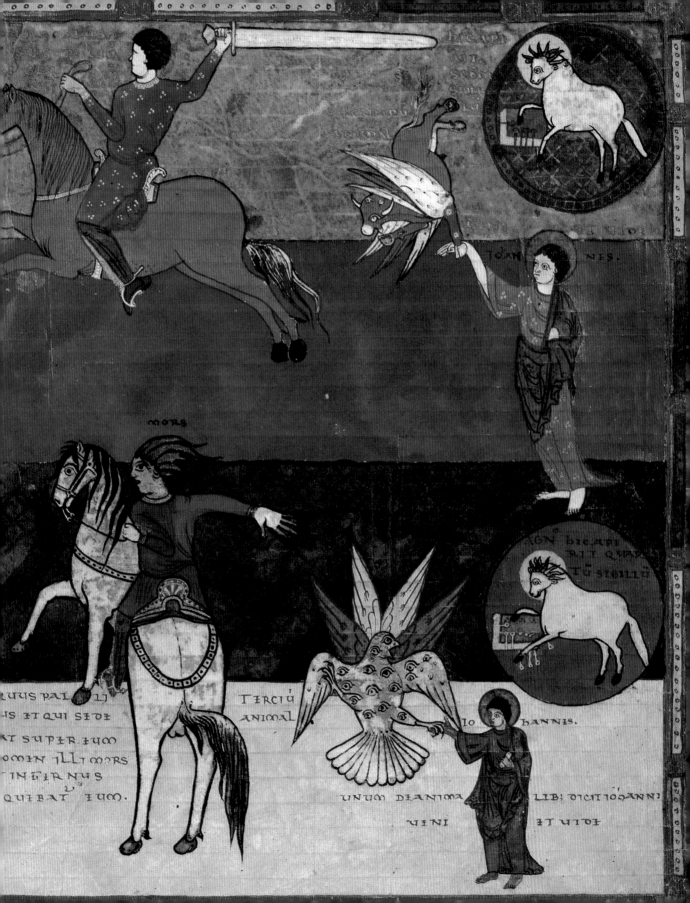

tions of the Apocalypse emerged in Spain between the tenth and thirteenth centuries. These "Beatus manuscripts" are commentaries on the Apocalypse, illustrating a text from c. 776 by Beatus de Liebana. Many of the illustrations are marked by dramatic, detailed depictions and give special emphasis to the last woes. There are also images rigorously organized around a central point, in which art historians see the emerging metaphor of an increasingly dogmatic, theocentric world view.

The manifestation of God in the apocalyptic vision of the Beatus manuscripts is limited to a few motifs, in which the Maiestas Domini, accompanied by symbols of the Evangelists, is most common, followed by the Adoration of the Lamb, and by Christ and the twenty-four elders. While the lamb of God has been used as an allegory for Christ since the second century, the twenty-four elders of Revelation are derived from the Greek office of the supreme judges. During the Middle Ages, they were identified with the twelve prophets of the Old Testament and the twelve apostles of the New Testament. Another significant Apocalyptic motif is the "Woman of the Apocalypse," who in the Middle Ages was equated with Mary, the holiest of women. Finally, in contrast with monumental painting, book illuminations generally included an image of the visionary himself.

The Evangelary of Henry the Lion

The Gospel Book of Duke Henry the Lion is one of the major works of twelfth-century book illumination in Lower Saxony. In light of the increasing agreement that the book formed part of the liturgical accoutrements of the Marian Altar at Brunswick cathedral, its uncertain date of c. 1175 should be shifted to 1188 when the altar was donated by the duke and his wife, Mathilda. The noble couple had commissioned the scriptorium of the Benedictine monastery of Helmarshausen to produce the magnificent manuscript. The dedication poem mentions the work of the monk Herimann in particular, who

seems likely to have been the scribe. While the script style is uniform, the creative approaches to the illumination vary. The extremely costly colors of gold and purple appear repeatedly, and the introductory poem itself is written in gold. The splendid binding was originally made of gold as well, but the book is now bound with numerous silver reliefs produced in 1594 at a workshop in Prague.

P. 229: **Evangelary of Henry the Lion,** Helmarshausen, c. 1175–1188, fol. 171 v, Wolfenbüttel, Herzog-August-Bibliothek, Codex Guelf. 105 Noviss. 2° and Munich, Bayerische Staatsbibliothek, Clm 30055

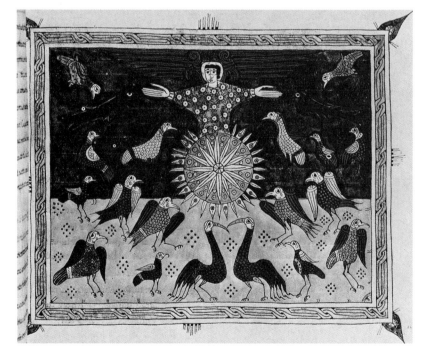

The angel collects the birds, Beatus de Liebana, commentaries on the Apocalypse, Santo Domingo de Silós, between 1073 and 1109, Add. Ms. 11.695, London, British Library

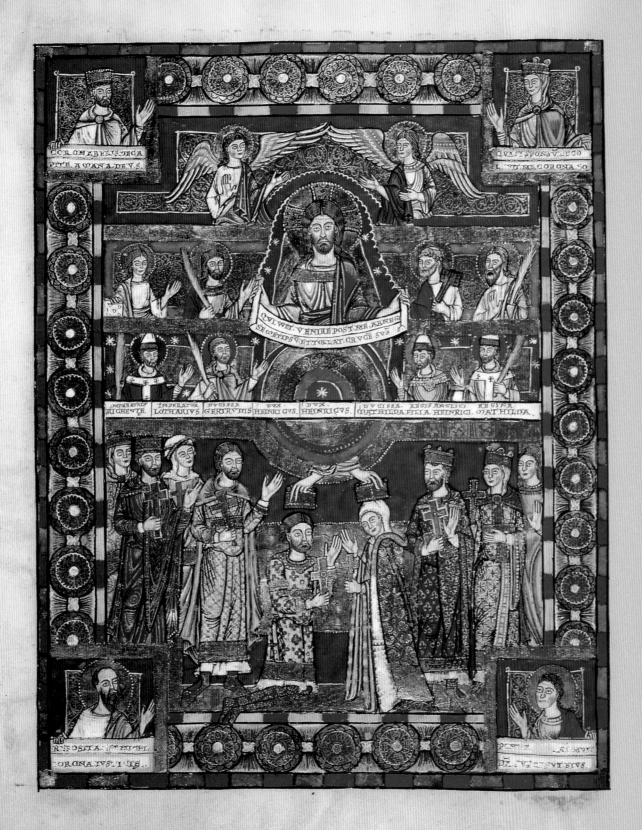

Winchester Bible, Winchester, 1160–1175, Ms. 17 fol. 169 r, Winchester, Cathedral Library

P. 231: **Scenes from the book of Exodus,** Pantheon Bible, Rome, c. 1125, painting on parchment, height 60.5 cm/ 24 in, Vatican, Biblioteca Apostolica Vaticana

Giant Bibles

A standard in Italian book illumination were the giant Bibles produced in the eleventh century in Umbria, Rome, and probably Tuscany and northern Italy as well. These were usually two-volume works, often with evenly trimmed book blocks (quire gatherings) that measured between 50 x 34 cm (20 x 13.5 in) and 66 x 41 cm (26 x 16 in). Some specimens run a little larger, such as a Bible from Regensburg-Prüfening that measures 71 x 48 cm (28 x 19 in), while the "Codex Gigas" in Stockholm attains a quite sizeable dimension at 90 x 50 cm (35.5 x 20 in). Large format Bibles were nothing new; they had been produced during the sixth and early eighth centuries, and we know of several giant Carolingian Bibles dating to the ninth century. Early Italian ones from the second half of the eleventh century, their decoration limited to ornamental initials, were exported in large quantities well beyond the Alps.

During the twelfth century, a genuinely Romanesque concept took hold in which the entire Holy Scripture was systematically illuminated in the giant Bible format. For some time, however, unrelated text and illustrations appeared alongside one another. This was because the large format at first primarily addressed the wish to reproduce monumental paintings in miniature, resulting in what were effectively the largest book paintings of their kind. In the scriptoria, where much experimentation went on, the miniaturists increasingly concentrated on devising historiated initials—decorated with figurative and narrative scenes—to improve the connection between text and image. The most prominent English Romanesque example is the Winchester Bible (illus. p. 230). Its fabrication took many years, involving the efforts of many artists, as well as 250 calf-skins.

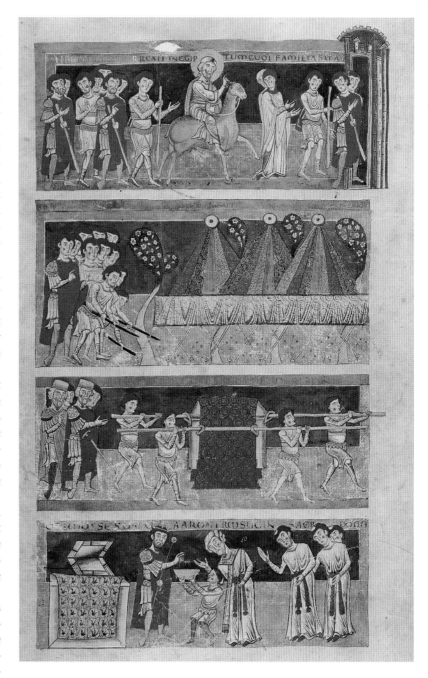

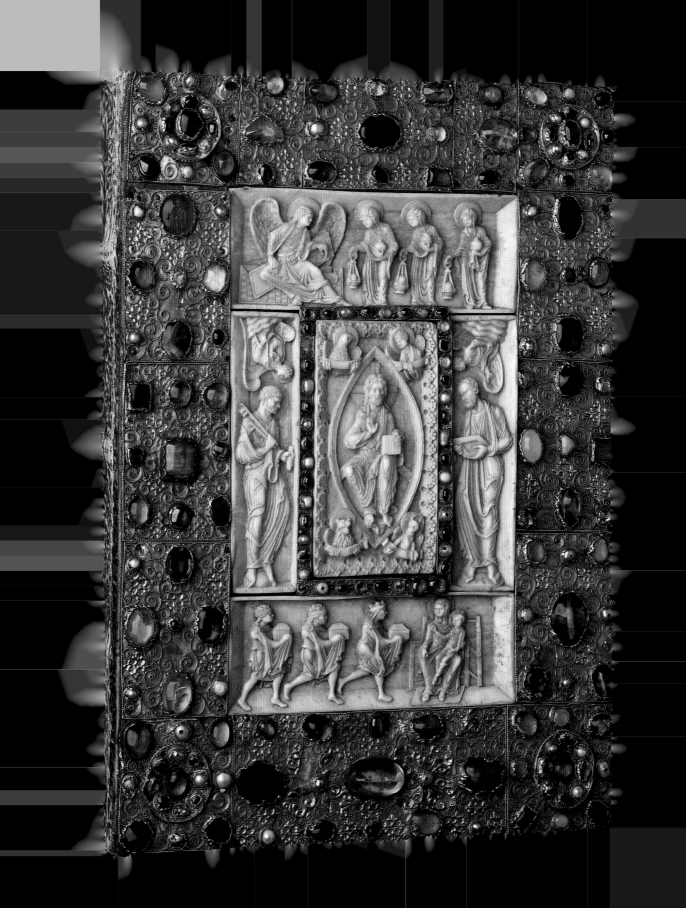

Binding and Initials

·Precious book covers

During the High Middle Ages, liturgical books in particular were identified so closely with their content that even their outer appearance was expected to reflect the divine truth presented within their texts. Thus they were bound with the same luxurious materials as were used to make· reliquaries, especially since the books were consecrated objects used in the church service. While there were bookbinders who saw to the actual assembly of the book, almost all the arts and crafts were involved in the creation of precious book covers. Late Antique mythological ivories were re-used on some of the earliest book covers, but specially-made ivory plaques were increasingly used. A good Romanesque example is the cover of the St Aegidian Gospels, whose

center is adorned with a Maiestas Domini with Evangelist symbols, surrounded by Gospel scenes and the saints Peter and Paul—all carved in morse ivory. In addition, eminent master goldsmiths were called in to encase the cover in the finest filigree and the most precious

gems. Still other artists produced elaborate enamel work for book covers. As the books were destined for liturgical use, the composition of their cover design remained limited to recurring central themes such as the Crucifixion or the Maiestas Domini.

Initials

As early as Late Antiquity, the initial letter—from Latin *initium* ("beginning")—of an important text was already being emphasized. While Antique tradition held to a strict distinction between text and illustration, medieval initials were used to fuse the two. Early on, the illuminators of the pre-Carolingian and later periods introduced the initial as a self-contained element that bridged text and illustration. During this time, the initial underwent substantial artistic evolution. Two

especially prominent scriptoria in this respect were at Lindisfarne in the British Isles, and Corbie in northern France. Zoomorphic figures were a favorite for transforming into whatever shape the different initials called for. Originally used solely to fill in spaces in letters, animal figures soon came into active use for the formation of the initials themselves. Since the animals used their own bodies to make the desired letter, often by performing acrobatic moves, the reader could witness the letter's conception.

Then, after its ninth-century invention in St Gall, a new form evolved at Reichenau which featured the initial, not at the beginning of the text, but located instead in the center of a framed "Incipit carpet page." One of the four decorated pages in the Gospels of Otto III, the first page of St Luke's Gospel, consists of an outer frame around an inner one whose corners expand into foliate medallions (illus. left). At the center of the page is the text, "Quoniam quidem." While the circular body of the initial "Q" is suspended in the middle of the frame and bound to it by interlacing, the remaining letters of the word appear above (and thus before) the initial. This represents a high point for initial design, in that the letter is assigned the status of a full-page illustration.

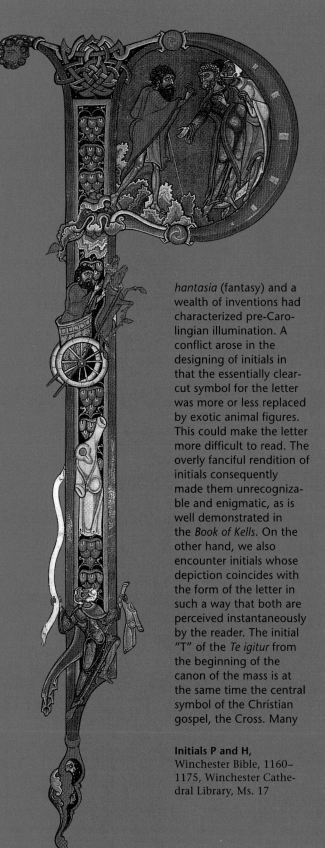

versions of this cross-shaped initial "T" have been produced. Nevertheless, the art of a medieval painter of miniatures was, on the whole, focused on transforming one thing into another, for instance turning the body of a fox or raven into a figural initial, or giving a letter the form of a fish or bird. Another fantastic composition was formed by the continuous decorative entwining of various animal bodies (zoomorphic interlace). This concept made a surprise reappearance centuries later, long after

this pre-Carolingian, Insular book design had passed; one example is the zoomorphic pillars at Moissac and Souillac (illus. p. 235 left). At the same time, something similar to a zoomorphic initial was appearing in illuminations, too, in the form of a demonic figural initial. This trend reached its height at the beginning of the twelfth century in Cîteaux, the founding monastery of the Cistercian order in Burgundy (illus. far right). Meanwhile, the most artistically significant development of the Bible

hantasia (fantasy) and a wealth of inventions had characterized pre-Carolingian illumination. A conflict arose in the designing of initials in that the essentially clear-cut symbol for the letter was more or less replaced by exotic animal figures. This could make the letter more difficult to read. The overly fanciful rendition of initials consequently made them unrecognizable and enigmatic, as is well demonstrated in the *Book of Kells*. On the other hand, we also encounter initials whose depiction coincides with the form of the letter in such a way that both are perceived instantaneously by the reader. The initial "T" of the *Te igitur* from the beginning of the canon of the mass is at the same time the central symbol of the Christian gospel, the Cross. Many

Initials P and H,
Winchester Bible, 1160–1175, Winchester Cathedral Library, Ms. 17

Right: **Zoomorphic beast column,** Souillac, former abbey church of Ste-Marie, trumeau, today on the interior west wall, 1120–1135

Far right: **Initial P,** St Gregory the Great, *Moralia in Job*, Cîteaux, early twelfth century, Dijon, Bibliothèque municipale, Ms. 173, fol. 7

initial had occurred in the famous scriptoria of England at about the same time. In the year 1100, various human and animal figures were still cavorting in and around the structure of illuminated letters in gymnastic contortions. Now the letter forms themselves were increasingly being transformed into a stage-like backdrop on which biblical scenes could be presented. The famous "P" initial of the Winchester Bible dates to about the middle of the twelfth century and form the pinnacle of this development, in which Elijah's ascension into Heaven is reenacted pictorially (illus. p. 234 left). Two versions from the school of Canterbury had preceded it, first in the Rochester Bible, and later in the Dover Bible. In both, the loop of the "P" forms the gateway to heaven into which Elijah's chariot disappears right in front of the eyes of his disciple Elisha (2 Kings 2:11–14). Elijah was a prophet who was believed to prefigure the Messiah. He did not

simply die, but ascended to Heaven in a fiery chariot drawn by flaming horses on a whirlwind, leaving behind his mantle for his disciple Elisha. The Winchester Master set this spectacular scene of the chariot in the shaft of the "P," dramatizing the calling of Elisha by displaying the empty mantle. This leaves the loop of the "P" available for another scene from the prophet's life.

Examples such as these, where the form of an illuminated initial provides

the framework for scenes, are referred to as "historiated initials." Their counterparts, the "inhabited initials," derive from a long tradition of interlaced tendril initials reaching back into pre-Carolingian times. In the struggle between the aggressive plant tendrils and fleet-footed creatures such as humans or animals, the inhabitants' freedom of movement is greatly restricted by the rampant tendrils. It should be mentioned that the motif of the inhabited plant trail

originated in ancient Rome, where prickly blackberry brambles overgrew everything and were among the most bothersome and impervious of plants. Recent insights indicate that these climbing plants, which appear in various sculptural forms and on church capitals, can be interpreted as apotropaic images (protections against the demonic). The "inhabited initial" continued to play a creative role in book illumination for quite some time.

Concepts of the World and Visions

A special type of Romanesque illustration grew out of a sixth-century decree by Pope Gregory the Great, who required that all images should be seen didactically, as Bibles of the illiterate (*Biblia Pauperum*). Although this ruling has been used ever since to justify illustrations of all kinds, a trend towards cosmological representations began in twelfth-century book illumination. Only this medium offered the possibility to set images of complex philosophical concepts of the world into a didactic relationship with the explanatory text. Outstanding examples of this can be found for ins-

tance in the Regensburg-Prüfening manuscript from the third quarter of the twelfth century. Its depiction of the human form as a microcosm, or "mirror of the world," refers back to ancient eastern and biblical world models that take into account the influence of the stars on earthly life. In this illustration, the different parts of the human body are accompanied by captions that indicate their counterparts in the macrocosm. For instance, feet and earth, breast and air, or head and Heaven are micro- and macro-cosmologically associated with one another. This mirrors all the while a philosophical-cosmological version of the biblical

creation of humans in the image of God. Another drawing from the same manuscript takes this even further, showing human dimensions in terms of outstretched arms; the span of one's arms should correspond to one's height, just as the expanse of the world can be contained within a circle. The figure is also shown in relation to the four winds, the four points of the compass, and the elements.

Besides cosmological-philosophical concepts of the world, some illustrations stem from religious visions in the tradition of the Apocalypse of John. Hildegard of Bingen's visions of the cosmos are among the best known examples of these.

236

Bestiaries

Collections of animal stories, often with spiritual or moral content, were popular all across Europe from the tenth century onward. This medieval literature genre was based on the *Physiologus*, a small book produced in the Greek world of Late Antiquity. After the Bible, it was the most widely distributed book during the Middle Ages. Although its title translates as "Natural History," the book's animals were presented more according to their allegorical attributes as they relate to biblical content. Since they dealt mostly with wild animals, or "bestiae," these books were labeled "bestiaries." From quite early on they came out in vernacular versions, of which the earliest is the Exeter Book from the second half of the tenth century in England. The bestiaries of the twelfth and thirteenth centuries increasingly addressed the demand for encyclopedic resources on the part of a newly forming society. The numerous bestiary manuscripts were always comprehensively illuminated. Because of occasional pronounced differences between written and visual descriptions of the "bestiae," art historians focus on the image traditions, independent of the text.

Lion, bestiary, c. 1210,
Ms. Ashmole 1511, fol. 10 v,
Oxford, Bodleian Library

238

Carmina Burana

The most famous surviving collection of Middle Latin "vagant" songs comes from the archive at the abbey library of Benediktbeuren, called "Benedictobura" in Latin, from which it takes its name. The anthology is preserved only in fragmentary form and was transferred to the court library at Munich in 1803. In 1936, Carl Orff reset the lyrics to music. The manuscript was apparently produced during the first half of the thirteenth century by two scribes thought to be from Seckau. The miniatures were painted by the same hand that fashioned the many illuminated initials, which are applied in red ink and take the form of vegetal ornamentation or human faces. The themes of the landscape and figural paintings are keyed to the content of the text. With few exceptions, the depictions appear in two registers against a blue background with a green border. Stylistic analysis tends to date the manuscript to c. 1230–1240.

Forest landscapes, Carmina Burana,
Kärnten, Styria, c. 1230–1240,
24.9 cm/9.8 in x 17.7 cm/7 in,
Clm 4660 et 4660a, fol. 64 v,
Munich, Bayerische Staatsbibliothek

Samson and the Gates of Gaza, window of the Alpirsbach Abbey, 1180–1200, Stuttgart, Württembergisches Landesmuseum

Glass Art

The oldest fully-preserved Romanesque glass art is the series of five windows with standing figures of prophets at Augsburg Cathedral. They date to the end of the eleventh century. Our knowledge of the technique of glasspainting comes to us from the early twelfth-century handbook by Theophilus (see p. 196), which explains how metal oxides were mixed in with molten glass to create vibrant colors. Details were painted onto the resultant colored glass and fired to fix them, and the whole was then assembled mosaic-fashion over a preliminary sketch on a whitened board before being set in lead came (strips).

Romanesque glass painting experienced its peak in the early twelfth century, first at Chartres, then in Ile-de-France. It was there that Abbot Suger of St-Denis, impressed by a new metaphysic of light, had his church built with diaphanous walls containing large windows. Consecrated in 1144, this church ushered in the Gothic style, and it was during the Gothic period that glass painting would reach its flowering.

Annex

Religious Building Types in the Eleventh and Twelfth Centuries

Ground plans

Nave: one, three, and five aisles
Transept: three or five bays
Choir: staggered or "Benedictine" choir with three or five straight ambulatories
– continuous choir ambulatory with or without radiating chapels

Elevations

There are just a few basic ground plans, and these vary little over time. However, because interior elevations support the vault, they underwent a complex series of changes in the eleventh and twelfth centuries. Thus it is helpful to organize the various elevations by type (and to set out their individual chronologies). A concordance of this kind is more than the mere listing of development and change. It demonstrates the prevalence of given types at different times and places, and shows at a glance the range of challenges—and their resolutions—addressed during the European Romanesque. Unless otherwise noted, all elevations listed below are nave elevations.

Three-tier basilica with gallery and clerestory but without stone vault

961 ff	Gernrode, former collegiate church of St Cyriacus (flat ceiling)
11th c.	Milan, S Ambrogio (rib vault)
c. 1000	Montier-en-Der (later vault)
c. 1000	Tours, Saint-Martin (elevation uncertain)
1001–1018	Dijon, Saint-Bénigne (elevation uncertain)
1005 ff	Reims, Saint-Remi (later rib vault)
c. 1030	Cologne, Holy Apostles (later vaulted and nave walls reinforced)
c. 1030	Nevers, cathedral (elevation uncertain)
c. 1030	Bernay, former monastic church of Notre-Dame, nave (wooden barrel)
c. 1030/1040	Vignory (open roof trusses)
1040–1067	Jumièges, former monastic church of Notre-Dame (planned barrel)
1045/1050 ff	London, Westminster (barrel project)
c. 1050 ff	Parma, cathedral (later vaulted)
c. 1055/1060	Mont-Saint-Michel, former monastic church (barrel project, now wooden barrel)
1063 ff	Pisa, cathedral (flat ceiling)
c. 1070	Caen, former monastic church St-Etienne, nave (planned barrel)
1070–1089	Canterbury, cathedral (later rib vault)
1070/1073 ff	Canterbury, St Augustine's Abbey
1077 ff	Saint Albans, former monastic church (flat ceiling)
1079 ff	Winchester, cathedral (planned barrel; survives in transept)
1080 ff	Hereford, cathedral (planned barrel; survives in one transept bay)
1080 ff	Rochester, cathedral
1081 ff	Ely, cathedral (chamfered wooden barrel)
after 1081 ff	Bury-St.-Edmunds, former abbey church
1080/1085 ff	Cérisy-la-Forêt, Saint-Vigor
1089–1197	Bari, San Nicola (flat ceiling)
1093 ff	Durham, cathedral (later rib-vaulted, or design changed to rib vault)
1096 ff	Norwich, cathedral (Late Gothic lierne vault)
1098 ff	Trani, cathedral
late 11th c.	Trondheim, cathedral (wooden barrel)
1099–1184	Modena, cathedral (later rib vault)
1100–1160	Pavia, San Michele
1108 ff	Southwell, cathedral (wooden barrel)
1118 ff	Peterborough, cathedral (chamfered wooden barrel)
1122 ff	Piacenza, cathedral (later rib vault)
1150/1170	Ribe, cathedral (Early Gothic clerestory and vault)
1160/1171 ff	Bari, cathedral San Sabino (open roof trusses)

1170/1190	Kalundborg, round church (open roof trusses)
1175 ff	Bitonto, cathedral

Special case: three-tier elevation with giant arcade, shallow gallery-triforium, clerestory with wall passage, and barrel vault

1084 ff	Worcester, cathedral, choir (later altered)
1089 ff	Gloucester, cathedral, choir (later altered); nave: arcade, triforium (later clerestory and vault)
c. 1080/1090	Tewkesbury, former abbey church, choir (later altered): nave: arcade, triforium (later altered)
c. 1080/1090	Pershore, monastic church (vaulting project)

Unvaulted two-tier basilica with arcade and clerestory

c. 1000–1042	Nivelles, Ste-Gertrude (flat ceiling)
1010–1033	Hildesheim, St Michael (flat ceiling)
1015 ff	Strasbourg, cathedral, Bishop Wernher's building
1025–1042	Limburg an der Haardt, former monastic church
c. 1027–1095	Como, S Abbondio (five aisles, flat ceiling)
c. 1030	Bourbon-Lancy, St-Nazaire (flat ceiling)
by 1032	Ripoll, Sta Maria (five aisles)
by 1036	Pomposa, former monastic church (open roof trusses)
1038 ff	Hersfeld, former monastic church St Wigbert
c. 1050 ff	Cologne, St Maria in Kapitol (later rib vault)
1070–1093	Florence, S Miniato al Monte (open roof trusses)
1070–1129	Quedlinburg, St Servatius (flat ceiling)
1082–1091	Hirsau, St Peter and St Paul (five aisles, flat ceiling)

1099–1125	Alpirsbach, former monastic church (flat ceiling)
1105–1115	Paulinzella, former monastic church (flat ceiling)
1130–1143	Palerme, Capella Palatina (stalactite ceiling)
1135 ff	Königslutter, former monastic church St Peter and St Paul (flat ceiling)
1140 ff	Halberstadt, cathedral (flat ceiling)
1144–1200	Jerichow, former Premonstratensian (Norbertine) collegiate church St Mary and St Nicholas
1160/1165 ff	Maulbronn, former Cistercian monastic church (later rib vault)
1160/1170–1215/1220	Ratzeburg, St Maria and St Johannes (flat ceiling)
1174 ff	Monreale, cathedral (open roof trusses)
1180 ff	Cefalù, cathedral, nave (open roof trusses)

Two-tier basilica with arcade and clerestory, and actual or planned stone barrel vault

c. 1000	Cluny II
c. 1000	Châtillon-sur-Seine, Saint-Vorles (later groin vault)
1119–1130	Tounus, narthex ground floor (barrel-vaulting project, now with groin vault in nave and transverse barrel vaults in side-aisles)
1023 ff	Mont-St-Michel, former monastic church, choir
from 1027	Spire I (planned)
1029–1040	Cardona, S Vicente
c. 1030/1040	Chapaize, St Martin (replaced with pointed barrel vault after collapse)
c. 1030/1040	Romainmôtier, former monastic church Saints-Pierre-et-Paul
1040 ff	Tournus, St Philibert (nave barrel; later replaced with transverse barrel)
c. 1040/1050	Payerne, former abbey church
from 1060/1065	Caen, Ste Trinité, forechoir (blind arcades and windows below barrel

c. 1070	Tournus, St Philibert, upper narthex
by 1076	St-Guilhem-le-Désert, nave
1080–1100	Vilabertrán, Sta María
by 1149	Léon, S Isidoro
1145/1150–1289	Salamanca, old cathedral (modified as rib vault)
1148 ff	Sénanque, Cistercian monastic church
c. 1150	Arles, St-Trophime
1151–1173	Zamora, cathedral (modified as rib vault)
1160–1230	Silvacane, Cistercian monastic church
1160–1240	Toro, Sta María la Major
1168 ff	Moreruela, former Cistercian monastic church

Three-tier basilica with gallery, clerestory, and actual or planned stone vault

1045/1050 ff	London, Westminster (planned)
1050–1067	Jumièges, Notre-Dame, nave (planned)
c. 1055/1060	Mont-St-Michel, former monastic church, nave (completed/collapsed?)
1063–1097	Nevers, St-Étienne (only surviving example!)
1060/1065 ff	Caen, St-Étienne, choir and nave (planned)
1079 ff	Winchester, cathedral (planned)
1080 ff	Hereford, cathedral (planned)
1131–1148	Cefalù, cathedral, east section (planned; rib vault after design change)

Three-tier basilica with triforium, clerestory, and actual or planned stone barrel vault

1056 ff	La-Charité-sur-Loire, former monastic church (planned or executed)
1070/1075 ff	Caen, Ste-Trinité, nave (planned)
1070/1080–1108	St-Benoît-sur-Loire, choir
1088/1089 ff	Cluny III

1090 ff	Paray-le-Monial, former priory church Notre-Dame
1120/1125 ff	Autun, St-Lazare
1120/1130 ff	Semur-en-Brionnais, St-Hilaire
1125/1130 ff	Beaune, Notre-Dame
1125 ff	Saulieu, St-Andoche
1125/1130 ff	Chalon-sur-Saône, cathedral
2nd half of 12th c.	La-Charité-sur-Loire, choir

Two-tier gallery churches without clerestory, with stone vault (pilgrim church)

c. 1018	Bernay, former monastic church Notre Dame, choir
1040/1050	Jumièges, Notre-Dame, choir
c. 1050 ff	Conques, Ste-Foy
c. 1080	St-Nectaire
c. 1080 ff	Toulouse, St-Sernin
c. 1100 ff	Clermond-Ferrand, Notre-Dame-du-Port
early 12th c.	Orcival, St-Austremoine
1110/1120 ff	Santiago de Compostela
c. 1130	Issoire, St-Paul

Vaulted aisleless churches

by 1103	Aix-en-Provence, cathedral, present nave
1107–1208	Orange, cathedral
by 1153	Montmajour, former monastic church
1160/1170 ff	Aix-en-Provence, cathedral, present southern side-aisle
1160/1170 ff	Avignon, cathedral
c. 1160	Cavaillon, cathedral
1170/1175	Carpentras, predecessor to cathedral
1170/1180	Les-Saintes-Maries-de-la-Mer
c. 1200	St-Gabriel, chapel

Vaulted hall churches

| 1001–1009 | St-Martin-du-Canigou, lower church |
| by 1026 | St-Martin-du-Canigou, upper church |

1060–1085 St-Savin-sur-Gartempe
2nd quarter 12th c. Poitiers, Notre-Dame-
 la-Grande

Pseudobasilica
(chapels substituted for side aisles)

1022 ff St-Pierre-de-Roda
1030–1047 Fontenay, former abbey church
1046 ff S Miguel de Fluviá
2nd half 11th c. Frómista, S Martin
1175 ff La Seu d'Urgell

Two-tier basilica with arcade and clerestory, and groin vaults

1065/1070 Spire, cathedral, vaulting
1081–1137 Mainz, cathedral (later rib vault)
1093–1185 Maria Laach, monastic church
2nd half 11th c. Anzy-le-Duc, former priory
 church

1140–1145 Lund, cathedral
from 1120 Vézelay, Ste-Madeleine
from 1130/1135 Avallon, St-Lazare
1150 ff Viborg, cathedral
1151–1165 Knechtsteden, St Marien and
 St Andreas
c. 1150 ff Eberbach, former monastic church
 St Maria
after 1150 Cologne, St Georg (original flat
 ceiling replaced with groin vault)
late 12th c. Pontaubert, Ste-Marie

Domed churches

1st half 11th c–c. 1130 ff Poitiers, Ste-Hilaire
1063–1094 Venice, S Marco
1120 ff Fontevrault, former monastic
 church
1120 ff Périgueux, St-Front
1120/1130 ff Angoulême, cathedral

Glossary

Abacus Flat, usually square slab at the top of a capital

Abbey A monastery or convent with certain privileges, including the right to establish daughter houses.

Acanthus A small, spiny Mediterranean shrub with long, jagged leaves that curl slightly at the tips. The leaves have inspired decorative designs since Antiquity, specifically those found on Corinthian capitals.

Allegory An analogy or illustration of an abstract concept or subject that is symbolically represented through personification or in scenes.

Altar Sacrificial platform; the Christian altar symbolically combines the tomb of Christ, the site of sacrifice, and the table of the Last Supper. Thus it is also the site of the consecrated Host. In its capacity as a conceptual tomb, it became also the repository of saints' relics.

Alternating pier system The use of contrasting pier forms to articulate the bays of a Romanesque building.

Ambulatory walkway In a basilical church, it typically functions as a side aisle. When it continues into or around a transept and/or choir it is termed an ambulatory.

Antependium Decorative hanging or solid screen for the front of an altar, lectern, or pulpit. Also called a frontal.

Apse Semicircular or polygonal building extension, usually vaulted or domed; especially at the east end of a church. For apses in echelon see Benedictine choir.

Apsidiole (also absidiale) Small or secondary apse.

Arcade Series of arches on piers or columns. A blind arcade is rendered in relief against a wall.

Archivolt Decorative molding(s) on the underside of an arch.

Atrium Forecourt of an Early Christian church, enclosed on three or four sides with colonnades, often with a fountain at its center. Also sometimes referred to as a paradise, though that term more often refers to a cloister garden.

Banded masonry Decorative masonry technique in which visible stripes are created with courses of contrasting color, texture or block size.

Barrel vault Continuous vault with a semi-circular or pointed cross section (pointed barrel vault).

Basilica Originally, an Ancient Roman town hall conferring imperial authority on the legal, administrative and trading functions conducted inside it. Once Christianity was adopeted, using the basilica form for churches conveyed similar legitimacy to them. Early church forms included nave with clerestory, side aisles, and apse; originally very rare, the transept became common in Carolingian times.

Bay Modular section of a building often articulated by alternating piers, wall responds, and the transverse arches of the vaults.

Benedictine Choir A form of choir associated with the second (Benedictine) church at Cluny (Cluny II). The main choir is flanked by progressively shorter ambulatories with apses. Also called staggered choir and choir with apses in echelon.

Bifora Double-arched windows; the arches separated by a small column. Commonly used in vernacular architecture.

Bower A lady's private, heated chamber or apartment in a medieval castle.

Calotte A section of a sphere; in church architecture, the semi-dome over the apse.

Canon of the Mass Consecration of the Host, or communion wafer.

Capital The decorative top piece of a column.

Centrally-planned/Central plan A rotationally symmetrical building plan, such as an octagon or Greek (equal-armed) cross. This form was inspired by Constantinian imperial and burial chapels.

Chapel A privately owned or separately dedicated place of worship.

Chevet A choir with continuous ambulatory and radiating chapels. This arrangement permits access (e.g. for pilgrims) to the chapels radiating around the apse (which often contain shrines and relics), without disturbing services taking place in the restricted areas of the choir or altar.

Choir The area of a church reserved for clerics and monks. From Carolingian times. The increasing use of transepts in the Carolingian period led to development of the long choir, which extends beyond the crossing. See also Benedictine choir and chevet.

Choir screen In monastic churches, a partition that separates the monk's choir from the lay brothers' space.

Clerestory Upper story with windows rising above rest of building; thus in a basilica the upper part of the nave.

Cloister An area reserved for the members of a religious community; also a courtyard surrounded by ambulatories.

Cluny The mother house of the powerful Benedictine monastic familia with imperial connections. The two reconstructions of its church (three were built in total) stimulated and endorsed major architectural developments. Cluny II (c. 955–c. 1010) is associated with the Benedictine Choir and nave with barrel vault; Cluny III (c. 1075–1121) is associated with double transepts, choir with ambulatory and radiating chapels, and pointed arches.

Codex Book.

Column A vertical support member with a cylindrical stem or shaft and a decorative capital; often used to form the responds on piers, where they are seen as half-columns (also called engaged columns) or as pilasters.

Conch In a church, a semicircular domed niche or apse.

Corbel A projecting wall member used as real or apparent support for a figure, balcony, or structural element.

Crossing The intersection of the nave and transept in a cruciform church. A nave and transept of equal width form a crossing square.

Crypt A cult or burial chamber, usually located under the choir of a church.

Diaphragm arch An arch spanning a flat-ceilinged nave; lacking structural function, it is designed to articulate the bay system. An especially common feature in Romanesque Italy.

Domical vault A vault resting on an octagonal base akin to a double groin vault; the eight projecting inter-sections (or groins) may rise to a point and are often decorated with ribs.

Donjon (French, from Latin *domus*: the lord's house) Fortified main tower of a (French) castle; see keep.

Donor Commissioner of an object or building, often commemorated with a notional portrait.

Dwarf gallery An external wall passage screened by a small-scale arcade; found especially in Italian and German Romanesque architecture.

Embrasure A splayed window or door opening in a thick wall.

Evangelary, or Gospel Book A volume containing the four Gospels preceded by canon tables (cross-references) and translator's prefaces by St Jerome. Compare to Evangelistary.

Evangelistary, or Book of Pericopes A book containing extracts of the Gospels in the order required for the complete liturgical year. Compare to Evangelary.

Exegesis Critical explanation or analysis of a text, especially the Bible.

Fresco (Italian: fresh) Watercolor painting on moist plaster, which absorbs and binds with the pigments as it dries.

Gallery A vaulted passageway above the side aisles of a church, sometimes encircling the entire building. Its width matches the side aisles and its arcaded interior wall opens onto the nave. Compare to triforium.

Gospel Book see Evangelary.

Groin vault A vault formed by the intersection of two barrel vaults, whose curved surfaces meet to form an X-shaped projection or "groin." It requires less buttressing than a barrel vault.

Hall church A church without a clerestory. Its nave and side aisles are of equal or near equal height. Especially common in Germany.

Hierophany An artist's presentation of a reality beyond this world, such as the emperor's place in the divine scheme of existence.

Iconography (from Greek *eikon*: image, and *graphein*: to describe) Description and sometimes also categorization of the content and parts of an image. Contrast with iconology.

Iconology The study of the symbolism attached to an image or its components (such as figures, gestures, objects, or geometric shapes). Contrast with iconography.

Impost A plain or projecting masonry block at the top of a pier that appears to support the spring of an arch.

Incarnation* In Christian terms, God as flesh-and-blood.

Jamb A vertical element framing a window or door opening and supporting the lintel; in portals, it is often stepped, molded, or decorated with colonettes or jamb figures.

Keep A high, fortified tower in a medieval castle complex; it served as a watchtower and as a last refuge for the inhabitants, as opposed to a donjon, which performed the same function in a castle not meant for permanent habitation.

Lesene A vertical strip in low relief on an exterior wall, also known as a pilaster strip. Compare pilaster.

Lintel A horizontal member forming the upper part of a door or window frame and supporting the structure above it.

Lunette Semicircular or crescent-shaped decorative area over a door or window; it may contain another window, a sculpture, or a mural.

Maiestas Domini, or Majesty
An image of Christ enthroned, in a mandorla and surrounded by the symbols of the Evangelists (see tetramorph). Can also be accompanied by other apostles, prophets and angels.

Mandorla An almond-shaped nimbus or glory motif surrounding the resurrected Christ or assumpted Virgin.

Missal A book containing the full text required for the Mass, including the order of service; it gradually replaced the sacramentary.

Molding Quasi-architectural element in relief articulating the physical or geometrical structure, or the bay system. Examples include ribs, half-columns, pilasters, responds, and corbels.

Morse ivory Walrus tusk, used in northern Europe as substitute for elephant ivory.

Narthex The vestibule of a basilical church, preceding the nave.

Nave The main longitudinal passage-way in a church, extending from narthex to choir; often flanked by aisles set off by rows of columns or piers, which may support an arcade.

Nimbus A bright or golden disc around a figure's head, signifying holiness or divinity.

Octagon A central building with an eight-sided floor plan.

Oculus A round opening or "eye" in the summit of a dome.

Paradise see Atrium.

Pendentive A triangular section of vaulting surface connecting the rim of a dome to adjacent supporting arches.

Pendentive dome A dome fused with (rather than resting on) its pendentives. This causes the arches to cut into the dome, giving it a scallop-edged appearance.

Pericopes, Book of see Evangelistary

Pier Vertical support member of any shape. Cylindrical piers (drum piers) and complex multiform piers (compound piers) were sometimes used in alternating systems to articulate the modular structure of a Romanesque church.

Pilaster A flattened column in low relief on a wall, often with fluting (vertical grooves) in the shaft.

Profile Contour or vertical section of an architectural element such as a rib, jamb, or cornice.

Radiating chapels Semicircular or polygonal chapels arranged radially around the choir and its ambulatory to form a chevet.

Relic An object of religious veneration, especially a part of a saint's body or personal items that belonged to a saint.

Respond Projecting molding that supports the spring of an arch.

Retable Altarpiece A painted or sculpted panel that functions as a decorative head piece for an altar.

Rib Arched molding forming part of the framework of a vault and usually projecting from the undersurface of the vault canopy. Ribs can run diagonally, longitudinally, or transversely (see also transverse arch).

Ridge turret A slender tower addition set on the ridge of a roof, frequently serving as the bell tower over the crossing of a church; they had special significance on churches of the Cistercian and mendicant orders, which usually had no other towers.

Rusticated block A masonry block with a projecting, roughly cut face that imitated the appearance of raw stone. In Romanesque Germany, they were often rabbeted (surrounded by a decorative, recessed flat strip).

Sacramentary A book containing the canon (consecration of the Host) and prayers for the Mass. In Carolingian times, its illustrations consisted primarily of illuminated initials. A fixed program of imagery included the Crucifixion, Maiestas Domini, scenes from the life of Christ, and images of the Evangelists and saints. Compare to missal.

Sanctuary In a church, the sacred space containing the choir and main altar.

Scriptorium Studio, office and writing room, often in a monastery.

Spolia Architectural elements—column shafts, capitals, friezes, entablatures, cornices, and more—salvaged from the ruins of older building and re-used for reasons of convenience, aesthetics, or symbolic connotations.

Squinch A hollowed out, pendentive-like structure formed by nested and staggered corbelled arches, connecting the rim of the dome to the angular support structure. Compare to pendentive.

Staggered choir see Benedictine Choir

Strainer arch A secondary arch bracing piers or walls against an unbalanced load.

Tetramorph A single figure combining the attributes of the four Evangelist symbols: a winged man, winged lion, winged bull, and (winged) eagle, representing Matthew, Mark, Luke and John respectively.

Transept The transverse part of a cruciform church meeting the nave and choir at the crossing.

Transverse arch A decorative, quasi-supporting arch in relief spanning the vault of a nave and connecting with the responds to articulate the bay system.

Triforium An arcaded passage inside the wall of upper regions of the nave. It usually was set above (or substituted for) the gallery, and below the clerestory.

Triumphal arch In Ancient Rome, a monumental, free-standing arch commemorating an irreversible victory. In a church, the arch leading from the nave to crossing, choir, or apse: i.e. immediately preceding the high altar.

Trumeau A pier or center post supporting the lintel in a window or doorway

Tympanum A recessed wall area inside a pediment, or the arched part of an elaborate window or doorway; often sculpted.

Vault A self-supporting, curved, masonry "ceiling." The most common Romanesque forms include the barrel vault and groin vault, often articulated with transverse arches.

Westwork The monumental west end of Carolingian, Ottonian, or German Romanesque churches, consisting of the narthex, imperial gallery or chapel, and twin towers.

Bibliography

Romanesque art in overview; social history

Borst, Arno, Lebensformen im Mittelalter, Frankfurt .a. M./Berlin/Vienna 1979

Dinzelbacher, Peter (ed.), Europäische Mentalitätsgeschichte, Stuttgart 1993

Droste, Thorsten, Romanische Kunst in Frankreich, Cologne 1992

Duby, Georges, Die Zeit der Kathedralen, Frankfurt a. M. 1980

Duby, Georges, Die drei Ordnungen, Frankfurt a. M. 1981

Duby, Georges, Die Kunst der Zisterzienser, Stuttgart 1993

Durliat, Marcel, Romanische Kunst, Freiburg 1983

Durliat, Marcel, Romanisches Spanien, Würzburg 1995

Fuhrmann, Horst, Einladung ins Mittelalter, Munich 1987

Goetz, Hans-Werner, Leben im Mittelalter, Munich 1986

Gurjewitsch, Aaron J., Das Weltbild des mittelalterlichen Menschen, Munich 1986

Klotz, Heinrich, Gesch. der dt. Kunst, vol. 1: Mittelalter, Munich 1998

Lambert, Malcolm, Ketzerei im Mittelalter, Munich 1981

Legner, Anton, and Hirmer, Albert and Irmgard, Deutsche Kunst der Romanik, Munich 1982

Legner, Anton (ed.), Ornamenta Ecclesiae. Kunst und Künstler der Romanik, Vol. 1–3 (catalog), Cologne 1985

Le Goff, Jacques, Die Intellektuellen im Mittelalter, Stuttgart 1986

Leriche-Andrieu, Françoise, Einführung in die romanische Kunst, Würzburg 1985

Oursel, Raymond, Romanisches Frankreich. 11. Jahrhundert, Würzburg 1991

Oursel, Raymond, Romanisches Frankreich. 12. Jahrhundert, Würzburg 1991

Petzold, Andreas, Romanische Kunst, Cologne 1995

Runciman, Steven, Geschichte der Kreuzzüge, 3rd ed. Munich 2001

Schwaiger, Georg (ed.), Mönchtum, Orden, Klöster, Munich 1993

Simson, O. v., Das Mittelalter II. Das hohe Mittelalter (Propylän Kunstgeschichte, vol. 6), Berlin 1972

Wollasch, J., Mönchtum des Mittelalters zwischen Kirche und Welt, Munich 1973

Wollasch, Joachim, Cluny – Licht der Welt. Aufstieg und Niedergang der klösterlichen Gemeinschaft, Zürich–Düsseldorf 1996

Architecture
General

Adam, Ernst, Baukunst des Mittelalters, 2 vol., 2nd ed., Frankfurt 1968

Bandmann, Günter, Die Bauformen des Mittelalters, Bonn 1949

Bandmann, Günter, Mittelalterliche Architektur als Bedeutungsträger, 10th ed., Berlin 1994

Conant, Kenneth John, Carolingian and Romanesque Architecture 800–1200, Harmondsworth ed. New York 1987

Das Reich der Salier. Exhibit catalog, Mainz 1992

Die Zeit der Staufer. Geschichte – Kunst – Kultur Exhibit catalog, Stuttgart 1977

Die Zisterzienser. Ordensleben zwischen Ideal und Wirklichkeit. Exhibit catalog, Aachen 1980

Gall, Ernst, Studien zur Geschichte des Chorumgangs, in Monatshefte für Kunstwissenschaft 5 (1912) 134–149, 358–376, 508–519

Kubach, Hans Erich, and Bloch, Peter, Früh- und Hochromanik, Baden-Baden 1964

Schütz, Bernhard, and Müller, Wolfgang, Romanik, Freiburg 1990

Germany

Adam, Ernst, Baukunst der Stauferzeit in Baden-Württemberg und im Elsaß, Stuttgart 1977

Dehio, Georg, Handbuch der deutschen Kunstdenkmäler in Neubearbeitungen

Deutsche Königspfalzen. Beiträge zu ihrer historischen und archäologischen Erforschung (Veröffentlichungen des Max-Planck-Instituts für Geschichte, II, 1-2) 2 vol.s, Göttingen 1963–1966

Kautzsch, Rudolf, Der romanische Kirchenbau im Elsaß, Freiburg 1944

Kubach, Hans Erich, Verbeek, Albert, Romanische Baukunst an Rhein und Maas, 4 vol.s, Berlin 1976/1989

Meyer-Barkhausen, Werner, Das große Jahrhundert Kölnischer Kirchenbaukunst 1150–1250, Cologne 1952

Schlag, G. Die deutschen Kaiserpfalzen, Frankfurt 1940

Schütz, Bernhard, and Müller, Wolfgang, Deutsche Romanik, Freiburg 1988

Stadtspuren – Denkmäler in Köln, 17 vol.s, 1984 ff.; vol. 1 Köln: Die romanischen Kirchen, Cologne 1984

Untermann, Matthias (ed.), Klosterinsel Reichenau im Bodensee. Arbeitsheft des Landesdenkmalamtes Baden-Württemberg 8, Stuttgart 2001

Verbeek, Albert, Kölner Kirchen. Die kirchliche Baukunst in Köln von den Anfängen bis zur Gegenwart, Cologne 1959

Winterfeld, Dethard von, Romanik am Rhein, Stuttgart 2001

Winterfeld, Dethard von, Die Kaiserdome und ihr romanisches Umfeld, Würzburg 1993

Wischermann, Heinfried, Romanik in Baden-Württemberg, Stuttgart 1987

Wischermann, Heinfried, Speyer I – Überlegungen zum Dombau Konrads II. und Heinrichs III., in Berichte und Forschungen zur Kunstgeschichte 11, Freiburg 1993

England

Bony, Jean, Tewkesbury et Pershore – deux elevations à quatre étages de la fin du 11e siècle, in Bulletin Monumental 96 (1937) 281 ff, 503 f.

British Archaeological Association Conference Transactions I Worcester 1975 (1978) II Ely 1976 (1979) III Durham 1977 (1980) IV Wells/Glastonbury 1978 (1981) V Canterbury 1979 (1982) VI Winchester 1980 (1983)

Clapham, Alfred W., English Romanesque Architecture after the Conquest, 2nd ed., Oxford 1964

Fisher, E. A., The Greater Anglo-Saxon Churches: An Architectural-Historical Study, London 1962

Webb, Geoffrey F., Architecture in Britain: The Middle Ages, Harmondsworth 1956

Wischermann, Heinfried et. al., Die romanische Kathedrale von Worcester – Baugeschichte und architekturgeschichtliche Stellung, in BuF 9, Freiburg 1985

France

Armi, Clement Edson, Saint-Philibert at Tournus and the Wall Systems of First Romanesque Architecture, diss. Columbia Univ., NY 1973

Baum, Julius, Rom. Baukunst in Frankreich, 2nd ed., Stuttgart 1928

Bony, Jean, La technique normande du mur épais à l'époque romane, in Bulletin Monumental 98 (1939) 153 ff.

Conant, Kenneth John, Cluny: Les églises et la maison du chef d'ordre, Mâcon 1968

Gaillard, Georges, Sur la chronologie de Tournus, in Revue archéologique 49 (1957) 47–59

Gall, Ernst, Saint-Philibert in Tournus, in Zeitschrift für Kunstgeschichte 17 (1954) 179–182

Laule, Bernhard and Ulrike, Wischermann, Heinfried, Kunstdenkmäler in Südfrankreich, Darmstadt 1989

Laule, Bernhard and Ulrike, Wischermann, Heinfried, Kunstdenkmäler in Burgund, Darmstadt 1991

Liess, Reinhard, Der frühromanische Kirchenbau des 11. Jahrhunderts in der Normandie. Analysen und Monographien der Hauptbauten, Munich 1967

Oursel, Charles, L'art roman de Bourgogne, Dijon – Boston 1928

Schlink, Wilhelm, Saint-Bénigne in Dijon. Untersuchungen zur Abteikirche Wilhelms von Volpiano (962–1031), Berlin 1978

Sedlmayr, Hans, Die Ahnen der dritten Kirche von Cluny, in Festschrift für Hubert Schrade, Stuttgart 1960

Sennhauser, Rudolf, Romainmôtier und Payerne. Studien zur Cluniazenserarchitektur des 11. Jahrhunderts in der Westschweiz, Basel 1970

Wischermann, Heinfried et. al., Die romanische Kirchenbaukunst der Normandie - ein entwicklungsgeschichtlicher Versuch, in BuF 6, Freiburg 1982

Wischermann, Heinfried et. al., Saint-Philibert in Tournus – Baugeschichte und architekturgeschichtliche Stellung, in BuF 10, Freiburg 1988

Italy

Cadei, F., L'Umbria, Mailand 1994

Chierici, S., La Lombardia, Mailand 1991

Ciccarelli, D., La Sicilia, Mailand 1986

Guyer, S., Der Dom in Pisa und das Rätsel seiner Entstehung, in Münchner Jahrbuch der Bildenden Kunst (1932) 351 ff.

Krönig, Wolfgang, Stefano, G. di, Monumenti della Sicilia normanna, 2nd ed., Palermo 1979

Krönig, Wolfgang, Kunstdenkmäler in Italien. Sizilien, Darmstadt 1986

Moretti, I., and Stopani, R., La Toscana, Mailand 1991

Rill, B., Sizilien im Mittelalter. Das Reich der Araber, Normannen und Staufer, Zürich 1995

Willemsen, Carl A., Apulien: Kathedralen und Kastelle, 2nd ed., Cologne 1973

Scandinavia

Bugge, Gunnar, Stabkirchen – Mittelalterliche Baukunst in Norwegen, Regensburg 1994

Phleps, Hermann, Die norwegischen Stabkirchen. Sprache und Deutung der Gefüge, Karlsruhe 1958

Cinthio, E., Lunds Domkyrka under romansk tid, Lund 1957

Cornell, H., Sigunta och Gamla Uppsala, Stockholm 1920

Lindqvist, S., Gamla Uppsala fornminnen, Stockholm 1929

Wrangel, E., and O. Rydbeck, Lunds Domkyrka, 3 vol.s, Lund 1923

Spain

Conant, Kenneth J., The Early Arch. History of the Cathedral of Santiago de Compostela, Cambr., MA 1926

Czuchra, Andreas, Abt Oliba Cabreta und der frühromanische Kirchenbau in Katalonien, diss. Freiburg 1985

Durliat, Marcel, L'architecture espagnole, Toulouse 1966

Palol, P. de, and Hirmer, Max, Spanien: Kunst des frühen Mittelalters vom Westgotenreich bis zum Ende der Romanik, Munich 1965

Zahn, Leopold, Die Klosterkirche Sant Pere de Roda, diss. Freiburg 1976

Romanische Skulptur

Ariès, P., Geschichte des Todes, Munich 1982

Barral, I. Altet, X., Avril, F., and Gaborit-Chopin, D. (ed.s), Romanische Kunst. Vol I: Mittel- und Südeuropa 1060–1220, Munich 1983, Vol II: Nord- und Westeuropa 1060–1220, Munich 1984

Beck, H., and Hengevoss-Dürkop, K. (ed.s), Studien zur Geschichte der europäischen Skulptur im 12./13. Jahrhundert. Vol. 1 Text, Frankfurt am Main 1994

Bredekamp, H., Die nordspanische Hofskulptur und die Freiheit der Bildhauer, in Beck, Hengevoss-Dürkop

Bredekamp, H., Romanische Skulptur als Experimentierfeld, in Hänsel/Karge (ed.s), Spanische Kunstgeschichte: Eine Einführung. Vol. 1: Von der Spätantike bis zur frühen Neuzeit, Berlin 1991

Bredekamp, H., Wallfahrt als Versuchung. San Martin in Frómista, in Kunstgeschichte – Aber wie?, Berlin 1989

Brepohl, E., Theophilus Presbyter und das mittelalterliche Kunsthandwerk. Gesamtausgabe der Schrift de diversis artibus in zwei Bänden, Cologne, Weimar, Vienna 1999

Budde, R., Deutsche Romanische Skulptur 1050–1250, Munich 1979

Bußmann, K., Burgund: Kunst, Geschichte, Landschaft, Cologne 1977, 1987

Chierici, S., Romanische Lombardei, Würzburg 1978

Claussen, P. C., Künstlerinschriften, in Ornamenta Ecclesiae. Exhibit catalog, Cologne 1985, vol. 1

Dietel, A., Künstlerinschriften als Quelle für Status und Selbstverständnis von Bildhauern, in Beck, Hengevoss-Dürkop

Duby, G., Sculpture: The Great Art of the Middle Ages from the Fifth to the Fifteenth Century, New York 1990

Durliat, M., La sculpture romane en Roussillon. Vol.s I–IV, Perpignan 1952–1954

Eliade, M., Die Religionen und das Heilige, Darmstadt 1976

Fegers, H., Provence, Côte d´Azur, Dauphiné, Rhône-Tal. Reclams Kunstführer Frankreich, vol. IV, Stuttgart 1967, 2nd ed. 1975

Fillitz, H., Das Mittelalter 1. Propyläen Kunstgeschichte. Special edition, Frankfurt am Main, Berlin 1990

Forster, K. W., and Benedetto Antelami. Der große romanische Bildhauer Italiens, Munich 1961

Geese, U., Reliquienverehrung und Herrschaftsvermittlung. Die mediale Beschaffenheit der Reliquien im frühen Elisabethkult, Darmstadt and Marburg 1984

Geese, U., Romanische Skulptur, in Die Kunst der Romanik: Architektur, Skulptur, Malerei, Cologne 1996

Grimme, E. G., Goldschmiedekunst im Mittelalter: Form und Bedeutung des Reliquiars von 800 bis 1500, Cologne 1972

Kauffmann, G., and Andreae, B., Toskana (ohne Florenz): Kunstdenkmäler und Museen. Reclams Kunstführer Italien, vol. III, 2, Stuttgart 1984

Kauffmann, G., and Emilia-Romagna, Marken, Umbrien. Baudenkmäler und Museen. Reclams Kunstführer Italien. Vol. 4, Stuttgart 1971, 3rd ed. 1987

Kerscher, G., Benedictus Antelami oder das Baptisterium von Parma: Kunst und kommunales Selbstverständnis, diss., Munich 1986

Legler, R., Apulien, Cologne 1987

Legler, R., Languedoc–Roussillon: Von der Rhône bis zu den Pyrenäen, Cologne 1981, 3rd ed. 1985

Lyman, Th., Heresy and the History of Monumental Sculpture in Romanesque Europe, in Beck, Hengevoss-Dürkop

Mende, U., and Hirmer, A. u. I., Die Bronzetüren des Mittelalters 800–1200, Munich 1994

Meyer Schapiro, Romanische Kunst, Cologne 1987

Pace, V., Kunstdenkmäler in Süditalien, Darmstadt 1994

Palol, P. de, Spanien: Kunst des frühen Mittelalters vom Westgotenreich bis zum Ende der Romanik, Munich 1991

Pevsner, N., Berkshire: Buildings of England, Harmondsworth 1966

Pevsner, N., Wiltshire: The Buildings of England, Harmondsworth 1963

Romanik in Mitteldeutschland, Wernigerode 1994

Rupprecht, B., Romanische Skulptur in Frankreich, Munich 1975, 2nd ed. 1984

Schomann, H., Kunstdenkmäler in der Toskana, Darmstadt 1990

Schomann, H., Lombardei: Kunstdenkmäler und Museen. Reclams Kunstführer Italien, vol. I, 1, Stuttgart 1981

Stocchi, S., Romanische Emilia-Romagna, Würzburg 1986

Willemsen, R., Abruzzen, Cologne 1990

Zimmermann, K., Umbrien, Cologne 1987

Romanesque Painting

Bauer, C., Corvey oder Hildesheim: Zur ottonischen Buchmalerei in Norddeutschland, Hamburg 1977

Bauer, G. Abendländische Grundlagen und byzant. Einflüsse in den Zentren der westlichen Buchmalerei, in Kunst im Zeitalter der Kaiserin Theophanu, Cologne 1993

Beet, E. J., Zur Buchmalerei der Zisterzienser im oberdeutschen Gebiet des 12. und 13. Jahrhunderts: Baukunst und Bildkunst im Spiegel internationaler Forschung. Festschrift für E. Lehmann, Berlin 1989

Bloch, P., and Schnitzler, H., Die ottonische Kölner Buchmalerei. 2 vol.s, Düsseldorf 1970

Blume, D., Wandmalerei als Ordnungspropaganda: Bildprogramme im Chorbereich franziskanischer Konvente Italiens bis zur Mitte des 14. Jahrhunderts, Worms 1983

Bornheim, gen. Schiffing, W., Bemalte und gemalte karolingische Architektur, in Deutsche Kunst und Denkmalpflege vol. 36, 1978

Burger, L., Die Himmelskönigin der Apokalypse in der Kunst des Mittelalters, 1937

Demus, O., Romanische Wandmalerei, Munich 1968

Frodl, W., Austria: Medieval Wall Paintings, New York 1964

Harnischfeger, E., Die Bamberger Apokalypse, Stuttgart 1981

The Golden Age of Anglo-Saxon Art 966–1066, exhibit catalog, British Museum, London 1984

Heinrich der Löwe und seine Zeit, exhibit catalog Braunschweig (ed. I. Luckhardt und Fr. Niehoff), Munich 1995

Hoffmann, K., Buchkunst und Königtum im ottonischen und salischen Reich, 2 vol.s, Stuttgart 1986

Klein, M., Schöpfungsdarstellungen: mittelalterlicher Wandmalereien in Baden-Württemberg und in der Nordschweiz, Freiburg 1982

Klemm, E., Das sogenannte Gebetbuch der Hildegard von Bingen, in Jahrbuch der Kunsthistorischen Sammlungen in Wien 74, 1978

Kluckert, E., Romanische Malerei, in Die Kunst der Romanik. Architektur, Skulptur, Malerei, Cologne 1996

Köhler, W., Mütherich, F., Die karolingischen Miniaturen V, Berlin 1982

Kühnel, E., Drachenportale, in Zeitschrift für Kunstwissenschaft vol. 4, 1950

Martin, K., Die ottonischen Wandfresken der St. Georgskirche, Reichenau-Oberzell, Sigmaringen 1975

Mayr-Harting, H., Ottonische Buchmalerei, Darmstadt 1991

Mazal, O., Buchkunst der Romanik, Graz 1978

Mütherich, F. Studien zur mittelalterlichen Kunst. 800–1250. Festschrift für E. Mütherich, Munich 1985

Murbach, E., Zillis, Zürich, Freiburg i. Br. 1967

Legner, A. (ed.), Ornamenta Ecclesiae: Kunst und Künstler der Romanik. Exhibit catalog, Cologne 1985

Nordenhagen, P. J., Studies in Byzantine and Early Medieval Painting, London 1990

Pächt, O., Buchmalerei des Mittelalters, Munich 1989

Pächt, O., The Pre-Carolingian Roots of Early Romanesque Art, in Studies in Western Art vol. 1, 1963

Rudloff, D., Kosmische Bildwelt der Romanik, Stuttgart 1989

Schrade, H., Die romanische Malerei, Cologne 1963

Stein, H., Die romanischen Wandmalereien in der Klosterkirche Prüfening, Regensburg 1987

Index

Picture Credits

Most of the illustrations, which are not listed individually here, were taken by the Cologne architecture photographer Achim Bednorz. The publisher thanks the museums, archives, and photographers for their permission to reproduce the images and their friendly support during the production of this book. The publisher and the editor made every effort to ascertain any additional holder of picture rights up until the time of publishing. Persons and institutions who possibly could not be reached and hold rights to images that appear in this book are kindly requested to contact the publisher.

m=middle a=above b=below l=left r=right

© 2002 Feierabend Verlag OHG
Mommsenstraße 43
D-10629 Berlin

Project management: Bettina Freeman
Translation from German: Eric Martinson
Editing: Perette E. Michelli
Coordination and typesetting: APE Intl., Richmond VA
Design management: Erill Vinzenz Fritz
Layout: Roman Bold & Black, Thomas Paffen
Picture editor: Petra Ahke
Lithography: scannerservice, Verona

Printing and binding: Eurolitho s.p.a., Milan

Printed in Italy
ISBN 3-936761-58-2
61 05 006 1